ALICE IN JAPANESE WONDERLANDS

ALLISON ALEXY
Series Editor

Animated Encounters: Transnational Movements of Chinese Animation, 1940s–1970s
DAISY YAN DU

Pop Empires: Transnational and Diasporic Flows of India and Korea
EDITED BY S. HEIJIN LEE, MONIKA MEHTA, AND ROBERT JI-SONG KU

Puppets, Gods, and Brands: Theorizing the Age of Animation from Taiwan
TERI SILVIO

Legacies of the Drunken Master: Politics of the Body in Hong Kong Kung Fu Comedy Films
LUKE WHITE

Queer Transfigurations: Boys Love Media in Asia
EDITED BY JAMES WELKER

Alice in Japanese Wonderlands: Translation, Adaptation, Mediation
AMANDA KENNELL

For Gwen Kennell and Betty Elam

Contents

Series Editor's Preface	ix
Acknowledgments	xi
A Note on Names	xiii

Chapter 1
A Re-introduction — 1

Chapter 2
Ryūnosuke Akutagawa in the Shadow of Early *Alice* Translations — 39

Chapter 3
Yayoi Kusama, the Modern Alice (Through the Looking-Glass) — 74

Chapter 4
A Profusion of Alices Flutter through Manga for Girls and Boys — 104

Chapter 5
Detecting *Alice* on Page, Screen, and Street — 138

Chapter 6
In Conclusions — 170

Appendix: Japanese Alices — 177

Notes — 191

Works Cited — 203

Index — 217

Color insert follows page 38

Series Editor's Preface

The first and only time my American mother visited Japan, she politely introduced herself to my friends by first explaining that her name, Alice, was old fashioned and no doubt unfamiliar to many of them. "Alice," one person explained kindly but assuredly, *"everyone* in Japan knows your name!" This new work from Amanda Kennell demonstrates the depth of that statement through the enduring, flexible, and complex associations generations of Japanese have had with Alice since her first appearance in Lewis Carroll's *Alice* books.

Alice in Japanese Wonderlands provides vital perspective on a fan (sub)culture that might be less visible to the mainstream—or is perhaps so visible that it's hiding in plain sight. As I read this book, I realized that I too have seen Alice characters in unexpected places in Japan—from TV commercials for seemingly random products to gothic-style manga and bank cards. Kennell reveals that Alice is truly everywhere in Japan and has been for many years. For her, this omnipresence offers a striking opportunity for culturally-located media analysis, an engagement with the media mix that neither ignores nor reinforces an exoticism and orientalism that might otherwise occur.

Through Kennell's thoughtful analysis, *Alice in Japanese Wonderlands* offers us an entry point to a particular fan culture that, in turn, pulls us in to deeper analysis and creative engagement—a magical, generative, and provocative wonderland into which we gladly fall.

Acknowledgments

Writing a book during a pandemic is its own journey through Wonderland, but one that is, thankfully, peopled by characters who give far better aid than the Mad Hatter. Material aid, as well. The final stages of this book's production were supported by a Publication Support Grant that was administered by the Association for Asian Studies with funding from the National Endowment for the Humanities. Earlier stages of the project were supported by the Sainsbury Institute for the Study of Japanese Arts and Cultures, the Andrew W. Mellon Digital Humanities program at the University of Southern California, USC Libraries and its Cassady Lewis Carroll Collection, the Nippon Foundation, the Shinso Ito Center for Japanese Religions and Culture, the East Asian Studies Center at USC, the North American Coordinating Council on Japanese Library Resources, Michael J. Downey's Hashi.org, George and Linda Cassady, and Barbara Inamoto.

The unusual nature of my research materials meant that the completion of this book depended on the kindness of individual collectors, all of whom were strangers when I first embarked upon this project. Their kindness and openness have affected far more than just *Alice in Japanese Wonderlands*. While I am indebted to dozens of Carrollians around the world, I would particularly like to thank Yoshiyuki Momma, George and Linda Cassady, and Clare and August Imholtz for their sustained support. Though I doubt they identify as Carrollians, Mike and Sue Resner also sponsored my *Alice* research. Nicole Coolidge Rousmaniere kindly opened my eyes to new ways of thinking about research and collaborating with others while we worked on the British Museum's *Manga* exhibit. That experience led to an expansion of my work with manga, including a collaboration with Shinichi Kinoshita that gave me a new perspective on *Alice* manga.

A wide variety of people aided me as I followed my own White Rabbit across high culture and low, new media and old, Asian and European nations. I am grateful to Seth Murray at North Carolina State University and Walt Hakala at the University at Buffalo for supporting my research while I held teaching positions at both universities. Marc Steinberg has repeatedly lent me his insights and encouragement while I tried to balance media analysis with *Alice* analysis.

xii Acknowledgments

Rayna Denison has helped me weld analysis, fandom, and leadership by her words and actions. Takayuki Tatsumi is due credit for ensuring that this Asian Studies scholar spoke somewhat intelligently about English literature, and Peter Mancall and Amy Braden guided me through digital Wonderlands. Thomas Lamarre, Mari Kotani, Griseldis Kirsch, Nobuko Anan, Michiko Oshiyama, Brett de Bary, Linda Flores, and Chris Perkins helped me develop as a scholar through the "Adaptation, or How Media Relate in Japan" workshop. Simon Kaner, Toshio Watanabe, Vanessa Schwartz, Kurosh ValaNejad, and Jan Bardsley helped me hone the book's interdisciplinary approach so that depth of knowledge was not sacrificed for broadness of approach. This project would never have gotten off the ground without David Bialock, Satoko Shimazaki, Sunyoung Park, Miya Mizuta, Ayako Kano, Linda Chance, and Leo Braudy. My deepest thanks go to Akira Lippit, who provided education, guidance, and serenity in an academic hat trick that has now gone on for over a decade.

I have benefitted more generally from the friendship and advice of a variety of scholars in the United States and Japan. My thanks go out to Rika Hiro, Young Sun Park, Kohki Watabe, Eike Exner, Kathryn Hemmann, Brooke McCorkle, Sean Rhoads, Chad Walker, and Jesse Drian for their support . . . and occasional kindly prods to do better. Victoria Davis aided in those respects and also provided hands-on assistance during a wild period that was worth its weight in platinum. Thanks are also due the pinch-hitting trio of Heather, Megan, and Kate for pitching in as only friends can.

My editor, Stephanie Chun, has shepherded this book from a rather inelegant collection of chapters into a proper book. An early version of one of those chapters, chapter 3, was published in the *Journal of Adaptation in Film and Performance* as "Yayoi Kusama, the Modern Alice" under the thoughtful guidance of its editor, Richard Hand.

Finally, I would like to express my appreciation for Colen and Elaine Kennell, who have supported me in every way for longer than I can remember. I hope you enjoy the results.

A Note on Names

All names in this book are written in the Western order (i.e., Given name Surname) except as indicated in the text.

This book distinguishes between fictional worlds and their physical instantiations in books, films, and other media. Worlds are generally indicated here by capitalizing the name commonly applied to them, as in Lord of the Rings. Specific instantiations, such as J. R. R. Tolkien's *The Fellowship of the Ring* novel, are treated as per the Chicago style. The only exception to this rule is the Alice in Wonderland world, which is indicated with both Alice in Wonderland and *Alice* for ease of reading. The Japanese-language titles of specific works of art are italicized or placed within quotation marks as they would be if they were in English.

CHAPTER 1

A Re-introduction

"Alice is Everywhere"
—Heather Haigha

As the twentieth century turned into the twenty-first, Japanese popular culture became global popular culture. Edgy animated films and television shows, risqué underground manga, or comics, and entrancing video games attracted teenagers and young adults around the world. These fans created circuits of media transmission and communities of cultural appreciation that familiarized the general population with characters like Sailor Moon and Godzilla, terms like anime and manga, and even the ur-code of gaming success, Nintendo's up-up-down-down-left-right-left-right-A-B-start. The dizzying array of Japanese characters, terms, hobbies, and standards that spread across the world was layered onto Orientalist lodestones like the kimono and samurai to paint a deeper, but still exoticized, portrait of Japan. This portrait lies.

If, lured by the wonders of Japanese popular culture, you visit Japan today, you might find yourself staying in the Alice Hotel & Healing Spa (figure 1.1a).[1] Beckoning customers into "Wonderland for adults," rooms are decorated with checkerboard, teardrop, and flower patterns that subtly nod to the imagery of Lewis Carroll's Alice in Wonderland novels. You could pass some time writing a letter home on *Alice* stationery (figure 1.1d) and enjoying a snack—perhaps some Earl Grey tea-flavored chocolates emblazoned with Disney's animated Alice by the chocolatier Meiji (figure 1.1b). Inspired by your evening, you might spend the following day shopping for more *Alice* goods: an *Alice* pin by freelance designer 0313 (figure 1.1c), a shirt emblazoned with young Alice by the Japanese fashion house Putumayo, Chiaki J. Konaka's *Alice in Cyberland* video game, an *Alice* washcloth (by Marushin), or the wide range of *Alice* fabrics, temporary tattoos, and other goods available at the department store Tokyu Hands. If hunger overcame you, you could settle into a booth at one of Diamond Dining Group's *Alice*-themed cafés to read Kaori Yuki's *Alice in Murderland* manga before continuing

1

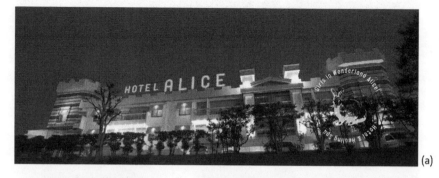

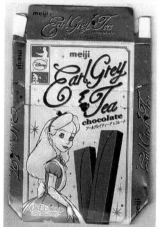

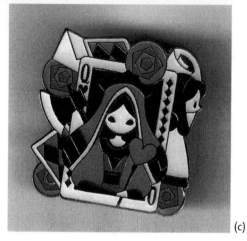

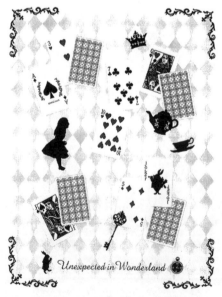

Figure 1.1. (a) Despite taking the name of *Alice*, Nagasaki's Alice Hotel & Healing Spa avoids overt *Alice* imagery in the headmast of its website. (b) A package of Earl Grey Tea chocolates featuring the Walt Disney Company's animated Alice in a half-drawn design echoes the silhouetted Alice motif that is popular in Japan. (c) Graphic designer 0313's pin features Alice half-hidden in the background to the right of the Queen of Hearts. (d) T. Haneishi's Unexpected in Wonderland stationery for Gakken Sta:Ful displays Alice in silhouette amongst fully detailed, multicolored cards.

your spending spree at the Alice on Wednesday store to acquire *Alice* accessories, home décor, and snacks as souvenirs of your trip. You might take in an art exhibit like *Carroll Modernology* (*Kyaroru kōgengaku*, plate 1) or enjoy a showing of Mika Matsukuni's *Alice in Fatland* (*Futome no kuni no Arisu*, 2012) film to rest your feet before visiting the famed Nakano Broadway mall to buy some fan-made *Alice* comics. Finally, you definitely want to detour to the nearby *Alice* bar on your way back to the hotel.

As iconic as Alice in Wonderland is, you probably would not expect it to form the heart of a trip to Japan. Nonetheless, it has become a central part of Japanese culture. Japanese companies have published over five hundred translations of Carroll's *Alice* novels by authors as prominent as Yukio Mishima and Ryūnosuke Akutagawa, while generations of Japanese students have muddled through their required English-language classes with the help of textbooks containing *Alice* excerpts (Momma 2015, 317–318). Modern Japan's most famous fashion vogue, Lolita, adapts *Alice* together with France's Rococo style (Takemoto 2014). Arguably the most successful fine artist in the world, Yayoi Kusama proclaimed herself the "Modern Alice," while creators as diverse as the best-selling manga artist collective CLAMP, screenwriter Chiaki J. Konaka, and director Shunji Iwai quietly produced entire series of *Alice* adaptations. Today, *Alice* is adapted into Japanese literature, fine art, manga, live-action film and television shows, anime, video games, clothing, restaurants, and household goods consumed by Japanese people of all ages and genders for a variety of reasons. Any analysis of Japanese culture that excludes *Alice* must therefore be incomplete.

Japan's riot of *Alice* adaptations exceeds *Alice*'s presence in other nations, but the tendency to adapt *Alice* exists everywhere. Japan's *Alice in Fatland* film is matched by Jan Švankmajer's *Alice* (Czechoslovakia, *Něco z Alenky*, lit. "Something from Alice," 1988); Eduardo Plá's *Alice in Wonderland* (Argentina, *Alicia en el país de las maravillas*, 1976); Claude Chabrol's *Alice or the Last Escapade* (France, *Alice ou la dernière fugue*, 1977); and Eun Hee Heo's *Alice: Boy from Wonderland* (South Korea, *Aelliseu: Wondeoraendeu eseo on sonyeon*, 2015).[2] Where Japanese gamers enjoy *Alice in Cyberland*, the first-ever *Alice* computer game appears to be Apple's 1984 *Through the Looking Glass* for the Macintosh computer.[3] Another American video game, *American McGee's Alice* (2000), is something of a landmark for its imaginative merger of *Alice* with the horror genre. Across the Atlantic, earlier game formats are preferred, as in House of Marbles' *The Wonderful Game of Tea Party Ludo, or Pachisi* (England, n.d.) and Aldébaran Geneste's *Play Me* (France, 2016) dice game. *Alice* tea sets have been produced by Japan's Musashino Kogyo Co., Ltd. and France's Georges Boyer porcelain company alike, while Japan's *Alice* eateries are matched by restaurants like White Rabbit (Russia) and cat cafés like

Figure 1.2 (a) Australian model Duckie Thot as Alice for Italian tire company Pirelli's 2018 calendar shot by Tim Walker. (b) A political campaign sign for the candidate running as "Mad Hatter," a party organizer and tour guide called Alasdair outside of political events. Seen in Oxford, England, in April of 2015.

(a)

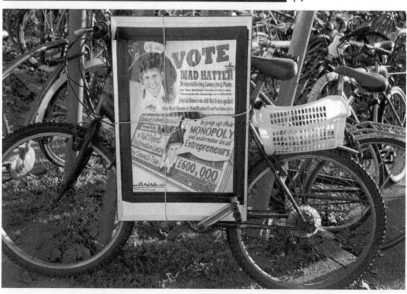

(b)

Lady Dinah's Emporium (England). Takako Hirai's *Alice* calendar (Japan, plate 2) contrasts with the Pirelli tire company's *Alice* calendar (Italy, figure 1.2a). *Alice* has even been adapted into political advertisements (figure 1.2b)! *Alice* ballets, plays, and operas have been staged and restaged around the world thanks to a globalized performance market. Elite creators like Salvador Dali (Spain), Vladimir Nabokov (Russia), Jaan Kross (Estonia), James Joyce (Ireland), and Gilles Deleuze (France) have adapted *Alice*. A listing of just some of America's *Alice*-adapting musicians covers a wide swath of post–World War II music history: Aerosmith, Avril Lavigne, Jefferson Airplane, Jewel, John Lennon, LaVern Baker, Tom Waits, and a joint effort by Panic! at the Disco and Fun.[4]

Japanese people's *interest* in *Alice* is thus normal to the point of banality. What is striking about Japanese *Alice* adaptations is not their existence or variety but their sheer number. With more than five hundred Japanese *Alice* translations, there are more editions of *Alice* in Japanese than in any other language but English. *Alice* may have been translated into Estonian by the Nobel Literature Prize nominee Jaan Kross, but his *Alice Imedemaal* (1971) is one of only ten translations in that language. South Korea produced one *Alice* video game— NARAENC's *Alice Summoning Project* (*Aelliseu sohwan peurojekteu*, 2015)—to Japan's dozens. Russia likewise has one *Alice* eatery to at least eight in Japan. Japan's *Alice* works are produced incessantly, which has led to both ubiquity and the refinement of what exactly constitutes *Alice*.

What Is *Alice*?

Most people seem to think that Alice in Wonderland is a book by Lewis Carroll. Some further know that Lewis Carroll is the pen name of Charles Lutwidge Dodgson. Yet, Carroll never wrote a book called Alice in Wonderland. He wrote *Alice's Adventures in Wonderland* (1865) and its sequel, *Through the Looking-Glass, and What Alice Found There* (1871), but not a book entitled *Alice in Wonderland*.[5] When people think of "Alice in Wonderland," they generally think of various aspects of these two books (hereafter *Alice's Adventures* and *Looking-Glass*, respectively). We might blame Walt Disney, Co., for the confusion, as their 1951 animated film *Alice in Wonderland* memorably blended the books together. However, Disney's current status as a cultural behemoth can blind us to the limitations of its reach. Disney's use of the *Alice in Wonderland* title here reflects a pre-existing tendency to conflate *Alice's Adventures* and *Looking-Glass*. As early as 1904, a handwritten English book cites a quote from *Alice's Adventures* as "(From Alice in Wonderland)" (*Ada Deene*, 3). This casual usage of a name that does not refer to a specific thing, yet still conveys . . . something to readers, is key to understanding media today.

6 Chapter 1

We often contact major cultural artifacts indirectly before we connect with them directly. Children are more likely to pick up phrases like "to be, or not to be" from hearing other people refer to *Hamlet* than from watching the play themselves. As we repeat, rephrase, adapt, and otherwise invoke older works, we change them. It may seem unremarkable to say that you will "go down the rabbit hole," but that phrase does not exist in Carroll's text. Carroll's actual phrasing, "in another moment down went Alice after it" (2015, 12), makes no sense outside of the context of the book. When we say that we are "going down a rabbit hole," we are invoking the essence of that particular passage, its significance. "Going down a rabbit hole" means leaving the safe, ordered confines of the everyday to adventure through an unlogical world for an unknown period of time.[6] We signify that essence with new phrasing that is detached from Carroll's texts.

The essence of Alice in Wonderland is also detached from Carroll's *Alice* texts, of which there are five. The published *Alice's Adventures in Wonderland* is based on a story Carroll told to his neighbors' children. Carroll hand-wrote and -illustrated an early version of the text, *Alice's Adventures Under Ground* (1864), for one of those children, Alice Liddell. This text was later copied and publicly published. Carroll later rewrote *Alice's Adventures in Wonderland* for a younger audience and published it as *The Nursery Alice* (1890). He also published an extended poem set in Wonderland and featuring a few minor characters from the prior books, *The Hunting of the Snark: An Agony in Eight Fits* (1876). A complete listing of Carroll's Alice in Wonderland books thus includes five books, three of which are rather obscure.[7] *Under Ground, Nursery Alice,* and *Snark's* inconspicuousness underlines how separate "Alice in Wonderland" has become from Carroll's books. These texts' content has filtered out into mass culture despite consumers' lack of knowledge about them. *Snark's* Boojum character, for example, appears in the cult hit video game *American McGee's Alice* (2000), while *Under Ground* "has been making inroads into classical music" (Fairman 2020) through ballets and operas. These adaptations are recognized as adaptations of "Alice in Wonderland" (Prolix 2000)—and sometimes just "Alice" (Nice 2016)—even though the books are known primarily by *Alice* aficionados.

The ad hoc name "Alice in Wonderland" represents just one example of how people engage with those aspects of culture that predate us. Many people casually describe the "world" of a work of art like *Star Trek* or *Star Wars: A New Hope,* but this informal usage points to a key truth. "Alice in Wonderland" denotes not a book or collection of books but an entire world, complete with settings, characters, histories, physics, logics, and so on. This world is recognizable to many, though most cannot identify in which of Carroll's books a character first appeared or how *Nursery Alice* differs from *Alice's Adventures.* Further

A Re-introduction 7

complicating matters, some aspects of "Alice in Wonderland" as it is understood today do not stem from any of Carroll's books. The iconic image of Alice as a young blond girl in a blue dress and white pinafore with black hairband and Mary Jane shoes never appears in any of Carroll's texts. Carroll drew a dark-haired Alice in various clothing, none of it in color, for *Under Ground*. John Tenniel's illustrations for *Alice's Adventures* make Alice blond, though without a hairband, and still in black and white. *Looking-Glass* updates Alice's outfit with black-and-white striped stockings and the black hairband, but still lacks color. Alice's outfit is finally colored in *Nursery Alice*: Alice wears a trendy yellow dress with a big blue bow under a white pinafore piped in blue, with matching blue stockings and a blue hair ribbon (plate 3). The first appearance of Alice in a blue dress is actually a pirated edition of *Alice's Adventures* released in 1893 by Thomas Crowell of Boston (Gardner in Carroll 2015, 11). The "Alice in Wonderland" world, which we might also call its essence or what makes *Alice Alice*, has evolved.

The essence of Alice in Wonderland is at once obvious and opaque. The phrase invokes very specific images and ideas, yet those same images and ideas are malleable. If several people were asked to list everything they know about *Alice*, their lists would accord on many points, but not all. Some would remember less-famous phrases like "Vorpal Sword"; others would accidentally conflate the Queen of Hearts with the Red Queen. The fact that the world of Alice in Wonderland can change over time complicates matters still further. A Japanese manga editor and theorist named Eiji Ōtsuka sifted through our loose use of the word "world" to explain how and why worlds work in the contemporary media environment.

Studying the Media (Mix) Environment

Our world is full of media. From the moment an alarm clock wakes us in the morning until we finally turn off our smart phones before bed at night media craft the environment that we move through. Yet, we do not fully understand these media environments, the media that compose them, how those media relate to each other, or how we relate to them. Media environments are incredibly complex—they incorporate innumerable physical items, imagined worlds, and people whilst also being composed of distinct media whose specific affordances and limitations must be accounted for. Containing the diverse totality of a media environment in a single explanation that can cover all media, all people, all stories, and all situations is a daunting task, but the stakes are too high to abandon it. Media affect reality. The medium may not be the message as Marshall McLuhan so famously claimed (while repeatedly citing *Alice*). Yet medium and message, or

8 Chapter 1

content as it is often referred to in Japanese media studies, do affect each other in an intricate dance of modification and evolution.

The media environments in which we live are founded on the relationship between medium and content, so a complete study of a media environment must incorporate a fairly sustained examination of both media and content. To put it another way, "no denunciation without its proper instrument of close analysis" (Barthes 2013, x). Macroscopic analyses of media environments must be based upon close studies of actual materials—books, anime, clothing, tweets, etc. At the same time, even seminal works in the field are haunted by the difficulty of building a macroscopic study of a media environment out of microscopic textual analyses. Barthes's own *Mythologies* and Marshall McLuhan's seminal *Understanding Media: The Extensions of Man* (1964), for example, both segregate their macroscopic theoretical work from their closer textual analyses through a two-part structure. In consequence, Barthes notes that his book lacks a sense of "organic development" (2013, xii) due to the "quite various" and "quite arbitrary" (2013, xi) materials that launched his study. *Mythologies* is a fascinating and influential text even so, but the arbitrariness of the selected materials haunts the text. Are apples being compared to apples or oranges? Achieving a balance between microscopic and macroscopic analyses of media environments is vital, but clearly it is also difficult.

Compounding that difficulty, an extreme degree of interdisciplinary training is required to conduct close analyses of works in diverse media. Analyzing every medium in a given environment with the tools of just one academic discipline would provide limited insight into most of the media under examination. It is possible to conduct a literary analysis of a film by looking solely at the script, for example, but such an analysis would ignore specifically filmic aspects of the work like its soundtrack, framing, and tempo. Analyzing works in a variety of media using the tools of the appropriate academic disciplines requires extensive academic cross-training in the face of a horrendous job market based in disciplinary excellence. Nonetheless, the recent global popularity of Japanese media spawned a wave of increasingly interdisciplinary scholarship.

The contemporary Japanese media environment is a convoluted web of digital and analog media, horizontal and vertical integration, outsourcing, transnational coproduction, hopeful independent producers, practical conglomerate executives, and creatively productive fans. In this, it resembles the media environments of the United States, Great Britain, and other industrialized nations. Japan differs from these nations in that it developed a form of media production called the "media mix" decades earlier than they (Steinberg 2012a). Since variations on the media mix production method now dominate media industries around the

A Re-introduction 9

globe, studying the Japanese media environment enables not only greater understanding of the contemporary moment in Japan but also a degree of prognostication for other regions. Additionally, Japan has played a major role in the development of several of the twenty-first century's premier media, including video games and anime in particular. Consequently, the Japanese media environment became a hive of academic study in the twenty-first century.

Scholars writing about contemporary Japanese media have typically integrated multiple media and their attendant disciplines by focusing their books on individual fields of cultural production. A field of cultural production contains one main medium and its related people, organizations, and other media. Applying this approach to live-action film, for example, might mean examining not only films but also movie posters and magazines, social media statements made by actors and crew members, and television shows on which film actors appear as part of their films' promotional tours. Focusing on a field of cultural production enables authors to pare the overall media environment down to a more manageable set of media, works, organizations, and people. Fascinating books in this line have scrutinized anime (Denison 2015, Condry 2013, Steinberg 2012a, Itō 2006, and Nikkei BP sha 1999), manga (cf. Exner 2021, Oshiyama 2018, Araki 2015, Nakano 2004, Kinsella 2000), toys (Allison 2006), television (Yoshimoto et al. 2010, Chun 2007), smart phones (Ito et al. 2006), film (Zahlten 2017), literature (Long 2021, Mack 2010), and fashion (Monden 2015, Kawamura 2012). These books combine close analyses of specific works of art with examinations of the industry that produces them and the people who consume them to form a three-dimensional portrait of the field in question. Masafumi Monden, for example, dissects costumes in music video adaptations of Alice in Wonderland by the artists Tommy February, Alisa Mizuki, and Kaela Kimura to show how the medium of clothing is manipulated to craft and contest gender roles in Japan (2015, 77–105).

Some scholars of Japanese culture have expanded beyond a single field of cultural production by focusing on globalization vis-à-vis Japan rather than the overall Japanese media environment. For instance, Koichi Iwabuchi influentially integrated limited studies of specific works, primarily in television, film, and music, into a critique of globalization theory (2002). More recently, the anthropologist Christine Yano deployed fairly detailed analyses of various elements of Sanrio's Hello Kitty franchise in a wide variety of media to craft her theory of "pink globalization" (2013). Finally, the art historian Christine Guth inspected everything from murals to posters to socks to determine why Hokusai's "Great Wave" image became popular around the world and what its popularity says "about the processes of global cultural socialization" (2015, 1). These books offer glimpses of

what a dual micro-macro analytical approach might look like when applied on a grander scale, though they are not about Japan's media environment per se.

Whether focusing on a field of cultural production, globalization, or even just a specific aspect of contemporary Japanese culture like the apprentice geisha (Bardsley 2021) or subculture (Miyadai et al. 2012), today's studies of Japanese culture invoke more media in pursuit of their subjects than has historically been the case. Even studies of a specific author now feature detailed examinations of media such as manga as a matter of course (McKnight 2011). Scholars' emphasis of the multiplicity of media in the media environment stems from the standardization of the media mix production process in Japan across the late twentieth and twenty-first centuries.

The phrase "media mix" is something of a Hydra in that it refers to a method of media production, specific groups of products created through that method, and even specific media used as part of the media mix production method. In other words, the Japanese company QuinRose used the media mix production methodology to create the Alice in the Country of Hearts media mix, which primarily consists of the video game, manga, and anime media. The media mix production process is a form of industrial synergy wherein companies create a fictional world with the goal of instantiating it in multiple, noncompeting media within a relatively short period of time so that each iteration advertises all of the others (Steinberg 2012a; Ōtsuka 2010). A model media mix project would craft a unique and unified world through multiple media by companies with fairly established work ties, as when Marvel Studios teamed up with Marvel Entertainment and Marvel Press to release The Avengers as a film, comic book, and children's storybook almost simultaneously. As this example shows, the media mix methodology can be fruitfully overlaid on non-Japanese contexts. In fact, Henry Jenkins's concept of American transmedia storytelling (2008) is quite similar. Both terms describe methods of producing one overarching fictional world in multiple media in a controlled manner, and both have an industrial slant. Eiji Ōtsuka, who first depicted the media mix as a production method, did so through a case study of Bikkuriman chocolates. Jenkins used the Matrix franchise of films, video games, and other works. Both sets of products were created within recent memory, which is to say that they were formed with the current market in mind and are bound and protected by copyright and trademark laws. Thus, Ōtsuka and Jenkins elaborated these concepts on a contemporary, industrial foundation. Since both scholars are interested in discovering why successful media have been successful, this is perhaps unsurprising. After all, the biggest hits in any medium tend to be produced by people and organizations with the resources to produce, advertise, and sell media in massive numbers.

A Re-introduction 11

Producing media through the media mix method had the unintended effect of building connections between companies, industries, artists, and fictional worlds. In 1979, the animation studio Sunrise partnered with toy company Bandai to produce a media mix franchise called Gundam. Though it took a while to get established, Gundam is now a cultural touchstone for generations of Japanese children. New Gundam TV series and toys are released every year, making its earnings reliable in the fickle children's market. Years of successful collaboration led Bandai to acquire Sunrise in 1993, and the combined companies continue to produce new Gundam series today. Interindustry connections grow over time even aside from specific companies and collaborations. As more and more media mixes are produced, successful patterns emerge. The most successful stories about a young sportsman's journey to athletic victory, for example, are told in the manga, anime, video game, and theater media. Blockbuster mixes in this style—like Whistle!, The Prince of Tennis, Kuroko's Basketball, and Haikyu!!—give other creators a scalable blueprint to success. Creators without ties to the video game or theatrical industries may downsize those aspects of the project by replacing a video game with a smart phone–based game à la Yowamushi Pedal or switching out an expensive stage play for a live-action film (Chihayafuru) or even cheaper radio dramas (Yuri on Ice, Free!).

As creators and companies work together, they build relationships that then support and affect the creation of future products. In 2007, the video game publisher QuinRose released the first game in what would become the fledgling company's most popular franchise, Alice in the Country of Hearts (Hāto no kuni no Arisu). Players assumed the role of Alice in a Wonderland whose characters had all been transformed into eminently eligible bachelors. QuinRose teamed up with the publisher Ichijinsha the following year on a novelization by Momoko Komaki, Alice in the Country of Hearts: The Clockwork Knight (Tokei jikake no kishi). The Clockwork Knight led to five more Ichijinsha novelizations that were written by two new authors, Midori Tateyama (2008, 2009) and Sana Shirakawa (2009, 2010, 2010). QuinRose and Ichijinsha also began collaborating on a manga anthology series called Love and Fairy Tales (Ren'ai to otogi banashi, 2009–2010). Each of the series' five volumes contained short stories set in not only the Alice in the Country of Hearts world, but also those of other QuinRose video games. QuinRose was credited as providing the story, and each volume was drawn by a different artist. Thus, while Alice in the Country of Hearts' success produced a slew of new media mix iterations, individual novelists and artists did not necessarily succeed along with it. QuinRose's staff built relationships with Ichijinsha personnel through their repeated collaborations, but the freelancers who actually wrote and drew the new iterations—the people whose names were on the

12 Chapter 1

covers—were disposable resources. Furthermore, the anthology manga's promiscuous use of QuinRose's properties suggests that the adapted material became anterior to the QuinRose-Ichijinsha relationship itself. Successful media production in Japan today consequently depends on companies' and company employees' ability to collaborate with other media companies and their employees through the media mix production system.

Ōtsuka's initial essay describing the media mix production process is particularly tied to industrial concerns because Ōtsuka himself is part of Japan's manga industry. Ōtsuka wrote the essay while working as a manga editor for Kadokawa Books, a major force in early media mix practices (Steinberg 2012a). The main thrust of his essay is not describing the media mix so much as arguing that Japanese media companies should approach new media creation in a specific way. Ōtsuka would go on to model his theories over the years by scripting numerous manga in collaboration with various artists, including two *Alice* adaptations. He joined with Yumi Shirakura on *Alice in a Department Store* (*Depāto no Arisu*, 1991–1992), which Shirakura later adapted into an audiobook and a novel (Kinoshita and Kennell 2021, 26). Ōtsuka himself returned to *Alice* for a chapter in the long-running Hosui Yamazaki-drawn manga *Kunio Matsuoka, the Yōkai Slayer* (*Matsuoka Kunio yōkai taiji*, 2006–present) (Kinoshita and Kennell 2021, 29). Ōtsuka's theoretical work is therefore grounded in extensive industrial experience, which is to say that he focuses on original properties rather than adaptations of older material like fairy tales.

Jenkins conceived of transmedia storytelling as part of what he calls "convergence culture" (2008, 2), by which he means a contemporary media environment characterized by content flowing between media, corporations collaborating closely, and consumers actively pursuing the type of work in which they are interested. Jenkins was writing in the midst of the Recording Industry Association of America's series of extreme lawsuits against everyday Americans over the sharing of music files. Perhaps because of this, while Jenkins characterizes consumers as active participants in the media environment, his case studies largely examine (and defend) how consumers adapt and interact with large industrial franchises like Star Wars.

Ōtsuka described the media mix production process as part of a larger disquisition on what he called "narrative consumption theory" (*monogatari shōhiron*). According to narrative consumption theory, consumers are interested not in the specific media products they buy, but in a larger world that underlies any given product. He draws on a pair of kabuki concepts related to the creation of new plays, *sekai* and *shukō*, to formulate his theory. *Sekai*, which literally means "world," refers to a work of art's background information: the historical time

period, characters' names and basic personalities, and even the rough outlines of the events portrayed. As Ōtsuka describes it, "*sekai* has the same meaning as worldview or grand narrative" (Ōtsuka 2001, 19).[8] While his phrasing draws parallels between kabuki playwrights from the eighteenth century and Jean-François Lyotard's twentieth-century grand narrative concept, kabuki's use of *sekai* is more complex than this would imply. Satoko Shimazaki describes *sekai* as "established historical frameworks . . . that had long been central to the theater" (2016, 24), which amounts to "the basic background story of a play, a story that a playwright could expect his audience to know" (Saltzman-Li 2010, 129). A *sekai* was a specific body of information playwrights could use as a sort of scaffolding on which to build a play, which audiences would then recognize while viewing the play. While the English word "world" is used in a similar manner as *sekai*, *shukō* does not have an exact English equivalent. Katherine Saltzman-Li provisionally defines it as "plot" and then clarifies that kabuki playwrights began new plays by first choosing the *sekai*, then adding "innovative twists in plot," or *shukō* (2010, 129). In its most accurate and least compact translation, *shukō* refers to a change made to a pre-existing property to mark a new creation as one's own.[9] This method of production reflects historical Japanese media production methods more generally, as it did not originate with kabuki but descended from a method of writing poetry called "taking from the original poem" (*honkadori*) by way of *jōruri*, or puppet theater plays (Saltzman-Li 2010).

Ōtsuka weaves *sekai* and *shukō* into his narrative consumption theory to provide a model for content creators. First, you draft the outlines of your *sekai*, then you embody that *sekai* uniquely in various media. Each unique embodiment constitutes a *shukō*. In essence, Ōtsuka's theory provides an organizational framework to support the deep, occasionally tense inter- and intracompany relationships underlying contemporary media production in Japan. Companies should collaborate to devise the initial world, but they can operate freely within that world's agreed-upon confines.

Ōtsuka's narrative consumption theory has been criticized as not reflecting how actual consumers relate to actual media, most prominently by media theorist and manga artist Hiroki Azuma (2009). Incidentally, though Ōtsuka theorized media production prior to Azuma, Azuma beat Ōtsuka to the punch where adapting *Alice* is concerned. Azuma's manga *Heartbeat Alice* (1984–1985) was published seven years before Ōtsuka's first *Alice* manga. Regardless, Ōtsuka's nonfictional work set off a chain of influential scholarship (including Zahlten 2017, Shamoon 2012, Steinberg 2012a, Azuma 2009, and Ōtsuka 2001). In line with the industrial orientation of Ōtsuka's writings, this body of scholarship has generally focused on works of art that were produced under the control of a single person

14 Chapter 1

or corporation. However, the overall media environment is not restricted to the products of a single corporation or artist.

Media environments are primarily composed not of strange new works but reworkings of old, familiar tales. The bulk of new media products consists of retellings, sequels, and spinoffs of other successful products, multivolume series, and so on. Some of these works are controlled by a specific group of rights-holders through media mix–style production processes. Many more adapt our common cultural heritage—fairy tales, fables, historical events, religious texts, classic literature, and fine art (and increasingly cinema). Though a creator may claim rights over their personal adaptation of Cinderella, no one controls *all* of the Cinderellas.

Ōtsuka's conception of the media mix is not oriented toward adaptations of existing material that are produced in the wild, as it were, but the framework he devised can be applied to them rather neatly. Kabuki's *sekai* and *shukō* resemble adaptation in that new plays are created by taking a known entity (the *sekai* or "world") and altering it to add originality (the *shukō* or "iteration"). Much as media mix has a variety of meanings, iteration refers to both the process of adding a new contrivance to a pre-existing world and any individual piece of art that results from this creative process. Iterations are adaptations of imaginary worlds instead of specific, material items. Moreover, world and iteration are scalable concepts. Ōtsuka uses iteration in regard to specific anime series but also to single episodes of anime series. In the same way, world might be used to refer to the world depicted within the direct-to-video anime *Ciel in Wonderland*, or it could pertain to the greater world depicted across *Ciel in Wonderland*, the televised anime series *Black Butler* that *Ciel in Wonderland* spun off of, and the Yana Toboso manga *Black Butler* from which both were adapted (plate 13). The scalability inherent to Ōtsuka's work combined with the historical origins of the world and iteration concepts merges fruitfully with adaptation as it is practiced in real life. Applied to adaptations, these terms might be used to refer to the greater world that multiple iterations share. *Ciel in Wonderland* and the *Black Butler* manga and anime can all be subsumed into the still-larger world of Alice in Wonderland, which also includes Ōtsuka and Azuma's *Alice* manga as well as every other adaptation of *Alice* mentioned in this text. Looked at in this light, it becomes clear that "Alice in Wonderland" refers to not a specific work of art but a world. Every work within the *Alice* world is thus an adaptation on equal footing with all of the other adaptations, regardless of the year of release—including Lewis Carroll's own publications.

Looking at adaptation in this way clarifies a number of problems that may not have been previously apparent. Everyone knows that revision improves a work,

so it follows that many of the best works of art are known in revised condition. What is a revision, if not an adaptation? *Alice's Adventures in Wonderland*, for instance, is quite similar to the earlier *Alice's Adventures Under Ground*, except that they look entirely different. Carroll hand-wrote and -illustrated *Under Ground* in a simple notebook, while *Alice's Adventures* was professionally typeset and famously illustrated by one of the premier illustrators of the time, John Tenniel. The distinctions between the two books are significant enough to mark *Alice's Adventures* as an adaptation. Of course, the question remains—adaptation of what? Carroll's text adapts various poems and songs in both books, and John Tenniel published illustrations of Alice and other characters in the magazine *Punch* prior to the release of *Alice's Adventures*. These prepublication peregrinations may seem minor, but they point to a key truth about how media are produced. The final version is rarely the first, the most unusual work builds on existing material, and intermediary iterations can hold vital importance. The recent smash hit musical *Hamilton* (2015), for example, was originally conceived as a rap concept album, but it evolved into its final form through a series of performances of the in-progress work (Viagas 2015). Both creators worked out what they were producing by publishing multiple versions, or in other words, creators adapted the worlds inside their heads into multiple iterations in multiple media.

The media mix production process may have been intended as a thoroughly practical way of working in contemporary Japanese media industries, but it also solves the problem of how to craft a cohesive macroscopic analysis of Japan's media environment out of close analyses of specific materials. On the most basic level, it becomes possible to analyze materials in greater detail without spending more time on any one of them. Since every close analysis is of a variation on the same world, an author need only introduce the world once and thereafter compare how each work relates to the world. This enables a balance between microscopic and macroscopic analyses. Further, confining case studies to iterations of a single world illuminates how media differ from and connect with each other in a way that comparing distinct works of art in different media would not. For example, Masafumi Monden's dissection of *Alice* music videos (2015) shows how the music video medium contributes a sense of physicality and enables discourse on gender roles in a way that the music alone could not. Had he analyzed instead music videos for the Divinyls' classic song "I Touch Myself" (1990) and Pinkfong's viral hit "Baby Shark" (2016), readers would have struggled to connect the materials to each other, let alone agree with his overarching conclusions. The media mix's world-iteration framework makes it possible to build an analysis of the Japanese media environment out of close analyses of a world so long as it is

16 Chapter 1

adapted in sufficient number and media, but not governed by copyright. This of course raises the question of why this particular book focuses on *Alice*.

Why *Alice?*, Part I

Toward the end of the twentieth century, the field of English literary studies took an interesting turn in the West. Inspired to think more carefully about non-Western nations by intellectuals like Edward Said, English literature scholars began to question whether non-Western nations' reception of English literature might provide new insights into that literature—whether, in other words, "in the so-called global village a Japanese Shakespeare speaks our language" (Mulryne 1998, 2). As this quotation suggests, Japan became a key locus for, and Japanese artists and scholars key participants in, these efforts.

This shift is a fascinating example of how what we see depends on what we are looking for. The movement prompted scholars to rethink key concepts like Victorian, transnational, and even the discipline of English literature itself (Jones 2018), yet the articles and books produced as part of this movement circle back to English literature through analyses that track how translations and other adaptations (do not) display fidelity to English texts. Greg Clingham characterizes the shift as an "orientalizing" (2021, xvi) of English literary studies, for example, rather than suggesting that this new, wider perspective means that "English literature" no longer describes the discipline in question. In an influential article, Juliet John recounts hearing a "brilliant" (2012, 505) presentation on Chinese translations of Charles Dickens's writings and is inspired to wonder what Chinese people liked about Dickens's works and whether Chinese Dickens translations should even be considered as authentically Dickens due to their variations from the English texts. Her comments recall translation scholars' debate over fidelity in translation (Venuti 2008, Bassnett 2014) while highlighting that her interest lies with English literature, not Chinese literature or culture. This is not to say that the scholars involved in this shift have not learned about other cultures while conducting this type of study. Judith Pascoe's fascinating memoir-cum-examination of Japan's reception of *Wuthering Heights* details a striking evolution in her thinking, for instance. She initially focused on *Wuthering Heights* because of its relationship to the rest of the English literary canon and her own "uneasy" relationship to the book, entirely "unaware" that the novel was popular in Japan (2017, 1). She attempted "to seek out Emily Brontë in Japan" (2017, 3) rather than use the novels as a window into Japanese culture. Japan seems almost incidental to her work, which is really about English literature. However, as she details her research, it becomes apparent that she was actually

quite curious about Japanese culture. By the end of her book, she is describing her research in more qualified terms: "I had been working on my Brontë study for a long time. I thought about *Wuthering Heights* as a tiny pinhole into Japanese literature and culture, and about all the Japanese literature and culture I still wanted to absorb" (2017, 119). Pascoe's willingness to look at what was going on in Japan allowed her to see a sliver of Japanese culture through English literature. Still, Western English literature scholars' investigations of Japan's reception of English literature generally circle back to English literature and how Japanese materials affect our understanding of it rather than revealing much about Japan.

There is also a significant body of Japanese scholars of English literature who have written extensively about Japan's reception of English literature in English and Japanese. These publications are more likely to discuss Japanese literature, history, and culture than those by non-Japanese scholars of English literature, but Japanese scholars' publications do display the same tendency to track adaptations' fidelity to English literary texts. Tsuyoshi Ishihara carefully details how several Japanese adaptations of Mark Twain's novels differ from Twain's texts to "show how Twain resonates with Japanese social, cultural, and literary traditions and sensibilities" (2005, 3). Akiko Okada's study of Japan's reception of Romanticism and the oeuvre of John Keats (2006) presents an additional level of recursion. While Okada discusses Japanese history in great detail, she not only draws conclusions from the discrepancies between Japanese adaptations and Keats's poems; she also details how Japanese scholarly publications on Keats align with or differ from English-language scholarly texts.

English literature scholars' focus on fidelity highlights that this strand of research evolved out of and is aimed at the scholars of English literature. Because scholars are prepared to look at English literature, they see English literature. This restricted vision also affects which works scholars are examining. William Shakespeare, who has doubtless spawned more English-language scholarly essays than any other English writer, has also spawned more Japanese reception studies than any other English writer (Joubin 2021; *Re-imagining Shakespeare* 2021; Kishi and Bradshaw 2006; *Performing Shakespeare* 2001; *Shakespeare and the Japanese Stage* 1998). Other English writers whose Japanese reception has been the subject of an English-language book include Samuel Johnson (*Johnson in Japan* 2021), John Keats (Okada 2006), and Mark Twain (Ishihara 2005), all of whose literary merit has long been established. Greg Clingham sums up the goals of *Johnson in Japan* by asking whether its collected essays might "play a role in the current 'orientalizing' of eighteenth century studies—that is, the growing interest in acquiring critical and historical perspectives *from the Orient* in order to open eighteenth century studies and our educational paradigms themselves to

18 Chapter 1

a more comparative, global consciousness" (emphasis in original, 2021, xvi). The consensus seems to be that Japan provides an intriguing new lens on well-known subjects.

There is another body of scholarship on Japan's reception of English literature that ought to be discussed separately, and that is the vast array of publications, conferences, and other intellectual work produced by learned societies devoted to individual English authors or works. These societies are composed of a broad sweep of professors, writers, fans, and collectors of a specific author or set of texts, and they are often part of global networks of intense intellectual activity. While their publications correlate with English literature scholars' work to a degree, these societies exist outside of the traditional academic framework and rely on their own networks for peer review and other quality assurance measures. Sir Arthur Conan Doyle's Sherlock Holmes has the Baker Street Irregulars, which published *Japan and Sherlock Holmes* (2004). Lewis Carroll has inspired five Lewis Carroll Societies—one of which is Japanese—whose members can collectively be called "Carrollians." Literary learned societies often create and publish journals and books containing scholarly studies related to their subject. The Lewis Carroll Society of North America alone has published over two dozen books, including a six-volume compilation of pamphlets written by Lewis Carroll, and releases the *Knight Letter* journal biannually.

Literary learned societies have served as a framework for the formation of international communities. Members of one society will correspond with members of another, travel to other societies' conferences, and republish materials previously published by each other. For example, the Lewis Carroll Society of Japan's academic journal, *MischMasch*, published an essay by the influential British Carrollian Edward Wakeling (2012) that drew on Wakeling's work editing Lewis Carroll's diaries for publication in English by the Lewis Carroll Society based in London. *MischMasch* published Wakeling's text simultaneously in English and in a Japanese translation by Kimie Kusumoto, who had previously translated both *Alice's Adventures* and *Looking-Glass* into Japanese. This article is a fairly representative publication for an author-centered learned society in that it elaborates the conception of *Alice's Adventures*. These societies' publications consequently resemble those of English literature specialists in their foregrounding of English literature and authors.

Learned societies and their members are distinguished from English literature scholars by a longer and deeper history of international research and collaboration. The Lewis Carroll Society of North America (LCSNA) copublished an annotated international bibliography of Carrolliana in 1980 that included fairly detailed descriptions of various Japanese materials, including one of the books with which

Yasunari Takahashi sparked an explosion of Japanese *Alice* studies in the 1970s. Members of the Lewis Carroll Society of Japan (LCSJ) have participated directly in other Lewis Carroll Societies' events, and indeed, many people are members of multiple Lewis Carroll Societies. LCSJ member Yoshiyuki Momma is one such internationally prominent scholar-collector. He was a featured speaker at the LCSNA's second conference in 1994, and his presentation, "Why is *Alice* Popular in Japan," was published as part of the handsome volume containing the conference's proceedings. He has continued to present, publish, and otherwise participate in international Carrollian circles across the intervening decades.

Alice in Japanese Wonderlands has benefitted mightily from the strong foundation of Carrollian knowledge, resources, and expertise built by Carrollians. Similarly, English literature scholars' fascinating studies of Japan's reception of English literature have provided useful grounds for identifying how Japan's treatment of *Alice* aligns with its treatment of comparable works of English literature. At the same time, both bodies of critical work exist because of the authors' interest in learning about *English* literature through a Japanese perspective. *Alice in Japanese Wonderlands* was initially motivated by the obverse interest: to study Japanese culture through a fictional world that we happen to think of as English.

One of my reasons for writing this book is to provide a sustained example of what the Japanese studies approach can add to the large body of critical writing about Japan's reception of English literature produced by English literature specialists. This means situating Japanese *Alice* adaptations first and foremost in terms of Japanese culture, Japanese media, and other Japanese adaptations of *Alice*. Doing so brings to light how prominent artists in a variety of periods and media have used *Alice* to promote artistic movements as well as how *Alice* has functioned as a sort of cultural commons through which Japanese people build the imagined community that is Japan. Perhaps the most prominent example in this vein is the influential screenwriter Chiaki J. Konaka. Konaka has produced a series of *Alice* adaptations in the live-action film, anime television series, video game, nonfiction literature, and web media. His stories are often on the bleeding edge of techno-cultural developments, so naturally a large body of critical analyses by Japanese studies scholars has sprung up around his oeuvre (Boyd 2018; Brown 2010; Wada-Marciano 2010; Prévost 2008; Long 2007; Napier 2007). Scholars have directly cited and structured their writing around Konaka's adaptation of *Alice*, yet he and his oeuvre seem to be virtually unknown in Carrollian and English literature circles. *Alice in Japanese Wonderlands* thus constitutes the first sustained analysis of Japanese *Alice* adaptations in terms of what they mean for and in Japanese culture.

20 Chapter 1

Why *Alice?*, Part II

Modern Japanese culture is built on adaptation. The Japanese government pursued a policy of strict isolation from foreign influences from the 1630s to the mid-nineteenth century out of fear of Western colonialism, both direct and indirect. Japanese isolationist policies ended with a vengeance when the weak, samurai-run government failed to effectively counter the American commodore Matthew Perry's demand for trading rights. Emperor Meiji, initially a figurehead, seized power and not only allowed more international trade but actively sought Western knowledge in every field from weaponry to literature, military uniforms to photography. Every aspect of Japanese culture was affected by this rush to learn about the world, but calculating the exact importance of any given adapted work, concept, or technology is practically impossible. The prevalence of some forms of adaptation, such as translation, can be quantified to an extent, which allows a degree of comparability.

The modern Japanese period, which begins with Meiji's rule (1868–1912), saw an avalanche of Japanese translations of Western literature that continued until shortly before Japan entered World War II. Carroll's *Alice* novels, first translated into Japanese in 1899, were part of this avalanche. Translations educated both the translators and the public about the newly widened world in which they lived. Translation inspired authors to create new genres, tell stories about people who had not previously been considered worthy of literary treatment, and develop new writing styles. Not only Japanese literature but the Japanese language changed massively as a result of this tsunami of translation.

The explosion of translation that began under Emperor Meiji's reign set the stage for a contemporary Japan that still values translated literature quite highly. Many new translations of both contemporary and classic literature are released every year. This can lead to rather staggering numbers, such as the more than two hundred editions of Mark Twain's *Tom Sawyer* and *Huckleberry Finn* that have been produced in translation for Japanese children since the end of World War II (Ishihara 2005, 2).[10] Like *Alice*, Twain's oeuvre was introduced to Japan in the 1890s (Ishihara 2005, 10), but Japanese translators continued to introduce new works of Western literature across the twentieth and twenty-first centuries. *Wuthering Heights* was first translated into Japanese in 1932, for example, while L. M. Montgomery's *Anne of Green Gables* (1908) was translated into Japanese only in 1952. Those books led to twenty further *Wuthering Heights* translations (Pascoe 2017, 9) and more than seventy *Anne* works (Uchiyama 2013, 156).

The *Alice* novels have spawned more than five hundred Japanese translations, or more than *Tom Sawyer*, *Huckleberry Finn*, *Wuthering Heights*, and *Anne of*

Green Gables combined. The first *Alice* translation appeared in 1899 and was followed by about thirty more in dribs and drabs before the financial and material privations of World War II descended. The vast majority of Japanese *Alice* translations were produced in the post–World War II era, the same period in which media mix–style production processes became embedded across Japanese media industries. Media mix–style productions, and the growing connections between media industries that developed into the media mix method, enabled *Alice* to spread from literature into a host of other media to achieve its current position of ever-presence. Yet, works like *Anne of Green Gables* are commonly understood to be more popular, arguably more important, in Japanese culture. If this book answers any question, it will be this: how is *Alice* visible everywhere in Japan without being fully seen?

Part of the answer to that question lies in the fact that *Alice* lacks a showman, a Walt Disney or P. T. Barnum who would advertise *Alice* while maintaining its consistency. *Alice* had no such ringmaster for the simple reason that no Japanese *Alice* adapter was constrained by copyright law.[11] *Alice* was adapted freely by anyone and everyone who felt so inclined, in both senses of the word. No one paid for the right to adapt *Alice*, and adapters altered it as much as they pleased. If a Japanese adapter wanted to make Alice male, he could. If an adapter wanted to proclaim herself to be the real Alice, she could. If an adapter wanted *Alice* to be a horror story, science fiction, romance, pornography . . . then they made it so. Likewise, if an adapter wanted to make an *Alice* play, manga, anime, video game, restaurant, outfit, ballet, or stationery set, they could. Since no person or organization controlled *Alice*'s development, it was adapted solely according to creators' desires and needs.

The closest any specific adaptation has come to dominating *Alice* in Japan is Walt Disney Company's animated *Alice in Wonderland* film. The Disney film is popular in Japan, but Disney's style of *Alice* has hardly been hegemonic. In fact, Disney appears to be matching Japanese tastes where *Alice* is concerned. *Alice* is a much more prominent feature in its Japanese merchandise lines than in its American merchandising operation, for example, and Disney has repeatedly teamed with Japanese video game companies to adapt *Alice*. Most recently, they hired the manga artist Yana Toboso to provide creative direction for *Twisted Wonderland*, a smart phone–based game Disney co-created with the Japanese production house Aniplex. Toboso had already adapted *Alice* in her hit series *Black Butler*, while Aniplex worked on *Alice* adaptations like *Sword Art Online*, *Persona*, *Gakuen Alice*, and of course, *Black Butler*. *Twisted Wonderland* was released in Japan in 2020 as a game, a manga, and a short-term set of hotel suites on the way to the game's 2022 release in the United States. The world of Disney's

22 Chapter 1

American film was thus reworked by Japanese *Alice* experts, honed through exposure to Japanese consumers, and exported back to the United States. *Twisted Wonderland*'s gameplay is a similarly transnational mash-up of Britain's Harry Potter, Japanese gaming's *otome* genre, and *Kingdom Hearts*, an earlier *Alice* game that Disney co-created with Japan's Square Enix video game publisher. Viewed through the lens of *Alice*, Disney's role is to respond to Japanese desires and amplify Japanese creativity rather than to import foreign masterpieces.

In contrast to *Alice*, many other novels imported to Japan become associated with one or two specific Japanese adaptations. Johanna Spyri's *Heidi* (1881) is best known in Japan for a 1974 anime adaptation called *Heidi, Girl of the Alps*. Much like *Twisted Wonderland, Heidi, Girl of the Alps* would prove influential beyond Japan; it was popular on airwaves from Italy to South Africa. Heidi was directed by the now-renowned director Isao Takahata, and its popularity led to the development of a popular and respected series of anime adaptations of classic literature. This series included a smash hit 1979 adaptation of *Anne of Green Gables, Akage no An* (dir. Isao Takahata), which continues to influence *Anne* imagery today. The anime's title reveals another major influence in Japan's reception of *Anne*. "*Akage no An*" literally means "Red-Haired Ann," but this phrase has come to be the standard Japanese translation of *Anne of Green Gables'* title. It was devised by *Anne*'s first Japanese translator, Hanako Muraoka, whose work is "still the most influential and highly regarded" (Somers 2008, 46) Japanese translation of *Anne* today. Muraoka's translation and Takahata's visualization have combined to effectively construct and demarcate the limits of the Anne of Green Gables world in Japan, such that the world seems to have exceptional force. No such *Alice* adaptation dominates any medium.

Countless Japanese creators working in a truly stunning variety of media have stepped into this vacuum of hegemonic *Alice* adaptations. The combination of these three factors—massive numbers of *Alice* adaptations, diverse media, and creators free to do as they pleased with the *Alice* world—enables this book to function on two levels. On one level, it dissects the essence of *Alice*. What has changed in Wonderland since 1899? What has stayed the same? For all that *Alice* has evolved through adaptation, something must be consistent or else we would not recognize a given adaptation as Alice in Wonderland. On another level, tracking how *Alice* evolved through so many media, created by distinct people and organizations operating independently, affords the opportunity to explore the overall Japanese media environment. *Alice*'s ability to support a double-bladed study of this sort is the most intriguing reason to research Japanese *Alice* adaptations.

Alice in Japanese Wonderlands resituates adaptation in the current media mix milieu by tracking adaptations of a single world, Alice in Wonderland, over

time and across media by a diverse multitude of people as the media mix system develops around it. I use the world of *Alice* to examine the totality of the Japanese media environment while attending to the specificity of the individual works and media that compose said environment. I also show how an unknown set of foreign novels became a vital, if overlooked, part of Japanese culture. *Alice* is uniquely suitable for such a study because of the massive number and mediatic variety of Japanese *Alice* adaptations, *Alice*'s extended history in Japan, and the freedom with which Japanese creators adapted *Alice*. This final point is particularly important because of a historical tendency to deride Japan's adaptive activities as mere copying. The form *Alice* takes in Japan today reflects domestic considerations and creativity rather than foreign pressure. Japanese people chose to adapt *Alice*, and not once or twice or seventy or even two hundred times; *Alice* is everywhere in Japan today. Examining one *Alice* adaptation after another over time and across media permits *Alice*'s essence, the thing about *Alice* that has drawn adapters' and consumers' attention so consistently for so long, to slowly rise to the surface of the giant pool of *Alice* adaptations. After all, to constitute an adaptation of *Alice*, a work must naturally convey *Alice*-ness to the consumer.

What Is an Adaptation?

Humans today are confronted with more media than at any other point in history. Children wake up between sheets decorated with Pokémon while parents watch *Good Morning America* over breakfast and listen to podcasts on their way to a job where, like as not, they will work on a computer all day. Along the way, children and parents alike are bombarded with advertisements and merchandise, quotations and references, to say nothing of their own possessions—fine art, clothing, films, books, and so on. We do not yet know how this multi-mediated, semi-digitized environment affects us. Nor do we comprehend how these many media interact with each other. Tracking one world, *Alice*, across media, times, and places can constitute a step toward enlightenment, but only if the analysis incorporates every way that a person might come into contact with *Alice*. In effect, that is what adaptation means in this book: any remaking, invocation, reference, bricolage, parody, re-use, translation, commentary, citation, or other appearance of a world in any medium. This is a much wider definition of adaptation than is usually deployed in academic studies of adaptation.

"Adaptation" here refers specifically to the English language word and its usage as these provide the context in which readers will understand this book. Japan proffers a much more complicated linguistic and historical background for understanding adaptation—to the extent that the word "adaptation" is not easily

24 Chapter 1

translated into Japanese. Though the language provides a literal translation of the word, *kaisaku*, no one actually uses *kaisaku* in speech or writing. Instead, Japanese people deploy a host of specialized adaptation words—*animeka*, *mangaka*, *eigaka*, *hon'yaku*—that refer to adaptations in a specific medium or of a specific type (anime, manga, live-action film, and translation, respectively). The rich adaptive environment this variety of terminology implies is yet one more reason to study adaptation in Japan.

Outside of Japan, adaptations were viewed as derivative, their creators less-talented imitators of great artists, during much of the modern period in the West.[12] They were consequently valued based on their perceived fidelity to the works they adapted. Scholars such as Walter Benjamin and André Lefevere parried those slights by theorizing that adaptation might serve a higher purpose: bringing people together. Later scholars like Susan Bassnett, Linda Hutcheon, Robert Stam, and Lawrence Venuti built on this idea through close analyses of specific works that showed what adapters were doing through the act of adaptation as well as the cultural achievements of specific adaptations. Scholars' efforts were matched by artists, who set up one prestigious award for adaptation after another beginning in the late 1970s.[13] Both artists and scholars based their defenses of adaptation in the championing of specific adaptations, which they viewed in relation to the adapted work.

The prevailing definition of adaptation reflects this history: an adaptation is "an acknowledged transposition of a recognizable other work or works; a creative *and* an interpretive act of appropriation/salvaging; an extended intertextual engagement with the adapted work" (emphasis in original, Hutcheon 2013, 8). The requirement to use other works in "a creative *and* an interpretive" way neatly forestalls any criticism of adaptation as derivative or lacking artistic value. Likewise, by requiring a work's engagement with the other work to be "extended," adaptations are effectively separated from works that are explicitly derivative of other works, like merchandise and advertising materials. These two requirements have the unfortunate side effect of excluding a wide swath of works that collectively constitute the primary way people interact with a given world, including merchandise and advertisements, fan-made art and fiction, products which merely allude to other works, and secondary media tie-ins such as sequels and spinoffs. These exclusions make sense if you are studying an adaptation to learn about the adaptation itself, the adapted material, or how the society behind the adaptation differs from the society that fomented the adapted work. Yet, these three goals are based to varying degrees on an inescapable binary of adaptation and adapted work.

If we were to map out how a person comes into contact with *Alice*, we would create a glorious cobweb of connections and interstices composed of a multitude

of mediatic quotations, citations, parodies, extended intertextual engagements like Walt Disney Company's live-action *Alice in Wonderland* film (dir. Tim Burton, 2010), and perhaps even a novel or two by Lewis Carroll. Eliminating works from consideration due to the length or depth of their connection to a world fundamentally restricts our understanding of *Alice*'s presence in our lives. This limitation also unintentionally restrains the amount of respect due a certain type of adaptation. Specifically, some adaptations adapt not one but a plenitude of other works. These adaptations effectively use the adapted works not for themselves, but because they share a trait or delve into a larger issue of which the adapter wishes to make use. For example, Ikuko Itoh's anime *Princess Tutu* (2002–2003), adapts a host of European story ballets and related works, many of which are not engaged with extensively, to explore what it means to create, to own, and to exist in the contemporary world (Kennell 2016). Looked at in terms of a single opera or folk tale, *Princess Tutu* might fall into this category of works that merely allude to other works. Yet, the series' recognizable, extended, creative appropriation of classic European story ballets writ large clearly constitutes adaptation.

The question of merchandise is even more complicated. Merchandise might not constitute a creative act of appropriation, but it can affect the creative trajectory of the product it advertises. Media mix theorist Marc Steinberg discovered that when a set of stickers advertising the *Astro Boy* (*Tetsuwan Atomu*, 1952–1968) anime was included in the packaging of a brand of children's chocolates, the stickers came to have greater cachet than the chocolates themselves. Ultimately, the chocolate company changed the form of their own chocolates to match the *Astro Boy* characters on the stickers (Steinberg 2012a, 43–85). *Astro Boy* exerted so much pull that its merchandise altered the shape of a pre-existing product in a medium with no innate relationship to anime.

Merchandise is also important because its consumption is more active than is commonly assumed. Consumers often use merchandise to transform how they experience their own lives. An average Joe may revel in the sense of power he gains by donning his *Iron Man* costume, while a stressed-out high school teacher may enjoy escaping to her Disney-themed home. As one such teacher notes, "decorating a room with a Disney theme could be one of your best options to keep that vacation feeling alive after you return from your trip" to Disney World (Major n.d.). The line between production and consumption blurs as she acquires and creatively deploys Disney merchandise to construct a relaxing home environment. If the consumer-creator in question is skillful enough, she may end up earning money through the sale of her newly improved house (or by monetizing a blog about Disney World). Mixing consumption and production is common outside of merchandise as well. As art critic Nicolas Bourriaud notes, "artists who insert

26 Chapter 1

their own work into that of others contribute to the eradication of the traditional distinction between production and consumption, creation and copy, readymade and original work" (2007, 13). Consumption can be and often is productive.

This book further steps away from the prevailing view of adaptation by incorporating Eiji Ōtsuka's conception of the media mix. Adapters are viewed here as adapting worlds as opposed to directly adapting other works of art. This negates any potential for criticizing an adaptation's fidelity as in the media mix system, the whole point of a new iteration is that it injects novelty into a world. New iterations *must* vary in some way; so too must new adaptations. Incorporating the media mix as Ōtsuka conceived of it rectifies the potentially elitist exclusion of fan-made works as well. *Dōjinshi*, or amateur stories and comics that often adapt manga and anime, have come to be a major business in Japan. Popular *dōjinshi* artists can sell tens of thousands of copies, and many successful manga artists got their start through *dōjinshi*. Some artists continue to work in *dōjinshi* even after becoming professionals to maintain a connection with their fans or for the artistic freedom. Yet, companies rarely earn money on *dōjinshi*.[14] Ōtsuka argues that since a manga is merely a doorway consumers pass through to reach a greater world, there is no intrinsic reason that potential consumers should read an official manga instead of an unofficial *dōjinshi* that would grant the same entry. Ōtsuka raises the issue somewhat ambivalently by saying that "concretely realized 'works' are at the least not plagiarism" (Ōtsuka 2001, 18). Although this is not exactly rousing support, when Ōtsuka's quiet insistence that producers achieve success by producing superior products is considered, the message is clear: companies need not fear fan-made adaptations of their products as long as their creative staffs are doing their jobs properly.

"Adaptation" redefined for the contemporary media environment, which is to say in light of the media mix, constitutes any invocation, reference, bricolage, parody, re-use, translation, commentary, citation, or other recognizable appearance of a world in a creation, where a world is comprised of an evolving body of characters, events, settings, physics, imagery, and other information that commonly appears together in a subset of works of art. Whether creations are sold or freely used is irrelevant, as is the duration or creativity of the world's usage. This definition of adaptation is specifically aimed at understanding how a world moves through time, space, and media. Put another way, this theory of adaptation privileges the world over any work within it.

Scholarly Production as Adaptation

Defining adaptation as broadly as I have here presents a quandary as far as Japanese scholarly production is concerned. On one hand, there is a broad and deep

body of Japanese *Alice* scholarship that can and should be used to support my analysis of Japanese *Alice* adaptations. On the other hand, each and every piece of Japanese *Alice* scholarship constitutes an adaptation of *Alice* in and of itself. Further, because there is a high degree of integration between intellectual, cultural, and public activities in Japanese society, scholarly essays, articles, and other materials became entwined with other media—in other words, they become part and parcel of the advertising package for new Japanese *Alice* translations, films, and other works. Therefore, I offer a concise overview of Japanese *Alice* scholarship in its own right here prior to delving into other *Alice* adaptations.

When the Japanese government ended its program of severe isolationism in the mid-nineteenth century, artists took on a key role in researching and translating foreign knowledge and culture for the Japanese nation. Prominent artists produced art concomitantly with scholarship on art, and their scholarship had to be geared to an audience that possessed only general knowledge of the foreign traditions in question. Thus, famed authors Ryūnosuke Akutagawa and Jun'ichirō Tanizaki publicly debated the proper constitution of the novel in between publishing new works of fiction, while Kan Kikuchi paired playwriting with editing series of translated literary classics. Japanese culture evinces this melding of art and public scholarship even today. Professional scholars are likewise integrated more closely into everyday society than is common in the United States. For example, popular magazines like *Bungei Shunjū* (1923–present) and *Eureka* (*Yurīka*, 1956–present) offer readers a selection of essays, poetry, roundtables, photographs, and assorted other works by professors, translators, politicians, artists, and so on in every issue. Education and amusement are consequently merged to an unusual extent in Japanese culture.

The earliest scholarly writing in Japanese on *Alice* was published in popular media, and in particular, with Japanese translations of *Alice*. Japanese publishers commonly include additional, educational materials in their fiction publications. Some of these, such as Kan Kikuchi's introduction to his co-translation of *Alice's Adventures* (1927), are quite short. Longer materials of this sort usually take the form of a *kaisetsu* (lit. "explanation"), which is an essay at the end of a novel wherein someone—usually a scholar or editor—explains the import of the preceding text. Yumie Kittaka's six-page discussion of Lewis Carroll and nonsense literature for her translation of *Alice's Adventures* (1990, 270–276) is a representative example of the genre. Kittaka's translation was published along with original illustrations by Mariko Matsunari as one volume in a forty-volume series of classics of world literature, all of which are aimed at a child readership. Her *kaisetsu* informs those children that *Alice's Adventures* is a famous book, offers a biographical sketch of Carroll, discusses John Tenniel's illustrations (two of which

28 Chapter 1

are reprinted in the *kaisetsu*), and so forth. It conveys enough information that a reader could knowledgeably converse on *Alice* without fear of looking ignorant.

Kaisetsu amount to a bid to shape readers' perceptions of a book's main text. They are intended to convince readers that the rest of the book, which said consumer presumably bought, was worth their while. Skilled writers can raise *kaisetsu* to an art form, and their *kaisetsu* may later be collected into anthologies of their essays. When Yukio Mishima, then a hot new author, translated *Alice's Adventures in Wonderland* in 1955, his publisher appended a *kaisetsu* that subtly explains why Mishima's translation elides much of Carroll's book. Lewis Carroll, "though a mathematician, harbored cultural skill, so crafted novels and poems. Liking children, he also made several outstanding fairy tales" (in Mishima 1955, 67). The publisher's backhanded compliment echoes Mishima's erasure of the mathematical and scientific material in *Alice's Adventures*, which educated readers might have noticed and disapproved of. (In fact, the name of Carroll himself is erased from the book's cover and title pages. The publisher finally deigns to include it in the *kaisetsu*.)

Kaisetsu and other, similar forms of scholarly production can form part of the attraction for a new work of art in Japan. A *kaisetsu* by a prominent cultural figure might be part of the advertising for a new book, for example. Other media also produce short scholarly materials that function like *kaisetsu*. Japanese movie theaters sell lush, full-color booklets alongside major theatrical releases. When Walt Disney's animated *Alice in Wonderland* (1951) film came out in Japan in 1953, theatergoers were able to buy multiple accompanying booklets that featured different cover art and content that was similar but not quite the same. One booklet contained a short piece on Kathryn Beaumont (the actress who voiced Alice), an essay on Lewis Carroll, a description of the film's story, and similar materials about a nature film that was shown with *Alice* in theaters. These booklets function as collectible souvenirs whose value stems more from their nostalgic connections and visual pleasure than their content (plate 4).

Japanese scholarship about *Alice* was largely limited to *kaisetsu*, film booklets, and the like until a group of scholars and scholar-artists took up its cause in the freewheeling 1970s. Several underlying developments converged, and Japan was suddenly in the midst of an *Alice* boom. On a basic level, awareness of *Alice* had spread as generations of Japanese children had grown up reading the books. Concomitant with this development, the number of Japanese *Alice* adaptations had grown into a significant body and included several adaptations by highly regarded artists like Ryūnosuke Akutagawa and Yayoi Kusama. These latter adaptations demanded respect by virtue of who had done the adapting. Respect had grown in Japan for children's literature in general as well. Finally, several academic theories

then in vogue in Japan, such as semiotics and structuralism, paired well with Carroll's books (Tatsumi in *Yurīka* 657 2015, 161). A loosely connected group of scholars, artists, and critics created an *Alice* feedback loop by producing innovative *Alice* adaptations that drew on consumers' pre-existing knowledge of *Alice*, using those adaptations and the then-stylish academic theories as an excuse to analyze *Alice* in new ways, and subtly pressuring other Japanese people to respect *Alice* by conferring awards on new Japanese *Alice* adaptations.

Japan's effusion of love for *Alice* began in 1970, when the esteemed modernist playwright Minoru Betsuyaku compiled several of his *Alice* plays, and the *Alice* music that he had composed for them, into the book *Alice in Wonderland: Second Drama Compilation* (*Fushigi no kuni no Arisu: Dai ni gikyokushū*, 1970). The following year, he was granted the Kinokuniya Theater Award in part for the anthology's titular play, *Alice in Wonderland* (*Fushigi no kuni no Arisu*, 1970). Betsuyaku also participated in public scholarly activities, including *Alice*'s breakthrough academic text in Japan, a special issue of an intellectual magazine called *Modern Poetry Notebook* (*Gendaishi techō*).

When *Modern Poetry Notebook* released a special issue dedicated to Lewis Carroll in 1972 (*Bessatsu gendaishi techō dainigō*), it opened the floodgates for Japanese *Alice* scholarship. At the time, Carroll was primarily known in Japan as the author of the children's novels *Alice's Adventures* and *Looking-Glass* (Momma in Momma and Kennell 2021). *Modern Poetry Notebook* resituated Carroll and *Alice* in media and cultural history through a mix of articles, art, and translations of previously untranslated works by Carroll. Translated essays by French surrealist writer André Breton and British mystery author G. K. Chesterton link *Alice* to the then-popular art movement and genre, respectively. Essays by scholars like the philosopher Shōzo Ōmori, linguist Kuniko Imai, and English literature specialist Yasunari Takahashi (who also co-edited the issue) suggested that the *Alice* books warranted high regard in a variety of ways. Finally, a number of up-and-coming artists participated in the special issue, including the award-winning Minoru Betsuyaku, collage artist Yuri Nonaka, and poet Sumiko Yagawa. Yagawa's essay "The Eternal Girl" ("*Fumetsu no shōjo*") constitutes an early critical look at the role of the girl in Japanese culture that would later become one of the theoretical foundations for analyses of Japanese girls' culture (Aoyama and Hartley 2011, 3). The *Modern Poetry Notebook* special issue thus positioned *Alice* within a network of fashionable intellectual theories and subjects through articles and art created by up-and-coming talents.

Modern Poetry Notebook was quickly followed by additional *Alice* scholarship. One of the special issue's co-editors edited a book, *Alice Picture Books* (*Arisu no ehon*), in 1973. Special issues were devoted to Carroll and/or *Alice* in

30　Chapter 1

Monthly Picture Book (*Gekkan ehon*, 1976), *Japanese Children's Literature* (*Nihon jidō bungaku*, 1977), *The World of Children's Literature* (*Jidō bungaku sekai*, 1978), and *Eureka* (*Yurīka*, 1978). Several books by and about Lewis Carroll were newly published in Japanese (Momma in Momma and Kennell, 2021) across the 1970s. The *Monthly Picture Book* special issue was so popular that its contents were repurposed into the stand-alone book *Alice Fantasy* (*Arisu gensō*, 1976) within a year.

Surveying early *Alice* essays and books, it becomes clear that many of the authors were concerned with how we see *Alice*. This emergent motif is introduced in Minoru Yoshioka's opening poem for *Alice Picture Books*. Yoshioka writes: "This evening I reminisce about the 'non-image' of that singular girl, ruined by misguided hands" ("*Koyoi kakisonji no hitori no shōjo no 'hizō' wo tsuisō suru*," 1973, 24). Yoshioka is interested in not Alice but her image, or rather her "non-image" (*hizō*). His focus on and questioning of Alice's visibility, this contradiction of a viewing object that fails to be viewed, is repeated in various ways by other artists and intellectuals as *Alice* jumped across an array of media in the following decades.

The 1970s' boom in Japan's scholarly and cultural recognition of *Alice* has had lasting effects on Japanese culture due to the influence of its varied works and the role it played in the careers of its participants. In addition to Minoru Betsuyaku, up-and-coming artists including the surrealist playwright Shūji Terayama and painter Kuniyoshi Kaneko contributed to the *Alice* boom and its curiosity about Alice's visage. Terayama wrote several *Alice* pieces, including the short story "Alice in Shadowland" ("*Kage no kuni no Arisu*," 1976, English translation 2014). Terayama's submersion of Alice into shadows suggests the difficulty he has in visualizing her. Kaneko, on the other hand, built his career out of a body of portraits, an over-imaging, of Alice. His depiction ranges from straightforward illustrations of events—like Alice's swim in the pool of her tears—to original pornographic scenes to slightly menacing displays of implicit violence. His multiplicitous creations imply through their dissimilarity that Alice is too complex to be fully rendered in a single image. Terayama and Kaneko's art was matched by the critical insights of Masuko Honda, who is known today as one of Japan's foremost scholars of contemporary Japanese culture, and in particular, Japanese girls' culture. Honda built her influential theory that Japanese girls' culture is marked by liminality in part through an article on *Alice* (1977).[15] Honda's theory is explored in further depth in chapter 4 of this book.

The 1970s' glut was capped by Hiroshi Takayama's *Hunting Alice* (*Arisu gari* 1981, reprinted in 2008). Skimming through Victorian history, literature, and culture, Takayama searched for the "essence" ("*honshitsu*," in *Arisu gari*, 2008) of

"the age of 'art'" ("*geijutsu' no jidai,*" 2008), which is to say the Victorian era, in *Alice*. Takayama points out that "the Two *Alices*" ("Futatsu no Arisu," 2008, 31), or *Alice's Adventures* and *Looking-Glass*, "leave a decisively different impression" ("*ketteiteki ni chigatta inshō wo ataeru,*" 2008, 34) that generates a sense of "ambivalence" ("*ambivarensu,*" 2008, 54). Takayama's ambivalent wavering between multiple *Alices* recalls Yoshioka's earlier "non-image" and Kaneko's endless Alice portraits while echoing Honda's theory of liminality in girls' culture.

Hunting Alice set the standard for understanding *Alice* in Japan (Tatsumi in *Yurīka* 657 2015, 161), which is to say it affected how *Alice* appears. When the renowned cultural theorist Mari Kotani wrote an article in celebration of the 150th anniversary of the publication of *Alice's Adventures*, she titled it "Hunting Carroll" ("Kyaroru gari," in *Yurīka* 657 2015) in a sly twist on Takayama's famous tome. Where previous writers had written of multiple Alices and envisioning Alice, Kotani offered a doubled sense of vision: Alice as a viewer in possession of her own "strong stare" ("*tsuyoi gyōshi,*" 2015, 71) and Alice as a reproducible ("*utsushitoru,*" 2015, 70) image.

Questions surrounding whether *Alice* can be visualized and if so, how to depict it recur in newer Japanese *Alice* scholarship. The 1970s' special magazine issues devoted to Carroll and *Alice* are now supplemented by special issues about *Alice* artists like Kuniyoshi Kaneko (in addition to newer special issues about *Alice*). The Lewis Carroll Society of Japan was established in 1994 and began publishing an academic journal, *MischMasch*, in 1996. Where popular Japanese magazines like *Eureka* mix intellectual articles in with art, fiction, and other materials, *MischMasch* features illustrations, including those by the prominent *Alice* artist Takako Hirai (plate 2), among its wide-ranging scholarly material. Hirai's numerous *Alice* illustrations depict all the characters of *Alice* at a much smaller scale than their surroundings. Alice does not simply appear in a Hirai artwork; viewers must search for her miniaturized, distorted figure as she moves through a gigantic Wonderland. Hirai's interesting, attractive style contrasts with Kuniyoshi Kaneko's at times off-putting Alice paintings, but the inclusion of both artists' work in scholarly publications reveals that scholars' repeated musings on non-images, doubled *Alices*, and shadowed lands are not merely analyses of a separate text or texts, but rather contribute to shaping the *Alice* world in their own right. Repeated *Alice* translator Kimie Kusumoto highlighted how *Alice's* multiplicity affects artists as well as scholars through her comparative critical analysis of over a dozen early Japanese *Alice* translations, *Alice in Translation Land* (*Hon'yaku no kuni no Arisu,* 2001). Japanese *Alice* scholarship overall also reveals a degree of confusion between Alice and *Alice*. This confusion stems from the complex relationship between characters and their worlds.

32 Chapter 1

Adapting *Alice*, Adapting Alice

A work's relation to a world may come through a variety of means. Ronnie Spector's "Be my little baby" refrain against Eddie Money's verses in "Take Me Home Tonight" (1986) cues listeners in to the song's adaptation of Spector's 1963 hit, "Be My Baby."[16] Where sound links "Take Me Home Tonight" to "Be My Baby," Elton John uses a setting to link his song "Goodbye Yellow Brick Road" (1973) to the Wizard of Oz world. However, the primary way works connect to worlds today is the character, as in Maaya Sakamoto's *Boy Alice* CD (*Shōnen Arisu*, 2003) or Jefferson Airplane's "White Rabbit" song (1996).

Characters are useful bridges to worlds for a variety of reasons. Obviously, people may identify with a given character's story arc, but the character, as a construct, unites two seemingly contradictory affordances into a powerful whole. First, the character possesses what Marc Steinberg calls a "gravitational pull" (2012a, 44). Applying a character's image to something inexorably changes that thing to be more like the character, as when the Meiji chocolate company changed the shape of its chocolates to match the characters pictured in the included *Astro Boy* stickers. Characters in effect remake their surroundings to be like the worlds from whence they sprang. At the same time that the character is thus pulling its surroundings into its world, it travels, or has a "tendency toward diffusion" (Steinberg 2012a, 44). A character's image can be slapped on a sticker or T-shirt and carted around the world with ease; a person might even dress up as a character herself and so take the character everywhere she goes.[17] As these examples show, the character's utility increases in a media environment that resembles today's media mix–dominated condition. Characters' ability to travel combined with their ability to influence their surroundings enables them to seed our environment with their worlds, which raises sales for other works in their media mix.

Put another way, characters' power comes from their liminality. Characters are independent from both the texts in which they appear and the narratives of their lives (Itō 2006, 54). This becomes particularly obvious in regard to adaptations. For instance, before seeing Manami Konishi play Alice in *Scary Story: Alice in Wonderland* (*Kowai dōwa: Fushigi no kuni no Arisu*, 1999), viewers had already connected Alice to other texts and narratives. To say that characters are independent from both texts and narratives does not mean that they lack meaning. Rather, it means that they invoke their worlds. Characters can summon a world without being tied to a specific adaptation of that world. A character bridges consumers' lived environment and the character's own world. Extending into both the real world and the artistic one, a character fully inhabits neither.

They are, instead, "a material-immaterial composite" (Steinberg 2012a, 194) composed of physical instantiations, but linked to another, metaphysical world. In practical terms, they play an unusually prominent role in the media environments in which we live. Shunsuke Nozawa notes that there is a "fantastic but real world of characters that is grafted into our kind of world" to create a "layering of worlds" (2013, 8). We cross paths with characters every day, and in passing them, are thrust into a liminal state where our perceptions are simultaneously affected by real and fictional worlds.

Alice becomes a key figure in adapting *Alice* not just because she is the story's protagonist, but because she is the pinnacle of liminality. Alice has one foot in England and another in Wonderland; she is larger than Goliath and smaller than Thumbelina. Despite her movements and transformations, she retains cohesion. Alice walks through a mad land untouched by madness. Her story is not a hero's journey, wherein the hero matures through her travels. Alice converses with the mad and interacts with physical environments that do not match her physical state *without herself changing*. Alice's ability to exist stably across two worlds makes her the perfect character. She is material, in that her image and name have been splashed on everything from films to handbags, but she is also immaterial inasmuch as her body is ever-changing, ever-moving. Alice's liminality makes her the quintessential character.

Liminality, Alice, and *Alice*

The concept of liminality is itself fascinatingly liminal. A thing can be liminal if it simultaneously exists on both sides of a boundary, in which case it does not fully exist in either state. A woman with one foot inside her doorway and one foot outside her house is neither fully inside nor completely outdoors, but she does nonetheless exist in both places. At the same time, liminality can mean to completely exist in between, in transition. A mathematics teacher might create a worksheet to guide students through the transition from $3*2=6$ to $3x=6$. That worksheet exists unchangingly in the liminal space between multiplication and algebra. The meaning of liminality itself thus wavers between change and persistence; it is a simultaneous existence and nonexistence.

Though the term liminality is used infrequently, liminality surrounds us cloaked in many forms. Characters' material-immateriality constitutes a form of liminality, for example. Similarly, Karen Beckman ties the popularity of the trope of the vanishing woman to its "simultaneously avoiding the perils of total presence and the powerlessness of utter absence or invisibility" (2003, 15). Neither fully there nor entirely gone, vanishing women are a trope of liminality.

34 Chapter 1

Ghosts are another trope of liminality, proving the one-time existence of someone who is now deceased while bridging the real world to another "invisible world" (Braudy 2016, 113). The question of visibility tends to recur when we discuss tropes of liminality. If the woman is there, we should see her, but if she has vanished, we should not. The doppelganger, or "double [who] speaks your own dark thoughts" (Braudy 2016, 199) is another trope of liminality. Characters are not the only tropes of liminality, however. Cyberspace—with "its spaceless space, its scaleless scale and its timeless time" (Bukatman 1993, 121) that straddles reality and unreality—is often treated this way. Physical items can also function as tropes of liminality. Luc Peters and Anthony R. Yue astutely point out that "there are always at least two sides to every mirror" (2018, 2), which, Leo Braudy points out, transforms every mirror into "a potential doorway to an alternate reality" (2016, 194).

My discussion of liminality began with the character of Alice, and with mirrors it must return to Wonderland. Scholars regularly connect *Alice* to liminality. For instance, Braudy's description of the mirror's liminality continues "when Lewis Carroll's Alice, for example, goes through the looking-glass, she enters another world, in which her outside-the-mirror sense of self is severely tested" (Braudy 2016, 194). Akira Lippit connects specters to the film *Sink or Swim* (dir. Su Friedrich, 1990), whose protagonist's "tears exteriorized until they fill the world and she is forced to swim in them, like Alice in her own tears" (Lippit 2012, 85). Marshall McLuhan more elliptically connects automation to non-Euclidean mathematics, which "enabled Lewis Carroll, the Oxford mathematician, to contrive *Alice in Wonderland* [sic], in which times and spaces are neither uniform nor continuous," but rather a "fantasia of discontinuous space-and-time" (1964, 302, 149).

The connection between *Alice* and liminality is so strong that entire books have been structured around it. Inspired by "the technorati's enduring fascination with Carroll's novel" (2014, xiv), Heather Warren-Crow refuted masculinist readings of the digital world by using young Alice as a "guide" (2014, xiii) to digital image culture. Warren-Crow emphasizes that her interest lies in the character, rather than a book or author, because of Alice's "ability to use (and withstand) consumption as an activator of transformation, her capacity (and imperative) to change to suit different media and mediums, her stubborn engagement with problems of scale. Alice points us toward key attributes of digital images: malleability, transmediation, and instability" (Warren-Crow 2014, xiv). Alice's ability to straddle or oscillate over boundaries makes her the perfect guide to digital culture. She is also the perfect guide to nondigital culture, however, as Gilles Deleuze models in his analysis of sense (1969). Deleuze's musings on sense begin with Plato's conception of becoming: "a pure becoming without measure, a

veritable becoming-mad, which never rests. It moves in both directions at once. It always eludes the present, causing future and past, more and less, too much and not enough to coincide in the simultaneity of a rebellious matter" (Deleuze 1990, 2). He sees this becoming in Alice's many oscillations: Alice's wavering between larger and smaller sizes, time's straddling of future ("jam tomorrow") and past ("jam yesterday") but not present ("never jam *to-day*"), cats eating bats versus bats eating cats, and so on (Deleuze 1990, 3). Her pure becoming creates a "paradox of infinite identity" which somehow "strips Alice of her identity" (Deleuze 1990, 2–3). Alice is infinite; Alice does not exist.

Where Deleuze sees a paradox, I see liminality. It is possible to be everywhere yet go unnoticed. Every day we inhale air without giving it a thought. *Alice* saturates Japanese culture. Yet, the degree of its presence continually goes unnoticed, and the influence of *Alice* adaptations is regularly underrated. I argue that the reason for *Alice*'s pervasiveness and the reason *Alice*'s importance goes unnoticed are one and the same: liminality. Looking at the overall body of Japanese *Alice* adaptations, practically everything that we might associate with *Alice* has been changed or ignored by at least one, if not many, of them. Blonde Alice in her blue dress is sometimes brunette, sometimes male, sometimes wearing neither a dress nor the color blue. Sometimes she does not appear at all. The Mad Hatter, White Rabbit, and other characters likewise may or may not appear in forms familiar or otherwise, and the plot (if it exists) may not resemble that of any other *Alice* tale. Visual tropes like roses and card suits may be bypassed in favor of new imagery. The one thing that stays the same, that contains the vast seas of *Alice* adaptations, is liminality.

Alice in Japan

Liminality is innately multiple. Being composed of both existence and *in*existence means that a person confronted with liminality is faced with a known absence, a thing that actively advertises its partial existence elsewhere. Viewers are led to question what they are *not* seeing. This creates a dynamic wherein the absence of clear markers of *Alice*-ness can function as evidence that a given work is in fact an adaptation of *Alice*. Yūji Moriguchi's "Poisonous Mushroom Dream" (see plate 1) does not illustrate any event from the *Alice* narratives, is set in early twentieth-century Japan, and features two Japanese women. Nonetheless, viewers can recognize it as a depiction of Alice and the caterpillar. A display of mushrooms, a hookah, and a young female character are the only apparent connections to *Alice*, but the very lack of specific (or perhaps I should say blatant) identifiers in and of itself suggests that this painting depicts another Alice's journey into a

36 Chapter 1

different sort of Wonderland. The mushrooms and hookah beckon to viewers—"Think about it, you can figure this out. You've seen this somewhere before . . ."—and with that alone, viewers fill in the blanks like manga readers imaginatively filling in the gutter between two panels.

Manga hold one key to understanding *Alice* and the contemporary Japanese media environment. Manga is a central medium in Japan's media environment. Most if not all successful media mixes will ultimately contain at least one manga. Manga are serialized in dozens of dedicated manga magazines that are sold in the ubiquitous convenience stores for reading (and depositing) on the trains of Japan's world-class mass transit system. Different magazines are published on different intervals, but the most successful manga may be serialized on a weekly basis for decades, ultimately totaling tens of thousands of pages. Maintaining an audience base becomes increasingly difficult as time goes by. New readers need to be introduced to the characters, while old readers need innovation and complexity to remain engaged. Therefore, every single chapter must connect readers to a detailed, cohesive world that is constantly evolving in only a couple dozen pages. The less information readers require to connect a chapter to a world, the more useful that world becomes for manga artists. Because *Alice*'s liminality means that an absence of information effectively becomes information, it is no surprise that many, many manga artists have adapted it. The worlds of their iterations then spawn new media mixes that launch *Alice* into more media.

Alice's liminality not only enables but actively encourages its reproduction in the contemporary Japanese media environment. The media mix production process that underlies so much media production in Japan today is based on two principles: production in multiple, and connections between those multiple works and their shared worlds. *Alice*'s liminality allows it to function as a bridge between different works and worlds, and consumers are able to follow this connection with surprisingly little overt direction. Walter Benjamin famously argued that mechanical reproduction has a negative effect on works of art, yet in *Alice*'s case, the reverse seems to be true. The more *Alice* circulates—the more familiar consumers become with its various markers—the easier it becomes to recognize *Alice* at a glimpse. In turn, since adapters can invoke *Alice* with ease, they are more likely to do so. This explains why *Alice* can be ever-present in Japan without its centrality to Japanese culture being recognized: even when *Alice* is there, it really is not there.

Each of *Alice in Japanese Wonderlands*' chapters explores how a given trope of liminality appears in *Alice* adaptations. Chapter 2, "Ryūnosuke Akutagawa in the Shadow of Early *Alice* Translations," focuses on the silhouette, which came to be associated with *Alice* as it was adapted over time in Japan. In particular, young

Alice's silhouette appears regularly in *Alice* adaptations today. Alice's silhouette is clearly recognizable amidst a rain of detailed, full-color cards on T. Haneishi's "Unexpected in Wonderland" notebook of stationery for Gakken Sta:Ful (figure 1.1d). This notebook particularly emphasizes silhouettes by bookending the notebook's title with a small silhouette of the White Rabbit. Silhouettes are recordings of shadows, and shadows are perhaps the ultimate example of liminality: they exist, and that existence can be proved by the naked eye, yet they have no physical substance and therefore cannot be grasped (regardless of what Peter Pan might tell you). A silhouette in turn is proof that something existed, but it is also independent of that thing. The silhouette exists where the person whom it memorializes does not. Like a character, the silhouette travels and invokes an Other wherever it goes. In an uncanny echoing of Steinberg's material-immaterial composite, art historian Emma Rutherford notes that "a silhouette is both something and nothing, a negative and a positive" (2009, 8). The silhouette motif has been modified as it spread throughout Japanese media. The Meiji Company's co-branded *Alice* chocolates (figure 1.1b) evoke the same empty substance by depicting Alice with thin draft marks showing how she was drawn, for example. Freelance designer 0313's *Alice* pin (figure 1.1c) partially submerges Alice in a shadowy background behind the Queen of Hearts to create a similar sense of silhouetting. The character's material immateriality merges with the silhouette's something and nothing in contemporary Japanese *Alice* adaptations through young Alice, who exists in England and Wonderland, largely and smally, but always as herself.

Chapter 2's silhouettes are followed by an examination of the looking-glass in chapter 3, "Yayoi Kusama, the Modern Alice (Through the Looking-Glass)." Fine artist Yayoi Kusama initially came to the art world's notice for her innovative paintings, but today she is famed for her "Infinity Mirror Room" series of mirrored installations. These installations have proven to be blockbuster exhibits at museums around the world. Chapter 3 re-reads Kusama's career from the perspective of the looking-glass to show how the *Alice* world unites themes, imagery, and concepts from across Kusama's oeuvre into an integrated whole.

Chapter 4, "A Profusion of Alices Flutter through Manga for Girls and Boys," connects Masuko Honda's conception of fluttering to *Alice* manga. Honda argues that fluttering, or oscillating back and forth over borders, is a technique used to subtly transgress gendered societal norms. I link fluttering's active obscuring of transgression to the unintentional obscuring of *Alice*'s centrality to contemporary Japanese culture. *Alice* manga boomed in the 1980s as the media mix production system came to ascendancy across Japanese media industries. Chapter 4 skims through manga for girls and boys, manga where Alice is male, manga tied

38 Chapter 1

to musical subcultures, and more to show that *Alice*'s massive popularity in manga stems from the twin developments of the media mix and what is called girls' culture in Japan.

Chapter 5, "Detecting *Alice* on Page, Screen, and Street," tracks the mystery genre's development in Japan through *Alice* to reveal that *Alice*'s liminality enabled creators in multiple media to mend the Japanese mystery genre's mid-twentieth century division into two schools (Orthodox and Society). While every chapter in this book examines works in a variety of media, I have tried to cover as many media in this chapter as possible to show how far this method of analysis might be taken. Chapter 5 consequently examines various forms of literary fiction, live-action film and television, clothing, manga, scholarly writing, anime, drama, CDs, artbooks, gravure photobooks, illustrations, restaurants, and magazines. The final chapter brings together the book's key conclusions in a discussion of recent transnational *Alice* co-productions such as the hit Netflix show *Alice in Borderland*.

Modern Japanese culture, like cultures around the world, is marked by an explosion of media. *Alice*'s liminality bridges the gaps between media to exact a unifying force on this profusion. Ultimately, *Alice* is powerful because of its weakness. Because its liminality can be indicated so easily, *Alice* can travel farther faster than other worlds. *Alice* is thus perfectly suited for this media moment, so it should be no surprise that *Alice* is proliferating in Japan and around the world.

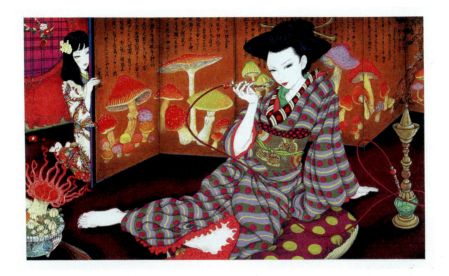

(above) Plate 1: A kimono-clad Alice gazes upon a temptress-style Caterpillar from behind a shoji screen in Yūji Moriguchi's "Poisonous Mushroom Dream" ("Dokutake no yume," 2007) from the *Carroll Modernology* exhibit. (Photo courtesy of the University of Southern California's Andrew W. Mellon Digital Humanities program.)

(left) Plate 2: Viewers have to hunt to find Alice and the White Rabbit as they run behind the oversized bottles in the July illustration from Takako Hirai's 2012 *Alice* calendar.

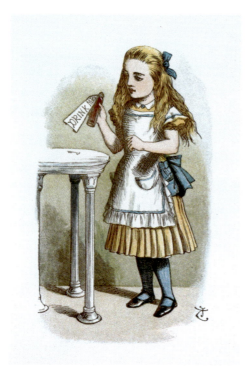

Plate 3: The first official colored version of Alice was illustrated by John Tenniel for *The Nursery Alice* (1890). (Image courtesy of the British Library and Wikimedia Commons.)

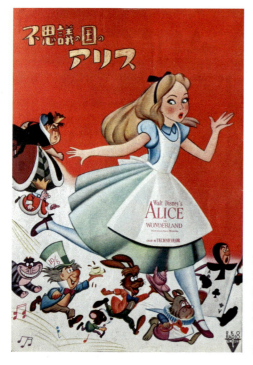

Plate 4: An image of Alice fleeing from Wonderland's kooky residents promises viewers a fun film, but this pamphlet sold in Japanese theaters with the release of Disney's *Alice in Wonderland* contains educational material.

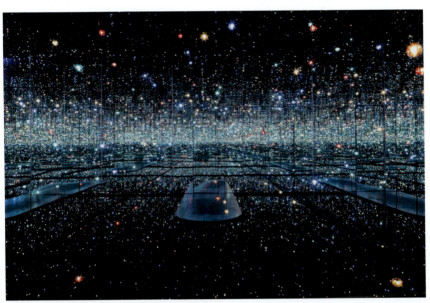

Plate 5: The fairy lights of Yayoi Kusama's *Infinity Mirrored Room-The Souls of Millions of Light Years Away* (2013) at the Broad Museum in Los Angeles are beautiful as they repeat infinitely in the exhibit's mirrored walls, but the work comes alive when visitors set foot inside it.

Plate 6: *Alice's Adventures in Wonderland with artwork by Yayoi Kusama*, written by Lewis Carroll, translated by Kimie Kusumoto (2012). The first spread shows Kusama's polka dots surrounding the text and serving as a foundation for her floral illustration on the book's opening pages; in the second spread, text behaves like an illustration while the polka dots merge illustration with text. (Second photo courtesy of the University of Southern California's Andrew W. Mellon Digital Humanities program.)

Plate 7: Tohru Kouno in a traditional Japanese boy's school uniform on the cover of the first volume of Mikiyo Tsuda's *Princess Princess* manga (originally published in 2002).

Plate 8: Kouno dressed in drag as Alice on the cover of the final Princess Princess publication, the *Princess Princess Premium* artbook (2007).

Plate 9: *Tokyo Babylon*'s Subaru Sumeragi strikes a pose.

IN TOKYO THE GIRL IS PRINCESS

Plate 10: *Tokyo Babylon*'s shrunken Hokuto Sumeragi as Mad Hatter drinks tea with the White Rabbit.

Plate 11: Mitsukaz Mihara, a regular illustrator for the *Gothic and Lolita Bible* magazine and a repeat *Alice* adapter, created this two-page spread of the Mad Tea Party especially for her *Alice Addict* (*Arisu Chūdoku*, 2003) artbook.

Plate 12: (left) Diamond Dining Group's *Alice* restaurants feature unique decorations, but all reflect the Lolita style. (right) At this restaurant with ornate chandeliers and an effusion of patterns, *Alice* characters gaze upon diners while they eat.

Plate 13: The normally calm, cool, and collected detective Earl Ciel Phantomhive is dropped into Wonderland in the Original Video Animation (OVA) *Ciel in Wonderland* (2010). Ciel meets many characters from the *Black Butler* manga, but the story contained within this OVA is not connected to the manga series.

CHAPTER 2

Ryūnosuke Akutagawa in the Shadow of Early Alice *Translations*

Lewis Carroll's Alice in Wonderland novels have played an important role in the development of modern Japanese culture, a role that began, unsurprisingly, with the medium of literature. The novels were first adapted in Japan through an 1899 translation by Tenkei Hasegawa, since which time they have been translated more than five hundred times. This chapter examines *Alice*'s early history in Japan through two case studies that show how a set of books known primarily as children's literature in the West came to be central to contemporary Japanese culture. The first case study involves Hasegawa's initial translation and the literary milieu that birthed it. It is difficult to situate this first Japanese *Alice* precisely, because it was published in an era of massive literary and cultural upheaval. *Alice* served as a shadowy nexus within developing literary styles and genres, as well as for new audiences. At the same time, Hasegawa's translation, *Mirror World* (*Kagami sekai*), epitomizes the literary environment of the time. Translated by a man who worked primarily as an editor and critic, and published in a new magazine aimed at a new reading audience, *Mirror World* reveals the foundations of today's Japanese literary environment even as the reason for its existence remains indistinct.

If Hasegawa's translation reveals the industrial basis of contemporary Japanese literature, Ryūnosuke Akutagawa and Kan Kikuchi's joint 1927 translation of *Alice* betrays its artistic grounds. Where Hasegawa is largely known for his editorial and critical accomplishments, Akutagawa earned his place as modern Japan's premier short story author through the happy meeting of stylistic genius and a vast knowledge of global literature. In his turn, Kikuchi merged the Irish and Japanese theatrical traditions to great acclaim. Their *Alice Story* (*Arisu monogatari*) thus represents an unprecedented artistic co-production between two titans of modern Japanese literature.[1] Despite the rarity of two writers as elite as Akutagawa and Kikuchi co-authoring literature, their *Alice* is little known outside of Carrollian circles. Yet, examining it as part of Akutagawa's oeuvre, in particular, forces a reconsideration of said oeuvre as well as of Akutagawa's life and how he is remembered today.

39

40 Chapter 2

While we can learn much about Japanese literature and authors from early *Alice* translations, they also provide fascinating insight into the birth of contemporary Japan's vibrant visual culture. The period spanning the Hasegawa and Akutagawa-Kikuchi translations saw violent transformations in Japanese visual media at every level. A host of new technologies, styles, subject matter, and even media were introduced to Japan, debated, and modified in an exhilarating blast of visual artistry that laid the foundations of today's Japanese media environment. Film scholar Inuhiko Yomota notes that a film was first shot in Japan by a Japanese person in 1897. The earliest extant Japanese film, *Momijigari* (1899), appeared in the same year as Hasegawa's translation, after which a slew of technological, industrial, and cultural developments spawned the first golden age of Japanese cinema in the late 1920s (Yomota 2019, 2). Though scholars debate the exact date of anime's birth, estimates center within the 1910s with the industry growing from early, "largely artisanal, small-scale productions" to "the industrialised output that characterised its move into profitability" (Clements 2013, 35) during the 1920s. As with anime, manga scholars are still nailing down exact dates but in general track the medium back to this period and the influence of imported comic strips (cf. Kinsella 2000; Gravett 2004; Exner 2021). The assorted media of fine art saw a number of developments as well. Shortly after their development in the West, a proliferation of new, modern art styles—including Impressionism, Post-Impressionism, Fauvism, Cubism, Futurism, Art Nouveau, Expressionism, and Art Deco—were imported to Japan, where painters, sculptors, and architects were inspired to experiment wildly (Tsuji 2018, 413–450). Competition from new, cheaper printing technologies like the lithograph likewise forced Japan's famed woodblock print medium to evolve in the early twentieth century (Tsuji 2018, 418–421).

The most interesting medium to compare with these early *Alice* translations, however, is *kamishibai*, or the paper theater. A *kamishibai* involves a single performer telling a story while moving a series of large cards that illustrate the story through a small theater-shaped stand. *Kamishibai* became a major medium of children's entertainment in the 1930s and are commonly credited for laying groundwork for anime's later popularity (Steinberg 2012a, 19–20). Yet, *kamishibai* also hold an intriguing position between the animated and the literary media, at least where children are concerned. Storytellers do not merely switch one card for another; they shake the card to replicate an earthquake, slowly drag it off of the card below to reveal a hidden monster, and otherwise animate the immobile *kamishibai* cards (Steinberg 2012a, 24–25). On the other hand, *kamishibai* plays often retold existing stories. For example, *Alice's Adventures* was transformed into a pair of *kamishibai* illustrated by Seiichi Yuno in

Ryūnosuke Akutagawa in the Shadow of Early *Alice* Translations 41

1965. Performers needed to know the stories involved (and which card the children were looking at), so scripts were printed on the reverse side of the cards. Thus, Yuno's *Alice kamishibai* featured a script by the proletarian children's author Daiji Kawasaki.

Like *kamishibai*, children's literature features a complementary mix of text and image. The technologies behind Japanese children's literature illustrations have changed astronomically since 1899. Yet, examining the illustrations of early Japanese *Alice* translations reveals a visual motif, the silhouette, that continues across *Alice* texts and images even today. The word "silhouette" is derived from the name of a short-lived French finance minister, Étienne de Silhouette (1709–1767), whose zealous cost cutting tied him to all things inexpensive in the public mind. In particular, a style of portraiture composed of paper cutouts that had previously been called shades or profiles came to bear de Silhouette's name: "first, due to his request that a plate be melted, the word *silhouette* signaled a reduction to the simplest form; second, it implied that the victims of his tax policies were reduced to mere shadows" (Rutherford 2009, 27).

Silhouettes have similarities with images from as far back as the Paleolithic period, but their apocryphal invention comes from a roughly seventh-century-BCE woman named Dibutade. Facing her lover's departure on a long journey, Dibutade traced the outline he cast in candlelight on a wall. Early shades retain this memorial orientation, but by de Silhouette's time the practice of cutting paper shades had bifurcated. Quick artists sold shades cheaply to those who could not afford painted or drawn portraits. However, the upper classes also enjoyed making silhouettes as a hobby in much the same way that the next king's wife, Marie Antoinette, enjoyed playing at being a milkmaid.

What, then, is a silhouette? At its heart, a silhouette is a shadow. It may be gussied up with a bit of detail by the artist, but it is the physical and temporal capturing of a shadow. Shadows are perhaps the ultimate example of uncertainty: they exist, and that existence can be proved by the naked eye, yet they have no physical substance and therefore cannot be grasped. By their existence, shadows prove that something else also exists. Should an artist paint a landscape, she most likely stood at the vantage point depicted as she painted and looked directly at the scenery rendered on the canvas. In contrast, silhouette makers work not with the face or figure that they are attempting to portray, but the shadow it casts. Silhouettes are thus one step further removed from their subjects than are other art forms that purport to represent reality. The shadow stands as a third partner in the relationship between the silhouette art form and the subject much as a translation stands between a translated book and a foreign-language reader.

42 Chapter 2

What Is Alice in Wonderland?

While this book has a very wide definition of adaptation, for simplicity's sake this chapter focuses specifically on translations of Lewis Carroll's *Alice* books. Carroll wrote five *Alice* books—*Alice's Adventures Under Ground* (1864), *Alice's Adventures in Wonderland* (1865), *Through the Looking-Glass, and What Alice Found There* (1871), *The Hunting of the Snark: An Agony in Eight Fits* (1876), and *The Nursery Alice* (1890)—but some of these books are more important in Japanese literary history than others. Translation here is considered a type of adaptation in which a writer rewrites a text. Complicating matters, some of Carroll's *Alice* books qualify as translations of his other *Alice* books. As discussed in the first chapter, *Alice's Adventures Under Ground* is an early, handmade version of *Alice's Adventures in Wonderland*, which was then rewritten in *The Nursery Alice*. Carroll's translations of his own work highlight intriguing differences in English and Japanese literature.

Of Carroll's five *Alice* books, only *Alice's Adventures* and *Looking-Glass* are popularly known in Japan. *Under Ground* and *The Nursery Alice* are known to Japanese *Alice* aficionados, but not the general public. *Under Ground* differs from the later *Alice's Adventures* in some ways, and it has a complicated publication history. The original, handmade volume given to Alice Liddell is now part of the British Library, but Carroll published a facsimile of it in 1886, and various other groups have republished it in limited editions. As such, *Under Ground* has always been a niche product pursued by readers who are already interested in further study of Alice in Wonderland regardless of their national origin.

The Nursery Alice, on the other hand, reveals subtle differences between what constitutes literature for children in Japanese and English. It has become common to rewrite classic literature for younger audiences in both the West and Japan, but how books are rewritten varies. In the English-speaking world, the complexity of words used in a book increases concomitantly with the intended readers' age. Likewise, some topics are deemed too mature for younger readers, so sections of a book might be censored. The extensive use of racial slurs in Mark Twain's *Adventures of Huckleberry Finn* (1884), for example, has prompted substantial debate over whether to edit the classic so that students are not forced to face the complicated problem of racism while they are too young to understand its complex history.[2] *The Nursery Alice* reflects these two strategies with simpler words and a curtailed plot, but Carroll utilized another tactic as well: revising the narrative voice to simulate an adult reading a story to a child. The text of *The Nursery Alice* includes questions about a theoretical young listener's preferences and opinions that parents are supposed to read to their children. This novel

Ryūnosuke Akutagawa in the Shadow of Early *Alice* Translations 43

approach has remained relatively rare in literature rewritten for children in both English and Japanese. In contrast, one Japanese strategy for translating literature for younger audiences is unique. Written Japanese is composed of a mix of complicated *kanji* and simple *katakana* and *hiragana* characters. While adults read and write Japanese using a mix of *kanji, hiragana,* and *katakana,* writing aimed at small children uses only the simple *hiragana* and *katakana* characters. For example, the sentence "The cat died" ("*Neko ga shinda*") might be written as "猫が死んだ" for adults, but "ねこがしんだ" for children. Because the Japanese school system introduces a set list of characters to children in each grade, publishers know precisely which characters each age group will be able to read. Therefore, publishers can vary the characters used in each publication depending on which age group they are targeting. In practical terms, this means that a Japanese translator's first concern while rewriting literature for younger children is neither the complexity of the words used nor the level of maturity in the story but which of several ways to write each word she will choose.

Early Japanese translations of *Alice* departed significantly from the two novels' content in terms of the plot, cast, and concepts employed.[3] *Alice* was initially translated into Japanese as part of a wave of translations spurred by a desire to learn more about Western culture. As such, translators were actively selecting which new concepts they wanted to introduce to their readers through their *Alice* translations. The earliest Japanese translators thus manipulated the text much like Carroll himself did while writing *The Nursery Alice,* drawing readers' attention to certain sections of the text while minimizing or outright dispensing with others.[4] Later translators attempting to rewrite Alice in Wonderland for young audiences were able to draw on these early Japanese translations instead of *The Nursery Alice.* As a matter of course, translators intending to create Japanese *Alice* translations for younger children focused on translating *Alice's Adventures* directly. This manipulation of *Alice's Adventures* is fascinating, but it would be obscured should *The Nursery Alice* be treated as having equal prominence in Japan as *Alice's Adventures.* Thus, *Under Ground, Nursery Alice,* and *Snark* make minimal appearances in the novels' Japanese translation history.

Children, Women, and Literature: Testing the West in Turn-of-the-Century Japan

In 1899, the children's magazine *Shōnen sekai* (*Youth World*) began serializing Tenkei Hasegawa's translation of an English novel previously unknown in Japan: Lewis Carroll's *Through the Looking-Glass, and What Alice Found There.*[5] They named it *Mirror World* (*Kagami sekai*) in a canny play on the magazine's own

44 Chapter 2

title, and it fit directly into newly developing conceptions of childhood, femininity, and literature in Japan. 1899 was a pivotal year in Japanese history only in the sense that it marks the midpoint between the 1894–1895 Sino-Japanese War and the 1904–1905 Russo-Japanese War. However, a three-decade-old push to modernize Japan by importing foreign knowledge on a massive scale had produced a cultural maelstrom wherein signs of change could be found every year. Basic social concepts like womanhood, childhood, and children's literature were in flux. The wave of foreign culture contained too much information for anyone to internalize completely. The Japanese people were inundated by Western science, literature, language, clothing, social structures, food, medicine, gender norms, art, and more. They had to quickly prioritize which materials, concepts, and customs to adapt. The question of how much Western culture to adapt and how to adapt it thus became a national concern. Turn-of-the-century Japan was a turbulent and confusing place to be, and the *Alice* novels functioned as raw material for people to work through their thoughts and aspirations regarding the major changes underway in Japan.

Early *Alice* translators were introducing Western social and cultural mores alongside the novels themselves. For example, Alice's behavior throughout the books—which includes arguing with royalty and travelling unchaperoned—ran counter to Japanese standards for both women and children in 1899. Before tackling Carroll's famous wordplay and nonsense language, translators had to impart basic cultural information, like what the White Rabbit's pocket watch was. Japanese Carrollian scholar Mikiko Chimori has detailed several changes made to *Mirror World* due to Japanese children's lack of familiarity with British concepts. For instance, "shaking hands" becomes "bowing" (Chimori 2006, 121) as readers would not have known that one shakes hands as a way of greeting someone. This type of alteration gradually disappeared from *Alice* translations as the Japanese people learned more about Western culture, yet it highlights a key function of early *Alice* translations: limning the outlines of foreign—and specifically, British—culture to the distant Japanese public.

The necessity of introducing readers to an exotic culture was complicated by the fact that the roles played by children and their literature within Japanese society were evolving with the times. Drawing on work by the Japan Children's Literature Association, translation theorist Judy Wakabayashi proffers a three-part definition of children's literature as it is conceived in Japan today: that it is written or translated by adults for children; that it socializes the child; and that it triggers children's emotions and interest (2008, 228). Wakabayashi observes that literature meeting some of these criteria existed in Japan as early as the late seventeenth century, but that no literature met all of them until the close of the

nineteenth century.[6] R. Keller Kimbrough (2015) later used a little-known collection of one boy's books to prove that at least some literature meeting the modern Japanese definition of children's literature did in fact exist in Japan in the 1660s, but even those books seem to lack an original child protagonist. This suggests that children were not seen as fitting protagonists for their own literature at the time.[7] Historian Brian Platt argues that childhood was not widely understood to be important in Japan until the 1890s, which he traces to a mix of economic developments combined with a strong interest in social regulation by prominent members of Japanese society (2005, 975). The flood of translated Western literature entering Japan in the late nineteenth century carried with it a significant amount of literature meeting all three of Wakabayashi's criteria, and prompted Japanese authors to greatly expand upon the amount and variety of children's literature available in Japanese. In particular, the importation of Western children's literature—including works such as Frances Hodgson Burnett's *Little Lord Fauntleroy* (1885) and assorted fairy tales—seems to have spurred the proliferation of stories for children about children.

When creating literature for children that featured child protagonists, translators had to decide whether to depict children realistically or as virtuous paragons that could serve as exemplars to their actual, imperfect young readers. In *Mirror World*, Hasegawa made a complex alteration to a poem about a carpenter and a walrus that exemplifies early translators' difficulties. In Carroll's version, the carpenter and the walrus lure a group of young oysters off of an oyster bed against the elder oysters' advice only to eat them. In *Mirror World*, this becomes a song honoring the sun and the moon. Hasegawa thus changed a comical and dark episode into a strong moral narrative conveyed through a familiar, Buddhist form.[8] Tarokichi and Jirokichi, a.k.a. Tweedledee and Tweedledum, provide the chapter's comedy through their obstreperous arguments and general foolishness.

Just as the role of the child in Japanese society was changing, so too was women's place. Exposure to Western society brought with it the idea that women could be prominent in society, like Queen Victoria, as well as new standards for educating girls. Different strands of thought developed regarding what role women should play in Japanese society, and these strands coalesced around a series of symbols of femininity: the New Woman (*shinfujin*), the Good Wife and Wise Mother (*ryōsai kenbo*), and the Modern Girl (*modan gāru*). These symbols were discussed in detail in the pages of newspapers and formed the basis of characters in literature and film. Yet, while these symbols took on the pretense of uniformity, actual women's incorporation of Western culture into their lives varied widely. Some women pursued the new educational opportunities available to

46 Chapter 2

them yet avoided Western clothing, while others worked in the new, Western-style cafés, but lacked interest in higher education. The overarching trend was for women to assert themselves in society more publicly. Men played an active role in opening up new opportunities for women, in particular in the realm of education. Consequently, while changes in the Japanese conception of childhood had an effect only on the content of Japanese *Alice* books, the changing conception of womanhood led to changes not only in how female characters were portrayed within the books but also in who translated and read *Alice*.

Foreign manners and materials, a new understanding of children's literature, and a shifting conception of womanhood would have created a complicated enough environment in which to translate, but early *Alice* translators had to face an additional complication: the Japanese language itself. In the late nineteenth and early twentieth centuries, the Japanese literary world was consumed by a debate over whether to write in colloquial terms that anyone could understand or in the classical literary language understood only by elite members of society.[9] The difference between oral and literary language was stark: literary Japanese was a conglomeration of the oral Japanese and written Chinese languages.[10] Chinese characters, now called *kanji*, were used to read and write Chinese in Japan starting in the fifth century CE. Four centuries later, the Japanese began modifying *kanji* to represent their own language. These modified characters initially appeared as a reading aid in the margins of Chinese texts before eventually being used to write Japanese texts outright. Today, written Japanese is composed of a mix of *kanji*, which can be read multiple ways and are attached to a specific meaning, and simplified *hiragana* and *katakana* characters that can only be read a single way and carry no independent meaning.

While a written Japanese language developed, the Japanese elite adopted a variation on classical Chinese writing as their *lingua franca*. This variation involved writing in Chinese characters coupled with guidance marks that indicated the Japanese reading order, and it remained dominant in Japan until the late nineteenth century.[11] At that point, Indra Levy notes, "the palpable threat of Western domination supplanted the study of Chinese with the study of multiple Western languages (with English at the forefront)" (2012, 2). This change in geopolitical focus led Japanese authors to reconsider what could constitute "written Japanese." A similar shift occurred in China in the early twentieth century with the May Fourth intellectual movement and its attempts to modernize the Chinese people through, among other things, colloquial literature and a new understanding of childhood. Zhao Yuanren's 1922 translation of *Alice's Adventures* played a vital role in this development in China by "construct[ing] a modern child that came to embody the May Fourth imagination of an ideal modern

Chinese citizen" (Xu 2018, 75–76). In contrast, no single translation of *Alice* played an overwhelming role in the modernization of Japanese literature; rather, several translators used *Alice* as raw material to test different ways to modernize Japan and Japanese literature over the course of several decades.

Members of a Japanese movement referred to as *genbun itchi* (言文一致) were supposedly reformulating the relationship between oral (*gen*, 言) and written (*bun*, 文) Japanese. Yet, eminent Japanese literature scholar Kojin Karatani describes *genbun itchi* as not a specifically literary project, but a general movement to emphasize direct experience over idealization that was enacted differently in different media.[12] Though *genbun itchi* ostensibly revolved around the unification of spoken and written Japanese, Karatani determines that it was actually "a reform of writing, 'the abolition of *kanji*'" (1998, 51). In other words, Japanese authors began to turn away from the idealized concepts that *kanji* signified in favor of the direct meanings created by stringing together phonetic *hiragana* and *katakana* characters. This in turn changed the possibilities available for translations. Translators could use *kanji* to transmit idealized concepts, or they could use *hiragana* and *katakana* to transmit foreign sounds. If they felt like getting creative, they could even invent new combinations of *kanji* or juxtapose old *kanji* combinations with new offset readings in *hiragana* or *katakana*. For instance, Tadataka Okada glossed the *kanji aijaku*, or "attachment," with *hiragana* reading *suijaku*, or "weakness," to translate the nonsense word "mimsy" in his 1959 translation of *Looking-Glass*. Okada's neologism traces the shape of Carroll's text without exactly replicating it, rendering a silhouette of the original for Japanese readers. Translators and authors alike exploit this flexibility in Japanese literature even today.

Genbun itchi's effect can be seen in translators' treatment of Alice's name. Early translations of Carroll's novels experimented with different ways to name the protagonist. Some, like Hakuya Maruyama's *Ai-chan's Dream Story* (*Ai-chan no yume monogatari*, 1910), used *kanji* to create a new name for Alice; Ai (愛) means "love" and is a common component of female Japanese names. Other translators, like Hasegawa, attempted a new name that used the phonetic *hiragana* (in his case, Mii-chan, or みいちゃん). The debate over how frequently *kanji* should be used and which *kanji* should be required knowledge still rages today with descendants of the *genbun itchi* movement arguing that Japanese has too many *kanji* to be understandable and conservatives arguing that *kanji* are linked to Japanese identity and therefore must be protected. Regardless of whether *genbun itchi*'s proponents were attempting to merge oral and written Japanese or whether they aimed to reform the relationship between experience and expression, their actions were spurred by the widespread introduction of Western

48 Chapter 2

culture to Japan and they themselves were "driven by a desire to achieve parity between Japanese and modern European languages" (Levy 2006, 38). Thus, both the stories being translated and the form of language they were being translated into were new to Japan and marked by the changing relationship between Japan and the West.

These trends—the sudden influx of Western culture, the development of the concept of childhood, changes in women's social roles, and an evolution in written language—created a vibrant environment for *Alice*'s introduction. Yet, *Alice* translations did not merely reflect the contemporary environment. They provided a medium for authors to experiment with new styles, examine who their audiences were, and think through the massive cultural changes occurring around them. Translations of children's literature played an important role in the development of Japanese literature at the time. For example, Rebecca Copeland credits author Shizuko Wakamatsu's 1890 translation of *Little Lord Fauntleroy* (*Shōkōshi*) with not only opening "the door to the entirely new genre of children's literature" (2000, 100), but even "substantially advanc[ing] the campaign to invent a modern literary idiom" (Copeland 2000, 100) as the earliest example of the *genbun itchi* movement. Similarly, other authors and translators of Japanese children's literature used the many new child protagonists appearing in the genre to experiment with new forms of literary subjectivity, a concern that would ultimately lead to the creation of the influential I-novel genre. Japanese translators used Alice in Wonderland to stake out their own ground in this literary and cultural upheaval.

Alice: The Early Years

Carroll's Alice in Wonderland novels are often considered part of children's literature in the English-speaking world, but *Alice* translations helped define what children's literature is in Japan today. The incredible increase in literary production that attended Japan's mass importation of Western culture quickly prompted enterprising publishers to create a new reading audience for their newfangled magazines: children. *Shōnen Sekai*, or *Youth World*, was one of the first magazines aimed at this new audience.[13] Launched in 1895, it published *Mirror World*, an unannounced translation of *Looking-Glass*, four years later. Leaving aside the content of the translation for a moment, the fact that it ran in *Shōnen Sekai* presages the shifting place *Alice* would take in Japan's evolving gender landscape. The standard translation of *Shōnen Sekai* is *Youth World*, but today the term "*shōnen*" refers specifically to boys. Japanese terms related to childhood underwent an expansion and compartmentalization over the course of the twentieth century.

Ryūnosuke Akutagawa in the Shadow of Early *Alice* Translations 49

As discussed above, the concepts of childhood and children's literature were reinvented towards the end of the nineteenth century in Japan. A century later, the "youth" had been subdivided into the boy (*shōnen*) and the girl (*shōjo*). These divisions are codified within Japanese culture. For example, boys have their own comics anthologies, such as *Shōnen Jump* and *Shōnen Sunday*, while girls have manga magazines like *Shōjo Comic* and *Shōjo Friend*.[14] Over the course of the twentieth century, youths were further divided by age group, with children passing through a nongendered state during the toddler years (*yōnen*) before becoming boys (*shōnen*) and girls (*shōjo*) on their way to a similarly gendered young adulthood as *seinen* (young, male adults) and *josei* (adult women). All of these terms—*yōnen, shōnen, shōjo, seinen*, and *josei*—are now standard categories in the Japanese magazine industry and related industries such as bookselling and manga. The gendered path from birth to adulthood demarcated by publishers developed over time, however, and we can see how it was established through an examination of *Alice*'s publication history.

The first Japanese magazine aimed at children was 1888's *Shōnen'en* (*Youth Garden*), which emphasized educating children over entertaining them (Carter 2009, iv). *Shōnen Sekai* was established with the obverse emphasis seven years later. The meaning of "*shōnen*" was already in flux when it appeared in the title of this groundbreaking magazine. Japanese children's literature scholar Nona Carter contrasts *shōnen* with *jidō*, the other major term used to refer to young people at the time, observing that *jidō* "referred to the rather undefined group of people who were not yet adults" (Carter 2009, 6), while *shōnen* pertained specifically to the young. In other words, people of all ages who were seen as immature—perhaps simply because they were unmarried—were considered *jidō*, but *shōnen* referred to young non-adults. Neither term referred to a specific gender. When *Shōnen Sekai* launched just seven years after *Shōnen'en*, it was created for children by people who were debating what exactly children were. *Shōnen Sekai* "ushered in a new era of popular magazines" (Carter 2009, 63) for these uncertain "children," distinguished by a higher degree of professionalism and competition.

Mirror World, which follows a young girl named Mii-chan into a mirror and on several adventures, was serialized in eight issues from April to December of 1899. Hasegawa was a respected member of the literary establishment, but he is better known as an editor and critic than as a translator. *Looking-Glass* was one of his earliest assignments upon joining *Youth World* and remains one of few translations by him. Like other Japanese translators of the time, Hasegawa took great liberties with his source. He began with *Looking-Glass* despite the fact that *Alice's Adventures* had not been released in Japan, and he altered its story

50 Chapter 2

considerably. *Mirror World* follows Carroll's book rather closely at first, only for Hasegawa to take Mii-chan on a journey of his own devising midway through the eighth chapter, "The Lion and the Unicorn." After a short digression wherein Mii-chan is chased by a traditional Japanese demon, she awakens at home again much like Alice. Hasegawa's inventions form only a small part of the serialization but solve a pressing problem presented by *Looking-Glass.*

While the plot of *Alice's Adventures* is fairly straightforward, *Looking-Glass* is structured around a game that was more or less unheard of in nineteenth-century Japan: chess. Hasegawa dealt with this difficulty by replacing chess with the Japanese game of go, but his substitution did not solve the issue completely. The plot of *Looking-Glass* follows Alice's journey from pawn to queen, yet go's playing pieces have no equivalent progression. Given that Mii-chan could not follow Alice's path fully, it is unsurprising that Hasegawa abandoned the final chapters of *Looking-Glass* in favor of a variation on traditional Japanese folk tales. By temporarily abandoning the text when the constrictions of its chess-based plot progression became tightest, Hasegawa was able to present a significant chunk of *Looking-Glass* to Japanese readers despite their ignorance of British culture.

Mikiko Chimori further points out that, because *Mirror World* was serialized and *Looking-Glass* was not, *Mirror World* "needed the thrill of serialization, which would be different from the original novel. At the end of each issue, child readers should look forward to the next, be tantalized, and finish the chapter by complaining that 'hey, Mii-chan is about to go on a trip'" (2015, 190). As a canny editor, Hasegawa would have made a point of ending each issue's installment on a high note. His treatment of the third chapter suggests he held the twin goals of entertaining and educating his readers paramount. This chapter, "Looking-Glass Insects," begins with a ride on a train (a technology that was new to Japan), followed by discussions between Alice and every child's favorite creature: bugs. Hasegawa even extended "Looking-Glass Insects" to the point of breaking it into two installments, padded out with material from the following chapter, "Tweedledum and Tweedledee." A perennial favorite in English, "Tweedledum and Tweedledee" features the long poem about oysters discussed above. In addition to changing the poem, Hasegawa cut it out of "Tweedledum and Tweedledee" and inserted it into the following chapter. His rationale can only be speculated at, but his changes ensure that the third, fourth, and fifth chapters of *Mirror World* all end on an interesting note. Ultimately, Hasegawa's alterations to *Looking-Glass* made *Mirror World* more compelling for a young, Japanese audience reading a serialized text.

Aside from the nascent literature for and about children, *Mirror World* was also published in a landscape where old genres were shifting to make room for

new. Within twenty years of *Mirror World*'s publication, Japanese literature would be dominated by genres like the I-novel, mysterious stories (*kaiki monogatari*), and proletarian literature. In her analysis of Japanese *Alice* translations, Kimie Kusumoto notes that *Mirror World* is a minor chapter in the history of *Shōnen Sekai* translations, but argues that it is important not just as the first Japanese *Alice* translation, but also because it "prepared the way for mysterious stories" (2001, 26) by introducing characters, images, and plot devices that were strikingly different from local traditions. Hasegawa's translation, which helped develop a new audience, new social roles for girls, and a new genre, might thus be viewed as a foot soldier in the fight for a modern Japanese literature.

Looking-Glass was not translated by anyone else until 1920. By that time, *Alice's Adventures* had been translated thirteen times.[15] The 1920 book, *Wonderland* (*Fushigi no kuni*, figure 2.1), shows how far knowledge about the West had spread into Japanese culture. Alice is denoted by the Japanized version of her name, *Arisu*, which had already become a set translation for "Alice."[16] In

Figure 2.1. Pages 332–333 of Masao Kusuyama's 1920 *Wonderland* showing mix of English and Japanese text.

52 Chapter 2

addition to using the name Arisu, *Wonderland* contained new translations of both *Alice's Adventures* and *Looking-Glass*, and it was released as a novel from the start instead of being serialized in a magazine first. The translator, Masao Kusuyama, assumed that his readers knew fairly complex Western terms, such as Anglo-Saxon (*Anguro · sakuson*, 345), and even inserted English words that Carroll had invented—"mome" and "outgrabing" (332), for example—in Roman letters with *hiragana* glosses on the side to preserve rhyme and rhythm (see figure 2.1). Kusuyama clearly expected his readers to be familiar with British culture, but he still adjusted the text in some areas: ham sandwiches seem to have been a known entity (*hamu · sandouicchi*, 345), but the Queen's tarts became *manjū*, or steamed buns.

Mirror World may not have been thought of as one of *Shōnen Sekai*'s major serials historically, but it reveals quite a bit about children's magazines, Japanese literature, the gendering of Japanese children, and the relationship between Japan's interest in the West and its people's desire to hold onto Japanese traditions at the dawn of the twentieth century. Literary experimentation was occurring at such a great rate that it could be found even in minor translations published for minors. British culture was deeply interesting, but it had to be introduced carefully and reflect Japanese morals. Those morals, however, were changing. Alice had to behave politely to the adults around her, but she could enjoy train rides, travel independently, and converse with strangers in her search for knowledge. Hasegawa's ode to the sun may seem quaint now, but he subtly encouraged both girls and boys to behave like children—a rather audacious proposition for a society whose children's literature had thus far depicted idealizations more often than actual children.

The first twenty Japanese translations of *Alice's Adventures* and *Looking-Glass* suggest a unified literary world. Eleven translations were published as single volumes of literature. Of the remaining nine, five ran in magazines aimed at a general child audience and one—Sumako's *Golden Key* (1908–1909)—ran in a magazine aimed at girls, *Girls' Friend* (*Shōjo no tomo*).[17] Two translations ran in magazines aimed at women, leaving the final translation to run in a magazine aimed at English-language learners. Those translations published initially as stand-alone volumes of literature also proffer hints that they were intended for diverse audiences. Iichi Ōmizo's stand-alone 1911 translation *Alice's Dream Story* (*Arisu yume monogatari*), for instance, features a two-page spread that enabled readers to compare the English text of *Alice's Adventures* on the left page with Ōmizo's translation on the right. In other words, *Alice* was introduced to a Japanese audience comprised of boys and girls, women and men, all of whom were assumed to benefit from the same literature. *Alice* translations introduced

children and adults to rudimentary aspects of European life and culture, but they also served as a tool to help elites learn English. While there is no evidence that *Alice* was marketed towards adults solely for their own reading pleasure, it is clear that *Alice*'s exact place in the literary firmament was undecided as of the early 1920s.

By way of comparison, the first Korean translation of *Alice* was published in 1959 under the title *Alice in Wonderland* (*Isanghan naraui Aeriseu*, literally "Wondrous Land's Alice").[18] Like many Japanese translations, it was published as part of a series of books for children. Like early Japanese translations, the first Korean *Alice* was published with what might be called benevolent ulterior motives. Kang-hoon Lee notes that the series that included *Alice*, "Boys and Girls World Literature," is a rare example of Korean literature aimed at children in the period immediately following the Korean War (in Lindseth and Tannenbaum 2015, 331). Perhaps due to the story's later introduction in Korea, a standard translation of the title solidified instantly. Occasional translations have appeared under alternative titles—such as 1972's *Ippeuni in Amazing Land* (*Singihan naraui Ippeuni*) and 1987's *An-Il Sook's Adventures under the Land of the Morning Calm* (*Anilsugui joyonghan achimui naramoheomgi*)—but these translations are anomalies. The latter translation, for example, was created by an American couple while they lived in Seoul. Carrollian collectors and enthusiasts Victoria and Byron Sewell were dismayed at their inability to find Korean translations and, in Victoria Sewell's words, amused themselves, "by creating a Korean version of *Alice*" (in Lindseth and Tannenbaum 2015, 333) that localized the text. Korean poems were parodied rather than the British poems and songs parodied in the English novel, for example, and Korean clothing, technologies, and social systems are interposed throughout the text (in Lindseth and Tannenbaum 2015, 333–334).[19]

Japan already possessed several translations of the *Alice* novels aimed at relatively diverse reading audiences by the 1920s. Yet with no particular audience or cultural authority championing it, *Alice*'s popularity might have died out. That it did not is due to the efforts of authors and artists from all levels of society over the ensuing decades. One such author was Ryūnosuke Akutagawa (1892–1927), but the fact and extent of his involvement has been overlooked outside of Carrollian circles.

Reading and Rereading Akutagawa

In many ways, Ryūnosuke Akutagawa is an unlikely candidate to spread Alice in Wonderland in Japan. Akutagawa specialized in short stories, almost to the

54 Chapter 2

exclusion of long-form work, and he rather famously drew silhouettes of a water demon as a hobby. He is best known today for stories that invoke historical Japan, Christianity, and the erotic grotesque, elements missing from Alice in Wonderland.[20] Yet, Akutagawa became deeply involved with *Alice* towards the end of his life, and that involvement is directly related to how he and his oeuvre should be understood within Japanese literature and culture.

In the ninety-five years since Akutagawa's suicide, scholars have struggled to comprehend his works, his life, and his relationship to the tumultuous political, cultural, and economic world in which he lived.[21] Akutagawa committed suicide the summer following the death of Emperor Taishō, and his death in that pivotal year was read from the start as marking the end of an era. Because the Taishō emperor was a sickly man, the fifteen years of his reign saw imperial power devolve to Japan's National Diet. As a result, the Taishō period (1912–1926) is commonly considered a brief flowering of democratic society prior to a rise in fascism under the Shōwa emperor (reigned 1927–1989) that ultimately led to World War II. The related historical periods—Taishō, Shōwa, and also the preceding Meiji period (1868–1912)—demarcate political transitions that may be superficial.[22] Extending these weak political divisions into the realm of literature makes even less sense. However, as literature scholar Seiji Lippit has described, contemporary scholars and the general reading public both memorialized Akutagawa at the time of his death as an emblem—if not the embodiment—of a literary age that had passed into history with the Taishō era (2002, 39–41). The wide variety of works Akutagawa published in the months leading up to his death was thus seen not as an accomplished artist's experimentation but the artistic defeat of a practitioner of pure literature. This simplification of Akutagawa and his work made him into an icon inextricably tied to wider events despite the fact that his writing was known for its distance from contemporary life.[23]

The impact of Akutagawa's work is undercut not only by the political implications of his death but also by critics' response to his use of adaptation. Criticism of his work as derivative and unoriginal haunts even those praising Akutagawa's oeuvre.[24] Yet, critiquing Akutagawa's works as imitative is simply another way of saying that Akutagawa's ability to reinvigorate older stories is unparalleled. Akutagawa was a voracious reader of both European and Japanese literature, and he siphoned ideas from the texts he read that reemerge in his works in startling new configurations, bred together by Akutagawa and guided by his masterful styling.

Critiquing Akutagawa's writing for his adaptation of other works obscures the fact that his widely praised writing style also stems from adaptation. Akutagawa regularly encases his stories in a frame; a narrator tells the reader

how he came to hear a story, recounts said story, and then ends by saying something to the effect that he does not know if it really happened. The frame narrator is even Akutagawa himself occasionally, like when he narrates a story as it was supposedly told to him in "Death of a Disciple" ("Hōkyōnin no shi," 1918). By placing himself in the position of a mere transmitter of information, Akutagawa highlights that the central story is fictive (since Akutagawa tacitly admits having chosen the wording himself) while simultaneously positioning it as something that might have actually happened in some form, albeit to someone else. This sense of a real basis behind his stories is heightened by Akutagawa's extensive use of adaptation: stories are likely to seem familiar to readers even when they cannot identify the adapted work. The affect generated by Akutagawa's writing style depends on readers' awareness of adaptation as a process.

Akutagawa adapted foreign literature as well as Japanese, though he rarely acknowledged his works as adaptations. "The Spider's Thread" ("Kumo no ito," 1918), for example, was only revealed to be an adaptation of Paul Carus's *Karma: A Story of Buddhism*—itself an adaptation of Fyodor Dostoevsky's *The Brothers Karamazov*—in 1968, over forty years after Akutagawa's death (Miller 2001, 1–3). Mats Karlsson similarly describes Akutagawa's "Cogwheels" ("Haguruma," 1927) as an adaptation of August Strindberg's *Inferno* (1898), though he notes that some of the things that Akutagawa took from *Inferno* had actually been picked up from other literature by Strindberg. Ultimately, "Akutagawa's personal hell turns out not to be completely his own after all. It is not even, in the final analysis, Strindberg's. On the contrary, what we find on the pages of 'Cogwheels' are verbal constructions, reverberations, and echoes from all kinds of literary sources and cultural trends" (Karlsson 2011, 186).[25] It's unclear whether Akutagawa knew of Carus's lifting of *Karma* from *The Brothers Karamazov*, but as an astute reader of up-to-the-minute European literature he would have understood the complex literary background that produced *Inferno*. Akutagawa was thus a conscious adapter of works that were embedded in a constantly shifting cultural milieu. There would have been no need to announce his works as adaptations; educated readers understood the literary and stylistic conversations in which he was engaging while uneducated readers enjoyed the well-written stories in their own right.

Though this manipulation of the vast world of global literature swirling into early twentieth-century Japan was technically formidable, Akutagawa also displayed humor and finesse in his works. He occasionally played with his readers' expectations by falsely claiming sources in his stories' frames. For example, Akutagawa professes within the frame of "Death of a Disciple" that he is merely republishing a section of a certain Japanese translation of Jacobus de Voragine's

56 Chapter 2

Legenda Aurea (c.1259–1266), but Thomas Beebee and Ikuho Amano note that the translation Akutagawa indicated does not in fact exist (2010, 23). They also detail Keiko Ikegami's discovery that Akutagawa did rely upon a number of other texts in writing "Death of a Disciple," including French and English translations of the *Legenda Aurea* and Lafcadio Hearn's Japanese translation of Anatole France's novel *Le Crime de Sylvestre Bonnard* (Beebee and Amano 2010, 23). Donald Keene points to the latter novel as one of several influences for "Death of a Disciple"—along with Lamartine's *Jocelyn*, Henri de Régnier's *Vengeance*, Ōgai Mori's translation of Hans Christian Andersen's *Improvisatoren*, Henryk Sienkiewicz's *Quo Vadis*, Friederich Hebbel's *Judith*, and a number of Japanese works. Faced with a list that long, it is unsurprising that Keene concluded that "Akutagawa's lack of originality" was his "crucial weakness" despite there being "no question of direct imitation" (1984, 565–566). It seems that Jorge Luis Borges had it right when he wrote that "to strictly differentiate the Eastern and Western elements in Akutagawa's work is perhaps impossible" (1999, 437). Yet, because reading an Akutagawa piece with this or that other work in mind inevitably affects one's view of the Akutagawa story, scholars must continue the search for source works and inspirations. James O'Brien points out that that may even be part of the appeal of an Akutagawa story: that it "is primarily a puzzle to be worked out" (1988, 10), a mystery for readers to solve.

Akutagawa's ingenuity in obscuring his adaptive activities has led scholars to search his works for any hint of influence. It is natural for authors to be influenced by other writers' work, but in Akutagawa's case those more common influences have been merged with the materials he outright adapted to create at times an image of him as a stylistic genius with no creativity. Keene summed up this view succinctly by saying that "later in his career, a seeming inability to invent materials forced him to draw on even the most trivial incidents of his life" (Keene 1984, 565). Yet, the final year of Akutagawa's life brought forth a flowering of works of startling breadth and ingenuity, many of which stand among his greatest masterpieces today. Two of those works represent a little-known, yet extended engagement with the world of Alice in Wonderland.

Akutagawa's *Alice Story* and Remembering Literature

That Akutagawa co-translated *Alice's Adventures in Wonderland* may surprise scholars of Japanese literature, but it has been common knowledge in Carrollian circles for years. Kimie Kusumoto devoted a section of her history of *Alice* translations to it (2001, 98–101), and Mikiko Chimori regularly introduces it in both her English- and her Japanese-language work on *Alice* (see in particular

Chimori 2015, 349–357). In contrast, Akutagawa's translation, *Alice Story*, was omitted from publisher Chikuma Shobō's *Complete Works of Ryūnosuke Akutagawa* (*Akutagawa Ryūnosuke zenshū* 1958, hereafter *Complete Works*) reference collection, does not appear alongside Akutagawa's other works on the fairly comprehensive Japanese literature website Aozora Bunko, and has not been referred to by those writing about modern Japanese literature more broadly. *Alice Story*'s omission in the *Complete Works* is particularly striking because the latter does include Akutagawa's translations of Anatole France's *Balthasar* (1889), W. B. Yeats's "The Heart of the Spring" (1897), and Théophile Gautier's "La Morte Amoureuse" (1836). The Akutagawa expert Seiichi Yoshida tackles several of Akutagawa's lesser-known works in a tome dissecting Akutagawa's life and works, but he skips *Alice* (Yoshida 1993).

The general consensus among scholars is that translations of Western literature played a vital role in the development of modern Japanese literature, yet scholarly neglect of those translations has undermined their position in literary history. Three factors have further enabled the sidelining of *Alice*, in particular, from studies of Akutagawa specifically and Japanese literary history more generally. First, the *Alice* novels have been perceived as part of children's literature, which has historically been understudied (and underestimated). Julia Mickenberg and Lynne Vallone note that children's literature "was not thought important" (2011, 7) in the English-speaking academic world as recently as the 1980s. Scholarly writing on children's literature has been similarly slighted in Japan, though Michiyo Hayashi and Ariko Kawabata trace the history of scholarly Japanese writing on children's literature back to a 1909 book by Fukuo Kishibe (2003, 242). It is worth noting that the three translations included in the *Complete Works*—*Balthasar*, "The Heart of the Spring," and "La Morte Amoureuse"—were written for an adult audience. Moreover, they feature male protagonists and were written by men. In contrast, *Alice*, while written by a man, features a young female protagonist. Alice's youth and femininity served as a second factor encouraging readers to discount *Alice* when considering Japanese literature. Canonical works of literature from 1920s Japan tend to focus on male protagonists. When women, such as the titular character of Jun'ichirō Tanizaki's *Naomi* (*Chijin no ai*, 1924), appear within these books, they tend to be the superficial, erotic objects of men's thoughts.[26] In contrast, Akutagawa's novella *Kappa* (1927), which received far more acclaim than *Alice Story*, features an adult male protagonist. Alice's young female protagonist and primary child readership thus sidelined it from the view of the majority of critics.

The final factor abetting the scholarly community's ignorance of *Alice Story* relates not to *Alice* but to the translation's awkward place within the translators'

58 Chapter 2

lives and oeuvres. Akutagawa was a sickly child, and the son of a sickly woman. His mother is said to have been mad, and young Akutagawa was haunted by the idea that he, too, would one day lose his mind. Whether his presumption was correct or whether his own belief in his oncoming madness eventually generated his symptoms is impossible to say, but Akutagawa sank into a deepening depression in the mid-1920s which ended with his suicide in the summer of 1927.[27] He was rather prolific in the period immediately before his death. He published the classic stories "Cogwheels," "A Fool's Life," and "A Note to a Certain Old Friend" ("Aru kyūyū he okuru shuki"), among other works, in 1927. Akutagawa's worsening depression was obvious to his friends and even the general public: his stories had changed over time, with madness becoming a key theme and Akutagawa's writing style morphing to resemble the semi-autobiographical I-novel genre. One of those friends, a schoolmate named Kan Kikuchi (1888–1948), thought he was in a position to help.[28]

Kikuchi's biography complicates *Alice Story*'s reception just as much as Akutagawa's life and writing process do. Kikuchi was a renowned playwright whose spiraling ambitions moved from writing to editing and finally politics over the course of his career. As part of his erstwhile political adventures, he supported Japan's wartime mobilization by collaborating with militarists in the years leading up to World War II. Consequently, his influence was drastically curtailed after the war. Even today, he is rarely discussed in scholarly literature despite the fact that many of the authors whom Kikuchi supported went on to become prominent in the modern Japanese literary pantheon.[29]

In 1927, Kikuchi was editing a series of books for children called *The Complete Collection for Elementary Schoolers* (*Shōgakusei zenshū*, hereafter *The Complete Collection*). Concerned at his friend's deepening depression, Kikuchi attempted to distract Akutagawa from his problems by asking him to translate *Alice's Adventures* and *Peter Pan* for *The Complete Collection*. Akutagawa committed suicide midway through his translation, on the 24th of July. Kikuchi finished the translation himself, making their *Alice Story* a rare co-publication by two of modern Japan's most prominent writers. As Kikuchi puts it in the postscript to *Alice Story*, "This *Alice Story* and *Peter Pan* were given to Ryūnosuke Akutagawa, and he started work on them during his lifetime. I took them up, and have finished them" (in Akutagawa and Kikuchi 1927, 254). Due to the unique circumstances behind these two translations, it is unlikely that a literary work like them will occur again.

Though it is unclear who wrote which part of each translation, Akutagawa seems to have written the majority of *Alice Story*. *Alice Story* was published on November 18, 1927, not quite three months after Akutagawa's suicide, while

Peter Pan was published almost two full years after Akutagawa's death, in April of 1929. It seems reasonable to assume that Akutagawa had made significant progress on *Alice Story* at the time of his death but may have completed little to no work on *Peter Pan*. Further, Shinichi Kinoshita trenchantly observes that because Kikuchi was embroiled in an acrimonious lawsuit in 1927, it is exceedingly unlikely that he had time to do much translating in the months between Akutagawa's death and *Alice Story*'s publication (Kinoshita 2008).

Alice Story was published in a Japan that already knew *Alice* fairly well. By 1927, enough Japanese translations of *Alice* had appeared that the transliteration Arisu had become the standard way to translate "Alice." *Alice Story* contains all twelve chapters of *Alice's Adventures*. Like most Japanese translations, it omits Carroll's prefatory poem "All in the Golden Afternoon." In consequence, the volume opens with Alice's story directly rather than prefacing the story with an account of the ensuing story's gestation. Given Akutagawa's habit of framing his stories within other stories, the removal of a pre-existing frame seems curious, but the story of Alice's sojourn in Wonderland is still framed by two short interludes set on an English embankment. Even so, by removing "All in the Golden Afternoon," Akutagawa also removed the English text's confusion of Alice-the-character and Alice Liddell, the girl whose name Carroll adopted for his protagonist. This erasure solidified the character of young Alice in a way that she was not in the English version.

Akutagawa and Kikuchi may have removed "All in the Golden Afternoon" because Masao Kusuyama excluded it in *Wonderland* (*Fushigi no kuni*, 1920), his translation of *Alice's Adventures* and *Looking-Glass*. Prompted by Kō Onishi, Shinichi Kinoshita determined that *Alice Story* "uses the Kusuyama translation as a rough copy" (2008). Thus, *Alice Story* was touched by the hands of four authors—Carroll, Kusuyama, Akutagawa, and Kikuchi, though Kusuyama's influence is not acknowledged in the text. The resulting work is a functional translation that maintains Carroll's sense of humor. With the removal of the "All in the Golden Afternoon" poem, *Alice Story* depicts a concretized Alice. It is fun to read, but the translation would remain an amusing oddity in Akutagawa's oeuvre were it not for one thing: *Alice Story* is not his only *Alice*. In the same year that Akutagawa turned his hand to *Alice Story*, he published a loose adaptation of *Alice's Adventures* under another title, *Kappa*.[30]

Attributing *Kappa*

As stated above, *Alice Story* is well-known amongst Japanese Carrollians whilst being virtually unknown amongst scholars of Japanese literature. Akutagawa's novella *Kappa*, on the other hand, is reasonably well-known among scholars of

Japanese literature but has traditionally been of no particular interest to Carrollians. The novella begins with a narrator's visit with a man living in a mental institution, though the ailing man quickly takes over the narration to tell of his sojourn in the underground land of the kappa. *Kappa* is one of Akutagawa's best-known works amongst the global reading public; Akutagawa scholar Beongcheon Yu argues that Akutagawa first became famous outside of Japan through *Kappa* and a film, *Rashomon* (dir. Akira Kurosawa, 1951), adapted from two of his short stories (Yu 1972, ix). Scholars have yet to connect *Kappa* with *Alice* in any meaningful way. *Kappa* is fairly prominent among Akutagawa's works, in part because it is his most successful long-form piece, but also because of Akutagawa's lifelong habit of drawing silhouettes of the titular kappa. Akutagawa published *Kappa* in March of 1927, the same year that he translated *Alice Story*, the same year that he committed suicide.

Kappa is closely associated with the mental and emotional deterioration that led Akutagawa to commit suicide, to the extent that the anniversary of Akutagawa's death is called *Kappaki*, or "Mourning *Kappa*." On July 24 of every year, people celebrate Akutagawa's life and works using the name of *Kappa*. In 2016, the online platform Twitter saw forty-six tweets on or around July 24 that used the *Kappaki* hashtag (#河童忌). Some of these are general wishes for Akutagawa to rest in peace, but the majority refer specifically to *Kappa*. Manga artist Tomoya Kuroya, for example, tweeted a photograph of a sign wherein a kappa warns readers not to litter. Kuroya appended the note, "Today is the anniversary of Akutagawa Ryūnosuke's death, *Kappaki*, isn't it? Here's a photo of a scary *kappa* I met in Shizuoka Prefecture. #*Kappaki*" (figure 2.2). Other tweeters were less

Figure 2.2. *Kappaki* tweet featuring photo of sign in Shizuoka prefecture by user @kuroyatomoya from July 24, 2016.

Ryūnosuke Akutagawa in the Shadow of Early *Alice* Translations 61

irreverent, but all saw Akutagawa's death through the lens of *Kappa*. Akutagawa and his overall oeuvre are now intrinsically tied to *Kappa*.

Kappa has been associated with Alice in Wonderland before, but not directly tied to it. In his book on modernism in Japanese literature, William Tyler likens *Kappa*'s protagonist's fall into Kappaland to Alice's into Wonderland. Tyler concludes that "what may seem like *Alice in Wonderland* [sic] can all too quickly devolve into *Animal Farm*" (2008, 35). In the same year, Akira Lippit read *Kappa* together with Carroll's *Alice* novels and Franz Kafka's *The Metamorphosis* (*Die Verwandlung*, 1915) in a study of animality in the modern period.[31] Neither of these scholars alleges that Akutagawa adapted—or even read—*Alice*. Instead, scholars often attribute *Kappa* to Jonathan Swift's *Gulliver's Travels* (1726). The first English translation of *Kappa* was even subtitled *Gulliver in a Kimono* (translated by Seiichi Shiojiri, 1948). Thus, Lippit introduced *Kappa* "in part as a response to Swift's *Gulliver's Travels*" prior to mentioning *Alice* (A. Lippit 2008, 154). Scholars including Seiji Lippit and Jonathan Abel have also likened *Kappa* to *Gulliver's Travels* to varying degrees. Sometimes *Kappa* is "modeled on" *Gulliver's Travels* (S. Lippit 2002, 48); at other times it merely displays "a satirical derangement on par with" the novel (Abel 2012, 63). Seiichi Yoshida, the Akutagawa specialist who edited *The Complete Works*, lists *Gulliver's Travels*, Samuel Butler's *Erewhon: Or, Over the Range* (1872), and Anatole France's *L'Île des Pingouins* (1908) as sources (in Akutagawa 1958, 3:417). It is easy to see the connection: both *Kappa* and *Gulliver's Travels* feature, after a short frame that impugns the narrator's sanity, a man describing his travels in a strange, fantastical land to the reader. However, differences abound between the two texts. Where *Kappa*'s narrator travels to only one land, Gulliver travels to an assortment of complementary nations. For example, Lilliput, land of miniscule people, is followed by Brobdingnag, land of giants. Where Gulliver travels outside of his home nation to reach these various islands, Kappaland exists underneath Japan. The connection between Gulliver's madness and sea travel suggests that an exterior trauma lies behind the character's madness, while the madness of *Kappa*'s narrator can only stem from himself. Further, Gulliver never met fantasy creatures that could match Japan's kappa. Rather, he met tiny humans, massive humans, weird humans, and horses. *Kappa* is reminiscent of *Gulliver's Travels*, but it differs in key respects.

Kappa closely parallels the plot of *Alice's Adventures*, while also riffing on other aspects of the novel. *Kappa*'s narration begins amid the greenery of the Japan Alps as *Alice's Adventures* begins under a tree near Alice's home. Both protagonists spy a strange animal—whether kappa or talking rabbit—and give chase, ultimately falling down a seemingly endless hole until a new land opens up

62 Chapter 2

before them. *Kappa*'s protagonist sojourns awhile in this strange land, which like Wonderland is governed by a type of unlogic where the rules of human society sort of, but do not quite, apply. Akutagawa describes his kappa at first as appearing gray and later green, before he finally notes that kappa change color like chameleons. Given that kappa are traditionally a muddy shade of green, Akutagawa's decision to make his narrator chase a whitish creature from a grassy glade down an animal-made hole and into an at times scary land ruled by unlogic clearly parallels *Alice's Adventures*.

The character of *Kappa*'s protagonist is similar to Alice in that both display curiosity, practicality, and a pragmatic fearlessness, and these qualities set up much of the comedy in the texts. Both characters find that the fear they feel whilst falling down the endless animal hole fades until they begin to think of commonplaces. Both characters also prosaically question the locals they meet as to how their unlogical underground societies operate, and both at times find the answers alarming. For instance, one group of kappa are propounding a breeding program intended to raise the quality of the kappa species as a whole. Where real breeding programs of this sort have historically relied on the suppression of breeding by undesirable populations, the kappa encourage the mating of superior kappa with lesser kappa. The protagonist responds thusly: "Of course, I informed [my friend] Lap then as well that that sort of thing couldn't work out" (in Akutagawa 1958, 3:348), only to be laughed at by all of the kappa within earshot. Lap points out that humans already practice kappa-style breeding whenever elite sons fall in love with maids or elite daughters fall for chauffeurs. In this exchange, Akutagawa plays with readers very much in the style of Carroll. First, he presents a jarring scenario in a strange and fantastical land prompted by a normal human's sojourn there. Then, local residents turn the visitor's pragmatism on its head to make everyday human life seem absurd and comical without any sense of mean-spiritedness. Compare Akutagawa's protagonist with Alice's response to the Cheshire Cat's repeated disappearances and reappearances:

> "I wish you wouldn't keep appearing and vanishing so suddenly: you make one quite giddy!"
>
> "All right," said the Cat; and this time it vanished quite slowly, beginning with the end of the tail, and ending with the grin, which remained some time after the rest of it had gone. (Carroll 2015, 80–81)

Alice makes a simple request that most readers would understand to mean that she found the act of disappearing and reappearing mid-conversation disconcerting and wanted the Cat to leave by walking away. However, when the Cheshire

Cat good-naturedly acquiesces to her request *as she worded it*, the situation becomes even more comical. The protagonists of both *Alice* and *Kappa* regularly present logical, practical arguments that somehow fail to persuade the unlogical locals of the underground worlds in which they travel.

Kappa resembles *Alice* stylistically in a variety of ways. Akutagawa matches Carroll's simultaneously odd and familiar character names with alien-sounding kappa names that resemble English words. Character names like Lap (*Rappu*), Bag (*Baggu*), Chuck (*Chakku*), Tock (*Tokku*), and Mug (*Maggu*) are clearly marked as foreign by the *katakana* in which they are written, yet are pronounced much like transliterated English words and onomatopoeia.[32] The kappa are further tied to the Romantic family of languages through the deployment of the Kappanese language within the text. When Akutagawa inserts Kappanese in his novella, he uses Roman letters that stand out against the backdrop of Japanese characters. The few Kappanese phrases in the novella are reminiscent of the brief references to Latin common in English literature of the nineteenth and early twentieth century. Take, for example, "Quax, Bag, quo quel quan?" (Roman letters in the original, Akutagawa 1958, 3:345). By removing the first *x* and taking advantage of the French *quel* in addition to elementary Latin, this phrase could be read, "Which way, Bag, where which how?" Though the majority of Akutagawa's readers would be unlikely to know Latin and French, a reasonable proportion could be relied upon to at least recognize the words as having Latinate roots that might suggest some form of query. The Kappanese writing within the book's text consequently appears rather like the Western languages flooding into Japan in the late nineteenth and early twentieth centuries, which even younger readers were studying at the time. Much like Alice's inability to get a straight answer from the Mad Hatter or the Cheshire Cat, Kappanese denies speakers the ability to express logical thoughts, let alone answer questions. Akutagawa thus adapts the dichotomy between Alice's direct practicality and unlogical characters like the Cheshire Cat to the rapidly modernizing Japanese cultural milieu.[33] Given that Akutagawa was likely already preparing to translate *Alice's Adventures* for Kikuchi when he wrote *Kappa*, and that the Kusuyama translation on which he relied in crafting *Alice Story* came out seven years earlier, as well as the many, many similarities in plot, setting, characterization, and style, it can be said that *Kappa* is yet another unannounced Akutagawa adaptation, this time of *Alice*. Akutagawa read and was doubtless influenced by *Gulliver's Travels*, but that novel is not the sole or even primary inspiration for *Kappa*.

To understand *Kappa*, one has to keep in mind that Akutagawa excelled at obfuscating his inspirations, influences, and sources. The bulk of *Kappa* was written in a fortnight in February of 1927, with the final version published in

64 Chapter 2

March. While it is uncertain exactly when Akutagawa was first introduced to *Alice*, he did know of the series for which he would translate *Alice*. In a March 2nd letter to poet and psychologist Mokichi Saitō, Akutagawa notes that "when I arrived in Tokyo, it seemed Kikuchi and the rest were beginning some sort of literary work again with a great deal of energy" (Akutagawa 1958, 8:90). He writes as though he is still writing *Kappa*, saying that he hoped, "to add tens of more pages to *Kappa* if I can only find the time" (Akutagawa 1958, 8:90). Moreover, Seiichi Yoshida states that Akutagawa was actually a co-editor of said series as of early February, when he was writing *Kappa* (in Akutagawa 1958, 8:291). It is clear that Akutagawa's knowledge of *The Complete Collection* overlaps at least to some degree with his work on *Kappa*.

There does not appear to be any record of when Akutagawa first read an *Alice* novel, but it is highly likely that he knew of *Alice* prior to 1927. Since the first Japanese translation of *Alice* was serialized in a popular children's magazine when Akutagawa was seven years old, he may have read it as early as 1899. Masao Kusuyama's *Wonderland*, which greatly influenced *Alice Story*, was released in 1920, seven years prior to the period in question. Nine other Japanese *Alice* translations were published between *Wonderland* and *Alice Story*, including two serialized in the prominent children's magazines *Red Bird* (*Akai tori*) and *Girl's Friend* (*Shōjo no tomo*), which suggests that Akutagawa either chose a translation with which he was already familiar or spent some time researching others' *Alice* translations before beginning his work. Finally, Asuka Toritamari notes that *Alice* was particularly trendy in 1926, the year before Akutagawa wrote *Kappa*, such that "*Alice* became widely read within wealthy households to a degree" (2011, 13). Since Akutagawa was quite successful at this point in his life, avidly supported reading, and possessed three children that would have been one, four, and six years old in 1926, it is reasonable to assume that if *Alice* had not previously entered the Akutagawa household, it did so in 1926.

In addition to providing evidence about when Akutagawa learned of the *Complete Collection*, his letters offer glimpses into Akutagawa's stated influences behind *Kappa*. In a February 2, 1927, letter to Mokichi Saitō, Akutagawa wrote that he was in the middle of two works, one of which was "a piece called *Kappa* in the style of *Gulliver's Travels*" (Akutagawa 1958, 8: 84). However, nine days later Akutagawa wrote his disciple Mosaku Sasaki to say that *Kappa* was influenced by an entirely different novel. It was, in fact, "my *Story of Reynard the Fox*" (Akutagawa 1958, 8:85), a satiric fable about a sly fox by Johann Wolfgang von Goethe. Akutagawa may have been inspired by both works while writing *Kappa*, but he may also have been tailoring his letters according to what he thought his addressee knew or how he wanted them to think of the novella. Alternatively, he

may have been misleading his readers yet again. Most likely, he was taking pieces of these three and perhaps even more works for *Kappa*. Akutagawa's letters show that he was thinking about a host of other works of literature during the short period in which he wrote *Kappa*. While writing to various friends and associates, Akutagawa explicitly refers to several British men of the Victorian age, including John Ruskin, William Morris, and George Bernard Shaw, as well as some religious works and an assortment of Japanese authors and writings. To say that any one work—*Alice* included—was Akutagawa's sole inspiration would be inaccurate. However, it is clear that *Alice* played a much larger role in *Kappa*'s conception than has previously been acknowledged, and that *Kappa* should be understood as an adaptation of *Alice*.

Akutagawa's early response to *Kappa*'s reception is vital to understanding his role in eliding *Kappa*'s sources. *Kappa* was published in the March issue of the journal *Reconstruct* (*Kaizō*). On April 3, he wrote Yasushi Yoshida, a stranger, in response to Yoshida's review of *Kappa*. He declared that Yoshida's review was the only one to move him, as the novella had been born from his disgust with the world and himself, such that others' praise of *Kappa*'s "cheerful wit" ("*akarui kichi*," 1958, 8:90) merely depressed him further. Yet, cheerful humor with a dark edge is a hallmark of both Goethe's *Reynard* and Carroll's *Alice*. Further, Akutagawa's letters make clear that his mood was not unrelievedly dark at the time he was writing *Kappa*. For instance, the day after he told Sasaki that he had finished *Kappa*, Akutagawa wrote about William Morris's "Love Is Enough" in a letter to the poet Nobuyuki Okuma. "Love Is Enough" movingly evokes the beauty of love in an often tragic world, suggesting that the literary arts Akutagawa loved seem to have still been shining in the depths of his mind despite his growing despair. That *Alice*'s structure, plot, style, and tone haunt *Kappa* is clear. Akutagawa's irritation with his reviewers' immediate attraction to those aspects of *Kappa* that most resemble *Alice* and his repeated attempts to align *Kappa* with other works merely reveal that he either was unaware of *Alice*'s presence within his mind or, more likely, chose to hide his main source for *Kappa* as he had for "Death of a Disciple," "The Spider's Thread," and numerous other works.

Akutagawa thought of *Kappa* as a dark, serious tale. He sold it to *Reconstruct*, a serious-minded journal that often published left-leaning nonfiction alongside its literature. He framed the novella as such to his colleague Mokichi Saitō, connecting *Kappa* to the serious satire of *Gulliver's Travels*, though he let slip a slightly less serious inspiration, *Reynard the Fox*, to his close disciple Mosaku Sasaki. Akutagawa's extratextual efforts to frame *Kappa* betray the fact that *Kappa* does not have to be read as a serious satire of modern Japanese life. In fact, reading *Kappa* as an adaptation of *Alice* alters its affect significantly.

66 Chapter 2

Kappa Through *Alice*

Understanding *Kappa* as an adaptation of *Alice* naturally changes how one reads the novella. Akutagawa's adaptation makes two major changes to Alice's tale. First, he exchanges the British girl for a Japanese man. Akutagawa was ahead of his time in making Alice male: *Kappa* was the first Japanese adaptation of Alice to feature a gender-switched protagonist, but it was far from the last. *Alice* adaptations featuring a male Alice are so prevalent in Japan today that a small subgenre of male-Alice manga developed (see chapter 4). The first of these manga, Tamayo Kobayashi's *Boy Alice in Wonderland* (*Fushigi no kuni no shōnen Arisu*) appeared in 1993, however, sixty-six years after *Kappa* was published. Akutagawa's innovation was so very far *avant la garde* that it partially explains why the novel has been so little associated with *Alice* despite so many people connecting the two on a superficial level. While the majority of scholarly analyses of *Kappa* stress the novella's darker aspects and tie those sections directly to Akutagawa's worsening depression, examining *Kappa* in relation to Carroll's work highlights the humor reviewers were drawn to prior to Akutagawa's suicide (much to his distress). The Queen of Hearts' incessant threats to behead her subjects could be terrifying were it not for the fact that no heads actually roll. Similarly, the death of a kappa child could be horrific were it not for the fact that the fetus chooses not to be born in the first place in a comical sequence that sees the fetus's father kneeling by his wife's groin and having a whispered conversation with the fetus. *Kappa* is dark, as were many of Akutagawa's 1927 works, but to focus exclusively on that darkness because of Akutagawa's actions after writing *Kappa* is a disservice to the text.

The second major change Akutagawa wrought to *Alice* lies in a manipulation of the story's frame. In both *Alice's Adventures* and *Through the Looking-Glass*, there is a framing device around Alice's journey that is entirely separate from Wonderland. Alice's sojourn is described as a dream with no lasting effects. The continuing popularity of the *Alice* stories stems in part from this stability. To read *Alice* is to be faced with a world where logical thought no longer yields logical results and to return from this world unscathed. *Alice* deals with a central paradox of human communication: if humanity could truly communicate perfectly, the arguments that persuade oneself ought also to persuade others, yet disagreements persist. *Alice* shows that a person can travel into the unlogical mind of the other and return safely. Wonderland's array of charming cats, crazy teatime rituals, and dictatorial queens appeals to readers of all kinds because the concern being remedied exists for all ages, genders, and nationalities. As Akira Lippit and Antonin Artaud argue, Carroll "like Alice returns, in the end, to his

Ryūnosuke Akutagawa in the Shadow of Early *Alice* Translations 67

senses" (in A. Lippit 2008, 142). In contrast, *Kappa*'s frame opens with a potential madman and closes on an undeniable lunatic.[34]

Lippit ties *Kappa, Alice,* and *The Metamorphosis* together through their common depiction of "the collapse of a stable human subjectivity" (2008, 159), but the cause of these collapses differs. In *Alice,* subjectivity collapses because Wonderland lacks "a referentially stable language" (A. Lippit 2008, 138), i.e., words spoken in Wonderland no longer mean what one would expect them to. This unstable subjectivity is expressed differently in Kappaland as "Akutagawa explodes his mother's madness . . . across the landscape" (A. Lippit 2008, 159). Though one hesitates to read an author's biography into his work, madness and the possibility that he had inherited insanity from his mother inarguably haunted Akutagawa in 1927. Akutagawa wrote many times of his belief that his mother's madness was hereditary. His growing mental distress led him to retreat to his wife's hometown for most of 1926. Unfortunately, four days after their return to Tokyo the family was greeted with the news that Akutagawa's brother had committed suicide. Given Akutagawa's belief in the hereditary nature of his mental issues, the open contrast between his wife's (presumably) sane parents and his own family must have been obvious and appalling. In the context of two sons suffering hereditary suicidal tendencies, *Kappa*'s darkly comic depiction of a fetus choosing whether or not he ought to have to live takes on new light. The kappa fetus gives as his reason for choosing death his father's insanity rather than his mother's, but female kappa literally run through *Kappa* forcing male kappa to propagate against their will. The children thus produced live incredibly insecure lives; in Kappaland economic difficulties are dealt with by killing and eating excess kappa. Producing kappa children is a mad process, pursued by female kappa who act madly and whose immoderate actions provoke more madness to ensure the species' continuation. Though the kappa fetus declines to live because of its father's madness, it would not have been conceived in the first place had its mother not pursued its father, seemingly against his will. The continuation of insanity consequently becomes the mother's fault, but Akutagawa is incapable of blaming her. It is difficult to see the shift of madness from Akutagawa *mère* to Akutagawa *fils* as wholly separate from Akutagawa's alteration of the protagonist's gender in his adaptation of *Alice.*

Kappa marks a pivotal point in Akutagawa's final works. A year pondering hereditary madness resulted in a short burst of intensive work on a novella that constitutes Akutagawa's most extensive engagement with the ongoing effects of his mother's madness. That novella is also indelibly marked by a famous children's story that Akutagawa may well have read in his own childhood, but certainly researched and translated around the time he wrote *Kappa.* Exorcising his

68 Chapter 2

mother's madness left Akutagawa with only his own self to examine. Between *Kappa*'s publication in March and Akutagawa's death in July, he wrote and rewrote his own madness into "Cogwheels" (written from March to April), "A Note to a Certain Old Friend" (written in July), and "A Fool's Life" (left as a suicide note and published post mortem in October). All three works draw on Akutagawa's biography and mental distress for material. If the point of *Alice* is that one can enter the world of unlogic—a world one might call insane—and return safely, Akutagawa's death was likely forecast in his manipulation of Carroll's novel to center on a man doomed to insanity rather than a girl who remains perennially untouched by madness.

From Text to Illustration

Alice Story and *Kappa* have been discussed to this point in terms of their creation and their text, but illustration plays an unusually important role in understanding Akutagawa's *Alice* works. The first Japanese translation of an *Alice* novel, Hasegawa's *Mirror World*, plagiarized John Tenniel's illustrations for the English publication of *Looking-Glass*. By 1908, Sumako's abridged translation of *Alice's Adventures* was published with original illustrations by Shōtarō Kawabata. From then on, both Japanese and foreign illustrations appeared on a regular basis in new Japanese translations of *Alice*. Tenniel's images are a perennial favorite in Japan as they are worldwide, but the illustrations of Margaret Tarrant, Blanche McManus, Thomas Heath Robinson, Tove Jansson, and others have found a ready audience as well.[35]

Akutagawa's co-translation of *Alice* was illustrated by one Bunkichi Hirasawa (figure 2.3b) and featured a frontispiece by Seikō Unno. Hirasawa's spare, Art Nouveau–inflected illustrations strike a markedly different note from Seikō's vibrant celebration of childish glee (figure 2.3a).[36] Seikō's joyful, colorful frontispiece is in line with Kan Kikuchi's description of *Alice* as "a story that takes children's hearts to the land of dreams all unawares" (in Akutagawa and Kikuchi 1927, 3). Hirasawa's illustrations suggest another sort of dream, a refined realm that surrounds a girl in distinctly modern Western garb with comical crocodiles and dark hallways. Nonetheless, both artists' imagery aligns with Akutagawa and Kikuchi's promotion of an educated child audience. Seikō's Alice is depicted in modern Western garb, surrounded by Western playing cards. Hirasawa's art repeats the Western clothing motif, but deploys an up-to-the-minute art style imported from Europe and incorporating Japanese, Middle Eastern, and other cultural references. Alice's expression even resembles a "Western doll" (Toritamari 2011, 15) in Hirasawa's hands. These two visions of Wonderland were able

 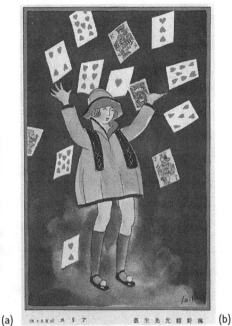

Figure 2.3. Two illustrations from *Alice Story*. (a) Bunkichi Hirasawa's haunting image focuses on a refined setting over characters or action, while (b) Seikō Unno's opening color plate reflects a strikingly different focus on energetic characters and events at the expense of a background. (Photos courtesy of the University of Southern California's Andrew W. Mellon Digital Humanities program.)

to coexist in a single volume because Japanese artists had already developed the ease that comes from familiarity where *Alice* was concerned by 1927.

As *Alice* was illustrated by more and more Japanese artists, a clear trope emerged. This trope centered on the character of Alice herself, and over time it came to be the predominant way of depicting Alice in Japan. Specifically, Alice has come to be embodied by a silhouette. Silhouettes were relatively common within children's literary magazines in the early years of the twentieth century, presumably because of their economical use of colored ink and the speed with which they could be produced. Silhouettes first appeared in an Alice in Wonderland translation in 1921 through Yaso Saijō's *Travels in Looking-Glass Land* (*Kagamigoku meguri*), a translation of *Looking-Glass*. A few silhouettes of animals illustrate the text of *Travels in Looking-Glass Land*. *Travels* was serialized in the children's magazine *Golden Ship* (*Kin no fune*), whose table of contents was also illustrated with silhouettes.

70 Chapter 2

Alice herself is tied to silhouettes four years later, in Tomoji Washio's 1925 translation of *Alice's Adventures, The Wondrous Garden (Fushigi na oniwa)*. From this point on, Japanese artists first occasionally, and then regularly, began to depict characters and tropes from Carroll's novels as silhouettes. Even as the connection between *Alice* and silhouettes grew, silhouettes became less common in other Japanese children's stories. Though the role of silhouettes in other children's literature is not a focus of this book, the decline of the silhouette in non-*Alice* children's stories paralleled the rise of multicolor illustration in children's literature. One conjectures that silhouettes were common in early Japanese children's literature less because of artistic taste and more because of economic constraints.[37] Nevertheless, the silhouette has persevered in and even dominates depictions of Alice in Japan today.

In 1927, when Akutagawa was feverishly writing *Kappa*, Alice was already associated with silhouettes through its role in the evolving genre of children's literature. Akutagawa was conversant with new developments in children's literature. His letters are littered with references to works written for or associated with children, including *Peter Pan*, Wilde's "The Happy Prince," and *The Jungle Book*. Moreover, he edited a collection of foreign fairy tales in Japanese translation that he explicitly introduced as "so-called youth literature" (in Akutagawa 1958, 5:368). Though it is unlikely he knew of all twenty-six *Alice* translations published from 1899 to 1926, he may well have seen *Alice* connected with silhouettes in some way, and he most likely saw children's magazines illustrated with silhouettes. He may even have been aware of the planned art for *Alice Story*, the inside covers of which feature an illustration of Alice, the Mad Hatter, the Cheshire Cat, and assorted other characters in silhouette. Regardless, *Kappa* was illustrated with a silhouette of a kappa created by Akutagawa himself (figure 2.4).

Over the course of his life, Akutagawa drew many kappa. His kappa illustrations are relatively easy to find. The Museum of Modern Japanese Literature displayed one in 2016 and 2017 as part of an exhibit on Akutagawa's personal possessions ("Akutagawa Ryūnosuke—uchinaru yorokobi to kunō"), while another Akutagawa kappa appeared on an *Antiques Roadshow*–like Japanese television show ("Akutagawa Ryūnosuke no kappazu"). *Kappa* is the only text that Akutagawa illustrated. It is perhaps more accurate to say that Akutagawa was drawn to sketch kappa silhouettes, and having later written a book featuring kappa, he incidentally provided illustrations to suit. Akutagawa's obsessive interest in drawing kappa can be seen in two ways, which is to say that he drew kappa, and he also drew silhouettes. Every kappa image Akutagawa made is a silhouette. *Alice* and its emerging association with silhouettes enabled Akutagawa to stretch

Figure 2.4. Cover of Seiichi Shiojiri's 1949 translation of *Kappa*, featuring an illustration of a kappa by Ryūnosuke Akutagawa.

his *idée fixe* in new, Japanese-inflected directions. Where both text and illustrations of *Alice Story* overtly draw on Western sources, *Kappa*'s story and illustrations obscure its adaptation of *Alice* with the Japanese form of the kappa.

Akutagawa's Kappa-Alice silhouette, like the novella itself, came to represent more than just *Kappa*. Where Akutagawa's death is memorialized by *Kappaki*, Akutagawa's *Complete Works* are marked by a simple kappa silhouette on the cover—the same silhouette shown above on the cover of *Kappa*. Just as *Alice* rooted itself in Akutagawa's mind only to emerge in *Kappa*, *Kappa* rooted itself so solidly in readers' minds that Akutagawa's kappa silhouette now stands in for his entire body of works. Thus, the way we view Akutagawa today is indelibly

72 Chapter 2

inscribed with the works of Lewis Carroll. Yet, even a translation of *Alice* openly bearing Akutagawa's name on the cover and containing a memorial to him by an influential co-translator has been neglected by all who study him.

The disappearance of *Alice* in Akutagawa's works can be attributed to a number of factors. Akutagawa's suicide so soon after publishing *Kappa* led later consumers to read *Kappa* through the lens of Akutagawa's mental deterioration. Where early reviewers irritated Akutagawa with praise of *Kappa*'s light-hearted tone, later critics viewed it as a straightforward satire, focusing on how "the mistakes and hypocrisy of human society are ridiculed" (Keene 1984, 580) rather than on *Kappa*'s zany humor. Further, Akutagawa's playful attitude towards his inspirations—sometimes denying a source, at other times actively misleading readers—combined with the massive library of works he is known to have read, makes it difficult to say precisely which works influenced him when and in what ways. Correctly identifying those influences is particularly important because of the deep intertextual network in which Akutagawa placed his stories; in the case of *Kappa*, attributing Akutagawa's muse to *Alice* or *Gulliver's Travels* alters the story's affect from a light-hearted tale with a seedy underside to an unrelentingly dark satire of human life with a side of insanity.

Understanding *Kappa* as an adaptation of *Alice*, or in other words, within the history of Japanese *Alice* adaptations, is also important because *Kappa* is a key step in the development of the *Alice* world and Japan's media industries. *Kappa* seems to be the first time silhouettes were used to depict *Alice* outside of children's literature. Akutagawa's kappa silhouettes circulated outside of the text of *Kappa* itself in a presaging of how the character image moves within the media mix. Akutagawa's kappa silhouettes also suggest why the silhouette might later become particularly useful for *Alice* adapters despite the children's literature industry's rejection of the art form. Akutagawa was an author rather than an artist. Silhouettes required little artistic skill, and he could create them quickly. The legions of fan-creators active today no doubt contain many people with similarly limited skill sets who must nonetheless illustrate their stories. Quick, cheaply made art also benefits media companies that must constantly produce new advertising material and merchandise for various media mix projects. Aside from the silhouettes, *Kappa* extends our understanding of how the male-Alice subgenre developed. Akutagawa's use of a male Alice effectively elevated *Alice* to a higher plain of critical regard in a Japanese literary world that rarely awarded stories about girls' adventures. It no doubt also appealed to some male readers who would otherwise avoid a story about a girl.

Akutagawa is noteworthy in the degree to which he adapted other works to his own ends, but he is hardly alone. Modern Japanese literature is marked by

translation, but outside of the period immediately following Japan's opening to the West, scholars have tended to avoid acknowledging Japanese authors' intense and profitable relationship with non-Japanese literature.[38] Akutagawa is an exception to this rule to some extent as his playfulness with his sources has led scholars to actively search for potential sources. Even so, commentators tend to view Akutagawa's adaptive activities negatively. His use of other sources tends to be depicted as reflecting a lack of originality rather than as a masterful re-embodiment of global cultural concepts. Ultimately, this negative view of adaptation obscures important aspects of literature and our understanding of the authors who create it. In Akutagawa's case, scholarly neglect of translations resulted in an incomplete *Complete Works*. Moreover, with *Alice Story* ignored, it was easy to misread the novella that has come to represent both Akutagawa and his oeuvre. Finally, in centering *Alice*'s imagery on a (kappa) silhouette, Akutagawa drew out the kernel of Carroll's stories: the shadowy, unknown quantity that is Alice herself. This mysterious Alice came to dominate Japanese *Alice* adaptations in literature, film, clothing, stationery, cafés, manga, and a host of other media over the course of the twentieth century. Ryūnosuke Akutagawa adapted *Alice* repeatedly in the shadows, so that his connection to *Alice* was obscured. Another artist, born two years after Akutagawa's death, would openly and dramatically dive through the looking-glass throughout her career. That artist is the world-renowned polka dot queen, Yayoi Kusama, and she is the subject of the next chapter.

CHAPTER 3

Yayoi Kusama, the Modern Alice (Through the Looking-Glass)

To enter *Infinity Mirrored Room—The Souls of Millions of Light Years Away* (2013, plate 5) is rather like entering a very exclusive closet. After waiting in line in a roped-off section of Los Angeles's The Broad art museum, your credentials are checked by a staff member who then opens a bare, industrial door into a dark box that is not quite nine feet tall. The staffer's flashlight guides you onto a slim platform jutting out from the door, she tells you that the lights will come on when the door closes, and then she shuts you in. At the exact moment that the museum's ambient light is eclipsed, a myriad of multicolored fairy lights spring out of the darkness all around you to reveal . . . yourself, reflected in mirrors affixed to the inside walls of the closet-room. Even as your reflected self spreads out in the infinite reflected void, your physical body is restricted to the thin strip of platform on which you stand. The platform floats above a pool of water that twinkles with the reflection of the lights above as the vibrations from your feet create slight waves. You perforce float in the space, suspended above, below, and beside reflections that take on a greater weight than the lights and body that they reflect. Time seems to alternately speed up and slow down as you try and fail to see everything in the infinite vista, as you try to understand everything in this space while realizing that it is really only filled with yourself.

This infinite, illusory void is brought to life by you, the person who enters it and in so doing precipitates the lights' activation and the subtle motion of the water. *The Souls of Millions of Light Years Away* is thus entirely concentrated on you. It is a multimillion dollar work of art that exists solely for your own personal pleasure. It can do so because of the mirror's "complex metaphorical significance, epitomising both the vice of vanity and the virtue of prudent self-knowledge" (Jonathan Miller 1998, 13). Mirrors do not distinguish between teenage boys narcissistically examining their skin and professional ballerinas carefully checking the elongation of their legs. The mirror reflects both extremes of the sociocultural register: shallow preening and deep cultural appreciation. Kusama's deployment of mirrors in *The Souls of Millions of Light Years Away* capitalizes on this dichotomy to concomitantly function as a work of fine art and a populist entertainment.

Kusama's overall oeuvre displays this same duality between fine and popular art, but *The Souls of Millions of Light Years Away* provides evidence of a subtler factor linking the diverse body of art that Kusama has created over the course of her roughly seventy-year-long career. Specifically, Yayoi Kusama has wielded Alice in Wonderland to add depth and cohesion to her art throughout her career. She explicitly ties some of these adaptations, such as her 1968 happening at José de Creeft's Alice in Wonderland statue in New York City's Central Park, to *Alice*. At other times, *Alice*'s role is less obvious, as in *The Souls of Millions of Light Years Away*. Complicating matters, Kusama has vigorously explained her artistic practice through memoirs, interviews, and ephemera like the press release she created for her Alice in Wonderland happening. Patterns have emerged over time as she first created and then later revisited past experiences and artworks through these types of materials.

This chapter constitutes a rewriting of history, in a sense. It begins with today's Yayoi Kusama, whom we know to have adapted *Alice* repeatedly, and then reviews her entire career through the lens of *Alice*. Tracking *Alice*'s appearance in Kusama's oeuvre makes clear the intricate intellectual foundation of Kusama's art, *Alice*'s ability to join visuals to concepts, and how the liminality of the mirror merged the greatness of the two.

Yayoi Kusama and the Artistic Process

Yayoi Kusama was born to a wealthy agricultural family in Matsumoto, Japan, in 1929. Her family home was unsettled by her father's incessant affairs, while her nation was rocked by political and economic instability. Art became Kusama's refuge. She began drawing as a child and convinced skeptical parents to allow her to study art in Kyoto, show her art in Tokyo, and finally move to Seattle to pursue her artistic career in 1957. She quickly left Seattle for New York City, where Kusama established a place for herself at the forefront of the global art scene while living amidst the hippie generation from 1958 until 1973. Health troubles prompted Kusama's return to Japan, where she lived relatively quietly until a 1989 exhibit of her works in New York reinvigorated her international career.

Today, Yayoi Kusama is arguably the world's foremost living artist. She was elected as a member of France's Ordre des Arts et des Lettres at the Officier rank in 2003 and as an honorary member of the American Academy of Arts and Letters in 2012. Major players of the contemporary art world have exhibited her art, including New York's Museum of Modern Art (MoMA), the Los Angeles County Museum of Art (LACMA), the Centre Pompidou in Paris, and London's Tate Modern. She is even more revered in her native land, which granted her the

76 Chapter 3

prestigious Praemium Imperiale award in 2006. Her works have set multiple records at auction and drawn record attendance numbers at several museums, leading the *Art Newspaper* to crown her the world's most popular artist in 2014 (Pes and Sharpe 2015). She has thus achieved both critical and popular acclaim.

Kusama's oeuvre has evolved over time to encompass sculptures, traditional Japanese-style paintings, memoirs, participatory performance events called happenings, films, novels, abstract oil paintings, a clothing line, poetry, book illustrations, and even stuffed pumpkins. The diverse media in which she works are matched by a dissimilar quartet of images to which she returns over and over again: flowers, the human body, pumpkins, and polka dots. These manifold media and distinctive images are tied together through Kusama's artistic persona.

Yayoi Kusama's career is based on a simple equation of Kusama herself to both her art and a larger, sometimes vague, other world. She portrays herself as existing simultaneously in the real world and these other worlds, a liminal existence that she exploits to make her alternate worlds available to consumers through her works of art. Her artistic process mirrors popular culture's media mix production process. An artwork by Kusama may sell for millions of dollars more than a manga, but in both cases the primary role of the physical item in question is to open a door to another world. Readers enter a manga's world through its characters, as discussed in chapter 1. Consumers enter one of Kusama's fine-art worlds through the carefully crafted artistic persona of Yayoi Kusama herself.

In order for Kusama to serve as a link between the here-and-now and another world, she must become part and parcel of her artworks. As Marie Laurberg notes,

> Kusama's art is about herself, but it is also about everyone else. The person *behind* the work is such a powerful presence *in* the work that it somehow becomes impersonal: she dissolves herself in the story and becomes part of it as a substitute for the viewer to whom her work so directly and seductively appeals: "I am here—but nothing," as the title of one of her works put it. (2015, 12; emphasis in original)

Laurberg points to a fascinating contradiction in Kusama's oeuvre. Kusama is amply present, multiply present, in her works, existing behind the paintbrush but also reflected in photographs of the final piece, press releases, and so on. Yet, Kusama's overdetermined presence is ultimately insubstantial. It is the viewer, rather than Kusama, who "becomes the visual center and source of meaning for the piece" (Dumbadze 2017, 122). *The Souls of Millions of Light Years Away* is merely a closet unless someone is inside it. Each and every artwork that Kusama

Yayoi Kusama, the Modern Alice (Through the Looking-Glass) 77

creates thus functions as a form of self-portrait, but a self-portrait of an artist who has no self, an artist whose disappearance somehow pulls the viewer into the world of the work. Kusama's oeuvre can thus be considered a single, long-running series of self-portraits, wherein Kusama herself is always present but never there. This existent nonexistence at the foundation of Kusama's art mirrors the dynamic immobility of the media mix anime character.

Because Yayoi Kusama explicitly ties herself to her art within the artworks themselves, it is necessary to consider her personal life when examining her art. This counters the normal approach to art, wherein some separation is maintained between the art and the artist's life. A distressed artist may yet produce an uplifting sculpture, while a contented artist may craft scenes of anguish. Kusama's insertion of herself into her art requires analyses of the art to also attend to the artist. However, the method by which Kusama combines herself with her art makes this a delicate operation.

Kusama merged her art, her carefully crafted worlds, and herself into a cohesive whole by exploiting depersonalization disorder, an illness from which she has long suffered. Depersonalization disorder involves a sense of detachment or distance from one's own self in body and mind. However, there are really two depersonalization disorders to consider regarding Yayoi Kusama: her illness itself, and her illness as she has portrayed it within her art. In other words, to discuss the role of depersonalization disorder in Kusama's art is not to render a medical opinion on her mental state, but to examine Kusama's artistic persona and how she has framed her oeuvre.

Kusama's use of depersonalization disorder turns sexist gender norms to her benefit. Art critic John Berger argues that a woman "is almost continually accompanied by her own image of herself" (1972, 46) in a permanently doubled existence because of sexism. Berger reasons that this reflective reality leads women to model how they would like to be treated by others rather than directly stating their needs. In contrast, Kusama ingeniously drew on depersonalization disorder to assert that if she was viewing herself from another location, then ipso facto that other location must exist. She developed from this basic rationale a series of detailed worlds that, by definition, she alone could access.

Because Kusama's other worlds are tied to her individual perspective, she can redefine the world for each new work of art she creates. While discussing her childhood in her first autobiography, Kusama contrasted her actual surroundings with what we might call the global political sphere: "The war that had been going on for so long ignited into the Second World War. And it was from about that time that I began to experience regular visual and aural hallucinations" (2002, 61–62).[1] Kusama's parallel statements imply that she is directly tied to that

78 Chapter 3

world, such that her health reflects the general status of world peace. On another occasion, Kusama contrasted "the decadence of humanity" in that same global sphere with her own existence, "in illusions in a brief moment of quietude amidst hundreds of millions of endless light years" (2017, 120). In contrast to the industrialized, war-torn world of her biography and her later meditation on deep space, her manifesto for a 1968 event ordered participants to "forget yourself and become one with Nature" itself (reprinted in Kusama 2013, 123). The other worlds of her other works span science-fictional universes, fantasy lands, and metaphysical meditations. Though the worlds change from one artwork to the next, they generally have metaphysical and New Age overtones as she encourages consumers to leave commonplace cares and societal pressures behind on their journey to the new world.

Kusama's molding of her various other worlds makes clear just how distinct medical depersonalization disorder is from depersonalization disorder as deployed by Yayoi Kusama in her art practice. Medical depersonalization disorder affects its sufferers, but in Kusama's art we see her manipulate the disorder. Curator Louise Neri asserts that Kusama "convincingly collapsed the distinction between her own consciousness and external realities" (in Neri and Goto 2012, 25) through these manipulations. Kusama's illness did not collapse the barrier between her mind and the outer world in such a way that it happens to be reflected within her art. Rather, Kusama has deliberately, intentionally portrayed herself as inextricable from a wider world through an artistic process that evolved to include depersonalization disorder.

In recent years, Kusama has linked herself to her art even more forcefully. In 2009, she began a series of paintings entitled "My Eternal Soul," which now includes more than five hundred paintings. Curator Yusuke Minami explains the importance of the "My Eternal Soul" title as follows: "Artists generally think of their most recent work as their best and most important. Kusama's emphasis on "My Eternal Soul," though, has a deeper significance. It indicates a view that the paintings in this series are a compendium of all she has experienced and achieved during her 70 years as an artist" (2017, 262). In other words, Kusama's art does not reflect her soul: it *is* her soul.

Even at the beginning of her career, Kusama linked herself to her art consistently, albeit more subtly. She collaborated with the psychiatrist Shihō Nishimura, who studied the minds of geniuses, as early as 1952 (Yamamura 2015, 32). Nishimura presented a paper on Kusama, whom he called a "Genius Woman Artist with Schizophrenic Tendencies," that led to Kusama's art appearing on the cover of a prominent art magazine and in a major Tokyo display space (Yamamura 2015, 32). Kusama regularly orchestrated photographs that ostensibly

Yayoi Kusama, the Modern Alice (Through the Looking-Glass) 79

showcased her newest artistic creations but actually highlighted herself. For her unauthorized art project, *Narcissus Garden* at the 1966 Venice Biennale, Kusama posed in the center of the camera's field while wearing a kimono in an untraditional silver color that danced with light reflected off the myriad metallic balls at her feet (figure 3.1a). Light, color, and framing combine to draw viewers' attention to her. She composed even more complex photos for her 1965 *Infinity Mirror Room—Phalli's Field*. The photo's frame encompasses both Kusama and enough of her reflection in the installation's mirrored walls to convey the impression of two Kusamas—one in the room and the other literally through the looking-glass (figure 3.1b). Here too Kusama wears a custom red leotard that simultaneously limits the color variation in the frame and draws viewers' eyes to the two Kusamas, who appear to be framed by the red polka-dotted stuffed items strewn across the floor. Each photograph visually ties Kusama to art by physically placing her beside works of art while simultaneously tying her to the creation of said art via the intense visual connection between her purpose-made clothing and the matching works of art behind her. Jo Applin, a scholar of contemporary art who has written widely on Kusama, suggests that "whether to retrospectively read such photographs as critical feminist interventions or evidence of the artist's savvy self-publicizing remains a subject of some debate" (2012, 3). Debating Kusama's motives in this way inherently relies on the assumption that she is acting in response to how others see her. Society provides her with a mirror in which to view herself, and she reflects her view of herself-as-artist back at society.

Just as Kusama has two depersonalization disorders—the illness itself and her portrayal of it within her art—there exists a pair of mirror image Yayoi Kusamas: Kusama herself and Kusama's performance of herself-as-artist. Art historian Midori Yoshimoto notes that it has been "rather overlooked" just "how conscious and careful [Kusama] has been in creating a public image of herself" (2005, 46), while Bree Richards succinctly points out that "the countless art works carrying Kusama's nets and dots out into the world, when seen as a whole, are the outward result of a disciplined, single-minded performance that has lasted for more than 60 years" (2011). Kusama's art is innately tied to Kusama herself, but that self is a performance, a role that Kusama has enacted for decades. Both artist and art thus have one foot in two worlds, which themselves exist on opposite sides of the looking-glass.

Portraits and Kusama

The photographs that Kusama staged of herself with her art are as much a part of Kusama's oeuvre as the pieces of art included within them. Signe Marie Ebbe

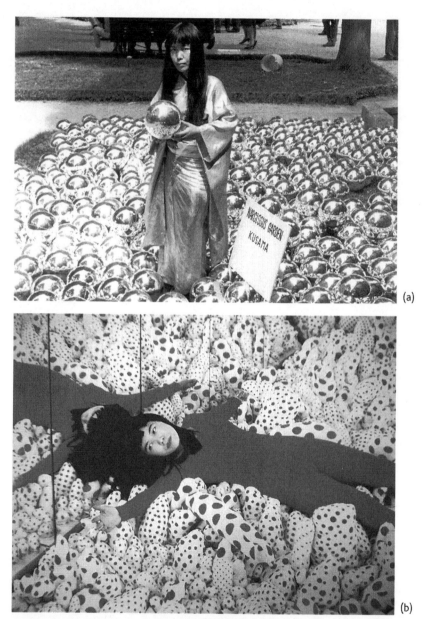

Figure 3.1. (a) Yayoi Kusama orchestrated photographs of herself with her art where she dressed in custom outfits that matched the artworks in question. Here, a silver kimono to match the silver balls in *Narcissus Garden* (1966) and (b) a red leotard to stand out in *Infinity Mirror Room—Phalli's Field* (1965). Photos of Kusama in her Infinity Mirror Rooms tend to portray both Kusama and her reflection(s) through the looking-glass.

Yayoi Kusama, the Modern Alice (Through the Looking-Glass) 81

Jacobsen says of these images that Kusama "insists on remaining an integral part of her works" (2015, 2) rather than allowing the art to be seen separately from herself. Some of the photographs circulate more widely than the artworks they depict, either because the work of art in question was an event (and thus only available to participants) or because the artwork was bought and hidden away by a private collector while the picture continued to circulate through reprintings in magazine articles and museum catalogues. In those cases, the photograph may have greater impact than the artwork captured within it. Photographs dominate the reception of Kusama's participatory art in particular. Gloria Sutton points out that interpretations of these events "are often historically fixed by a single grainy image, not because it is definitive or even accurate, but merely because it is extant and affirmed through subsequent recirculation" (2017, 145). The various stages of the event, the actions taken and environmental factors involved, are elided in favor of singular moments and viewpoints. This simplification sifts the totality of the event down to its essence, as Kusama sees it, and that essence is Kusama herself.

Whether photographers shot one of Kusama's events or her static art, the subject of their photographs was not an event or painting but Kusama herself. She is almost always in the foreground, with various works of art framing her body. Sometimes, Kusama poses inside a mirrored installation such that the artwork's mirrors reflect Kusama back to the viewer as if to say that she alone is important here. At other times, Kusama is carefully poised with a paintbrush amid an event's hand-painted, brush-less participants. Because Kusama stages the photographs and designs the costumes, these photographs constitute a form of self-portrait. These photographs exemplify how Kusama has connected her art to herself throughout her career, but they also highlight the role of portraiture in Kusama's performance of herself.

Several of Kusama's early photographs are set in her studio-cum-apartment in New York City, which is shown to be full of canvases but lacking any furniture. This leaves viewers with no context in which to place Kusama except artistic production. Because there are multiple paintings in each of these photographs but only one person, they resemble portraits more than documentary records of artistic production. Kusama's self-portrait photographs recall Jan Van Eyck's *Arnolfini Portrait* (1434) and Diego Velázquez's *Las Meninas* (1656) in the way that the process of artistic production is cannily reflected within a finished portrait. Kusama's studio photographs also fall in with female artists' twentieth-century reworking of the self-portrait to include paintings of the artists' rooms (Borzello 2016, 142).

Kusama's careful positioning of herself in relation to her body and her work neatly addressed a hurdle standing in her path to artistic greatness. Namely,

82 Chapter 3

Kusama was female and Asian at a time when few globally successful artists were either female or Asian. One of the few famous female artists of the time, Georgia O'Keeffe, mentored Kusama in her youth, but even so sexist and racist biases meant that Kusama was "destined to be marginalized" (Yamamura 2015, 2). The negative effects of sexism on Kusama's career—which naturally worsened her mental state—are detailed in Midori Yamamura's *Yayoi Kusama: Inventing the Singular* (2015) and Heather Lenz's documentary *Kusama Infinity: The Life and Art of Yayoi Kusama* (2018). Yamamura and Lenz show how artists including Andy Warhol, Lucas Samara, and Claes Oldenburg achieved great success with works directly inspired by (if not stolen from) Kusama's work. Art arbiters were more supportive of male artists as well. As Yamamura notes, "the best seasonal slots in first-rate galleries were usually reserved for young male artists" (2015, 113), which naturally helped those artists riffing on Kusama's work gain more attention than she herself had earned from the originals. Exploiting her depersonalization disorder allowed Kusama to twist stereotypes of Oriental mystique and hysterical femininity into a new, empowering form.[2] At the same time, by situating herself at the center of her art, by turning her work into a series of self-portraits, Kusama placed herself into a difficult position.

Portraiture is a particularly difficult genre, which is not made any easier by the absence of an independent sitter with their own ideas about the final product. The artist Edmund de Waal CBE described the thought process behind a self-portrait by asking, "How are you going to represent yourself when every choice of medium, of scale, of dress and posture, of background and foreground, of how you hold yourself in the world, is going to be noticed?" (2013, 9). Because a portrait is done by another person, the sitter can always disclaim responsibility for any unfortunate outcomes. In contrast, the artist behind a self-portrait has total control over and responsibility for every aspect of the final product. Every detail of a self-portrait attests to the artist's capabilities, and those details must build to a complex but coherent artistic brand. Self-portraits are particularly fraught territory for female artists as they must simultaneously present themselves as feminine women and as professional artists, mutually incompatible concepts throughout much of history (Borzello 2016, 36). Historically speaking, female artists had to walk a tightrope wherein they avoided subject matter deemed inappropriate for female eyes as well as attitudes and behaviors deemed unbecoming for women, whilst simultaneously proving that they were accomplished professionals in an industry where success required intimate contact with strange men, intent study of nude bodies, and shameless self-advertisement.

Self-portraiture may be a difficult genre for female artists, but Yayoi Kusama has never been one to shy away from a challenge. Midcentury photographs of

Kusama especially address the historical bind female artists faced by intensifying the role played by both art and femininity. Kusama bypasses an artist's smock in practical white or black for homemade, hand-sewn dresses in bright colors that match those in her artworks. She poses much like the fashion models that came into prominence alongside her in the 1950s and the 1960s. Where self-portraits commonly feature an artist holding a paintbrush or palette, Kusama either declines these tools or lightly poses with them in the fashion model's unproductive stance. Yet, even as she distances herself from the production process through decorative clothing and lounge lizard poses, the constant, profuse presence of artworks that reflect her clothing within the frame forces viewers to reckon with her career. The fashionable, feminine outfits that she designed and wore only existed because of the paintings and installations that she had created, and the art behind her only existed because of the feminine costumes it set off so nicely. Art existed because the female artist existed; the artist was feminine because the art called for femininity. In performing a sort of exaggerated femininity that stemmed from her profession, Kusama simultaneously drew attention to her femininity and her artistic skill.

Kusama was hardly the first female artist to draw on stereotypically feminine activities and characteristics to justify her work. The esteemed Dutch painter Rachel Ruysch (1664–1750), for example, was one of many female artists to build a career with still-life paintings of beautiful (and very proper) flowers. Botanical artist Pierre-Joseph Redouté, preferred painter of both Queen Marie Antoinette and her successor, Joséphine Bonaparte, taught seventy-eight women out of a total of eighty-five students (Scrase 2011, 8). This history of female floral artistry is reflected within and built upon by later artists like Frida Kahlo, the computer-generated animation artist Jennifer Steinkamp, and Yayoi Kusama.

Kusama's linking of her body to her art to invoke a fantastic other world is particularly reminiscent of the English spiritualist and artist Georgiana Houghton (1814–1884). Spiritualism, a movement whose adherents attempted to communicate with the dead, flourished in Europe and America from the mid-nineteenth century to the early decades of the twentieth century. As it happens, Charles Dodgson wrote his *Alice* novels in the middle of the same spiritualist craze in which Houghton participated. The two even moved in similar social circles (Grant and Pasi 2016, 14). Spiritualists communicated with the dead in séances where a spirit was called into the body of a medium, usually female, who had gone into a trance. The prominence of female mediums was a legacy of sexism; women, historically said to lack souls, were seen as empty vessels into which a spirit might enter with some ease, unlike supposedly strong-willed men. Georgiana Houghton was one such medium.

84 Chapter 3

Houghton manipulated stereotypes about women's suitability as mediums to argue that women were especially suited to create spiritualist art. Male spiritualist artists such as Dante Gabriel Rossetti incorporated "knowing symbolic references and images of women in trance-like or dream-like states" (Grant and Pasi 2016, 12) in their works as a reference to the gendered nature of the séance, with its limited, largely spectatorial role for men and the active inaction of the female medium. Houghton's "spirit drawings," a series of abstract images that she produced by allowing an otherworldly spirit to guide her artistically trained hand, remove men from spiritualist art entirely in favor of inactively active women. By reworking a pre-existing stereotype, Houghton created a form of art at which women were automatically more likely to succeed than men.

In Kusama's studied portrayals of herself, we can see a similar manipulation of pre-existing stereotypes of femininity. Houghton exploited a sexist conception of women as lacking interiority—as empty vessels into which the spirit of a deceased person could settle with ease—to argue that her art provided a unique value to society. Kusama exploits the same stereotype via her depersonalization disorder, which literally de-personifies her or removes her personhood. Thus de-personified, Kusama is able to link herself to a wider world as a twentieth-century medium. At the same time, where Houghton shared credit for her work with mystical spirits, Kusama claims sole credit for her artistic accomplishments by ensuring that they are all positioned as the background of her self-portraits. Kusama's characterization of her performance of herself thus becomes crucial to understanding her art.

Kusama, the Modern Alice

Where Georgiana Houghton drew on the then-trendy mysticism of the spiritualist séance, Kusama invoked hipper trends, like the participatory artistic events called happenings. Kusama organized her happenings into series with each new series evolving from the last. For example, the indoor Naked Happenings were followed by the outdoor Anatomic Explosions of 1968 and 1969. An *Anatomic Explosion* largely consisted of various participants gathering at a famous location in New York City, only to remove their clothes and let Kusama paint their bodies with brightly colored polka dots. The Anatomic Explosions also responded to contemporaneous political events like the assassinations of Martin Luther King Jr. and Robert F. Kennedy (Yamamura 2015, 165). Between the events' public nudity and timely political inflections, Anatomic Explosion happenings generated a lot of free advertising from journalists. Kusama capitalized on the headline-grabbing nature of her events to spread her public performance of herself as artist.

Figure 3.2. Yayoi Kusama and participants in her 1968 *Alice* happening at José de Creeft's *Alice* statue in New York City's Central Park pose artistically.

On August 11, 1968, Kusama adapted Lewis Carroll's world into a happening set at one of the two *Alice* statues in Central Park (figure 3.2). After gathering in front of José de Creeft's statue of Alice, the Mad Hatter, and the White Rabbit, participants stripped naked and donned an assortment of masks while Kusama painted them with polka dots. This event, like the rest of the Anatomic Explosion series, is primarily remembered and studied through a set of photographs featuring Kusama and five masked, but otherwise nude, and polka-dotted participants. With Kusama holding a paintbrush in the foreground—the sole clothed person visible—these photographs are part of her body of self-portraits. At the same time, the *Alice* self-portraits add another layer to the standard formula for a Kusama self-portrait. Kusama's self-portrait photographs do not just place Kusama in front of or surrounded by art, they place her amongst art she herself created. The *Alice* happening photos do place Kusama within a work of art that she orchestrated, the happening, but they further superimpose Kusama and her happening on top of de Creeft's statue. Furthermore, de Creeft's statue explicitly adapts Lewis Carroll's Alice in Wonderland books. Excluding architectural features incidentally in the background of other happenings, this happening appears to be the only instance of a Kusama self-portrait that includes another artist's work. If, as Signe Marie Ebbe Jacobsen argues, Kusama's self-portrait photographs represent her, "insist[ence] on remaining an integral part of her works" (2015, 2), then the photographs of the *Alice* happening represent a similarly intentional tying of her work to the *Alice* world and the character of Alice.

86 Chapter 3

Kusama's happenings are and always have been consumed primarily through their paraphernalia. The events were primarily aimed at the mass media, which were supposed to disseminate information about them (and their creator) to a vast audience. The small number of people who actually participated in the events is dwarfed by the number of people who heard or read about the happenings later. Midori Yamamura observes that "the *Anatomic Explosions* were brief and heavily targeted on the mass media, most importantly major news agencies such as Associated Press and United Press International" (2015, 165; italics in original). Yamamura points out that the first "lasted a mere five minutes" (ibid.). Their impact came from their sensational nature and photographic evidence rather than from their duration. Consequently, the self-portrait photographs of Kusama's happenings play a larger role in building her legacy relative to the pictured works of art than do the self-portrait photographs of her paintings and installations, which functioned—or were expected to function—primarily as works of art in and of themselves. Given the prominence of materials created around the Anatomic Explosion series, Kusama's framing of her *Alice* happening is particularly important.

Photographs of the *Alice* happening are perennial favorites amongst those writing about or reporting on Kusama and her art. Pictures of the *Alice* happening are regularly republished in catalogues of Kusama's art (including *Love Forever*, Zelevansky et al. 1998; *Yayoi Kusama*, Morris 2012; *Yayoi Kusama*, Neri and Takaya 2012; *Yayoi Kusama in Infinity*, Jørgensen 2015; *Life is the Heart of a Rainbow*, Storer 2017; *Yayoi Kusama*, Tatehata et al. 2017). They also appear in publications geared at popular audiences. When the magazine *Elle Japan* decided to devote its cover feature to Kusama, the *Alice* event was the only happening to be pictured (Sumiyoshi and Aono 2017). This single event thus functions as a synecdoche of all of Kusama's happenings despite the unusual inclusion of other artists' work in the event and key differences between Kusama's assorted series of happenings.

The *Alice* happening constituted only the fourth Anatomic Explosion event ("Documents: Yayoi Kusama" 2004). The course of each event was largely the same, but the *Alice* happening stands out for its comparatively apolitical theme. Kusama describes her 1968 happenings as "not solely about art but increasingly reflect[ing] the social turmoil of the times and opposition to both the war in Vietnam and the government" (2002, 121). Anatomic Explosions occurred on Wall Street and at the Statue of Liberty, the United Nations building, and the New York Board of Elections. Kusama crafted press releases for the events that explicitly protested economic inequality, war, and similar issues. Locations reflected the content of a happening, as when she burned a flag in front of the United Nations building. Only two of the happenings that Kusama details in her autobiography

were not located in politically useful locations: November's Homosexual Wedding, which was held in a rented loft, and August's *Alice* event in Central Park. Kusama's remembrance of the *Alice* happening in this book is apolitical, yet the event did have a political vein. Photographs of the *Alice* happening clearly show participants wearing masks of the political figures Fidel Castro, Richard Nixon, and Jacqueline Kennedy. Nonetheless, neither Kusama nor any of the scholars and journalists to discuss this happening seem to have discussed a political aspect to the *Alice* happening. The happening's press release instead emphasizes *Alice* and the then-trendy subculture of psychedelic drug devotees:

ALICE IN WONDERLAND

Featuring me, KUSAMA, mad as a hatter, and my troupe of nude dancers.

How about taking a trip with me out to Central Park where free tea will provided under the magic mushroom of the Alice in Wonderland Statue. Alice was the grandmother of the Hippies.When she was low,Alice was the first to take pills to make her high.
I, KUSAMA, AM THE MODERN ALICE IN WONDERLAND.

Like Alice,who went through the looking-glass,I,Kusama(who have lived for years in my famous,specially-built room entirely covered by mirrors), have opened up a world of fantasy and freedom.My world is peopled by a group of real nude girl and boy dancers covered by genuine hand-painted polka dots.You,too,can join my adventurous dance of life.

Paint the beautiful blonde Lydia Lee.
Paint your friends.
Have your friends paint you.
All together in the all-together.
LOVE-LOVE-LOVE-LOVE-LOVE

Rendez-vous at the ALICE IN WONDERLAND Statue in Central Park.
(reprinted in Kusama 2013, 180)

Like Houghton, Kusama refers to another source, another world. However, where Houghton was struggling to be recognized as an artist, Kusama had already proven herself by 1968. The surety that comes from her position amongst the avant-garde shows through in her press release. In an event adapting Carroll's books, she adamantly claims the protagonist's position for herself in capital

88 Chapter 3

letters. Furthermore, she strengthens Alice's role in the story. Where Carroll's Alice happened across adventure whilst idling away her time, Kusama's Alice actively "opened up a world of fantasy and freedom" that Kusama claims she can re-open at will for her participants. Alice now has power over Wonderland, the power to enter it at will. In this sense, Kusama is not Carroll's Alice, she is the improved, the MODERN ALICE. Not only can Kusama locate and open Alice's Wonderland whenever she wants, she can also make it available to others. Kusama possesses control over the other realm that Houghton claimed guided her unknowing hand.

Psychedelic drugs play a prominent role in the press release. It is fairly easy to see why a young, avant-garde artist like Kusama might invoke Wonderland's trippy pills and potions in the middle of 1960s New York City. Other artists of the time were making a similar connection, as in Jefferson Airplane's "White Rabbit," a top-10 hit song from 1967 that was likely still playing on the radio in the summer of 1968. Kusama exploits the trendiness of *Alice*'s drug culture connection in this happening to be sure, but she is able to layer on two additional symbols that were unavailable to the artists with whom she was in competition for sponsors and renown. First, she connects her mental health struggle to Wonderland's Mad Hatter. Kusama's statement that she is "mad as a hatter" in the opening sentence of the press release subtly implies that the artist's depersonalization disorder gives her a stronger claim to Wonderland than other, saner artists have. Secondly, Kusama strikes directly at the sexism that hindered her career by implicitly arguing that her femininity allows her to play a role no man ever could: Alice herself.

As the press release continues, Kusama switches her focus from the drugs Alice takes to Alice herself. Hinging on the declaration that Kusama is the modern Alice, the pills and mushrooms of the earlier half of the announcement are replaced with repeated references to the looking-glass. That is in line with the trajectory of the books themselves; size-changing pills and the opium-smoking caterpillar's mushroom appear in the first novel, *Alice's Adventures*, while mirrors appear in the sequel, *Looking-Glass*. Like Disney's 1951 animated movie, this happening adapts not *Alice's Adventures* or *Looking-Glass*, but the wider world of Alice in Wonderland. Within that world, Kusama identifies herself as not just any Alice, but a Modern Alice who has dominion over Wonderland—and whosoever aspires to enter it. Adapting a world rather than a single book allows Kusama to draw on the of-the-moment psychedelia trend and then pivot neatly to her own art with a subtle reference to her mirrored Infinity Room installations.

Shaking off any potential sense of obsolescence, Kusama situates Carroll's Alice as the prototypical hippie or "Grandmother of Hippies." She further

Yayoi Kusama, the Modern Alice (Through the Looking-Glass) 89

contends that those hoping to become hippies should follow not Alice's lead but rather that of Kusama, the Modern Alice. Kusama identifies herself as Alice to make herself into a gateway to a better world, "a world of fantasy and freedom" for all the restless searchers in the big city. Like Houghton before her, Kusama suggests that she has special access to a mystical other world and that those experiencing her art can experience it through her art. However, unlike Houghton, Kusama claims control over her actions and access to the other world too. Kusama portrays herself as necessary to anyone desiring access to this other world, which incidentally implies that she is necessary for art like hers to be created. She continues this linkage between body, mind, (her) art, and the issues facing the world at large throughout her career, which means that her oeuvre can be considered a single, long-running series of self-portraits whose subject, Yayoi Kusama, is somehow never entirely present.

Kusama obfuscates who and what exactly she is by merging herself, her depersonalization disorder, and her art in a public performance of herself-as-artist, wherein her art reflects her artistic self. Beginning in 1968, however, Kusama adds a fourth dimension to this mix: *Alice*. In adapting Alice in Wonderland, Kusama concretizes the vague other world to which her art is supposedly transporting consumers as well as the role the artist plays in her art. *Alice* strengthens Kusama's claim to artistic importance: as a woman, she has more right to claim the title of *Alice* than any male artist, and as a person suffering from depersonalization disorder she has an innate ability to travel to Wonderland as well as an understanding of its off-kilter nature. *Alice* adds depth and a sense of history to various motifs and media that Kusama was already using and ties those disparate motifs together into a cohesive whole. Kusama's 1968 adaptation of *Alice* to strengthen her artistic persona and artistic motifs (including the other world and the mirror) will later be reused by David Elliott. Then director of the Mori Art Museum, he drew on *Alice* to explain why the Museum's 2012 exhibit of Kusama art has "a mirrored room at its heart. When we peer into or walk through it, we are also able to go through the Looking Glass [sic]—to enter, understand and enjoy Kusama's world" (2004, 90). Kusama equated herself to an updated Alice, a Modern Alice in her 1968 happening. Half a century later, Elliott takes that evolution a step further by renaming Wonderland Kusama's world. She no longer needs to draw on Alice's name. Now, *Alice* is secondary to Kusama.

Watery Polka Dots and a Pool of Tears

Yayoi Kusama is a consummate show-woman. She advertises her art with detailed, poetic press releases. She advertises herself through photographs featuring

90 Chapter 3

couture clothing of her own design. She stages everything—art, self, home, studio—so that viewers' attention is directed where it ought to go. In other words, Kusama visually and verbally explains to consumers exactly what she is giving to us and what it all means. She has explained time and time again, for example, that her polka dots symbolize infinity (unlike the plebeian polka dots created by other people). She has repeated that her polka dots are an instantiation of the infinite so often that it has taken on the force of complete truth. Yet, that is not the whole story.

Polka dots are so closely associated with Kusama that they became "the artistic equivalent of the commercial logo" (Hoptman in *Love Forever: Yayoi Kusama, 1958–1968* 1998, 55). Kusama (and her ceaseless self-promotion) has become so tied to polka dots that when the English artist Susan Gunn critiqued the idea of art as a commodity in her contribution to Norwich's GoGoHares trail of decorated sculptures, she did so by applying a red polka dot to a statue of a White Rabbit. Pity the contemporary artist who attempts to use polka dots, for they will be compared with the master.

> Comparing [Atsuko] Tanaka with Yayoi Kusama who used dots repeatedly in her work reveals how devoid of emotions Tanaka's work is. In one sense, Kusama adopted craftsman-like and analogue methods in extending the dots that she painted away from herself (self-diffusion) and out into the environment. In contrast to Kusama's work, in which each dot was imbued with a biotic and animistic vitality as if the dots were her alter ego, the repeated dots in Tanaka's work are exceptionally systematic. (Yuko Hasegawa in *Atsuko Tanaka: The Art of Connecting* 2011, 13)

Hasegawa's parallel analysis neatly touches on several key features of Kusama's art. Kusama works in multiple. She does not stage one happening, she stages dozens. When she began creating sculptures, she covered a chair in not one or two but thousands of stuffed fabric penises. This sculpture was fittingly called *Accumulation #1* (1962), and its mass of multiples was itself multiplied into the Accumulation series of sculptures. Where Gunn placed one red polka dot on her statue, Kusama covers bodies, rooms, statues in multitudinous polka dots in a variety of bright colors. That repetition enhances the effect of Kusama's diffusion of her work (through photographs and press releases), which Hasegawa calls painting away from herself out into the environment. If Kusama simply painted polka dots on canvases, she might be associated with polka dot paintings among those who follow contemporary art. However, Kusama paints polka dots on people, walls, books, statues, anything she can get her hands on . . . and she calls the

Yayoi Kusama, the Modern Alice (Through the Looking-Glass) 91

press beforehand so that they can spread her art even farther. Pushing her art out into the environment launches Kusama's carefully crafted artistic persona into the minds of people with no particular interest in art. Polka dots are her "alter ego," her mirror image. Where they go, she goes.

Kusama's polka dots exemplify the tension between simple surface meaning and the deeper world within her oeuvre. Kusama's writings showcase this polka-dotted tension, as in the press release for her December 1968 happening, "Kusama at the Fillmore East" (reprinted in Kusama 2011, 148). Kusama limns a much more complicated symbolic system in this press release than a simple equation of polka dot to infinity would imply. Kusama first "offers the new way to happiness by smashing to smithereens the old social morality" before she "asks you to become one with eternity by obliterating your personality and returning to the primordial state of union with the eternal forces of nature" (2011, 148). Kusama is setting up her event with anarchist promises of everlasting happiness achieved through self-destruction, shaded with the element of Mother Nature. Her final goal, oneness with eternity, is symbolized by a simple polka dot. She describes the process by which people might destroy themselves and achieve permanent happiness as follows:

My performances, in which I paint naked people with polka dots, are symbolic. A polka dot has the form of the Sun, which is a symbol of the energy of the whole world and of our living being. The polka dot has the form of the Moon, also, which is soft, round, peaceful and feminine. Polka dots never stay alone, but, like people, seek company. Polka dots multiply and become a movement for love and peace. Our Earth is only one polka dot among a million stars in the Universe. Polka dots point the way to infinity. (Kusama 2011, 148)

In this passage, Kusama lays out a detailed process that leads from the physical shape of the polka dot to the sun, the moon, Earth, and the rest of the universe. Kusama's logic is incredibly simplistic at heart—polka dots are round, stars and planets are round, so they must be the same! At the same time, she gives a depth to polka dots, treating them like the characters who began to take over Japanese culture in the 1950s, and which media theorist Marc Steinberg has shown link consumers directly to the worlds of stories like *Alice* (2012a, ix). Kusama's polka dots are energetic but peaceful, desirous of company, and inclined to spread love. Together, they form an infinite world of "love and peace." Consumers can only access this other world if they discard the clothing tying them to contemporary social mores and let Kusama paint their nude bodies with her polka dots.

92 Chapter 3

Consequently, Kusama is once again central to both the artwork and the world in question. Kusama gives herself a moniker to differentiate herself from the masses. Where she was the Modern Alice for her Alice in Wonderland happening, this time she is the "Polka Dot Girl" and the "High Priestess of Polka Dots" (Kusama 2011, 148).

In both the Fillmore East and *Alice* happenings, Kusama deploys a character—the polka dot and Alice, respectively—connects said character to another world that she depicts as peaceful and loving (in implicit contrast with our world), and renders herself as the personification of that character. She thus acts as a bridge linking participants with a peaceful other world through the auspices of the borrowed character. She can take on these characters' roles because her depersonalization disorder intrinsically prevents her from having a fully formed character of her own. Meanwhile, the polka dots simultaneously diffuse into the environment, in Hasegawa's words, and remake their surroundings into part of another world—just like a character in the media mix. Once a consumer equates polka dots or Alice with Kusama, they will be reminded of Kusama whenever they see polka dots or Alice again—regardless of whether or not what they are seeing was created by Kusama. That Kusama used polka dots and Alice in the exact same way a mere four months apart suggests that she found the two characters similar.

Kusama brought polka dots and *Alice* together again in 2012 through an illustrated edition of *Alice's Adventures in Wonderland* (plate 6). Perusing this book shows that polka dots have become so intrinsic to Kusama's view of Wonderland that they merge with the text, which itself begins to evolve artistically. Indeed, the cover design features a minimalist design of polka dots rather than an illustration suggestive of either Alice or Wonderland. The infinite, peaceful world of the polka dot has merged with the loving world of *Alice*, but readers still access this peaceful, loving *Alice* world through the auspices of Yayoi Kusama.

After the text of *Alice's Adventures* ends, the book contains a biography of Kusama and a short essay she wrote on what *Alice* means to her. The essay is preceded by a quotation from Kusama: "I, Kusama, am the living Alice of Wonderland" (in Kyaroru 2013, 192). She further titles the essay "Alice's World Is Mine, It Is My Everything" (Kyaroru 2013, 193). Kusama has refined her relationship with *Alice* since 1968. Kusama is still the Modern Alice, now rephrased as the Living Alice. Where she once claimed mastery over Wonderland, she now claims the entire Alice in Wonderland world.[3]

Kusama painted polka dots on participants' bodies in her 1968 *Alice* happening, but it is unclear why. While she may have explained the connection between polka dots and *Alice* at the happening itself, the remaining documentation does

Yayoi Kusama, the Modern Alice (Through the Looking-Glass) 93

not connect the two concepts, nor does Kusama seem to have connected the two in any after-the-fact discussion of the happening. In Kusama's 2012 illustrated edition of *Alice's Adventures*, polka dots are merged fully with *Alice* under the artistic guidance of Kusama, the Living Alice. That merger takes two forms—textual and illustrative—and in true *Alice* fashion, it depends on wordplay.

The Japanese language offers two ways to refer to polka dots. The first, *poruka dotto*, is a transliteration of the word "polka dot." The more common term is *mizutama* or *mizutama moyō*, meaning "water drop" or "water drop pattern." Kusama's polka dots are referred to by the latter phrasing. Considering Kusama's dots as droplets of water adds another dimension lacking from the English—especially when discussing an artist cognizant of *Alice*.

One of the most famous episodes in *Alice's Adventures* occurs in the second chapter, "The Pool of Tears." In this chapter, Alice grows to an alarming size and finds herself stuck in a hall full of doors too small for her new dimensions. She cries a great deal in distress before accidentally shrinking herself to the point that the pool of her tears becomes a sea through which she must swim. Lewis Carroll unintentionally created a slight conundrum when he wrote this episode. The tears that fall as teardrops from Alice's eyes land as drops of water in a pool. Linguistically, "drops of water" and "teardrops" are distinct concepts in both English and Japanese. The dissonance between the two concepts is reflected in both Kusama's illustrations for the second chapter and the translation accompanying her illustrations. Kimie Kusumoto, the translator of Kusama's illustrated *Alice*, titled the second chapter "Namida no Ike," or "Pond of Tears" (Kyaroru 2013, 29), and she sticks with *ike* as the translation of pool fairly consistently. However, the very first time the word "pool" shows up in the text of the chapter ("There was a large pool all round her," Carroll 2015, 23), Kusumoto translates it as *mizutamari* (Kyaroru 2013, 30). *Mizutamari* is generally translated as "pool of water," but it is a compound word that can be broken into two parts: "water" (*mizu*) and "accumulation" (*tamari*). Both *ike* and *mizutamari* are fine translations for the text, as one would expect from a skilled translator like Kusumoto. Those two words, which are very close to synonyms, contain a fascinating interplay of ideas. *Mizutamari* alludes to Kusama's oeuvre in a way that *ike* does not. *Mizutamari* has a clear aural similarity with Kusama's *mizutama* ("polka dots").[4] Where Kusama's *mizutama* are distinct drops of water, Kusumoto's *mizutamari* is an accumulation of water. The word *mizutamari* subtly emphasizes the joining of a multitude of individual drops of water, harking back to Kusama's statement that "polka dots never stay alone, but, like people, seek company" (in Kusama 2011, 148). *Mizutamari* also recalls Kusama's Accumulation series of sculptures due to *tamari*'s sense of "accumulation." After Alice shrinks, Kusumoto refers to

94 Chapter 3

the pool as *namida no ike* (lit. "pool/pond of tears"). This phrase lacks the sound of and character for "water" (*mizu*). It suggests instead a single, unified aquatic body. Kusumoto's translation thus subtly refers to Kusama's art whilst also emphasizing the transformation of Alice's individual teardrops into the combined mass in which she will shortly go for a swim.

The complexity of Kusumoto's translation is matched by Kusama's artwork and designer POSAVEC's layout. Polka dots naturally cover the pages of this chapter as they do all of the book's chapters and even the book's cover. In "The Pool of Tears," polka dots come to the fore on the same page that the word *mizu-tamari* appears, as Alice cries over her predicament. Three large, blue polka dots suggest the character's falling tears, while the facing page is entirely devoted to a drawing of grayish white dots in varying sizes on a black background. Unlike her normal, large polka dots, which float freely across the pages and underneath the text, these grayish dots are small and densely packed, almost as if the viewer were looking down on the floor of the hall as it was covered in Alice's tears. Kusama follows this illustration with bright yellow polka dots and a cheery crocodile in a polka-dotted bonnet to match the poem "How Doth the Little Crocodile" in the chapter's text, only to repeat the packed dot imagery on the following pages in a smaller form and with blue dots on a pink background. Rescaled and recolored, set against a background in another shade of pink, and surrounded by large, hot pink polka dots, the image now takes on an abstract and somewhat confusing air as Alice shrinks. Packed blue dots on a rose background are set in a light pink page over which three more large, dark pink polka dots are loosely arrayed. The reader flips the page to find a two-page spread of roughly drawn circles, mere black outlines on top of a grayish white background, as if the reader has been thrust underwater and is watching air bubbles rise around her (figure 3.3). Readers only discover that Alice too has slipped and fallen in the water when they flip to the text on the following page. This sequence of illustrations places readers in the position of Alice. Readers see her teardrops as she sobs, then see the hall floor from her perspective, and the crocodile she describes, before crashing into her confusion as she simultaneously cries and considers what lies below her. Finally, readers are submerged just as Alice is. Yayoi Kusama, the Living Alice, has turned her readers into Alice.

Kusama closes her illustrated edition of *Alice's Adventures* with an essay that ties together the various concepts she has associated with *Alice*. She opens with the updated declaration that she is the Living Alice. Kusama no longer needs to draw on *Alice*'s trendy association with psychedelic drugs. Nor does she require a respectable female character to grant her artistic authority in a male-dominated industry. Kusama is now an award-winning artist whose exhibits smash

Figure 3.3. Kusama drops readers into the pool of tears in *Alice's Adventures in Wonderland with artwork by Yayoi Kusama*, written by Lewis Carroll, translated by Kimie Kusumoto, 2012.

attendance records around the world. She does not need to be a modernized Alice anymore. She chooses to be a Living Alice. Alice, after all, encapsulates the system of concepts that Kusama has developed over her career. She, the depersonalized artist, serves as a bridge between the everyday and a better world through her art. She can do so because hers is a liminal existence, with one foot on each side of the looking-glass.

Kusama's explanation of the book's genesis explicitly declares that "if this book can serve as a bridge, I will be happy indeed" (in Kyaroru 2013, 193). This statement has two functions. First, it refers not to Carroll's text, but to the physical volume the reader is holding, that is, the Yayoi Kusama–illustrated edition of *Alice's Adventures*. This specific edition of the text features a new name—*Alice's*

96 Chapter 3

Adventures in Wonderland with artwork by Yayoi Kusama—that reminds readers of Kusama's indispensability to her art, reflecting Kusama's lifelong linkage of her art to herself. (It even subtly emphasizes Kusama over her art by failing to capitalize the word "artwork.") Secondly, the statement explicitly portrays the book as not a simple story but a "bridge" (*kakebashi*). Elsewhere in the essay, Kusama describes the two sides of this bridge as being "our world and space" (*"watashitachi no kono uchū ya sekai"*) on one side and *"Alice's* splendid dream world" (*"Arisu no hanabanashī yume no sekai"*) on the other (in Kyaroru 2013, 193). The everyday world in which we live is depicted as a place that we want to escape in favor of another, dreamlike world, which Kusama can get us to through the auspices of her art. Kusama continues: "Everyone, please love *Alice*. That is your true form" (*"Minasan, Arisu wo ai shite kudasai. Sore ha anata jishin desu,"* in Kyaroru 2013, 193). Where the Kusama of 1968 attempted to get participants in her happenings to another world for the duration of the happening, the twenty-first-century Kusama believes that we all have the ability to transport ourselves into another world at any time for as long as we wish—once we learn how to do it from her. Yet, Kusama returns to *Alice*, rather than adapting, say, the Bible or the Lord of the Rings trilogy, because of the mystery innate to the character of Alice. Kusama explicitly calls Alice "that world's beautiful phantom" (*"sono sekai no utsukushi maboroshi,"* in Kyaroru 2013, 193) in an explicit reference to the shadowy nature of Alice—the character, the Liddell girl, the depersonalized artist's performance, the consumer. *Alice* ultimately contains all of the symbols and concepts that Kusama has developed over the course of her career. In particular, connecting her mirrored installations to *Alice's* looking-glass enables Kusama to economically convey the complex philosophical experience contained within works like *Infinity Mirrored Room—The Souls of Millions of Light Years Away* to consumers by drawing on a deep, long-standing body of cultural knowledge about the mirror and its function in art.

Understanding Mirrors in Art

Mirrors have a long history in art. Mirrors have been treated as works of art in their own right, worthy of intricate frames made of precious metals. They have also been inserted into other works of art—like van Eyck's *Arnolfini Portrait* and Velázquez's *Las Meninas*—to play with perspective and space. The mirror invokes a myriad of associations that range from philosophical to fashionable, judgmental to playful. Because mirrors are filled in this way with a superfluity of meaning, they cannot function as a stable referent. To put it another way, a mirror must always be one thing *and* another; it cannot be just one thing. At the same

time, a mirror's associations come in binary pairs, which are linked by the mirror that reflects one to the other. Mirrors are consequently suspended between two things in a state of liminality. The mirror's liminality enables it to connect distanced peoples and spaces, such as when Native Americans used to flash reflected sunlight in coded intervals to communicate with far-off friends. These basic traits mean that mirrors carry within themselves a vast range of symbolic meanings and practical usages.

The mirror is placed in front of a room and creates a reflected room, between which two rooms the mirror remains. Yet, the reflected room is not simply a copy of the first. Obviously, left and right have been reversed. Far greater alterations may be initiated by the mediating mirror as well. *Las Meninas'* mirror transforms an image of the making of a painting into a portrait of a royal couple who remain frustratingly out of sight. A mirror might be curved so as to reflect a warped version of reality. An acoustic mirror such as sonar might be used to make visible the unseen. Mirrors' way of altering that which they reflect led to the development of the metaphorical multiplicity cited by Miller at the start of this chapter.

The mirror has been used metaphorically in art for thousands of years. The Christian Bible compares life and the afterlife through mirrors in Corinthians 13: "For now we see in a mirror, dimly, but then we will see face to face. Now I know only in part, then I will know fully, even as I have been fully known." The Christian reflection is thus partial, and the mirror of life separates people from a complete understanding that can only come after death. This morbid view of mirrors perhaps lies at the heart of urban legends like Bloody Mary, who appears to those who repeat her name in front of a mirror in the dark. Another metaphorical view of the mirror has it reflecting not a partial view but a true reality. Vampires' absent vital force is matched by their reflected absence. Snow White's stepmother turns to her mirror, mirror on the wall for a truthful view of herself in comparison with the rest of her people, while Narcissus only realizes his beauty when it is reflected back upon him. The physical mirror at times also functions as a safe barrier between reality and the viewer, as when the Lady of Shalott's life is protected via the invisible barrier of the mirror's surface.

When the person inside a mirror varies from the actual person reflected, artists tend to cast that variation as a moral difference. Leo Braudy contrasts Narcissus's recognition of himself as lovable with the Creature's opposing realization that he is abhorrent in Mary Shelley's *Frankenstein* (Braudy 2016, 193). Taken further, the mirror's "reversal of normal visual symmetry makes it a potential doorway to an alternate reality" (Braudy 2016, 194). This alternate reality is home to alternate versions of ourselves, doppelgangers, who match its morality by

98 Chapter 3

opposing our own. Mirrors are so important to this moral dichotomy that they are imposed into stories about people confronting evil doppelgangers. Dr. Jekyll informs readers that he brought a mirror into his room, "for the very purpose of these transformations" into Mr. Hyde (Stevenson 2022). *Star Trek*'s parallel universe, in which exist evil doppelgangers of all of the television shows' characters, is called the "Mirror Universe."

Though reflections of ourselves are so important to our understanding of mirrors that we have built an entire body of art around them, *Alice*'s looking-glass was initially less than reliable in that regard. Jonathan Miller points out that Carroll "conveniently forgets to mention" (1998, 119) how exactly Alice is able to pass through the body of her reflected self exiting the mirror at the exact moment that Alice enters it. *Alice* adapters have in turn conveniently forgotten Carroll's intentional oversight, especially when working in the horror genre. The hit horror film *Us* (dir. Jordan Peele, 2019) begins with the violent meeting of a girl and her white rabbit-eating doppelganger in a house of mirrors. The cult hit *Alice* anime *Serial Experiments Lain* (1998) is suffused with digital doppelgangers of its Alice character, the titular Lain (Brown 2010, 162–176). Lain is further paired with a second doppelganger of sorts, her friend Alice. Where Lain enacts the journey of Alice in Wonderland, her increasingly digitized, posthuman existence is reflected in her solidly embodied friend, who carries the name of Alice. The Resident Evil series of films (2002–2016), which adapts *Alice* together with the titular Japanese zombie video game series, takes a different approach to the body. The six films glory in tracking the physical prowess of their protagonist, Alice, as she shoots, hacks, and kicks her way through legions of the undead. The series culminates with the revelation that the body viewers have attentively followed through battle after battle is merely one of hundreds if not thousands of identical clones. The final film climaxes with a profusion of Alices raining across the screen in a battle to defeat the evil Umbrella Corporation and end its zombie apocalypse.

The doppelgangers of *Lain* and *Resident Evil* reveal a basic fact of mirroring: much as an adaptation only functions as an adaptation when the consumer recognizes it as such, a reflection can only function as a reflection if it is recognized *as a reflection* (Miller 1998, 59). If it is not recognized as a reflection, the consumer instead sees it as a three-dimensional space and anyone reflected in it as a unique individual. The other space functions as another world, which may jar with the real world around it. For example, if a mirror hanging on a building's exterior wall reflects a large interior room, a person who did not recognize it as a reflection would be confused to see that the building in fact ends at the wall that they had thought to be an interior barrier. In cases such as this, the mirror loses

its materiality and "is no longer seen as a surface" (Miller 1998, 59). The doppelganger cannot be bound within the mirror, because the mirror effectively no longer exists. Consequently, Luc Peters and Anthony Yue warn us that "mirrors are not to be trusted" (2018, 1). The truth they reveal may not be true, and the sensory confusion caused by our failure to recognize reflections as reflections induces wild imaginings wherein good becomes evil and vice versa. It is to this substantively insubstantial medium that Yayoi Kusama turned to connect us to her other worlds.

Kusama's Oeuvre as *Alice*

Yayoi Kusama's art is often organized into themed series, which has had unintended consequences. Dividing her works into series made sense early in her career, when an Infinity Net painting differed wildly from an Anatomic Explosion, which in turn bore little resemblance to an Accumulation sculpture. Tracking artworks as part of series can show how Kusama has developed certain images and ideas while leaving behind others. Yet, separating her works in this way creates an illusion of division when in fact she has consistently explored the same philosophical and visual territory. It is more accurate to say that Kusama cleaves to specific motifs and concepts, reiterating them in new media and new combinations ad infinitum. For example, Kusama painted pumpkins in Japan's *nihonga* style in her youth, but in the early 1980s she merged pumpkins with her polka dot motif to produce strikingly different polka-dotted pumpkin paintings and sculptures (Laurberg 2015, 28). Pumpkins consistently symbolize the rural home of Kusama's youth in these works, yet a viewer's understanding of the work will vary depending on their knowledge of this symbolism. The meaning of Kusama's illustrated edition of *Alice's Adventures* similarly varies depending on readers' knowledge of the pumpkin's role in Kusama's artistic pantheon. The page facing the end of the text is covered by an illustration of a large pumpkin with a window in its center, behind which a dark-haired woman in a polka-dotted dress stands. The pumpkin woman is not identified in the book, nor does Carroll's text mention pumpkins at any time. In fact, the image is quite confusing—I have heard multiple readers suggest that it is Alice, but that does not jive with the story's outdoor ending. After Alice's sister wakes her, Alice runs off while her sister settles into a dream of Wonderland and adulthood. No one is described as being indoors. In light of Kusama's identification of the pumpkin with her home and her insistence on her control over the *Alice* world, however, this image is clearly Yayoi Kusama herself, welcoming readers to this malleable other world that her book allowed us to enter.

100 Chapter 3

Close examination of Kusama's *Alice* happening and illustrated edition of *Alice's Adventures* shows that *Alice* encapsulates and strengthens the system of symbols and concepts that she has developed over the course of her career. However, the phantom of Alice haunts Kusama's career more broadly than these two works alone. Take Kusama's skill at advertising herself. The myriad portraits of Kusama made at her shows and happenings are regularly reprinted in magazine articles, blog posts, and exhibit catalogues, but they do not reappear on an equal basis. Time and time again pictures of Kusama's *Alice* happening are reprinted—in an article on Kusama in *Elle Japan*, a catalogue for a Tate Modern exhibit of her work, a catalogue for LACMA's *In Wonderland* exhibit of female Surrealists in Mexico and the United States . . . Certain other Kusama portraits do reappear regularly, but the *Alice* happening photographs are undeniably among the most frequently reprinted images. Moreover, Kusama returned to the *Alice* happening in both of her memoirs. She retyped part of the original press release in the first memoir and included a photograph of said press release in its entirety in her second memoir. While the original *Alice* happening spanned only a fraction of an afternoon, it has echoed across the decades through these diverse recurrences. Despite the years separating her two announced *Alice* works, *Alice* never left Kusama's art.

If *Alice* has been an important part of Kusama's oeuvre since her early years, then it makes sense to study her other works for hints of Wonderland. A loose connection might be seen in her polka dots, which can be connected to Alice's tears and the pool of tears as well as Kusama's conception of the infinite. However, Kusama's Infinity Mirror works have a much stronger connection to *Alice*. These are the mirrored installations that David Elliott argued take consumers "through the Looking Glass" into "Kusama's world" (2004, 90) despite the fact that mirrors do not appear to have played any role in Kusama's *Alice* happening or her illustrated *Alice*.

Kusama has worked with mirrors since the 1960s. At first, she created installations that included a few mirrors scattered across the room, but these limited uses of mirrors quickly gave way to complex mirrored environments featuring special lighting and structured methods of entry. *Infinity Mirror Room—Phalli's Field* (1965) and *Peep Show* (1966), though produced only one year apart, exemplify Kusama's early experiments with mirrors. In *Phalli's Field*, Kusama placed polka-dotted soft sculptures in a room with mirrored walls, while 1966's *Peep Show* consisted of a mirrored hexagonal room that consumers peered into through slots in the walls. Consumers viewed *Phalli's Field* from a polka-dotted pathway that kept them separated from the bulk of the installation even as the overall effect made, in curator Miwako Tezuka's words, "spectators part of her

art and her world" (2017, 199). In contrast, the majority of a consumer's body remained outside *Peep Show*, with only their faces reflected in the interior mirrors. Consumers remained physically in the everyday world as their minds (symbolized by the face) flew out of their bodies and through the looking-glass. Kusama explored different methods of moving consumers directly into the world beyond the looking-glass, i.e., Wonderland, with these two works.

Kusama does not appear to have ever stated that the Infinity Mirror Rooms are part of her *Alice* work, but they have come to include the pool of tears motif as she has created new iterations over time. Since 2000, Kusama has created several Infinity Mirror Rooms that feature a pool of water underneath the platform on which consumers stand, including the one described at the start of this chapter, *The Souls of Millions of Light Years Away*. In Kusama's Infinity Rooms, consumers' reflections "produce an 'out-of-body' experience as our eyes are disembodied and dispersed like the millions of reflected lights that are directed back to us" (Miwako Tezuka 2017, 31). Those lights, which are generally colored and always the size of Christmas lights, resemble polka dots made of light. Consequently, consumers become one with the polka dots, which is to say, our bodies are reduced to merely another part of Kusama's artwork. Tezuka ties this out-of-body experience to Kusama's deep "invest[ment] in working at both a microscopic and cosmological scale, creating works in which the simultaneous experience of intimate compression and epic expansion of the body in space remains a constant feature" (2017, 14). The simultaneous intimate compression and epic expansion of the body in *The Souls of Millions of Light Years Away*, which occurs over a pool of water in a limited space, parallels Alice's disorienting size changes in a hall that is simultaneously vast and cramped, as well as the resultant pool of tears, without Kusama making an explicit statement to that effect.

Laying aside the idea of series and instead examining Kusama's oeuvre holistically through the lens of *Alice* reveals connections between seemingly diverse works of art even when *Alice* is not explicitly cited. Kusama has repeatedly used a flower motif without attributing a specific meaning to it as she has to other motifs. Yet, an intriguing passage in her first autobiography grants an elliptical meaning to her flower drawings, paintings, and sculptures.

From a very young age I used to carry my sketchbook down to the seed-harvesting grounds. I would sit among the beds of violets, lost in thought. One day I suddenly looked up to find that each and every violet had its own individual, human-like facial expression, and to my astonishment they were all talking to me. The voices quickly grew in number and volume, until the sound of them hurt my ears. I had thought that only

102 Chapter 3

human beings could speak, so I was surprised that the violets were using words to communicate. They were all like little human faces looking at me. I was so terrified that my legs began shaking. (Kusama 2002, 62)

This section of Kusama's text parallels Alice's meeting with the talking flowers in chapter 2 of *Looking-Glass*. Obviously both texts include talking flowers, and naturally both Alice and Kusama are surprised by the discovery that flowers can talk. Moreover, both humans find themselves overwhelmed by the volume of the flowers' speech, which almost attacks them. Kusama is hurt by the force of the flowers' volume and attention, while Alice's intelligence is repeatedly maligned by Wonderland's proud floral folk. Alice's garden has more diversity in its plant life, though one violet does appear amongst the varied flora. It notes that it "never saw anybody that looked stupider" (Carroll 2015, 188) than Alice. Thus finding the experience not to their liking, both Kusama and Alice "eagerly" (Carroll 2015, 189) escape the immobile flowers. Kusama does not connect this episode to *Alice* in her text, nor has she stated anywhere else that her various flower works are related to *Alice*. Her illustrated edition of *Alice* does contain a few flower illustrations, but since that text is *Alice's Adventures* rather than *Looking-Glass*, the illustrations are generally untethered from the content of the text.

If we reconsider Kusama's flowers not as simple flowers but as *Alice*'s talking flowers, then the development of Kusama's flower works over time suddenly makes more sense. Kusama drew flowers long before she became a professional artist. She used flowers in her work on occasion in the 1960s and 1970s, but the turn of the century saw a significant increase in the number and type of flower art she produced. In particular, she has created many gargantuan outdoor flower sculptures. These sculptures naturally produce the "intimate compression and epic expansion of the body in space" that Miwako Tezuka identified as inherent to Kusama's works. The overly large flowers make people feel smaller as standing next to any overly large item would. If we instead understand these works as *Alice*'s talking flowers, the experience changes. Yes, we are smaller, but Alice both shrinks and grows. Our bodies oscillate between sizes in relation to our surroundings, which include both Kusama's giants and normally sized items. This oscillation culminated in the 2021 New York Botanical Garden exhibit *Kusama: Cosmic Nature*, which juxtaposed enormous flower sculptures with actual flowers. Attendees experienced a variety of physical dis- and re-orientations as they wandered across the Botanical Garden property much as Alice wandered across Wonderland, entering and exiting buildings and gardens as well as installations like *Infinity Mirrored Room—Illusion Inside the Heart* (2020), which function as buildings-within-buildings.

Including *Alice* in our analysis of Kusama's oeuvre adds a degree of focus and an additional layer to the established understanding of her works of art. Where Miwako Tezuka argued that the Infinity Rooms consistently feature a concurrent bodily compression and expansion, I would add that Alice's famous bodily contortions heighten the effect. *Alice* serves as a magnifying glass that clarifies Kusama's artistic preoccupations into their purest form. Viewing Kusama's oeuvre through the lens of *Alice* further shows how analysts' categorizing impulse separated Kusama's art into series in such a way as to hide cross-series similarities like her usage of *Alice*. Considering Kusama's adaptation of *Alice* over the course of her entire career quietly reminds us that Kusama faced an uphill battle to gain recognition for her work due in particular to her sex, while also reminding us that women and archetypes of femininity that could aid her did exist. Where Ryūnosuke Akutagawa used the world of *Alice* to pursue his artistic preoccupations, Yayoi Kusama used the character of Alice to first justify herself as an artist and then link seemingly distinct motifs and concepts. Kusama's deployment of this character has some similarities with the dynamically immobile character image that Marc Steinberg uncovered in anime. However, Kusama develops the philosophical system behind her art beyond character images via the concept of the looking-glass, and the resulting dual existence of the self and reflection. In this way, she has expanded the ways in which artists can exploit pre-existing stories and that stories can in turn continue to survive through adaptation. Ultimately, the seemingly diverse symbols, motifs, and themes of Yayoi Kusama's art—the looking-glasses, mystical other worlds, talking flowers, and polka dot/water drops—achieve their most forceful iteration when Kusama explicitly adapts Alice in Wonderland by channeling the titular protagonist. In *Alice*, Kusama found a world whose layers of meaning, symbolism, and imagery aligned beautifully with her own artistic preoccupations, identity, and methodology. Her *Alice* adaptations exploit that alignment to focus consumers' attention precisely where Kusama wants it: on herself and her work.

CHAPTER 4

A Profusion of Alices Flutter through Manga for Girls and Boys

In Mikiyo Tsuda's *Princess Princess* manga (2002–2006), an elite all-male high school deals with its lack of feminine energy by creating the Princesses, a group of students who cross-dress to act as cheerleaders at school events. In contrast with the series' internal celebration of femininity, each of the series' five volumes, as well as the one-volume spinoff *Princess Princess+*, features the cross-dressing protagonists in a traditional boys' school uniform called the *gakuran* (plate 7). This preemptive reminder of the characters' masculinity prevents the series from sliding into a pasquinade of femininity—something its mainly female audience would find particularly demeaning. Carefully balancing femininity and masculinity in this way is a hallmark of the Princess Princess world, which eventually grew to include a live-action television series, a video game, an animated television series, and three audio dramas in addition to the two manga series. The final instantiation of Princess Princess was a 2007 artbook, *Princess Princess Premium*. With no more *Princess Princess* works forthcoming, it became less important to harmonize femininity and masculinity. Thus, *Princess Princess Premium* became the only Princess Princess book to feature the protagonists in costume as cross-dressing princesses on its cover. The quintet appears as a circle of Alices around a giant stuffed rabbit wearing a waistcoat, jacket, and pocket watch (see plate 8). At once limited and meaningful, this adaptation of *Alice* exemplifies a common pattern in contemporary Japanese *Alice* adaptations: multiplying Alice into profusion within a single work in such a way as to obscure the meaning of the word Alice.

Like Tsuda, many *Alice* adapters refer to *Alice* only glancingly. Historically, adaptation theorists have struggled with this type of material, and for good reason. It makes sense to distinguish between, say, a filmic *Hamlet* and a friend joking that "there are more things in heaven and earth, Horatio, than are dreamt of in your philosophy." At the same time, creators adapt because adaptation gives meaning, and the power of alluded or referenced material is not lessened simply because the citation is brief. Linda Hutcheon's argument that a work must be recognized as an adaptation if it is to function as an adaptation can be reversed:

once a work is recognized as an adaptation, it functions as an adaptation. Once a consumer recognizes *Alice* on the cover of *Princess Princess Premium*, she will connect Alice's short-term adventure in an unusual Wonderland to the male Princesses' surreal journey through high school girlhood.

The number of transitory adaptations like Tsuda's exceed the number of extended adaptations simply because they take far less time and effort to produce. Studying adaptations collectively would be impossible if every study had to consider each time anyone has ever deployed a word or image that evokes another world. Yet, analyzing adaptations of a given world by default means discussing the reception of that world. Analyzing *Alice* adaptations in Japanese culture as I am here means discussing the reception of *Alice* by Japanese culture. That reception includes not only extensive retellings on stage and screen but also random comments, screen-printed designs on T-shirts, and the occasional cover image on an artbook. While it makes sense to separate these selective "allusions" and "echoes" from "extended intertextual engagements[s]" (Hutcheon 2013, 9) when examining works singly or conducting a horizontal analysis of classes of adaptations, it makes less sense when studying all the adaptations of a given source as a collective. In fact, because transitory adaptations are by their nature quick and easy to produce and distribute, these adaptations can achieve significant influence through sheer number where the creators of a more extensive adaptation must wage a long battle just to get their product to market, let alone make it a success.

Tsuda's *Princess Princess Premium* cover is important because it concludes the *Princess Princess* story. Moreover, covers are crucial to a book's success, as they can make their books stand out on a store's crowded shelves. The *Princess Princess Premium* cover image needed to capture consumers' attention, gesture at the volume's contents, and also sate fans' desire for a strong, somewhat nostalgic conclusion to the superficially feminine visual spectacle that previous *Princess Princess* works provided. Consequently, the cover image carries a weight that belies the paucity of *Alice* material in the various works instantiating the Princess Princess world. In addition to abandoning the established design of male characters dressed in standard-issue boys' uniforms, this final cover is also the only one to feature all five Princesses. That the massed power of all five Princesses is brought to bear on *Alice* is simultaneously evidence of *Alice*'s centrality to Japanese culture and a marker of a larger trend within Japanese *Alice* manga: the obfuscation of who or what exactly Alice is.

Obscuring content may seem incompatible with the manga medium, which is based in depiction rather than concealment. However, certain aspects of manga production and consumption today center on what Masuko Honda calls

106 Chapter 4

hirahira, or "fluttering" (2010). Fluttering, or making small, quick movements to and fro, blurs the boundaries between "to" and "fro" such that a thing's precise location cannot be measured. Likewise, its true nature remains vague. *Hirahira* was established in the early years of the twentieth century as part of a distinct girls' culture in Japan, which evolved over time to center on manga made by and for women and girls today.

While both male and female manga artists, creating manga for both male and female audiences, adapt *Alice*, female artists do so at a much higher rate. For example, Katsuhiro Ōtomo, globally famed for his *Akira* manga (1982–1990) and anime (1988), adapted *Alice* into a short chapter in a single-volume anthology of fairy tales (1981), while the similarly skilled female artist Keiko Takemiya adapted *Alice* for a chapter in one of her series (1982) and later contributed another manga to an *Alice*-themed anthology (1991). Other manga artists have taken Takemiya's doubling of Ōtomo's *Alice* production to another level. Haro Asō adapted his most successful manga, *Alice in Borderland* (*Imawa no kuni no Arisu*, 2010–2016), into three spinoffs and sequels (2014–2015, 2015–2018, 2020–2021). In contrast, popular female artist Kaori Yuki created five distinct series, one sequel series, and a host of one-shot, or single-chapter, *Alice* manga—almost all of which were produced for female reading audiences. The gendered imbalance in *Alice* manga production is an offshoot of a gendered youth media environment that developed in Japan in the early twentieth century, and which in turn encourages today's Japanese women to produce certain media, like manga, more than others, like video games. This chapter focuses on *Alice* manga, and in so doing shows that female manga artists adapt *Alice* so frequently because girls' culture impels girls to adapt—and specifically, to adapt into manga—but also because *Alice* exemplifies *hirahira*.

Understanding Girls' Culture

The rise of the magazine industry in early twentieth-century Japan brought with it a gendering of young audiences. Where the earliest children's magazines were aimed at an amorphous youth audience (and were probably actually read aloud by older family members), magazines like *Girl's Friend* (*Shōjo no Tomo*, 1908–1955) and *Boys' Club* (*Shōnen Kurabu*, 1914–1962) explicitly targeted a young, gendered readership. This shift was inadvertently supported by the 1899 Imperial Edict on Girls' High Schools (*Kōtō jogakkō rei*), which established girls' high schools across Japan (Kan, Dollase, and Takeuchi 2012, 7). Girls' high schools became majority-girl environments wherein girls could craft their own cultural norms, identities, and relationship models away from the constant oversight of

A Profusion of Alices Flutter through Manga for Girls and Boys 107

parents and neighbors (and the potential intrusion of boys). Magazines spread these schoolgirls' cultural influence far afield from the physical schools themselves. Relatively few girls were wealthy enough to attend girls' schools, but girls' magazines (and later, other media) enabled them to at least participate in girls' culture "peripherally" (Dollase 2010, 80).

Girls' magazines provided an outlet from gender-based societal strictures by actively encouraging readers' participation. While boy readers were expected to grow up and enter into public discourse, women were expected to refrain from voicing their opinions through public venues. However, girls' magazines' readers could convey their opinions to other girls all over Japan by publishing letters in the magazines' dedicated letters sections and joining magazine-organized social clubs. Thus, "prewar girls' culture created a private space of girlhood, a community of friends insulated from the pressures of a restrictive patriarchy" (Shamoon 2012, 11). This private community had its own references, stories, habits, and slang, as all private groups do, and it elevated the girls' school experience as transcendental.

Girls' culture expanded beyond schools and magazines to touch many aspects of Japanese girls' lives. The all-female Takarazuka Revue (est. 1913) allowed girls to imagine adventures and romances that evaded normal gender-based strictures, while artists like Yumeji Takehisa and Jun'ichi Nakahara produced fabrics, wallpaper, and stationery that enabled consumers to make their home environments over in the style of the artists' popular illustrations for girls' magazines. By World War II, a unique girls' culture had developed that had a huge impact on those (girls) who were part of it.

The insular, participatory nature of Japanese girls' culture generated a fascinating degree of intertextuality. Girls would "engage in highly sophisticated and complex borrowing and interweaving of themes and ideas across texts" (Aoyama and Hartley 2010, 5) both to showcase their own knowledge of girls' culture and to parry the adult male society that dismissed them (ibid., 6). The central texts of girls' culture are marked by girls' use of them; if a text is not alluded to or embedded in other texts, it must perforce be peripheral to girls. They built their own canon of literature by citing, alluding, borrowing, and otherwise adapting stories in their letters, art, fiction, and poetry. Unsurprisingly, girls seem to have ignored many canonical works of male-dominated modern Japanese literature. In turn, boys seem to have largely ignored most of the canonical texts of girls' culture. An author like Nobuko Yoshiya—whose *Flower Tales* series of stories about female friendship were so popular amongst (female) Japanese children that she spawned an entire genre (Shamoon 2012, 70)—would have had at best a vague sort of name recognition for Japanese boys. Yet even today, girls' manga often feature

108 Chapter 4

characters whose fantastically archaic, flowery names clearly descend from Yoshiya's own naming style. Though prewar girls were meant to remain quietly at home, their adaptive activities within this multi-sited, multimedia girls' culture enabled them to push back against the patriarchal control of cultural, industrial, and political elites.

Perhaps it goes without saying, but Japanese women were hardly in control of government or industry in the early twentieth century. The earliest *Alice* translations reflect Japan's male-dominated publishing industry in that *Alice* was almost exclusively translated by men prior to the end of World War II. There are rare exceptions, like Yuko Kako's *Alice's Adventure* (*Arisu no bōken*, 1918–1919) and Yoshiko Tamamura's *A Marvelous Tale: Alice's Exploration in Wonderland* (*Otogi kitan: Arisu no fushigiguni tanken*, 1926). However, male translators (as well as writers, editors, and publishers) were by far the standard. Female translators were so rare that works published under a female byline have occasionally been accused of having been actually translated by a man using a female pen name.[1]

Kako and Tamamura's translations are particularly interesting for what they reveal about how women could enter into an almost entirely male-dominated industry. Kako published *Alice's Adventure* in *Women's Weekly* (*Fujin shūhō*), and Tamamura's *Marvelous Tale* appeared in the aforementioned *Girls' Friend*. The latter translation thus exemplifies how the developing girls' magazine culture of participation encouraged girls (and the women they would become) to produce new literary works and even publish them for public consumption. Kako's translation, aimed at an older but still female audience, demonstrates that media aimed at women also provided a more welcoming environment to female literary efforts. *Marvelous Tale* and *Alice's Adventure* reflect the fact that early twentieth-century Japanese literary media aimed at female audiences at least accepted, and at times actively encouraged, female creation and publication in a way that media aimed at either the general public or male audiences did not.

Certain types of literature were more open to female authors than others. Women could draw on their supposed duty to educate their children to justify translating children's literature or writing essays about child-rearing, for example. They had less success publishing stereotypically masculine literature like journalism and war stories. Canny women manipulated what opportunities they had to engage in the many debates going on in Japan at the time: What would a modernized Japan look like? What should modern gender roles be? What kind of role should Japan play in the world? What should modern Japanese literature look like? Kako and Tamamura built on the work of earlier women like Shizuko Wakamatsu, who used her 1890–1892 translation of Frances Hodgson Burnett's *Little Lord Fauntleroy* to introduce a new way of understanding childhood and

motherhood to Japan (Ortabasi 2008). Like Kako, Wakamatsu published her translation in a magazine aimed at women, *Women's Education Magazine* (*Jogaku zasshi*), which happened to be edited by her husband, an advocate of raising educational standards for girls and women.

Japan's women's lives changed wildly between the middle of the nineteenth century and the end of World War II, but the publishing industry remained hostile to female workers. Literature aimed at female audiences was more welcoming to female translators and authors, but girls' magazines actively inculcated female creation and publication in a way that no other sector of Japanese society matched. The girls reading these magazines then developed a culture of intertextuality—of citing, of translating, of adapting—that would reappear in the postwar period through girls' manga.

Japanese women, like women across the globe, made great strides toward equality during and in the immediate aftermath of World War II. In contrast with the lack of female *Alice* translators in the first half of the twentieth century, at least six translations by women were published in the first decade of the postwar period alone.[2] The following decade saw another eight publications by women, and this growth continued, eventually totaling thirty translations by women in the decade spanning 2004 to 2013. This stratospheric growth in women's translations stems from a combination of postwar changes in Japanese society and the effects of the prewar girls' culture. Women made steady inroads into different aspects of the publishing industry over the postwar decades, and in so doing they often propagated the communal girls' culture into new environments that were not strictly for girls. In a history of female-authored Japanese science fiction from the 1960s to the 2000s, Mari Kotani notes that girls' manga and literature "establish a female-oriented consumer code" that involves a "network of texts" used in "subversion of the real world" (2007, 49, 70). Kotani writes about science fiction published in magazines aimed at both sexes, yet her analysis of postwar fiction written by women echoes the closed, intertextual prewar girls' culture that quietly disrupted real-world gender dynamics.

In the postwar period, manga effectively replaced prewar literary magazines as the mediatic home of Japan's girls' culture (Shamoon 2012). Most of today's manga are initially serialized in magazines that are divided into age and gender groupings much like prewar magazines. Girls' manga magazines retain certain traditions from the prewar literary magazines. Both types of magazines regularly came packaged with presents called *furoku*. *Furoku* ran the gamut from games like *sugoroku* to fans, postcards, posters, fortune-telling kits, bags, boxes, dolls, and even Christmas tree ornaments (*Shōjo zasshi furoku korekushon* 2007). Manga magazine readers are regularly encouraged to participate in the

110 Chapter 4

magazines' creation by sending in postcards where they rank their favorite series, posting fan mail and presents to their favorite artists, attending magazine-specific conventions, and so forth. Manga readers' participation is somewhat more circumscribed than literary magazine readers' activities were, in the sense that publishers encouraged activities that revolved around professionally published manga. At the same time, manga magazines were liberated from the prewar preoccupation with girls' schools, which allowed them to create "a manga culture for girls, where fandom became a means of connecting with other girl readers and with young women artists" (Shamoon 2012, 103). The manga medium thus took the place of the girls' school as the lynchpin of the community, which means that participation in girls' culture came to require some form of manga activity. The distinction between woman and girl simultaneously blurs as girls age into women while continuing to engage in the activities, habits, and traditions of girls' culture. Girlhood becomes "the transience that lasts forever" (K. Saito 2014, 155). Women's taste and values are influenced by both the girls' cultural canon and the canon of mainstream, male-dominated Japanese literature and culture.

By the 1980s, "some form of manga activity" had taken on a fairly concrete form. Girls read girls' manga, then went to fan conventions like Comiket to either buy or sell *dōjinshi*, or fan-made adaptations of professionally produced works. The largest fan convention in the world, Comiket draws half a million fans to its twice-yearly events in Tokyo (Comic Market Committee 2014, 5). Upon arrival, fans are faced with endless rows of tables at which sit other fans who are selling their *dōjinshi*. There are only two major activities at Comiket: buying *dōjinshi* and cosplay, or dressing up as a manga/anime character. Industry professionals do speak at the event, but they are not the primary attraction. While Comiket is open to both men and women, women were the primary drivers behind its establishment and continued success (Kinsella 2000). Though the number of male *dōjinshi* artists has increased since the 1980s, women still comprised 57 percent of participating artists in the summer of 2013 (Comic Market Committee 2014, 19). Manga editors have used Comiket and other *dōjinshi* conventions to scout new talent like CLAMP and Kaori Yuki, both of whom have been highly successful.

Dōjinshi, and especially *dōjinshi* created by successful artists, often physically resemble girls' magazines and girls' manga magazines.[3] Prior to becoming professional artists, CLAMP published the *dōjinshi Shōten*. Each edition of *Shōten* contained a variety of comics and short stories alongside various other things that encouraged readers' participation. The spring 1989 issue, which was released just before CLAMP's professional debut, included a half-dozen comics, a bingo-like game, a crossword, an address for fan letters, an advertisement for a

A Profusion of Alices Flutter through Manga for Girls and Boys 111

poster that CLAMP had independently produced for sale to other fans, two short stories, color title pages for three manga, three different types of paper, the names of the contributors and what each was responsible for, an advertisement for the group's forthcoming professional debut, and a decorative box with colored illustrations on the front and back. These various pieces construct a 223-page tome of a collector's item. CLAMP could afford to splurge on *Shōten*'s production to that extent because they achieved an unusual degree of success, but their inclusion of a variety of works, their emphasis on readers' active participation, and their creation of additional merchandise that readers could buy all fit into the model first established by prewar literary magazines.

Dōjinshi reflect the habits and values of girls' culture in addition to the form of the magazines that shaped it. The bulk of *dōjinshi* adapt the worlds of professionally published works, which means manga but also anime, live-action films and television shows, video games, literature, and so forth. Like prewar girls' magazines, *dōjinshi* thus become a proving ground wherein girls and women craft their own canon. A given world's importance in girls' culture can be determined by examining the extent to which it is adapted into *dōjinshi*. As girls aged into women with professional careers of their own—and as Japanese women made space for themselves in the publishing industry through translations, children's literature, original literature, and manga—the adaptive emphasis of girls' culture inflected women's creative production. Female manga artists' heavy reliance on adaptation—even within their own oeuvres, as in CLAMP's case—is rightly understood as part of a larger system of cultural production that values adaptation, or intertextual citation, as a communicative tool and a hallmark of quality craftsmanship.

Girls' culture's emphasis on adaptation created a "private world" (Shamoon 2012, 100), closed off from authority figures and politico-economic events. Pioneering girls' culture scholar Masuko Honda likens girlhood to dreaming while safely cocooned from the outer world (2010, 20). Girls' reflexive adaptation of each other's language, literature, clothing, and so forth effectively built a cocoon sparing them from, for example, misogynist mainstream novels like Jun'ichirō Tanizaki's *Naomi* (*Chijin no ai*, 1924). While one might expect girls to choose symbols of strength to build this protective barrier, Honda argues that girls chose instead to draw on symbols that evoked *hirahira*. The word *hirahira* itself is an onomatopoeia that evokes the sound of fluttering, as ribbons might in a breeze. Fluttering enables girls to check patriarchal authority because it subtly "extends and blurs boundaries" (Honda 2010, 35). A fluttering girl covertly moves into prohibited territory only to flicker back out again before anyone can respond. *Hirahira* protects the closed world of girls' culture by subtly confusing where

112 Chapter 4

exactly its boundaries lie. Girls are drawn to *hirahira* for its "liminality" (Honda 2010, 33), which protects and transports them to a safe, private world. It was perhaps only to be expected that female manga artists raised in Japanese girls' culture would draw on Alice's own liminality, her fluttering between the everyday world and a private Wonderland, to build the next generation of girls' culture through their manga.

Manga Multiples

The first manga adaptation of *Alice* was Hiroshi Nakamura's 1951 *Masterpiece Manga Alice's Adventures in Wonderland* (*Meisaku manga fushigi no kuni no Arisu-chan*, Ohnishi 2021). Alice in Wonderland manga were published on a fairly regular basis from the start, but there was a stark rise in their popularity in the 1980s. That decade alone saw the publication of at least twenty *Alice* manga, including works by acclaimed artists such as Keiko Takemiya, Waki Yamato, Hideo Azuma, Katsuhiro Ōtomo, Yun Kōga, Yumiko Igarashi, and Mamoru Oshii. There are now enough *Alice* manga to identify trends and subgroups. In particular, most *Alice* manga obfuscate exactly who, or what, Alice is. Several *Alice* manga do so by presenting readers with multiple Alices. If there are multiple Alices, then no single Alice can be the definitive Alice. Alice is often multiplied simply by giving several characters equal claim to the name of Alice. Bisco Hatori exemplifies the approach in her series *Ouran High School Host Club* (*Ōran kōkō hosutobu*, 2002–2010).[4] *Ouran* is a romantic comedy about a group of wealthy male high school students who become enamored of a female scholarship student at their private school. Hatori appended a side story to the series' fourth volume that begins as though it were a straightforward retelling of *Alice's Adventures* using *Ouran*'s characters to play Alice, the Cheshire Cat, and so on. This premise quickly falls apart as the male characters realize that Haruhi, *Ouran*'s female protagonist, is far too indifferent to bother chasing a rabbit down a hole. One of the male characters thus changes into an Alice costume and plays Alice until he too is deemed unsuitable, setting off a comic marathon—one *Ouran* character hands the Alice-baton off to another until they run straight off Carroll's rails. At the climax, the male characters descend into an argument over which of them will get to win Haruhi as their romantic partner (their goal in *Ouran*'s main story) while Haruhi awakens next to one of the few male characters who is not attracted to her much as Alice awakens next to her sister at the end of Carroll's novel.

 Ouran obscures Alice twice over in this side story. From the start, Alice is played by characters known to readers from the main *Ouran* story. *Alice*

A Profusion of Alices Flutter through Manga for Girls and Boys 113

adaptations often have an air of mystery or ethereality about them, exuding the sensation that the consumer has stepped outside of the everyday world. However, Hatori singles out the character of Alice for a second round of mystification. Almost every character has played Alice by the end of the story, but no other character from *Alice* has been portrayed by more than one member of *Ouran*'s cast. In other words, every single resident of Wonderland can be amply portrayed by a single member of the main cast, even if that member occasionally abandons their duties to play Alice as well, but no one is capable of completely representing Alice; all are insufficient in some way. They can only join together to limn her outline, leaving Alice's true nature obscure. Like *Princess Princess*, *Ouran* thus treats Alice almost like a costume that anyone can don instead of a person that actually exists.

Alice manga grew out of a tradition of illustrated *Alice* translations and *Alice kamishibai*, or children's illustrated storytelling. Early *Alice* manga retell Carroll's stories in manga form much like those earlier illustrated translations and small-scale theatricals. The manga medium has always been known for a degree of edginess, however, so it should come as no surprise that artists quickly begin to manipulate *Alice* in their manga. Koremitsu Maetani's "Robot in Wonderland" ("Fushigi no kuni no robotto," 1963), for instance, replaces young Alice with a hapless robot (Kinoshita and Kennell 2021, 23). Artists' molding of *Alice* reached a new level of complexity in 1974 with the "complex, dual-layered structure" (Kinoshita and Kennell 2021, 19) of Shinji Wada's "Stumbler in the Cabbage" ("Kyabetsu-batake de tsumazuite"). On one level, the story's characters enact Alice's journey through Wonderland. On another level, the characters are aware of Carroll's *Alice* novels and the history of their production. "Stumbler in the Cabbage" flutters between nondiegetic and diegetic adaptations of *Alice*, that is, between a manga set in the world of *Alice* and a manga in whose world *Alice* exists and is therefore known by the characters. Moving between these two levels complicates every aspect of the manga. Wada's innovation has proven influential. Manga adaptations of *Alice* wherein the characters are also aware of Carroll's books—including in particular the character of Alice and her inspiration, Alice Liddell—are now a common way of multiplying Alice. Haruhi's re-enactment of Alice's dream journey in *Ouran* exemplifies this type of multiple-Alice *Alice* manga.

One strikingly popular alternative to portraying Alice in multiple is to carefully have a not-exactly-Alice that is nevertheless called Alice. For example, in Higuchi Tachibana's *X-men*-like series *Alice School* (*Gakuen Arisu*, 2003–2013), an "Alice" is a superpower rather than an actual person. Underlining the ineffability of these superpowers, the nature of the protagonist's Alice is continually in question, and the quest to understand her Alice provides the dramatic thrust of

114 Chapter 4

the series. Other characters have obvious Alices (a fire Alice, for example), but the source of their Alices' powers and duration are unknown; some Alices burn up their users' lives, others disappear at puberty. Famed anime director Mamoru Oshii and animator Yuji Moriyama's joint manga *In the End* . . . (*Todo no tsumari* . . ., 1984–1985) reflects a similar strategy: when a number of vagrant children suddenly appear out of nowhere, the government categorizes them as Alices. Reduced to a designation rather than a name, Alice instantly applied to countless people.

Jun Mochizuki's *Pandora Hearts* (*Pandora hātsu*, 2006–2015) added depth to this pattern of flaunting several semi- or not-quite-Alices in front of readers. The protagonist of *Pandora Hearts*, a boy named Oz Vessalius, falls into the Wonderland-like Abyss in the very first chapter. His journey clearly mimics Alice's, but his name and gender proclaim him Not Alice. Oz is protected on his journey through the Abyss by a young woman introduced as the Bloody Black Rabbit, or B. Rabbit. B. Rabbit possesses two forms: a gigantic black rabbit in a red coat and a young girl who physically resembles John Tenniel's Alice illustrations, albeit with a red-and-black color scheme. Partway through the story, it is revealed that B. Rabbit's real name is Alice. This Alice-by-name has a sister who is introduced as the Will of the Abyss, but later described as the original Alice from whom B. Rabbit inherited the name of Alice. Like B. Rabbit, the Will of the Abyss resembles John Tenniel's Alice. The Will of the Abyss does have the blue and white color scheme, though she does not wear the outfit Tenniel designed. Finally, B. Rabbit and the Will of the Abyss are the daughters of Lacie, an unfortunate woman who gave birth to her daughters after she was cast into the Abyss. Lacie, whose name is an anagram of Alice and who is dead at the start of the series, also resembles Tenniel's drawings. To sum up, Oz Vessalius enacts Alice's journey, but Alice's name and image are attached to two other characters, both of whom were actually born in the Abyss, i.e., Wonderland. Meanwhile, a woman who initially enacted Alice's journey into the Abyss and resembles a classic visualization of Alice is explicitly named not-Alice through the use of an anagram. Mochizuki obfuscates which of several Alices is the real deal by distributing the Alice name and narrative amongst multiple characters whose non-Alice attributes are emphasized by comparison to the other pseudo Alices.

Ai Ninomiya and Ikumi Katagiri's *Are You Alice?* (*Ā yū Arisu?*, 2009–2015) muddles matters even further by refusing to explain who Alice is, let alone which character is Alice. The *manga* follows an amnesiac young man who is designated as "Alice?" within the text as he is forced to prove that he is the real Alice by killing the White Rabbit. In this world, failure to kill the White Rabbit leads to one becoming a type of ghost called a Regret. Because Alice? is the eighty-ninth Alice

A Profusion of Alices Flutter through Manga for Girls and Boys 115

to play the game, there are an additional eighty-eight Regrets who were once Alices. Moreover, the Rabbit guards a comatose character called Marianne who is actually Alice Liddell (real-life inspiration for Carroll's Alice). As Alice? puts together the mysteries of Wonderland, he discovers that he is Alice Liddell's younger brother, who was born dead. Alice Liddell's pet, the Cheshire Cat, pieced him together like Dr. Frankenstein's monster with things the Cat found in trash bins. Alice Liddell then gave Alice? the name Alice prior to her disappearance into Wonderland . . . which may have been caused by Alice?'s attempt to murder her. *Are You Alice?* is about Alice?'s quest to gain an identity by proving that he is the real Alice, but it is not clear whether the "real Alice" is the character of Alice Liddell in *Are You Alice?*, the character of Alice in Carroll's books, the Alice that the Cheshire Cat pieced together, or someone else entirely. The point of the series is to answer the titular question—Are you Alice?— yet the question is effectively unanswerable because the meaning of Alice—what it is to *be* Alice—is unclear. Fluttering between a multitude of Alices renders the name's meaning unclear in the same way that a girl's fluttering over boundaries renders the border unclear.

Boys and *Alice* Manga

Pandora Hearts and *Are You Alice?* represent another way that Alice is obscured in *Alice* manga. As noted above, Oz Vessalius acts out Alice's journey through Wonderland, but categorically cannot be Alice due to his name and rather obvious masculinity. Likewise, Alice? can only ever be Alice?, as opposed to Alice, to readers because of his sex. These series belong to a subgenre of *Alice* manga where artists manipulate Alice into somehow becoming male. The male Alices could be seen as enabling male readers to identify with the protagonist. Yet, not all of these manga are necessarily read by or even intended for male readers, which suggests that male Alices carry a deeper meaning.

The male Alice strain of *Alice* manga began with the robotic protagonist of Koremitsu Maetani's 1963 volume *Robot Fairy Tales* (*Robotto dōwa*). There are four main types of male Alices: those who appear alongside female Alices (as in *Pandora Hearts*), those who are robots that have been gendered male (as in *Robot Fairy Tales*), those who play Alice (as in *Ouran*), and those male protagonists who simply wander into Wonderland. This categorization is rough, however, as some manga fall into multiple categories. Male Alice manga appeared at an increasing rate around the turn of the twenty-first century. These series gained a higher degree of popularity among manga readers than had earlier male Alice manga. Tamayo Kobayashi's *Boy Alice in Wonderland* (*Fushigi no kuni no shōnen Arisu*, 1993–1995) and Hara Asō's *Alice in Borderland* (*Imawa no kuni no Arisu*,

116 Chapter 4

Table 1. Chart of male Alice manga, their publication dates, and the type of magazine each ran in

Manga	Magazine's Target Audience	Year of Initial Publication
Boy Alice in Wonderland	*Shōjo*	1993
Alice on Deadlines	*Shōnen*	2005
Pandora Hearts	*Shōnen*	2006
Are You Alice?	*Josei*	2009
Alice in Borderland	*Shōnen*	2010
I Am Alice	N/A	2012

2010–2016) joined *Pandora Hearts* and *Are You Alice?* in following male protagonists who accidentally wandered into Wonderland. The male characters in Ayumi Kanou and Visualworks' *I Am Alice* (*Ore Arisu: Danjo gyakuten*, 2012–2013) and Shiro Ihara's *Alice on Deadlines* (*Dsenjō no Arisu*, 2005–2006) switch bodies with female characters to become Alice. As the repetition of Alice's name in these manga titles suggests, both *Alice* and the idea that Alice could be male became much more prominent in turn-of-the-century manga. Collectively, these works suggest the creation of a new strain of *Alice* adaptations and its spread across the Alice in Wonderland world as it is embodied in manga.

Turn-of-the-century male Alice manga reveal that *Alice* appeals to both genders. *Boy Alice in Wonderland* was serialized in *Wings*, a weekly manga magazine aimed at *shōjo*, or a young teenaged female audience.[5] *Wings* specializes in fantastical stories, which often hint at or openly portray romance between male characters for female readers' pleasure. However, when *Alice on Deadlines* came out in 2005, it was published in a magazine, *Monthly Gangan Wing*, aimed at *shōnen*, or young teenage boys (table 1). *Pandora Hearts* and *Alice in Borderland* came out in magazines with a similar focus. 2009's *Are You Alice?* marked a return to the female audience when it was published in *Monthly Comic ZERO-SUM* (*Gekkan comikku ZERO-SUM*), a magazine that focuses on *josei*, or young, female adults. It was followed a year later by *I am Alice*, which ran in a relatively new magazine, Media Factory's *Monthly Comic Gene* (*Gekkan comikku Jīn*). *Monthly Comic Gene* was launched in 2010 aiming to "destroy the concept of shōnen- and shōjo-focused magazines!!" (Media fakutorī).

Analyzing manga magazines' stated intended audience is usually a pointless exercise. The magazines with the highest circulation numbers are all officially *shōnen* magazines, but they are known to have a significant female readership

A Profusion of Alices Flutter through Manga for Girls and Boys 117

(estimates range up to 40 percent). The magazines' supposed audiences are mentioned here to negate a common assumption about Alice in Wonderland and Japanese *Alice* adaptations. Contrary to what one might expect, Alice in Wonderland is not solely part of girls' culture in Japan. Rather than being relegated to a gender-defined box, Alice in Wonderland travels freely across gender and age binaries in the manga magazine world, hearts, cards, frilly skirt, and all. This gender fluidity even extends to Alice herself, as she becomes male and male readers are given a way to become her.

One peculiarity of the male Alice manga as it has developed over the late twentieth and early twenty-first centuries lies in the series' titles. There is a clarity and directness about the title *Boy Alice in Wonderland* that is lacking in earlier male Alice series. *Are You Alice?* also directly addresses both the reader and the (male) protagonist, suggesting that readers might be Alice (or Alice?). *Are You Alice?*'s question was quickly answered by *I Am Alice*, whose title is even more assertive than its English translation suggests. The full Japanese title is *Ore Arisu: Danjo gyakuten*. "*Ore*" does mean "I," but it is a gendered pronoun that is used almost exclusively by men. Moreover, the title does not contain a verb, so a literal (if clunky) translation of the first phrase would look like "I (male) Alice." The effect is similar to that of switching between the words actor and actress. The subtitle, *danjo gyakuten*, is also evocatively ungrammatical. "*Danjo*" means "both genders" or "men and women," while "*gyakuten*" refers to a reversal. Thus, the title simultaneously acknowledges that Alice is female and posits that Alice can also be male (in what would be a reversal of Alice's femininity). One might even say the title argues that Alice exists in multiple—male Alice, female Alice, other Alice? Consequently, male Alice manga implicitly assume that Alice exists in multiple.

Kaori Yuki's *Alice in Murderland*

Kaori Yuki's *Alice in Murderland* (*Kakei no Arisu*, 2014–2018) offers an intriguingly multiplied Alice in a fantastical tale of wealthy children forced to fight each other to the death in order to gain superpowers and succeed their mother as head of the powerful Kuonji family. The story opens as Stella, the protagonist, leaves school to re-enter the vast Kuonji estate for the family's monthly Mad Tea Party in the Red Queen's Hall. Once the party commences, Stella's mother, dressed as a Red Queen chess piece to match her husband's Mad Hatter outfit, announces the battle royal while spouting phrases like "Off with their heads" (Yuki 2015, 1:24). The remainder of the story is largely confined to this estate, which functions as a sort of Wonderland through which Stella moves as she attempts to convince her

118 Chapter 4

parents and siblings to abandon their mad game in an imaginative variation on the chess-based plot progression of *Looking-Glass*. Yet, the new Red Queen's use of classic *Alice* phrases is not a straightforward adaptation of the text. Rather, in this universe, the characters are fully aware of and intentionally cite Lewis Carroll's texts. Thus, Alice is automatically doubled: the Alice in Carroll's books and Stella.

The existence of Carroll's books within Yuki's world creates a sort of musical quality wherein *Alice*'s tropes both harmonize and clash with *Murderland*'s characters. For example, the introduction of one male character denotes him as the manga's version of the White Rabbit by explicitly drawing readers' attention to his white hair, rabbit-like hesitance in emerging out into the open, and of course his name: Tsukito, which literally means "Moon Rabbit." Other characters refer to him consistently as the White Rabbit, until Tsukito openly attempts to aid Stella in battle six volumes later. Then, the Red Queen rebukes him by shifting his Carrollian symbol: "If it isn't the White Rabbit, little Tsukito-kun! Nice work making your way here! You're like Stella's White Knight!" (Yuki 2017, 7:54). By switching Tsukito's Carrollian alignment from the White Rabbit to the hapless White Knight, she insinuates that he has overestimated his abilities . . . and also implicitly threatens him.[6] Tsukito remains a steadfast ally of Stella's and eventually guides her through the Kuonji Murderland much like the White Rabbit guides Alice in Wonderland. Aligning him with the White Rabbit from the beginning foreshadows his eventual role as guide. In contrast, the Red Queen's manipulation of Tsukito's association strikes a discordant note reminding him (and readers) that all of the characters' associations are constructed, and therefore both changeable and potentially misleading.

The deceptive nature of characters' associations in *Alice in Murderland* means that Stella's identification with Alice merits further scrutiny. Like Alice, Stella is a young girl attempting to live logically in an unlogical Wonderland, which she is unable to leave. Stella encounters a variety of characters who are identified with residents of Wonderland, including Tsukito, her mother, her father the Mad Hatter, and her twin brothers (Tweedledee and Tweedledum). In all cases, her relationship with the character in question is roughly in line with Alice's relationship to their counterparts. On multiple occasions, other characters even ostentatiously provide Stella with a costume like Alice's and request that she wear it. Early on, Stella is called "poor little Alice" by one of her brothers, Sid, as he orders her death in a sequence that simultaneously confirms and subverts Stella's identification as Alice (Yuki 2015, 1:44).

Sid Kuonji is the first heir to murder a sibling, which fits with his identification as not an *Alice* character but Jack the Ripper. After he murders Stella's

A Profusion of Alices Flutter through Manga for Girls and Boys 119

beloved brother Zeno in front of her, Sid turns his attention to Stella in a drawn-out sequence where fragments of narrative text float around scenes of violent action. Those fragments begin with an internal monologue describing Stella's distress, but then Stella's perspective disappears in favor of a variation of Carroll's narrative ("Alice found herself falling down a very deep well. She tumbled down and down and down and down . . . so deep and so dark . . ." [Yuki 2015, vol. 1]; figure 4.1). The disappearance of Stella's narration is matched by a change in her illustration. Stella's body is covered in shadow as Alice's story scrolls around panels depicting Stella and Sid. A small doll with rabbit-like ears that Tsukito gave Stella appears and beckons her to a tiny door that recalls the small door in the Hall of Tears in *Alice's Adventures in Wonderland*. The White Rabbit's rabbity doll leading Stella to a small door, Stella's metaphorical fall into despair being encompassed by the narration of Alice's fall into Wonderland, and Sid's outright naming of Stella as Alice all confirm her role as the Alice in Yuki's *Murderland*.

Even as her identification as Alice is confirmed, however, another Alice appears. The text retelling Alice's story crescendos with a full-page band of black in which white text details how Alice cries out, "'I can't stand this any longer!' . . . and plates, dishes, guests, and candles came crashing down together." (Yuki 2015, 1:46). On the other side of that black band, a rejuvenated, blonde "Stella" appears flaunting two guns in an action-heroine-worthy stance as she threatens Sid. Once again, a character knowingly refers to Carroll's oeuvre as Sid points out that "you're blond and blue-eyed now. You're looking like the real Alice, but you're . . . you're . . . looking a lot more insane!" (Yuki 2015, 1:49–50). He suggests that Stella appears more Alice-like physically after the change, but that Stella's mind was more Alice-like beforehand.

As the sequence progresses, Stella appears to have control over her body, though that control is limited by what appears to be rage. This battle-blonde Stella will later be identified as "Bloody Alice." Kuonji family members are revealed to be Bandersnatches, which Yuki describes as a supernatural creature rather like a vampire or witch. As Bandersnatches, each of the potential heirs is inhabited by a larva in possession of special powers. Those larvae, however, were created from the bodies of people who had been forced to fight to the death. Consequently, "Bloody Alice" is not a nickname for Stella, but the actual moniker of a girl who lived nearly a century earlier and shares Stella's body in the present day (at least, when she is not trying to gain complete control over it). Thus, there are three Alices in *Alice in Murderland*: Carroll's Alice, Stella, and Bloody Alice. Further, Bloody Alice lived in assorted previous hosts to whom readers are never introduced but whose certain existence raises the question of whether they too ought to be considered Alices.

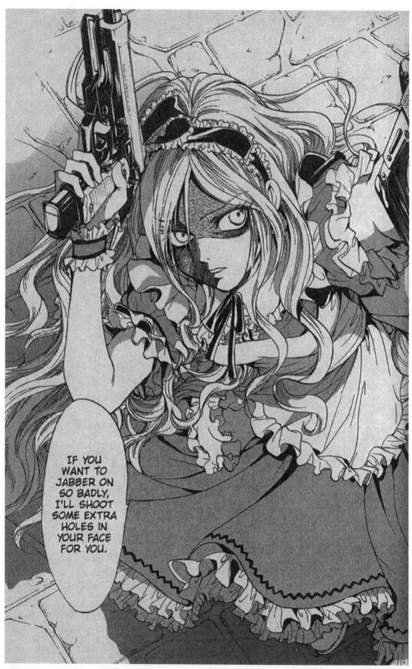

Figure 4.1. Alice's story overlaid in black over Stella's character progression in Kaori Yuki's *Alice in Murderland* (2014).

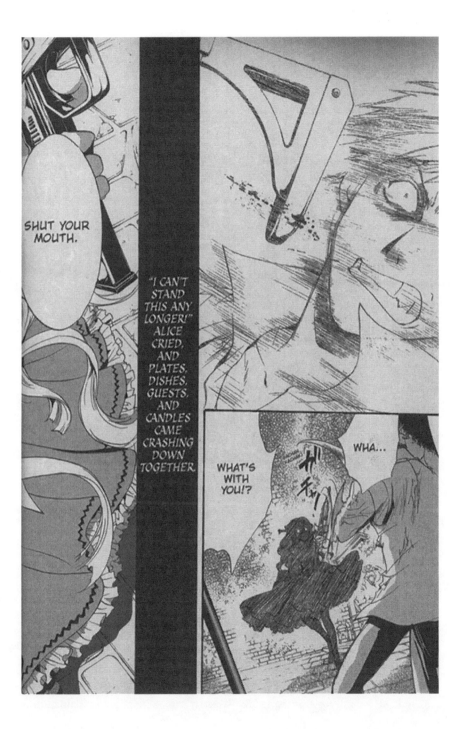

122 Chapter 4

Yuki's multiplication of Alices generates a concomitant multiplication of other Carrollian tropes, as when Bloody Alice traps Stella deep inside her mind and declares, "Welcome to Alice's Wonderland! You idiot!" (Yuki 2017, 7:69). The Kuonji estate may function as Wonderland, but Bloody Alice has her own Wonderland. The greatest multiplication lies in the Cheshire Cat, who initially appears as a decoration above the door to the Red Queen's Hall, only to reappear decorating various other areas, then becomes a character (a Bandersnatch capable of teleportation, naturally), until the story's end, when the Bandersnatch Cheshire Cat helpfully holds an actual Cheshire cat up for readers' approval.[7] The multiplication of Carrollian characters and tropes is enabled by that initial doubling of Alices through the explicit inclusion of Carroll's Alice in Stella's world. Alice is simultaneously a family-oriented Japanese middle schooler, an adventurous character in a series of Victorian novels, and the mystical spirit of a deceased murderer. Connected by their youth, femininity, and the strange Wonderlands through which they have journeyed, these three girls possess equal claim to the name Alice. At the same time, their abiding differences make clear that it is possible for multiples of a character to co-exist.

In *Alice in Murderland*, the multiplicity of other *Alice* characters and tropes combines with *Murderland* characters' shifting Carrollian associations to present a new view of *Alice*'s characters. Characters identify themselves or are identified with Carrollian characters as a way of signaling their personalities and goals, so identifications last only as long as a character's temperament and aims remain the same. The Red Queen warns Tsukito against becoming that incapable daydreamer the White Knight, but Tsukito remains steadfast in his desire to be Stella's guide, the White Rabbit. His steadfastness is recognized in the series' climax when Stella declines to flee to safety if doing so means abandoning Tsukito. As she points out, "You, my White Rabbit, have always been the light on my dark path" (Yuki 2018, 11:147). This explicit use of Carroll's characters to denote Yuki's characters' roles (and desired roles) in life enables the birth of an infinite number of Alices. Moreover, it becomes possible for characters to merge Carrollian tropes to create innovative new identities. Thus, the final volume of *Alice in Murderland* contains a full-color frontispiece featuring Stella in her Alice costume with Bloody Alice's blonde hair and blue eyes, but also in the Red Queen's chess-piece-style hat. As this ensemble indicates, the volume will end with Stella joining forces with Bloody Alice to best the Red Queen, whose place they then jointly take. The final page of the volume features a full-page illustration of the blonde protagonist in a new outfit topped by a new style of crown. The protagonist displaying this new style, created jointly by Stella and Bloody Alice, is perched on a chair in front of a giant portrait of all the Kuonjis, including

A Profusion of Alices Flutter through Manga for Girls and Boys 123

black-haired Stella in her original Alice outfit. The scared Stella from the series' opening has adapted Carroll's characters, including both Alice and the Red Queen, to create a novel and unique role for herself.

Kaori Yuki, *Visual Kei*, and Adaptation in Manga

Alice in Murderland culminated roughly a quarter-century of *Alice* appearances in Kaori Yuki's fictional and nonfiction publications.[8] Her oeuvre has included adaptations of a variety of works over the years, but none have been as prominent, or appeared as consistently, as Alice in Wonderland. Even aside from her fictional adaptations of *Alice*, Yuki regularly writes about *Alice* in artists' columns and afterwords. In fact, Stella's manipulation of Carroll's characters to create what amounts to her public persona as leader of the Kuonji clan mirrors Kaori Yuki's own use of *Alice* to build her career.

Before her professional career began, Kaori Yuki created and sold *dōjinshi*, or amateur publications, under the pen name Gemsilica in the 1980s. *Dōjinshi* are big business in Japan, and the market reached its zenith in the decade of Yuki's debut.[9] "*Dōjinshi*" is a fairly wide-ranging term that includes comics, fiction, illustrations, and other materials. The bulk of *dōjinshi* consists of fanfiction, or comics and stories created about an existing commodity. As the name suggests, fanfiction are created by fans rather than professionals and have no connection with the official commodity that is adapted within the *dōjinshi*.[10] Some of the adapted works are recent, such as anime and video games. At other times, *dōjinshi* artists adapt older sources, as when the *dōjinshi* artist Golduhr merged *Alice* with the jester tradition to create *Alice in Narrlant: Alice in Annoying-land* (*Alice in Narrlant otodoke no kuni no Arisu*, 2019). Most commonly, these *dōjinshi* tell romances wherein characters who are not romantically tied in the film, television series, or other work that the *dōjinshi* artist is adapting nonetheless fall in love. Artists are thus able to draw on a pre-existing world—including its characters, settings, technologies, and so forth, which means that creators only need to develop a story, dialogue, and art to craft the content of a *dōjinshi*.

Once a story is drawn, *dōjinshi* artists must take on the duties of a publisher, advertiser, and distributor to get it to market. The former is a relatively simple matter, but the latter two involve a lot of time, effort, and expertise.[11] *Dōjinshi* are primarily distributed through specialized conventions where a *dōjinshi* artist pays for a table and then sells her works directly to consumers. Financial pressures from below (production and distribution costs) and above (copyright holders) push artists to create *dōjinshi* that will be bought in consistent, and thus

124 Chapter 4

foreseeable, numbers. The easiest way to do this is for an artist to develop a brand or artistic persona.

Yuki's brand developed in concert with a style of Japanese music known as *visual kei*. Musically, *visual kei* incorporates a variety of genres, though the majority of early acts fell into a metal/rock/punk spectrum that stood in contrast to the clean-cut idol singers who dominated mainstream Japanese popular music in the 1980s and 1990s. *Visual kei* artists are connected less through their generic choices and more through their spectacular approach to performance. Bands like X-Japan and Buck-Tick don massive, multicolored wigs, neo-Victorian black and red outfits, and dramatic eye makeup in a Japanese variant on glam rock acts like David Bowie and Kiss. To attend a *visual kei* concert is to engage in an overwhelming, multisensory experience whose constructed nature is made apparent to audiences. For instance, audiences are fully aware that Gackt, one-time lead singer of *visual kei* band Malice Mizer, is not in fact a vampire born in the year 1540 as he once claimed. That claim is merely one piece of an extended performance of extremely decorative fantasy that played out across Malice Mizer's concerts, short films, and publicity appearances. *Visual kei* performers danced on the fringes of socially acceptable behavior through their lyrics in addition to their performances, as when X-Japan threatened a woman with a murder-suicide in the English-language song "I'll Kill You" (1985). The artists merged edgy lyrics and titles with an equally aggressive focus on visual pleasure as conveyed through explicit artifice.

Yuki built her brand in part through *visual kei* in her early years. She used *visual kei* band members as models for her male characters, for example. Using real people as models offered a crutch for the budding artist, but Yuki was also tying her work to the *visual kei* subculture. She acknowledged her unaware models by name in artist's columns and afterwords alongside discussions of the music she had enjoyed while drawing. Some of her first professional manga featured protagonists and love interests who worked in Japanese media industries, including multiple *visual kei* band members. By the mid-1990s, she had moved away from both *visual kei* character models and the Japanese music industry setting, but even today Yuki uses artists' columns to contextualize her manga within networks of other media.

Yuki's explicit use of *visual kei* served two key purposes. First, it built her brand, which is encapsulated in the title of her second professional volume, *Cruel Fairytales* (*Zankoku na dōwatachi*, 1993). A Kaori Yuki manga adapts foreign characters, locales, and narratives into dark and twisted stories whose outré contents are leavened by discordantly attractive artwork. *Visual kei* artists also relate violently dramatic tales set in a fantasy world full of extreme visual spectacle that

A Profusion of Alices Flutter through Manga for Girls and Boys 125

adapts European (and in particular Victorian) culture to fit turn-of-the-millennium Japanese youth tastes, so by pointing her readers to *visual kei*, the budding artist was able to conflate *visual kei*'s reputation with her own. Yuki's illustrations of *visual kei* performers in *visual kei*-esque settings bordered by nondiegetic lists of *visual kei* bands and related cultural touchstones seem to call out, "If you like *visual kei* music, here it is in manga form." Consequently, explicit references to *visual kei* faded from Yuki's work once she made a name for herself in her own right.

The second reason Yuki leaned on *visual kei* early in her career is that it aided her artistic development. *Dōjinshi* artists take on more aspects of manga production than professional manga artists do, but they are in turn artistically free in ways that professional artists are not. For example, where Kaori Yuki freely used real people as character models early in her career, simply redrawing a photograph of a real person can be considered plagiarism for a professional manga artist in Japan. Manga artists, and in particular female manga artists, can face extreme consequences for plagiarism. When Yuki Suetsugu was discovered to have copied basketball scenes from Takehiko Inoue's *Slam Dunk* in her drama *Flower of Eden* in 2005, the publisher halted distribution of *Flower of Eden* and canceled Suetsugu's then-ongoing series *Silver* (Macdonald 2005a). Despite a prompt public apology, she could not publish another manga professionally for two years. In 2009, Suetsugu's editor appeared in Suetsugu's place when she won a major award for her new series *Chihayafuru*. When a reporter asked about her absence, the response was: "There is the matter of the error committed in the past, and I am still not the kind of person who should appear in this sort of place. I can only repay it by dedicating myself to my manga" (in Natalie 2009). Suetsugu's pre-2007 works remain out of print today. The impact of a plagiarism accusation is not always this extreme—Takehiko Inoue himself was accused of copying NBA players' photographs without facing any apparent consequences (Macdonald 2005b)—but professional manga artists are generally held to a higher standard of originality than is imposed on *dōjinshi* artists. Yuki consequently moved away from modeling her characters on *visual kei* artists and other real people after she became a professional artist.

While plagiarism is not condoned within the manga industry, nonplagiarizing adaptations—homages, retellings of classic literature, and histories or historical fiction—are not only accepted but a vital source of material. Manga functions in Japanese culture much as literature or film do in the United States. It is a medium in which creators package their creations. The content of those creations ranges from nonfiction to fiction, history to future, real world to wild fantasy. All three media are produced by industries whose needs and practices

126 Chapter 4

govern what gets published. Adaptation thus works slightly different in each medium.

Creators adapt for four main reasons: cultural, personal, political, and economic (Hutcheon 2013, 86–95). Because the arts tend to be organized into a hierarchy of more- and less-respected media, a creator working in a less highly regarded medium can "gain respectability or increase cultural capital" by adapting a work from a revered medium (Hutcheon 2013, 91). When film began to make the switch from a weird new technology to a storytelling medium, for example, filmmakers adapted respected plays to prove that the new medium had cultural value.[12] This holds true for manga to an extent, but its impact is lessened by the fact that manga are a much more prominent industry in Japan than comics are in America. The Japanese manga market sold US\$3.96 billion of manga to roughly 125 million people in 2018 (Sherman 2019), while the American literature publishing market sold just under \$5 billion of non-comics ***material to 330 million people.[13] In other words, the manga industry is roughly 80 percent the size of the American non-comics publishing industry despite having less than half as many consumers. Manga are a regular part of Japanese readers' lives and have been for decades. Consequently, manga are themselves a source of cultural value. Manga's cultural power is best exhibited by Naoki Urasawa's award-winning series *Pluto* (*Purūtō*, 2003–2009), which adapts Osamu Tezuka's earlier *Astro Boy* (1952–1968). Manga adaptations may confer cultural power on an artist struggling to build her reputation, but only to a limited degree.

Aside from a cultural impetus, an artist might be personally or politically motivated to adapt something. An artist may intentionally create an homage to something, or they might simply happen to find another work useful. Yū Watase's *Alice the 19th* (*Arisu 19th*, 2001–2003) manga falls into the latter group. Watase describes her adaptation of *Alice* as almost haphazard: "I've never created a rabbit character before, because they are simply cute. The protagonist too, somehow before I noticed was 'Alice.' I thought of hanging the series' concept on Alice in Wonderland, and it was like, 'Oh, that's it'" (2001, 105). Other adapters update older works to match contemporary mores and interests, as when Waki Yamato adapted the classic novel *The Tale of Genji* (Murasaki Shikibu, c. eleventh century) in the popular series *Asaki Yume Mishi* (1980–1993). Yamato focused on the title character's romances in the midst of a contemporary "trend to dwell on Genji's youthful affairs" (Chance 2011, 47). Regardless, manga artists are affected by personal and political motivations just as artists in other media are.

The final impetus to adapt, economic considerations, stems from the fact that adaptations have built-in brand awareness, which is to say that potential consumers already know about the work and even whether they might enjoy a new

version of it. Publishers, film studios, and other companies can sell a product with brand awareness more easily, so are more likely to fund works that have it. This is particularly true for "expensive collaborative art forms like operas, musicals, and films" where production companies will need to make massive amounts of money just to recoup their production costs (Hutcheon 2013, 87). Manga is not an expensive collaborative art form.[14] Brand awareness is less important for a proposed manga because even a modest film or opera budget greatly exceeds the amount of money necessary to create a manga. At the same time, an artist like Yuki can build her own brand awareness, which can then generate sales for her books. There is one exception to this rule: manga artists sometimes adapt each other's manga on special occasions. For example, Kaori Yuki was one of fifteen artists to adapt Hitoshi Iwaaki's *Parasyte* (*Kiseijū*, 1988–1995) for the tribute anthology *Neo Parasyte f* (2015, English translation 2016). *Neo Parasyte f* both celebrated Iwaaki's long-running series and advertised an upcoming anime adaptation.

The four incentives to adapt can be divided into two categories: those stemming from artists and those imposed on artists. An artist's political or personal goals are just as important in manga production as in other media industries. However, cultural gatekeepers and publishers pressure manga artists to adapt less than they do artists working in other, more expensive media. This lack of structural forces pushing manga artists to adapt has had the odd effect of freeing those same artists to adapt wildly. Mikiyo Tsuda's adaptation of *Alice* into a single illustration of *Princess Princess* and Golduhr's creation of a *dōjinshi* melding *Alice* with the jesting tradition are evidence of a wild freedom extending across the amateur and professional manga industries. Kaori Yuki's *Neo Parasyte f* chapter adapts the Parasyte world, but it also adapts *Alice* into a story about a girl who throws things down a seemingly bottomless hole. If a film is funded because it is an adaptation of Alice in Wonderland, it must be recognizable as *Alice* to as many potential audience members as possible. It must be obviously *Alice*, overtly *Alice*—entirely *Alice*—to work as an adaptation. Likewise, if a filmmaker is adapting a work to borrow some of its cultural repute, that filmmaker is unlikely to muddy the waters by adapting other works. Not only are manga artists free from these concerns, but the serialized nature of their work encourages artists to adapt a variety of works into a single manga. This "malleability" is a characteristic of the manga medium (Penney 2012, 146). Manga artists merge genres and adapt promiscuously, while readers in turn consume the same manga for diverse reasons. For example, some readers will study Shigeru Mizuki's *Showa: A History of Japan* (*Komikku Shōwa-shi*, 1988–1989) for its well-researched history of the Shōwa period of Japanese history, while others will enjoy it as the

128 Chapter 4

autobiography of the beloved manga artist who created it. Manga's malleability allows Tsuda's cover illustration to simultaneously be *Alice* and *Princess Princess*, while Golduhr's slim volume is concomitantly about *Alice* and jesters and Yuki's chapter is both *Alice* and *Parasyte*.

Manga's malleability is revealed in characters that simultaneously serve a variety of readerly needs. Adaptations are a perfect example of manga's malleability, as when Osamu Akimoto celebrated the thirtieth anniversary of his everyday comedy series *This Is the Police Station in Front of Kameari Park in Katsushika Ward* (*Kochira Katsushikaku Kameari Kōen mae hashutsujo*, 1976–2016) with a series of crossover stories that adapted characters from the popular manga *Dragon Ball* and *Lupin III*. Neither the superpowered alien fighters of *Dragon Ball* nor the fantastical superthieves of *Lupin III* fit in with Akimoto's normal world of comically average police officers. Nonetheless, the special series shows readers what would happen if Akimoto's characters lived in a more fantastical world. Having depicted that congruence, the series returned to its normal status quo after the special series' completion. Akimoto's crossover series is a high-profile example of a quotidian aspect of manga: flexibility. Tsuda's brief, if revealing, adaptation of *Alice* and Akimoto's comparatively extended adaptation of assorted other series make apparent manga's regular, matter-of-fact adaptation of other sources.

CLAMP, Kaori Yuki, and Iterating *Alice*

Kaori Yuki's early works leaned heavily on *visual kei* as an aesthetic and as source material to bridge the distance between the artistic skills required of a *dōjinshi* artist and a manga artist. Over time, she gained the skill necessary to create wholly original character designs and imaginative worlds like a gothic Victorian England where people can be raised from the dead and a fantastical modern-day Japan populated by vampiric Bandersnatches. Drawing on manga's malleability, Yuki repeatedly adapts *Alice* into her disparate worlds.

Yuki is not the only manga artist to adapt *Alice* repeatedly. Best-selling manga collective CLAMP, which also started out as *dōjinshi* artists in the 1980s, used *Alice* to meld their various manga series into a massive, multidimensional world that they call the "CLAMP Universe" (*CLAMP School Detectives* 2: 201). The CLAMP Universe contains all of CLAMP's manga, and it is linked together by *Alice*. CLAMP's *Miyuki-chan in Wonderland* (*Fushigi no kuni no Miyukichan*, 1993–1995) is an *Alice* parody wherein a teenager named Miyuki falls into a variety of Wonderlands, some of which are actually the worlds of other CLAMP manga. Miyuki appears within the pages of several CLAMP manga, as well as in

A Profusion of Alices Flutter through Manga for Girls and Boys 129

a pair of music videos that feature characters from other CLAMP manga. Miyuki's presence, coupled with her ability to move from one world to another with ease, effectively greases the wheels for CLAMP as they attempt to combine ancient Hindu gods with twenty-first-century androids and characters from other, equally incongruous, manga. *Alice* is not the only bridge linking the various manga of the CLAMP Universe, but it, and in particular its protagonist's noted liminality, provided a vital key to the Universe's creation.

Alice plays an entirely different role in Yuki's manga. While CLAMP uses *Alice* to link disparate worlds, Yuki forms *Alice* into distinctly different worlds in what I call iterative storytelling.[15] Yuki's iterative storytelling involves adapting a given story multiple times, with each adaptation tackling the material in such a novel way that any given adaptation is incompatible with the others.[16] Yuki is not the only artist to engage in this practice. Manga artist Sakura Kinoshita, for example, sent the Norse god Loki chasing through a nighttime Wonderland after the stolen moon in chapter 9 of *The Mythical Detective Loki Ragnarok* (2005), then adapted *Alice's Adventures* into a full-color, oversize manga in 2006. However, Yuki has based her brand and career on this strategy.

To understand *Alice's* iteration within Yuki's manga, one must first understand just how pervasive *Alice* is in Yuki's oeuvre. In addition to *Alice in Murderland*, Yuki adapted *Alice* in her breakthrough Count Cain series, which itself includes five manga series (1992–2004), the five-volume *Grand Guignol Orchestra* (*Ginyōru kyūtei gakudan*, 2008–2010), and her twenty-volume masterwork *Angel Sanctuary* (*Tenshi kinryōku*, 1994–2000).[17] *Alice* appears in one-shot stories like "Camelot Garden" ("Kyamerotto gāden," 2008), "Backstage Mage" ("Butaiura no majutsushi," 1991), and of course, her contribution to *Neo Parasyte f*. Yuki has repeatedly cited and outright illustrated *Alice* in artist's columns and afterwords, as well as on her blog. She even created an *Alice* calendar as her graduation project; it was reprinted in one of the two *Angel Sanctuary* artbooks and has been made available for sale at Alice's Shop, an *Alice*-themed gift shop in Oxford, England.[18]

Yuki's iterative storytelling consists of two steps, both of which can be seen in the various Count Cain manga series.[19] First, she selects specific aspects of a pre-existing world to adapt into a cohesive, detailed world of her own. The Count Cain series follows the titular young Englishman with a penchant for poisons as he solves mysteries in a somewhat fantastical Victorian England. Ranging from Jack the Ripper to *Japonisme*, spiritualism to Alice in Wonderland, Count Cain manga relay multilayered tales adapted from the news items and fictional works that circulated in England during Queen Victoria's reign. *Alice's* first explicit appearance in a Count Cain work is a brief reference in a strange poem Yuki

130 Chapter 4

composed for her afterword to the first volume of *The Seal of the Red Ram* (*Akai hitsuji no inshō*, two volumes, 1994). The following volume concludes with the story "Elizabeth in the Mirror" ("Kagami no naka no Erizabesu"), wherein Cain attempts to aid a pair of twins who are both named Elizabeth. One twin explicitly invokes *Alice* to describe her thoughts: "I wish I could enter the mirror one day and play with Beth there like Alice in Wonderland" (2007, 5: 176); "Now that my hands are stained with blood, I won't be able to return to my Wonderland again" (2007, 5: 187). *Alice* is adapted alongside *Snow White* and *Cinderella* in this story. Specifically, Yuki adapts those sections of each story that suggest a lost girl in need of rescue. In consequence, the protagonist who attempts to rescue the lost girl appears necessary and heroic despite the fact that he ultimately leaves a pile of bodies in his wake while failing to save anyone. Cain's uselessness is foreshadowed in the title's parallel of the Japanese title of *Through the Looking-Glass, and What Alice Found There*. The title of Carroll's book is commonly translated as *Kagami no kuni no Arisu* (lit. Mirror's Land's Alice). In Japanese, "Elizabeth in the Mirror" is "*Kagami no naka no Erizabesu*" ("Mirror's Middle's Elizabeth"). Yuki's substitution of "middle" for "land" signals that Elizabeth will never leave the mirror. Unlike Alice, who travelled into and back out of another land through a mirror, the "Elizabeth" in the mirror is only the reflection of the sole surviving twin. Yuki draws only on those aspects of the *Alice* books that support a tale about a lost girl in "Elizabeth in the Mirror."

The second step of Yuki's iterative storytelling involves adapting the exact same work in a new way in a new manga. After completing *The Seal of the Red Ram* with the "Elizabeth in the Mirror" story, Yuki turned to another series, *Angel Sanctuary*. She returned to Count Cain several years later with a story, "Mad Tea Party," that adapts *Alice* in an entirely different way. This tale follows Cain's investigation of the decapitation of two girls named Lorina and Edith by a man wearing a mask in the shape of a white rabbit. In addition to the White Rabbit and Mad Tea Party references, Lorina, Edith, and their friend Alice are all named after the three Liddell sisters to whom Lewis Carroll originally told the story of *Alice*. Yuki's adaptation of the Liddell's sisters' names subtly connects the three characters in question, while simultaneously separating them from the fourth member of their friend group, the imperious Victoria. At the story's denouement, Cain reveals that Victoria and Lorina argued so heatedly at a tea party that Victoria, in a fit of madness, stabbed Lorina in the neck. Victoria's obsessive father hypnotized the other two girls into temporarily forgetting the incident and adopted the White Rabbit persona to hide Lorina's body. Because the two other girls' memories would eventually return, he donned the White Rabbit costume again to kill them. A flurry of other elements of *Alice* appear in

the story, including Tenniel-style portraits of various characters and quotations from the text, but all of the aspects of *Alice* used in this Count Cain story support a narrative of three girls whose attendance at a mad tea party led a queen's faithful white rabbit to fulfill the queen's aborted desire to remove their heads. There are no lost girls in this tale, which is set exclusively in Victoria's family home.

Yuki adapts different aspects of *Alice* in "Elizabeth in the Mirror" and "Mad Tea Party." The former focuses on the Looking-Glass and Alice's search for a way home, while the latter centers on the concept of a Mad Tea Party and the Liddell sisters. Even when there is apparent overlap, differences arise upon close consideration. Specifically, the name Alice appears in both stories, yet denotes different Alices. When Elizabeth wishes that she could be like Alice in Wonderland, she is clearly citing a book that she has read. On the other hand, the inclusion of Lorina and Edith in "Mad Tea Party"—combined with an artist's column where Yuki explains who Lorina, Edith, and Alice Liddell were—ensures that that story's "Alice" refers not to a character in the book, but the real Victorian girl who inspired it.

Yuki's iterative storytelling is possible because of the malleability of manga and the lack of cultural and economic pressures on manga artists to adapt. With no pressure to present a single, definitive *Alice* manga, Yuki is free to draw on *Alice* when and how she chooses. Furthermore, the malleability of manga allows the simultaneous adaptation of multiple works in a single manga, which in turn allowed Yuki to build her cruel fairytale brand quickly. Finally, because Yuki focuses on adapting specific aspects of a given work rather than retelling its overall story, she is able to adapt works incessantly whilst creating novel stories.

Malleable Manga and the Allusive Adaptation

Five years after *Godchild* ended and six years before *Alice in Murderland* began, Kaori Yuki began a series set in a vaguely French land where neither Lewis Carroll nor his novels seem to exist. *Grand Guignol Orchestra* initially appeared to be a simple, French(-ish) expansion of Yuki's twisted fairytale brand. A beautiful trio travels through a post-apocalyptic world to rid it of zombies with their magical music. The French ballet *Coppelia*, cited on the series' first page, adds some exotic beauty to the manga's zombies. Yuki further draws on European culture to name the disease turning people into zombies Galatea Syndrome after the doll that Pygmalion brought to life. *Grand Guignol Orchestra*'s zombies are called dolls and drawn like ball-jointed dolls. (They do try to eat people like normal zombies though.) The series' title underlines the doll conceit by referring to a traditional French puppet, Guignol. This remixed trio of classic European works and art forms provides a strikingly original take on dolls with nary an Alice in sight.

132 Chapter 4

In addition to classic European dolls and puppets, *Grand Guignol Orchestra*'s world is also marked by geologic features. When a character falls ill with Galatea syndrome, her body hardens and is marked by cracks like those that might appear in a mountain face as tectonic plates shift below it. Major characters are named after semiprecious stones like Celestite, Spinel, and Heliodor, while the titular Grand Guignol Orchestra performs with a piano made out of crystal.

Grand Guignol Orchestra's gem-characters, zombies, and explicit references to European doll culture encapsulate Yuki's brand of beauty, horror, and exotica. Yet, viewing the series as one iteration of Yuki's storytelling reveals much greater depth to the story. The prominent role of gems and other geologic features represents the reiteration of Yuki's old *dōjinshi nom de plume*, Gemsilica. Gem silica is a rare variety of blue chalcedony foreign to Japan that is one of the more highly valued quartzes (Admin 2019; King 2020). Using a blatantly false name that evoked a rare, eye-catching, foreign gemstone supported the amateur artist's burgeoning brand of exotic material transformed into darkly beautiful new fantasies while also aligning with *visual kei*'s emphasis on blatant artistry. Yuki switched to the Kaori Yuki name upon turning professional and Gemsilica disappeared . . . until *Grand Guignol Orchestra*.

The Grand Guignol Orchestra works for a queen named Gemsilica, who is also one of the series' antagonists. Where the queen is depicted confined within her castle, the Orchestra moves freely across the post-apocalyptic landscape—except when directed by the queen. Yuki's portrayal of characters forced to act against their will by a distant person named after Yuki herself might suggest a metacommentary on the role of creators over their creations. Yuki's use of the Gemsilica name, and its application to a figure of authority in the manga, certainly lend themselves to this interpretation. However, by the end of the series the idea of Gemsilica as a powerful antagonist will dissipate like an early morning fog, taking any such potential interpretations with it.

Queen Gemsilica is introduced slowly in *Grand Guignol Orchestra*. She initially appears in a series of inset images depicting the memories of Lucille, the head of the Orchestra. These shadowed ultra closeups of a nameless woman are accompanied by vaguely ominous phrases that hint at an overarching story, which will play out across the series. Around these slices of Lucille's memories, other characters refer to a Queen Gemsilica. The scattered visual and textual fragments come together at the end of the first volume. The protagonists are informed that "divine lightning" is about to strike the city they are in, with the warning, "Trespassers against the royal court! Know the wrath of Queen Gemsilica!" (Yuki 2009, 1: 197–198). The Orchestra flees, and Lucille reveals a hidden rage aimed at the queen. The page turns, and a full-page spread reveals the sinister Gemsilica in a neat positioning of the queen as the series' antagonist (figure 4.2).

A Profusion of Alices Flutter through Manga for Girls and Boys 133

Figure 4.2. On Queen Gemsilica's first appearance in Kaori Yuki's *Grand Guignol Orchestra* (2008–2010), the character herself lacks detail, but she is surrounded by neatly delineated Alice motifs.

Gemsilica's arrival adds a new, Carrollian layer to Yuki's Euro-doll-gem-music-self-referencing cocktail. The queen is centered on the page, sitting in a massive heart-shaped throne. The throne rests on a circular stage with a central staircase. Queen, throne, and steps are all depicted in shadow, which emphasizes the shapes within the image. A vast window with clock face–like metal detailing

134 Chapter 4

frames the throne. The edge of the stage is lined with unusually large chess pieces, two of which closely resemble John Tenniel's illustrations of the White and Red Queens in *Looking-Glass*. This dramatic image from an artist who has adapted *Alice* over and over again subtly equates Gemsilica with the Queen of Hearts.[20] The heart shape of the throne, the chess pieces, and the clock face are all classic *Alice* symbols that characterize the queen even as Yuki denies readers a clear view of her face. In other words, the shadows covering Gemsilica force readers to pay closer attention to the forms around her—heart, chess, clock—which clue astute readers in to the fact that Gemsilica should be seen as the Queen of Hearts.

As the manga continues, an eternally smiling man in a top hat, Cookeite, appears carrying a tea service. Just as the heart-shaped throne and chess pieces subtly suggest that Gemsilica should be seen as the Queen of Hearts, the top hat, tea service, and queer equanimity of Cookeite implicitly equate him to the Mad Hatter. This muted symbolism foreshadows the final twist of Yuki's tale: Gemsilica is not a person, but the ghost of a long-dead queen forced to possess Lucille's sister Cordierite by Cookeite, a mad, ancient king who is obsessed with Gemsilica.

This story—the Mad Hatter's attempt to dominate a Queen of Hearts who does not even exist anymore—will not play out until the series' final chapter. Intervening volumes provide an alternate set of *Alice* symbols that equate the Orchestra's head, Lucille, with the Mad Hatter. Though it is not the most famous aspect of the character, the Mad Hatter is associated with singing: he sings so atrociously before the Queen of Hearts that she accuses him of murdering the time, which angers Time into ensuring that it is always 6:00 p.m., that is, teatime, for the Hatter. Flashbacks in *Grand Guignol Orchestra* reveal that when the mad queen Gemsilica accidentally transformed some of her soldiers into guignols, Lucille sang them to death and was duly banished in an echo of the Mad Hatter's own banishment by the Queen of Hearts. Further, Lucille does not age, which is to say that Time stands still for him. Less important but still worth noting is Lucille's fondness for hats, and in particular, top hats.

While Yuki symbolically builds twin Hatters, she also remakes Gemsilica's symbolism. The text explains that Gemsilica is an ancient queen whose spirit is possessing Lucille's sister Cordierite, but the accompanying images of young Cordierite make clear that her appearance originally differed significantly from Gemsilica's mien. Gemsilica is drawn in Yuki's normal style with long, flowing hair and extravagant, sexualized dresses (figure 4.3a). Cordierite, however, is clearly modelled on the character of Anne from *Anne of Green Gables* as depicted in the famed 1979 anime adaptation directed by Isao Takahata. Her wardrobe

Figure 4.3. (a) Gemsilica's later appearance is marked by sumptuous detail from the braids looped over the buns of her half-updo hairstyle to the varied patterns on her layered outfit. (b) In contrast, Cordierite's freckled face, pigtails, and homely outfit align her with the famously plain heroine of *Anne of Green Gables* and the humble farm girl Dorothy from *The Wonderful Wizard of Oz*.

136 Chapter 4

includes multiple outfits that alternately reflect the costumes of Anne and Doro-thy from another older anime series, *The Wizard of Oz* (dir. Masaru Tonogawa-chi and Hiroshi Saitō, 1986–1987). A freckled girl with reddish-brown hair in ungainly pigtails and a plain dress, Cordierite looks wildly out of place in the sparkling palace of the queen of a gem-filled musical Wonderland (figure 4.3b).

The obvious inappropriateness of Anne consorting with Wonderland's resi-dents rather than her fellow Canadians launches the story's climax. Sexy, dra-matic Gemsilica is betrayed by plain Anne when Cordierite prevents her from destroying the world. Cookeite responds to Cordierite's failure to be the true Queen (of Hearts) by killing her so that he can try to revivify Gemsilica anew. That leaves the two Mad Hatters, Cookeite and Lucille, locked in battle for the fate of the world, a bleak, Alice-less Wonderland. One hatter wants a dark, Off With Their Heads! Wonderland while the other prefers a gentle Wonderland where older brothers come to their younger sisters' aid. Regardless, this Alice in Wonderland ends without an Alice.

Kaori Yuki exploits manga's malleability to adapt different aspects of *Alice* into a diverse body of manga that tackle different themes, worlds, characters, and stories. *Grand Guignol Orchestra*'s absent Alice contrasts with *Alice in Murder-land*'s plethora of Alices. Count Cain's Elizabeths are doomed by a mirror that cannot connect to Wonderland, while a Mad Tea Party attendee is saved by the name of Alice's real-world inspiration. Yuki's manga flutter between diegetic and nondiegetic adaptations of *Alice*, and she explicitly identifies her myriad adapta-tions to readers on the off-chance we are slow to notice her virtuosic sculpting of *Alice*'s material. Each of her manga clearly constitutes an adaptation of *Alice*, and yet they vary.[21]

At the same time, numerous other works must be introduced to analyze any of these manga. Fantasies like *The Wizard of Oz*, fairy tales like *Snow White* and *Cinderella*, elite works of art such as *Coppelia*, popular entertainments like the guignol theater, historical personages like Queen Victoria and Jack the Ripper—even the self-referential Queen Gemsilica must be traced back to another context to fully understand *Grand Guignol Orchestra*. Yuki-style iterative storytelling works in part because she repeatedly adapts a core set of worlds within her oeu-vre. *Alice* is by far the most prominent, but Jack the Ripper, Gemsilica, and *Sleep-ing Beauty* also appear in multiple Yuki manga. This re-iteration constructs a sort of evolving canon of cultural references, the full context of which can be invoked with ease, as one would expect of any member of Japanese girl culture.

A name here, a quotation there. Traditionally, adaptation theorists have cau-tioned against treating limited citations of other works as adaptations. There is good reason to draw that distinction. However, the *Alice* manga described here

A Profusion of Alices Flutter through Manga for Girls and Boys 137

show that in skilled hands a mere ribbon of information can prompt readers to remember the entirety of the *Alice* world and meld the relevant aspects of that world with a manga artist's own creations to generate a unique, layered whole. *Alice* particularly lends itself to this sort of adaptation because the world essentially is *hirahira:* both here and there, both logical and mad, both dangerous and safe. *Alice* epitomizes the indistinct existence of a fluttering ribbon. Yuki's legion of distinct *Alice* manga are so effective because she merges *hirahira'*s present absence with Alice's absent presence. Yuki includes just enough material that is recognizably *Alice* to prompt readers to recognize her manga as an *Alice* adaptation without carrying over so much information that her manga become repetitive. Yuki's army of *Alice* manga is impressive, yet the technique she uses is apparent in other artists' *Alice* manga as well. Though the cover image that opened this chapter seems to be the only appearance of *Alice* in Mikiyo Tsuda's Princess Princess world, it also constitutes a calculated adaptation of just enough—but not too much—*Alice* to end Tsuda's carefully gender-balanced world solidly in the realm of girls' culture.

CHAPTER 5

Detecting Alice *on Page, Screen, and Street*

The early chapters of this book analyzed specific adaptations of *Alice* to draw conclusions about the nature of *Alice* and the Japanese media environment. This chapter attempts the reverse by taking as its starting point the mystery genre as it has developed across Japanese media. Mysteries and *Alice* were introduced to Japan within decades of each other. Since then, the two have intersected over and over again as they both moved beyond the pages of prose fiction to proliferate across media. Japanese translations of *Alice* surged in the 1950s as Japan recovered from the devastation of World War II, and Japanese *Alice* scholarship and fine art boomed in the 1970s amid a wave of overlapping vogues for surrealism, structuralism, and semiotics. However, *Alice* truly came into its own as far as Japanese popular culture is concerned only in the 1980s. *Alice* owes its current omnipresence to changes that crystallized in and around the 1980s on an industrial level. In this chapter, I sketch the development of the mystery genre over the course of the twentieth and twenty-first centuries to show how *Alice* fit into the evolving needs and affordances of both the mystery genre and Japan's media environment. This sketch is hardly comprehensive, as I track issues that are relevant to *Alice* at the expense of those that are not. *Alice* mysteries in a variety of media show a qualitative shift in how media were produced around the 1980s, the effects of which we are just beginning to understand today. *Alice*'s liminality is eminently suited for this new, twenty-first-century media environment, which is why it so dominates other artistic worlds (foreign and domestic) in Japan today.

By mystery, I refer to what is more properly called detective fiction, or fabricated tales wherein a detective investigates a crime and ultimately discovers who committed it. These mysteries epitomize liminality because they are based on the simultaneous truth of two contradictory facts: that the criminal is unknown, and that they are always already known. The revelation of the central mystery of any work of detective fiction is in fact a *fait accompli* laid down long before the first consumer buys the book depicting it. A bored mystery reader can flip to the end of a book at any time to read the detective's succinct exposition of events.

138

Detecting *Alice* on Page, Screen, and Street 139

Even the genre's method of indicating a mystery's solution—the term "whodunit"—indicates its permanent state of transition between known and unknown.[1] We know that someone committed a crime, but we can only indicate that person through a noun that fails to identify her. We do not dare to call her a criminal because we do not fully understand the nature of the crime or even whether whatever she did *was* a crime. This liminality, this vibrato between known and unknown, guilt and innocence, forms the foundation of detective fiction.

Alice has proven fertile ground for mystery writers across the world. Authors often draw on a mix of *Alice*'s cultural imprimatur, liminality, and iconography to energize or distinguish their mysteries. The grande dame of the genre, Agatha Christie, repeatedly tied her peppy sleuth Tuppence Beresford to *Alice*. Her brilliant compatriot Dorothy Sayers likewise introduced *Alice* into two novels and assorted short stories, while *Alice* was adapted more briefly by an array of other prominent British authors, including M. C. Beaton, Nicholas Blake, and Gladys Mitchell. Best-selling *Alice*-adapting American writers of a murderous bent include Ellery Queen, Joan Hess, and Joanne Fluke. *Alice* mysteries have been televised on both sides of the pond through shows like *Inspector Morse* (1987–2000), *Lewis* (2006–2015), *NCIS: New Orleans* (2014–2021), and *Death in Paradise* (2011–present).

The strong ties between the mystery genre and *Alice* make it no surprise that Japanese mystery writers, who are extremely conversant in the global mystery tradition, have also adapted *Alice*. The mystery is one of modern Japanese literature's most popular genres, but its development has taken several twists and turns. In consequence, mystery scholar Sari Kawana declares that "the genre itself has defied rigid categorization and resisted strict definition" (2008, 1). Japanese mysteries have at times strongly resembled grotesqueries or science fiction more than stories of crime and detection. Crimes have of course been recounted within Japanese fiction for centuries, but today's mystery genre of fictional detection stories dates to the latter half of the nineteenth century.

Mysteries Come to Japan

The Japanese mystery genre was formed in direct response to the mass importation of foreign culture, including mystery fiction, that followed the mid-nineteenth-century opening of Japan's borders to wider trade. Mysteries and *Alice* consequently arrived in Japan within a few short decades of each other. Mysteries initially appealed to Japanese authors because their focus on reasoning reflected the ideals that swept through Japanese government and society as it

140 Chapter 5

opened its borders (Kawana 2008, 7). The genre's emphasis of logic and justice particularly appealed to the journalist and novelist Ruikō Kuroiwa (1862–1920), whose translated and original mysteries were the basis of the first mystery boom in Japan. Unfortunately, the genre atrophied when Ruikō abandoned it for political journalism in the 1890s (Kawana 2008, 11).[2]

The mystery would rebound in the 1920s as children who had read Ruikō's earlier publications grew to become writers themselves (Kawana 2008, 12). This new generation of mystery authors was less affected by the old ideal of modern rationality and more influenced by Japan's 1920s vogue for erotic grotesque nonsense (*ero guro nansensu*). Amid a post–World War I economic boom, the return of injured soldiers from various wars, and the stunningly speedy development of modern cities—complete with roads, trams, cafés, and Western-style clothing—Japanese culture came to resemble a montage celebrating the erotic possibilities of city life, the grotesque injuries inflicted by modern warfare, and the generally nonsensical aspects of modernity (Silverberg 2009).

One mystery author, translator, and theorist, mentored by Ruikō himself, revivified the genre by refocusing it on erotic grotesque nonsense and enmeshing mysteries within a global literary tradition. This author, Edogawa Ranpo (1894–1965), is the person most responsible for the genre's development in Japan.[3] Ranpo's pen name shows how vital foreign literature was to the mystery's development in Japan as well as how deftly Japanese authors adapted foreign works to their own needs. Though the name Edogawa Ranpo may seem Japanese, it is actually a cleverly disguised adaptation of the name Edgar Allen Poe (i.e., *Edoga Waran Po*) that playfully invokes Tokyo's Edo River (*Edo gawa*). Like his pen name, Ranpo's fiction played with a global knowledge base to create strikingly new, absorbing tales of murder, mayhem, and detection.

Because Edogawa Ranpo established much of the foundation for Japanese mysteries, his work exemplifies many features of the genre as it developed in Japan. In particular, we can see in the peregrinations of Ranpo's oeuvre a tendency for worlds to develop apart from the mystery books and plays that initially contained them. For example, Ranpo's mentor, Ruikō, adapted Alice Muriel Williamson's *A Woman in Grey* (1898) into Japanese as *The Phantom Tower* (*Yūreitō*) in 1901. Roughly a quarter-century later, Ranpo published a new version of Ruikō's text under his own name. This was not plagiarism; Ranpo explicitly stated what he was doing and why in an afterword to his version of *The Phantom Tower*. It seems that having read Ruikō's translation, Ranpo decided to create his own version. He attempted to read Williamson's text before preparing his own, but he was stymied by a typo in Ruikō's text: in the preface, Ruikō said that he had adapted "*The Phantom Tower*, by Mrs. Bendison" (reprinted in Edogawa 2015, 298).

Ranpo searched for a Mrs. Bendison but could find no record of her existence (for the obvious reason of her nonexistence). Further, since Ruikō had renamed *A Woman in Grey*, any attempts to track down a book by that title would also have failed. Thus, Ranpo wrote his version, "without reading the source text, based only on Ruikō's translation" (ibid.). The Phantom Tower world had become dissociated from the novel *A Woman in Grey*.

Much as Ranpo built on Ruikō's work regarding Phantom Tower, other mystery writers would build on Ranpo's own adaptations of foreign mysteries. These developments center on Ranpo's signature detective, Kogorō Akechi, who was inspired by Sir Arthur Conan Doyle's Sherlock Holmes. Today, Akechi is at least as famous in Japan as Holmes. Introduced in 1925's "The Case of the Murder on D–Hill" ("D-zaka no satsujin jiken"), Akechi would star in thirteen novels and assorted short stories by Ranpo. In *The Golden Mask* (*Ōgon kamen*, 1930) Akechi matches wits with the infamous gentleman thief Arsène Lupin, whom Ranpo adapted from French mystery writer Maurice Leblanc's character of the same name. Ranpo's unauthorized use of Lupin was rather fitting given Leblanc's earlier unauthorized use of Sherlock Holmes in "The Safe of Madame Imbert" ("Le Coffre-fort de Madame Imbert," 1906). By matching his Holmesian great detective against a pre-existing, globally renowned master thief, Ranpo elevated Akechi to the level of global mystery greats like Miss Marple, Professor James Moriarty, and Lord Peter Wimsey. This effectively created a global commons of mystery characters that mystery authors could draw on to flesh out their own stories.

Ranpo and Ruikō's free adaptation of Leblanc's character and Alice Muriel Williamson's novel, respectively, reflect a philosophy of mystery writing that would serve as the genre's foundation in Japan for decades to come. Sari Kawana describes this philosophy as viewing the mystery genre as an "imagined guild" (2008). Pre-existing mystery fiction provides "tools" (Kawana 2008, 24) in the form of narrative styles, tricks (for committing crimes but also narrating a mystery without revealing whodunit), character types, settings, and so forth. Guild members, i.e., mystery writers, can use those tools at their own discretion, but they must, in effect, cite their sources: "mentioning names and plots from preexistent works is not an admission of creative piracy but a way to show one's mastery of the genre's conventions" (ibid.). One consequence of this philosophy is that mysteries by Japanese guild members exhibit a higher degree of self-referentiality over time. In other words, authors will cite other mysteries within their mysteries at an astonishing rate, as is discussed regarding Alice Arisugawa below.

Ranpo contributed several new characters to the guild. He constructed a preteen assistant for Akechi, Yoshio Kobayashi, who becomes the protagonist of a

142 Chapter 5

spinoff series of novels. Kobayashi is a brilliant young detective in his own right, which inspires a mainly male group of children to form the Boy Detectives Club. Their very first case (Edogawa 2012) involves a master thief called Twenty Masks ("*Nijū Mensō*"). Both the Boy Detectives Club and Twenty Masks are clearly inspired by characters from the global mystery tradition. The Boy Detectives aid Akechi (by way of Kobayashi) much like the Baker Street Irregulars assist Sherlock Holmes, and Twenty Masks shares with Lupin a penchant for high culture, complex plans, and ostentatiously sending letters to his marks to let them know that they are about to be robbed. At the same time, Ranpo's creations are distinct in their own right: the Boy Detectives are portrayed as well-behaved, middle- to upper-class children in contrast to the poor ruffians paid by Sherlock Holmes, while Ranpo's Twenty Masks is more serious than Lupin. Further, the Boy Detectives Club novels concentrate on Kobayashi and his comrades rather than Akechi. All four of these characters—Lupin, Akechi, Kobayashi, and Twenty Masks—would go on to be adapted myriad times in Japanese mysteries without the creators' authorization or even knowledge.

Ranpo's mysterious thieves had a huge effect on the development of the mystery in Japan. He developed a thieving archetype through Lupin and Twenty Masks that, like Phantom Tower, becomes untethered from the source novels. Today, Japanese mysteries often counter their Great Detective with a character called the "Phantom Thief" ("*Kaitō*," lit. "mysterious thief"). Glamorous figures who dress in elaborate costumes, send messages to inform marks that they are about to be robbed of their grand cultural objects, and finally steal the treasures via elaborate, sometimes magical or science-fictional, plans, Phantom Thieves are extremely popular characters. Some creators put their own spin on the Phantom Thief, as when manga artist Arina Tanemura made the reincarnated Joan of Arc into *Phantom Thief Jeanne* (*Kaitō Jannu*, 1998–2000). Others adapt Lupin or Twenty Masks, as in CLAMP's gentle romantic comedy *Please, Twenty Masks!* (*Nijū Mensō ni onegai!*, 1989–1991). Mysterious thieves' historical connection to both the adult detective Kogorō Akechi and child detective Yoshio Kobayashi makes them adaptable for audiences of various ages.

While Ranpo focused on developing the mystery genre by adapting global mystery fiction, other writers cast a wider net. The earliest Japanese *Alice* mystery came out the year following Yoshio Kobayashi's debut. Masahiko Kuni's "A Murder in Wonderland" ("*Fushigi no kuni no satsujin*," 1937) appeared in what was effectively a fanzine published by the prolific writer and inculcator of Japanese science fiction Jūza Unno. The story is a bit of an oddity and reads more like an extended musing than a narrative of a crime. Kuni is such an obscure author that when his story was later collected in an *Alice* mystery anthology, the

Detecting *Alice* on Page, Screen, and Street 143

biographical section about him contained only a request for either the author himself or anyone who knew him to please contact the editors. Perhaps feeling the need for something more, the anthology's publisher appended a short analysis by budding mystery scholar Tsukasa Yokoi at the end of the volume. Yokoi insightfully noted a similarity between "A Murder in Wonderland" and Ryūnosuke Akutagawa's *Kappa* even though *Kappa* was not known at the time to be an adaptation of *Alice*.

"A Murder in Wonderland" was quickly followed by "Masako and Maki" ("Masako to Maki," 1938). Written by the better-known mystery writer Mushitarō Oguri, "Masako and Maki" is more easily recognized as a mystery. It falls in the locked room tradition and revolves around the forbidden love of two women. Despite *Alice*'s adaptation into two mysteries in only two years, it virtually disappeared from the mystery realm until the 1970s *Alice* boom discussed in chapter 1. Japanese mysteries evolved wildly in the intervening decades, spreading into new media and expanding into new stylistic and narrative territory.

A Mysterious, Mediatic Evolution in the Immediate Postwar Period

Publishing was severely limited during the height of World War II, and wartime materials shortages and censorship hit genre fiction like mysteries the hardest due to their insignificance to the war effort. The increasing pressure applied to Japanese authors to publish nationalistic materials in the lead-up to World War II may have discouraged authors from adapting foreign works like *Alice* even before materials shortages curtailed the available paper supplies. The end of wartime censorship and the postwar recovery of Japan's publishing industry led to an explosion in publishing that included prose literature, scholarly writing, and manga. The publishing industry's growth was part of an economic boom that eventually affected all media. The production and consumption of prose literature, manga, and television shows in particular skyrocketed from the 1950s to the 1980s as Japan rebuilt its war-torn infrastructure and Japanese citizens became wealthy enough to spend money on luxuries. That shift—from a mentality of poverty to a sense of financial security—was concentrated around the late 1950s, with a second shift occurring in the 1980s as Japanese people came to see their nation as wealthy and successful. Sales of television sets soared in Japan with the 1959 wedding of then–Crown Prince Akihito with Michiko Shōda, which suggests that fear of starvation was no longer quite so common. Genre fiction boomed across the media landscape.

144 Chapter 5

The postwar expansion of mystery publications played out differently in different media. Ranpo continued to write mysteries and advocate for the genre amongst the literary community. He cofounded the Mystery Writers of Japan (MWJ) association in 1947, with an initial membership of 103. The MWJ began giving out regular awards for mystery writing the following year as the genre coalesced into a mainstay of Japanese literary output. Postwar prose mystery authors drew on a global prose mystery tradition that included literary titans like the *Alice*-adapting Dame Agatha Christie, Sir Arthur Conan Doyle, Maurice Leblanc, and Edogawa Ranpo.

Prose literature provided the main basis for mystery films, but the connection was at times tenuous. Japan had a vibrant film industry in the prewar period, but the industry was hobbled during World War II and was almost entirely finished off with the postwar rise of television. Consequently, not many mystery films were produced during this time. The best-known Japanese mystery film from this period is Akira Kurosawa's famed *Rashōmon* (1950), which splices several testimonies given at a murder trial and was adapted from two earlier short stories by Ryūnosuke Akutagawa. Ranpo's "radically globalist" (Tatsumi 2008, xiv) oeuvre provided fertile ground for filmmakers, who adapted his stories into several films each year in the late 1950s. This wealth of Ranpo cinema dried up when the film industry declined in the 1960s, though the dearth of films did not equate to a complete loss of quality. 1968's *Black Lizard* (*Kurotokage*, directed by Kinji Fukasaku) is perhaps the best film that can be tracked back to a Ranpo novel, though it is considered an adaptation of the author and playwright Yukio Mishima's stage adaptation of Ranpo's 1934 Kogorō Akechi novel of the same name. *Rashōmon*'s careful mix of two Akutagawa stories and *Black Lizard*'s adaptation of an adaptation show that even mystery filmmakers who intended to adapt specific source works were separating worlds from the short stories and books that first iterated them.

Prose mysteries' success led to diversification. Ranpo-style mysteries, which puzzled out how at-times fantastical crimes were committed, came to be known as Orthodox (*honkaku*) mysteries. In contrast, newer authors began turning to crime as a useful structure around which to build realistic stories that dissected Japanese society. These works were called Society (*shakai*) mysteries, and they came to dominate the mystery genre in prose up to the 1980s. Mystery author Sōji Shimada attributes this shift to the literary establishment's enthusiastic support of Society mysteries, which were perceived as being of higher literary quality (2016). However, Society mysteries are also distinguished from Orthodox mysteries by their abandonment of the guild philosophy of mysteries. Other mysteries were not commonly cited within the text of Society mysteries as they

Detecting *Alice* on Page, Screen, and Street 145

were in Orthodox mysteries. Nor were fantastical archetypes like Phantom Thieves and Great Detectives.[4] They became the purview of other media, where they helped form a new way of producing media called the media mix.

The manga industry saw a great deal of flux in the 1950s and 1960s as publishing formats, art styles, types of content, and readership all changed (Kinsella 2000, 24–36). The manga industry embarked upon a period of massive expansion in 1959, as a result of which manga were produced in sizable enough numbers for artists to move into new genres and subject matter (Gravett 2004). Unfortunately, the limited amount of money available to pay for manga remained constant. While Japan's economy overall improved, increasing competition in the manga industry combined with a trend towards leftist-friendly narratives that appealed to low-paid workers to suppress the amount artists were paid per manga. Most artists needed to find additional sources of income to survive.

Manga artists' need for supplemental income affected the trajectory of the mystery genre's development in manga. Mystery manga boomed alongside prose mysteries in the 1950s and 1960s, but the Society mysteries that dominated the genre's prose form had little effect on manga. Instead, mystery manga artists merged Japan's earlier Orthodox mystery tradition with an exotic and profitable new style of mystery fiction: American superhero comics. Though they are probably thought of today as fantasy or science fiction action series, American superhero comics often require a superhero to detect who is behind an unfortunate event and how it happened before she deals with the event. Superhero comics' orientation towards the mystery genre can be seen in the character of Batman, who was introduced in issue no. 27 of *Detective Comics* (1939) before earning his own *Batman* series (1940).

American superhero comics and television shows flooded into Japan with American Occupation soldiers and immediately became popular among Japanese schoolchildren. Japanese manga artists and television broadcasters leapt on the popular imports with acuity. Superhero comics became popular in Japan alongside their television show adaptations, which encouraged Japanese media companies to co-create superhero worlds in both manga and live-action television series. Japanese media scholar Rayna Denison points out that the Japanese superhero's growth from 1958 to the 1970s is "part of a local set of exchanges between early television and other prominent Japanese media" (2015, 56). These "exchanges" deepened over the latter half of the twentieth century and merged with similar exchanges occurring in other media and other genres to become the media mix method of media production. The superhero mystery manga and television shows of the 1950s and 1960s thus laid the groundwork for the structure that underlies Japanese media industries today.

146 Chapter 5

Manga artist Jiro Kuwata was one of several pioneers of the new super sleuth manga who, in so doing, also pioneered the new, multimedia approach to manga production. Kuwata's breakthrough manga, *Phantom Detective* (*Maboroshi tantei*, 1957), follows a civic-minded young man who uses his job as a newspaper reporter to search for crimes. When he finds one, he dons a mask and rides his trusty motorcycle to the rescue. Kuwata's next successful manga, *Moonlight Mask* (*Gekkō kamen*, 1958), was adapted from a television show about a police detective who dons white tights and a cape to fight crime as Moonlight Mask. These early works show the outline of what mysteries would largely become in manga for the next few decades: stories about unique individuals secretly fighting crime in outlandish disguises. The success of *Phantom Detective* and *Moonlight Mask* led Kuwata to create a number of series in the science-fiction and superhero genres, including his most popular series, *8 Man* (co-created with Kazumasa Hirai, 1963–1965). *8 Man* stars a murdered detective who is revived as a superpowered cyborg. As this precis suggests, Kuwata's mysteries become increasingly soapy over time. Detectives cannot simply solve crimes, they must first die, be revivified, and suffer from having to hide their existence from their loved ones forevermore while superheroically solving crimes and physically capturing criminals. It is all very dramatic and distinctly different from the realist Society mysteries.

Kuwata's most successful series were all televised at some point. *Phantom Detective* was adapted into and *Moonlight Mask* was adapted from a live-action show, while *8 Man* was turned into an anime series. The televisual connection deepens with Kuwata's *Batman* manga (1966–1967), which he was asked to do in conjunction with the Japanese airing of the American live-action television show. Batman, who is sometimes called the World's Greatest Detective, fits into the mold of a successful Kuwata manga: an unusually wealthy orphan dons an outlandish disguise to fight crime, supposedly in secret, but actually in an overtly dramatic, attention-getting way.

Kuwata's *Batman* dovetailed with the television show, but it also fomented a nascent merchandising industry that was ready and willing to capitalize on both superhero television shows and superhero manga. It was already a matter of course to produce toys and other merchandise for the Batman television show. Though Kuwata was hired to make a Batman manga because of the campy 1960s show, he based his manga on the contemporaneous comics. That version of Batman was aimed at "returning the Dynamic Duo to its true scientific detective roots" (Ono 2014, 359) rather than indulging in flamboyant spectacle. Kuwata's *Batman* deployed a variety of Batman characters in original stories that highlighted (and expanded on) Batman's famous bat-tools through extensive

Detecting *Alice* on Page, Screen, and Street 147

depictions of Batman and Robin using their ropes, walkie-talkies, and vehicles to solve crimes and apprehend criminals. Naturally, masses of Batman toys were produced for sale (Kidd et al. 2008). Some of those toys were tied to the television show, but items like the Batman Moonstar shoes and the Flying Batman toy were adapted directly from Kuwata's *Batman* (Sugawara 2016, 335). Royalties from toys adapted from Kuwata's manga formed a secondary stream of income for him, while toy companies were able to further capitalize on the Batman world. The manga's publisher and the television network airing *Batman* both benefitted from what amounted to free advertising. Companies and workers in three media industries consequently found that they profited off each other's work.

Kuwata's superhero mysteries helped develop a new genre called the "hero series" (*hīro shirīzu*).[5] The hero series is best known internationally for its television incarnations, which include the massively popular *Power Rangers* television series. *Power Rangers* was adapted from a Japanese series called *Super Squadron Series* (*Sūpā Sentai Shirīzu*). The hero series genre concerns a group of everyday young adults who use gadgets to transform into costumed superheroes that fight fantastical evildoers.

Mysteries are plentiful if simple in the hero series. In each episode, heroes stumble upon clues about the latest plot and must track down the source of the problem. At this point, a giant monster appears to stop the meddlesome heroes, said heroes use some sort of gadget to transform into their costumes, and the monster is dispatched. The episode ends with order restored, while the chief evildoer ominously says that their next plan will not fail. A series (or a season of a series) ends with the heroes finally tracking down the evildoer in charge and dispatching them. *Super Squadron Series* first aired in 1975 as *Secret Task Force Five Rangers* (*Himitsu Sentai Go Renjā*). Together with 1967's *Ultraman* (*Urutoraman*) and 1971's *Masked Rider* (*Kamen Raidā*), *Secret Task Force Five Rangers* became the foundation of the hero series in its live-action television show incarnation (Denison 2015, 57).

Manga artists and television screenwriters maintained the fantastically mysterious elements of earlier Orthodox mysteries through the hero series' masked detective-superheroes even as prose authors turned away from them in favor of Society mysteries. Manga's Orthodox mystery consequently focused on a younger audience than the Society mystery and often could also be classed as science fiction or fantasy. The televised hero series, with its colorful costumes, elaborate special effects, and profusion of science-fictional gadgets almost obscuring the discovery and solution of crimes, offers a stark contrast with the realist Society mysteries that dominated the prose version of the genre.

The hero series style of mystery, with its television-ready content and merchandising-ready costumes and gadgets, naturally appealed to poverty-stricken

148 Chapter 5

manga artists. Artist Shigeru Mizuki details the industry's inhumane working conditions in his autobiography-cum-history *Showa, A History of Japan: 1953–1989* (2015). Mizuki was comparatively successful during the 1950s, but even he was reduced to wearing a pair of sandals everywhere for two years after being forced to pawn his shoes. Other artists fared far worse, including a friend of Mizuki's who died of malnutrition because he could not afford food and an assistant who had a seizure in Mizuki's home, only to disappear while Mizuki searched in vain for medical assistance. The very real economic considerations imposed on artists by the manga industry's structure encouraged artists towards material that offered secondary income streams. Publishers also faced economic pressures from new competitors. As the 1960s bled into the 1970s, manga publishers mimicked the prose publishers of the prewar period by launching manga magazines, such as *Weekly Boys' Jump* (*Shūkan Shōnen Janpu*, est. 1968), that explicitly divided the manga market into specific audience groupings based on readers' age and sex. Publishers began to tailor manga to more specific audiences' desires.

A 1970s Foundation and a 1980s Surge in Prose Mysteries

The mystery genre's growth between the end of World War II and 1970 in Japan reflects wider trends in Japanese culture. As Japan recovered from the war and its people were once more exposed to foreign cultures after years of wartime censorship and materials shortages, genre fiction metastasized. New, genre-specific magazines and awards were founded that brought fame and fortune to adventurous authors. In turn, early postwar authors emulated their turn-of-the-century forebears by reading widely and trying out new approaches, genres, and styles. Their explorations included fascinatingly promiscuous genre mixtures, like the mystery/science-fiction/superhero conglomeration called the hero series. Consequently, one hallmark of contemporary Japanese culture is its massive number of genres and subgenres. At the same time, Japan's devastated postwar economy meant that creators could not depend on high sales numbers or charge a lot for any individual work. Thus, creators were spurred to exploit works that were already popular by adapting them to or from popular media like manga, television, and merchandise. Creators also moved between genres and media as opportunities arose. For example, Tadashi Hirose worked as a screenwriter for children's science-fiction and fantasy anime like *Speed Racer* (*Maha Go Go Go*, 1967) and *Akko's Secret* (*Himitsu no Akko-chan*, 1969–1970) in the 1960s, but shifted to writing science-fiction and mystery novels in the 1970s.

Detecting *Alice* on Page, Screen, and Street 149

Alice reappears in prose mysteries in this increasingly vibrant media environment. The generic mixing seen in manga mysteries also appears in 1970s prose *Alice* mysteries. The first 1970s *Alice* mystery is written by Takashi Ishikawa, who is better known as one of the "founding fathers" (Tatsumi 2000, 106) of Japanese science-fiction than as a mystery writer. Ishikawa adapted *Alice* and *Moby Dick* (1851) into a nonsensical mystery, "Alice's Wondrous Journey" ("Arisu no fushigi na tabi") for *Mystery Magazine* in 1970. His injection of the dark, realistic *Moby Dick* into Wonderland fit in with the trend towards exuberant genre-blending, while his equal treatment of children's and adult literature fit in with scholars' growing respect for *Alice*'s cultural value. While not remarkable, "Alice's Wondrous Journey" is fun to read. Ishikawa exploits the fact that many animals play prominent roles in *Alice* to create an *Alice* story about a famous whale that plays with words related to both. Ishikawa's short story was shortly followed by Tadashi Hirose's *Alice in Mirrorland* (*Kagami no kuni no Arisu*, 1972).[6] *Alice in Mirrorland* depicts a young man who settles into a public men's bath one day, only to suddenly find himself in the women's bath instead. As he leaves the women's bath and investigates the world around him, he finds that he has somehow moved to a world where everything is precisely reversed from his world. Settling in the overlap between science-fiction, mystery, and fantasy, *Alice in Mirrorland* reflects how a general surge of interest in *Alice* played out in Japan's vibrant, genre- and media-mixing 1970s culture. Hirose's creativity was rewarded when *Alice in Mirrorland* won the 1973 Seiun Award, the oldest and perhaps most prestigious Japanese literary award for speculative fiction. *Alice* was in a sense recuperated for the mystery genre by authors like Ishikawa and Hirose, who were not dedicated to the genre so much as exploring how a variety of genres might be brought together in interesting new combinations.

The development of *Alice* mysteries from the 1970s to the 1980s reflects an evolution in Japan's overall media environment. The difficult-to-classify, mysteriously fantastical *Alice* fiction of the 1970s gives way to a multimedia surge of *Alice* mysteries in the 1980s as the Orthodox mystery resurged in popularity. The mystery genre is joined in its 1980s flowering by other genres; Japan's pre–World War II censorship of foreign materials combined with the nation's postwar economic devastation to effectively put modern genres like science-fiction and mystery on roughly the same developmental timetable. Science-fiction reached its "heyday" in the 1980s, while fantasy and horror would come to dominate the late 1990s (Tatsumi 2000, 106). New subgenres, like cyberpunk, were established and subgeneric battles, like the competition between Society and Orthodox mysteries, became less important as the market expanded enough to accommodate creators and consumers of both.

150 Chapter 5

The Orthodox mystery's return came courtesy of a group of prose mystery writers who started debuting in the 1980s and were collectively dubbed the "New Orthodox" (*shin honkaku*) school. Inspired by a new generation of foreign mysteries by authors like Ellery Queen, New Orthodox authors composed mysteries as puzzles against which readers were expected to test their wits. The New Orthodox mysteries of the 1980s lacked the fantastical elements of manga mysteries, which continued to merge action, science fiction, fantasy, and mystery in new hero series.

New Orthodox mysteries display a far greater degree of realism than the contemporaneous manga mysteries. Yet, *Alice*, with all its fantasy, lies at the heart of the New Orthodox movement. You might even say that *Alice* created the New Orthodox movement. Alice Arisugawa, that is. Alice Arisugawa, or *Arisugawa Arisu* in Japanese, is the pen name of an early proponent of the New Orthodox school, Masahide Uehara, whose professional debut with *Moonlight Game* (*Gekkō Gēmu*) in 1989 made him one of the central supporters of the New Orthodox school.

Uehara's pen name is a multilayered nod to the Orthodox mystery tradition and the man who established it. On one level, the doubled *Arisu* indicates a Western influence. Where Edogawa Ranpo referred to Edgar Allan Poe in his pen name, Uehara appeals to *Alice*. It is a deft twist; Ranpo invoked an author of grotesque crime stories to brand his writing, but Uehara appeals instead to the logical girl who sails through an unlogical Wonderland to contextualize his eminently logical prose puzzles. In effect, Uehara's pen name lightens the dark tales he tells by hinting at his protagonist's safe return whilst also suggesting the vital role played by logical thinking in his literature. Then, there is the matter of the authors' surnames. Where Edogawa is the name of a river in the modern city of Tokyo, Arisugawa invokes an old Japanese family. The Arisugawa family was a cadet branch of Japan's imperial family that died out with Imperial Prince Takehito Arisugawa-no-miya (1862–1913). Where Ranpo ties his artistic identity to his home and a literary master whom he sought to emulate, Uehara connects himself to an aristocratic Japanese tradition and a seemingly contrary children's fantasy. It is a fascinating move for an author whose career is based in the rejuvenation of clear, cool logic to adopt a romantically fantastical pen name like Alice Arisugawa, but Uehara adds a third layer to his name in the text of his mysteries.

Where early Japanese mystery writers like Ranpo were influenced by early foreign mystery writers like Edgar Allan Poe, the burgeoning New Orthodox school was inspired by slightly later foreign authors, such as Ellery Queen and the *Alice*-adapting John Dickson Carr.[7] Uehara was particularly influenced by Ellery Queen, the joint pen name of Americans Frederic Dannay and Manfred

Detecting *Alice* on Page, Screen, and Street 151

Bennington Lee. Dannay and Lee's Ellery Queen conceit extends beyond a mere pen name to a complete persona. They made Ellery Queen a character in the novels published under his name. Queen was supposedly a mystery writer who happened to aid in the solution of various mysteries, which he then wrote down and sold under his own name. Uehara adopts this pretense for Alice Arisugawa, who is both the author of *Moonlight Game* and its narrator.

Alice Arisugawa has a long career and an interesting life.[8] His interest in mystery fiction leads him to join the Mystery Club at Eito University, where he studies law. He becomes embroiled in various mysteries, writes down what happened, and publishes his observations as stories told from the perspective of someone who was actually there. Arisugawa is not a great detective like Kogorō Akechi but a bystander with a real knack for appearing near dead bodies. His mysteries fall in the country house mystery tradition wherein a group of people are sequestered away from the world such that when one of their number is murdered, they must deal with the matter themselves instead of waiting for the police. During his college years, Arisugawa watches and writes while the Mystery Club's president, Jirō Egami, solves various murders. Arisugawa continues to stumble upon mysteries after he graduates and becomes a professional writer, but now they are solved by Hideo Himura, a criminology professor amongst his acquaintance.

Arisugawa's mysteries reflect his accidental and unwanted inclusion in crime as well as his love of fictional crime stories. *The Moai Island Puzzle* (*Kotō Pazuru*, 1989), his second novel, encapsulates Arisugawa's background and goals. The members of the Mystery Club are invited by fellow member Maria Arima to spend a week at her family's vacation home. The vacation home is on a private island, but has a wireless set to call for help if something happens between weekly supply runs from a boat on the mainland. Arisugawa casually relates these details to readers in the second person, complete with any necessary contextual information and occasional pert comments. Unfortunately, the vacation is quickly interrupted by a double murder. Arisugawa relates the prefatory events and the following investigation with an extreme degree of detail, then interrupts his narration with a challenge: readers should draw their final conclusions before turning the page.

The Moai Island Puzzle is peppered with references to other mysteries thanks to the Mystery Club member-characters, who constantly discuss mystery novels. The members compare their efforts to Ranpo's Boy Detectives Club repeatedly, for instance. The non–Mystery Club members of the cast contribute a slew of additional cultural references that have nothing to do with mysteries. For example, because the head of the Arima family loved jigsaw puzzles, the vacation

152 Chapter 5

home is covered with puzzles depicting "Rembrandt's *Night Watch*, Monet's *Water Lilies*, van Gogh's *Cypress*, Renoir's *Young Girl Bathing*, Seurat's *A Sunday on la Grande Jatte—1884*" (Arisugawa 2016, 37). The unremitting litany of artists in this sentence reflects in a condensed form how one mystery after another appears across not only this book, but the rest of Uehara's oeuvre.

Arisugawa's life parallels that of Masahide Uehara in some ways, though Uehara has been lucky enough to avoid premature corpses. Uehara enjoyed mysteries from an early age, so joined a mystery club in college. He was also a law student, though at Dōshisha University instead of the fictional Eito University, and clearly he became a very successful mystery author after graduation.

Uehara's adaptation of *Alice* to develop the Alice Arisugawa persona is integral to his writing. Because Arisugawa both loves mystery fiction and participates in the mysteries being recounted, it is only natural that his conversations and observations regularly refer to other fictional mysteries. At the same time, by citing the works of Dorothy Sayers, Sir Arthur Conan Doyle, and other mystery writers so incessantly, Uehara forces readers *not* to suspend their disbelief. Uehara crafts mysteries as jigsaw puzzles that the readers are meant at least to try to solve instead of as a world into which readers are meant to enter. His detectives are tools that allow readers to check their answers. Since his detectives are so utilitarian, it does not really matter who the detective is. What matters is the identity of the observer, Alice.

New Orthodox authors revived the Orthodox mystery by adapting it for a new era. The rise of the Society mystery reflected later readers' distaste for the erotic grotesque nonsense that had been so integral to Orthodox mysteries. However, in rejecting Orthodox mysteries, Society mystery writers also cast aside the deductive aspect of the genre. New Orthodox writers emphasize this abandoned feature. Authors like Arisugawa painstakingly lay every clue and misdirection before readers so that we can determine whodunit ourselves. The New Orthodox mystery runs the risk of becoming a coldly detached intellectual exercise. Arisugawa's novels are an extreme example of the style and could be quite boring for that reason. Yet, Arisugawa's novels are not Arisugawa's novels. Readers know that Arisugawa is merely a figment of Uehara's imagination, and it is that phantasm that adds a sense of mystique to the novels. Uehara's adaptation of *Alice* exploits the world's liminality to distance his fiction from the banalities of real life. Arisugawa details these banalities—*must* detail them, in fact, so that readers know where each suspect is at every pivotal moment. Arisugawa writes everything he sees, hears, smells, feels in an avalanche of mundanities. Uehara balances this flow of necessary information with an explicitly "exotic" (Arisugawa 2016, 19) character whose very name conjures fascinating other worlds.

Should a reader manage to miss the *Alice* in Alice Alice-river, Uehara provides other clues. Some are overt, like the 1996 short story "Jabberwocky" ("Jabauokkii" 1996, collected in Arisugawa 1997). Others, like Uehara's application of English section titles like "Alice in Movie Land" and "Alice in Mysteryland" in his essay anthologies (Arisugawa 2003; Arisugawa 2006) are more lyrical. Uehara's adaptation of *Alice* transports his puzzle-mysteries and his explanatory essays to another, rather mysterious realm. Alice Arisugawa functions as readers' bridge to this other world, Wonderland. Yayoi Kusama positions her art similarly, but with herself as the bridge. Because Kusama is the bridge, when readers reach Wonderland through her illustrated edition of *Alice's Adventures* they find that she was always already there. In contrast, Uehara claims no authority over this territory. His fictional creation connects the two worlds, while he himself disappears from view. Thus, readers find at the end of Arisugawa novels not a reminder of the author's existence, tied as he is to the everyday world, but an emblem of a smiling Cheshire Cat (figure 5.1a).

As Masahide Uehara became a successful novelist and began playing a role in other media, he embodied his *Alice* adaptation, the Alice Arisugawa character, in these media as well. Arisugawa has written radio drama serials and drama CDs, created scenarios for a video game and a puppet play—he even served as president of the Honkaku Mystery Writers Club of Japan! Uehara's initial use of *Alice* to transmute the everyday into the extraordinary in his mysteries comes full circle as Alice Arisugawa crosses from fiction back into the very real role of Writers Club president.

Manga's Mysterious Thief Is Melded into *Alice*

Where prose mysteries killed off and then reanimated the Orthodox style for its excessively dramatic aspects, manga mysteries had never deserted the drama. The Orthodox style had evolved through the hero series, but manga mysteries offer an unrealistic level of drama—and draw on the Orthodox traditions of Phantom Thieves and Great Detectives—even outside of the hero series. Tsukasa Hōjō's hit manga *Cat's Eye* (*Kyattsu ai*, 1981–1985), for example, depicts a trio of gorgeous, globe-trotting sisters stealing back art that Nazis had stolen from their father. Their thefts were hidden behind a Phantom Thief persona, Cat's Eye, who sent notes alerting marks to their coming losses just like Edogawa Ranpo's Twenty Masks.

Cat's Eye clearly draws on Ranpo's Phantom Thief, yet Hōjō's manga shifts said thief from the antagonist's role to the protagonist's position while dramatically establishing the sisters' moral righteousness through the incorporation of

154 Chapter 5

Nazism. Hōjō was neither the first nor the most prominent manga artist to suggest that a Phantom Thief might be a good person, but her manga reflects the development of a new subgenre of mystery manga that follow well-intentioned, mission-driven Phantom Thieves on their assorted illegal adventures.[9] Like the hero series, Phantom Thief manga are episodic. The thief steals one item per chapter in the face of obstruction by a recurring detective character who is often adapted from Sherlock Holmes and/or Kogorō Akechi. As the good Phantom Thief subgenre develops, the hero series' transformation sequences are adapted for female Phantom Thieves. However, Phantom Thieves work alone and against the law, while the detectives work together with police officers to uphold the law.

Amongst this efflorescence of Phantom Thieves, a new manga collective forms that will use adaptation to craft not a world but a universe. The CLAMP collective originates as an amateur *dōjinshi* group that adapts manga, novels, and other works. They increasingly feature original characters, settings, and stories in their *dōjinshi* until 1989, when they switch to publishing manga professionally. Like Kaori Yuki, CLAMP continues to exploit adaptation as professionals by adapting pre-existing works that have fallen out of copyright. Their first professional manga, *RG Veda* (*Seiden Rigu-vēda*, 1989–1996), for example, adapts the ancient mythological collection of Sanskrit hymns called the *Rig Veda*.

Concomitantly with *RG Veda*, CLAMP begins publishing a second manga that adapts CLAMP's own amateur creations together with the Phantom Thief. The cute, comic romance *Please, Twenty Masks!* (1989–1991) follows an elementary schooler named Akira Ijūin who replaces his absentee father as the Phantom Thief Twenty Masks.[10] The Twenty Masks identity, a high school detective character named Ryūsuke Kobayashi, and Akira's uncle, Shigetaka Akechi, are all adapted from the similarly named characters in the global mystery commons. However, CLAMP also adapts original materials that they had independently published during their amateur period for this new professional publication. Young Ijūin attends CLAMP School, a setting from CLAMP *dōjinshi*, and he is on the student council with a character who previously appeared in CLAMP *dōjinshi*, Nokoru Imonoyama. CLAMP creates new characters like Suō Takamura, Akira and Nokoru's fellow student council member, to fill out the cast of *Please, Twenty Masks!*. The series consequently contains shared mystery figures, aspects of previously published CLAMP *dōjinshi*, and original features.

CLAMP's early publications roughly fall into two categories. The first body of works contains discrete manga like *RG Veda* that appear to take place in a unique world. The second body of works takes place in a gently science-fictional version of contemporary Japan. This second set begins with *Please, Twenty Masks!* and initially consists of mysteries. When *Please, Twenty Masks!* ends, CLAMP adapts

Detecting *Alice* on Page, Screen, and Street 155

Akira, Nokoru, and Suō along with the CLAMP School setting into the hero series *CLAMP School Defenders: Duklyon* (*Gakuen tokkei Dukarion*, 1991–1993). The trio plays supporting characters in *Duklyon*, but they take center stage in the next series, *CLAMP School Detectives* (*CLAMP gakuen tanteidan*, 1992–1993). *CLAMP School Detectives* turns Nokoru, Akira, and Suō into an elementary school detective agency in CLAMP's own take on the orthodox Boys' Detective Club mystery tradition. (Akira's dual role as boy detective and mysterious thief prompts an occasional, gentle joke.) CLAMP produces another manga during this period that could be taking place in the same world as *CLAMP School Detectives* but does not feature any of that series' characters. Titled *Tokyo Babylon* (*Tōkyō BABYLON*, 1990–1993), the series follows a Japanese magician-detective named Subaru Sumeragi as he tracks down a magical serial killer.

CLAMP effectively created a complex world and adapted it in a variety of iterations over the group's late amateur and early professional years. Despite falling into the mystery genre, *Please, Twenty Masks!*, *CLAMP School Detectives*, and *CLAMP School Defenders: Duklyon* all adapt this pre-existing world to different purposes. *Please, Twenty Masks!* is Akira's love story (conducted against a background of amusing thefts), while the CLAMP School Detectives focus seriously on solving the mysteries besetting the ladies around them. *Duklyon* spoofs the hero series by centering its action on comedic situations over drama or crime solving. This mysterious world can contain a wide variety of stories and characters, yet limitations remain. The largest limitation lies between its more-or-less contemporary Japanese setting and the fantastic settings of manga like *RG Veda*.

CLAMP drastically expanded the world of their mystery series into what is now called the CLAMP Universe by adapting *Alice* into a new CLAMP School manga, *Miyuki-chan in Wonderland* (*Fushigi no kuni no Miyukichan*, 1993–1995). CLAMP developed *Miyuki-chan in Wonderland* just as they had developed the other CLAMP School world manga. The titular Miyuki-chan first appears in *CLAMP School Detectives* as one of Nokoru, Akira, and Suō's clients. The detectives track down her lost pet over the course of a chapter, after which Miyuki-chan disappears from the manga. One year later, CLAMP adapted Miyuki-chan into her own, seven-chapter series. *Miyuki-chan in Wonderland* is the first CLAMP School manga to decisively abandon the mystery genre. It is rather a double-sided spoof of *Alice* and Japanese culture, with poor Miyuki-chan falling into and then escaping from a different Wonderland in each chapter. *Miyuki-chan in Wonderland* is also notable for having a higher degree of eroticism than earlier CLAMP School manga, inasmuch as the various Wonderlands are filled with scantily clad lesbians intent on stripping Miyuki-chan nude.

156 Chapter 5

Miyuki-chan in Wonderland is only one volume long, but it plays a key role in tying together CLAMP's manga. Miyuki-chan is cast as Alice in this adaptation in line with the title. As Alice, Miyuki-chan can link different worlds. Wonderland, however, looks a little different in *Miyuki-chan*. Miyuki-chan travels to Wonderland ("*fushigi no kuni*") in the first chapter and Looking-Glass Land ("*kagami no kuni*") in the second, but then CLAMP begins inventing wonderlands . . . and adapting their non-mystery manga. Miyuki-chan travels to Part-Time Job Land, TV Land, and X Land, among others. She meets characters from manga like CLAMP's fantastical *Magic Knight Rayearth* (*Majikku naito Reiāsu*, 1993–1995) and *X/1999* (*X/1999*, 1992–2003) in these various wonderlands.

Though *Miyuki-chan in Wonderland* began as a simple adaptation of *Alice* crafted using CLAMP's go-to method of adapting secondary characters into primary roles in new manga, *Alice*'s liminality afforded CLAMP a new way to deepen the links between their manga. *Miyuki-chan in Wonderland* effectively enlarged the contemporary Japanese world shared by their mystery manga by explicitly connecting other manga to the mystery manga. CLAMP quickly encodes this growth through the manga *X/1999*, which adapts *Tokyo Babylon*'s Subaru Sumeragi and his antagonist alongside Nokoru, Akira, and Suō into a story about a new character, Kamui Shirō, who must magically save the world. *X/1999* began publication prior to *Miyuki-chan*, but the mystery manga characters only appear in *X/1999* after *Miyuki-chan*'s release. By casting characters from *Tokyo Babylon* and various mystery manga together as the supporting cast of *X/1999*, CLAMP retroactively confirms that *Tokyo Babylon* is part of the shared world as well.

The *Miyuki-chan in Wonderland* manga constitutes a bridge between various CLAMP manga while also functioning as a nexus in the development of what is now commonly called the CLAMP Universe. The CLAMP Universe is a multidimensional space that contains the worlds of every CLAMP manga. Its structure was completed with *Tsubasa Reservoir Chronicle* (*Tsubasa-RESERVoir CHRoNiCLE-*, 2003–2009). *Tsubasa Reservoir Chronicle* is premised on three pillars: the CLAMP Universe consists of many dimensions (one of which contains the CLAMP School world); travel across these dimensions is possible; and different versions of a character may exist in different dimensions.[11] Naturally, Miyuki-chan appears in *Tsubasa* as well, linking together CLAMP's sprawling universe of worlds.

Linking Manga, Linking Media

The CLAMP Universe expands on Eiji Ōtsuka's conception of artistic worlds in intriguing ways. Ōtsuka devised the world/iteration binary in response to

Detecting *Alice* on Page, Screen, and Street 157

production methods that he had witnessed and engaged in as a manga editor. His advocacy of the media mix lay in his belief that working together to convey a cohesive whole, a world, to consumers benefitted companies producing diverse media. Yet, the multitude of *Alice* adaptations show that it is possible to create a set of works within the *Alice* world that cohere together in a way that is unique from other *Alice* works. Kaori Yuki's plethora of *Alice* works have an internal consistency that is recognizably *Alice*, intentionally *Alice*, necessarily *Alice*, yet Yuki's assorted *Alice* manga are distinct from each other and distinct from CLAMP's various *Alice* manga.

The CLAMP Universe suggests a new way of understanding how Yuki's *Alice* works relate to CLAMP's—or any other body of—*Alice* works. Examining the CLAMP Universe makes apparent that worlds are concomitantly polymorphic and stackable. Creators and consumers can delimit a world's boundaries according to need. For example, one can discuss the individual worlds that Miyuki-chan lives in and travels to in *Miyuki-chan in Wonderland*, the overall world of the *Miyuki-chan* manga (with its assorted Wonderlands), the world of CLAMP mystery manga that counts Miyuki-chan among its cast, the CLAMP Universe that includes all of CLAMP's manga, the global *Alice* world that now contains all CLAMP manga alongside Yuki's and other artists' works, or a variety of other worlds: the world of *Alice* manga, say, or the world of global *Alice* comics. Each world contains different works of art exploring different themes and adapting different imagery, characters, settings, and incidents. The world is a flexible concept, but that flexibility can be exploited without losing coherence or utility. In such cases, I propose adapting CLAMP's term. When discussing a world composed of goods produced by a single artist, company, or group, where that world has been adapted from another world, let us identify the larger world as a universe. The world of Black Butler consists of Yana Toboso's manga of the same name (2006–present), three anime (2014, 2014, and 2017), and works in various other media—all of which can be seen as part of the *Alice* universe.

Worlds are also stackable, inasmuch as consumers understand a manga like *Miyuki-chan in Wonderland* as both an adaptation of *Alice* and a new iteration in the world of CLAMP mysteries. Layering builds complexity in art. It is how genres, styles, and especially, the media that give form to art evolve. The medium is the message, Marshall McLuhan tells us, while Jay David Bolter and Richard Grusin contend that even today's much-lauded, much-derided digital media merely remediate older media. Likewise, old worlds are remediated through new adaptations. The pleasure of consuming an adaptation, like the pleasure of consuming genre fiction, lies in the pursuit of small changes. Some things stay the same, but enough transforms that consumers are prompted to re-view what we

158 Chapter 5

thought we knew. Seeing a world in a new light may induce us to remember what we loved about it, or it may highlight that we have grown beyond that world's limits. Adaptations in new media afford new possibilities. For example, Kan Kikuchi's 1928 translation of Maurice Leblanc's Arsène Lupin mystery *The Hollow Needle* (*L'Aiguille Creuse*, 1909) served wildly different purposes when it was first published than when it was digitized and loaded onto the EX-word Dataplus 6 electronic dictionary. Kikuchi originally translated the novel as part of a series of classic novels for children, while EX-word preloaded Kikuchi's text onto its electronic dictionary as an added bonus for people who bought the Dataplus 6. The textual content remains the same, but the text's function evolved with its adaptation into a new, digital medium.

When the fact of each medium's varying affordances and limitations collides with the media mix production process and its requirement that worlds be adapted into multiple distinct media, it becomes possible for a world's cohesion to fray. A film might cast a gentle, weak-seeming actress to play a novel's supposedly strong and confident protagonist, or a publisher could hire a high-profile artist to illustrate the novelization of a film only to find that the artist's style strikes a much darker note than the film's aesthetic. A world can grow and change over time, but too many dissimilar products released in too short a period simply spawn confusion. Christine Yano notes that Hello Kitty's global popularity stems in part from the fact that "Hello Kitty is pure product. . . . She goes beyond the constraints of narrative and rests in the commodity fetishism of a singular image" (2013, 10). That singular image marks the edges of the Hello Kitty world, but in turn, anything can be contained within the world so long as it has the image of Hello Kitty. Where Hello Kitty ties together disparate media through a singular image, *Alice* uses its inherent liminality.

Alice, like other worlds that have been adapted at will by discrete artists, lacks a singular image to constrain its world through multimedia contortions. This is not to say that there are no images that provoke viewers to think of *Alice*; Disney's animated *Alice* and Tenniel's *Alice* illustrations clearly function as icons of *Alice*. The problem is rather one of excess: too many images invoke *Alice*. This surfeit prevents any one image from limning *Alice*'s boundaries.

Alice in Babylon, *CLAMP in Wonderland*

CLAMP produced the entirety of its artistic output in an environment where media mix–style production was and is necessary for manga artists. By the beginning of the 1990s, the media mix method of production had developed to the point that key personnel in relevant industries were attuned to specific mixes,

Detecting *Alice* on Page, Screen, and Street 159

or sets of media. For example, an action manga serialized in the largest manga magazine, *Weekly Shōnen Jump*, is particularly likely to share its world with a long-running anime, a blockbuster video game, soundtrack CDs, and perhaps an artbook, while a romance published in the storied *Nakayoshi* (*Nakayoshi*, 1954–present) girls' manga magazine is more likely to come with a one- or two-season-long anime, one or more artbooks, a low-budget video game, and perhaps a short live-action televised drama series.

Experience has shown that certain media are more likely to make money with specific types of worlds. Companies seek out potential content accordingly and budget their projects with an eye to the profitable effects of a world's collective multimedia adaptations. Because blockbuster video games tend to be either action games like *Resident Evil* (*Baiohazādo*, 1996) or world-building games like *SimCity* (1989), game makers naturally invest more money in these types of games than in less-remunerative genres such as dating simulation games.[12] In the same vein, some types of content lend themselves to adaptation in more media than others. Dating simulation games are less remunerative in part because the genre depends on stalling narrative development until quite late in the game. Longer, more detailed narratives are necessary to sustain a full season of both animated and live-action television shows, so dating simulation games like NTT Solmare Corp.'s *Lost Alice* (2019) are generally limited to at most a half-season-long television show. Creators dependent on royalties from adaptations of their work into other media thus face a financial pressure to consider the needs of multiple media in creating new worlds.

CLAMP's initial media mix activities reflect their origin in manga and *dōjinshi*. The short, genre-bending romance *Please, Twenty Masks!* lacked enough dramatic action to warrant a blockbuster action video game, and its protagonist's quick romantic pairing and lack of romantic rivals precluded the creation of a cheaper dating simulation game. *Please, Twenty Masks!* spawned instead a pair of drama CDs (1990, 1991). The drama CD is effectively an updated version of the older radio serial. Despite the name, drama CDs do not necessarily contain just enacted dramas. A drama CD might contain songs written in the voice of a manga's character and sung by a voice actor hired to portray said character, adapt a manga's world into a new story, or even serve as a cheap way to suss out the potential popularity of a world—like that of Rejet's *Alice=Alice* dating simulation game (2013)—that a creator wants to publish in a more expensive medium like anime. Because CLAMP adapts characters from one series into other series, cheap media like drama CDs also test and maintain consumers' interest in characters who may later return in other manga.

Creative success in a media environment dominated by the media mix production methodology benefits from the creation of worlds prior to those worlds'

160 Chapter 5

embodiment in any medium, but with the affordances of many media in mind. CLAMP's early works coalesce primarily as manga, but the collective quickly moves from what might be called less-remunerative subject matter to more adaptable content. In contrast to the limited number of *Please, Twenty Masks!* adaptations, *Tokyo Babylon*'s visually spectacular, action-heavy mystery about dueling magicians spawned six drama CDs, a book of postcards, a calendar, a pair of direct-to-video anime, and a live-action television movie, all released between 1990 and 1994.

Adapting a world into a variety of new media raises the specter of discontinuity between different adaptations. CLAMP's method of spinning characters off into new series may have connected their assorted manga series, but their expansion into so many new media tested that unity. CLAMP used *Alice* to counter the threat diverse media posed to the cohesion of its initially manga-based world.

CLAMP released a variation of Tokyo Babylon in 1996 that layered multiple media into a single product. *Tokyo Babylon Photographs* contains original illustrations of Tokyo Babylon's three primary characters posed like fashion models (plate 9). Manga artists often release artbooks, or large books containing a mix of full-color illustrations originally created for their manga and new illustrations featuring characters from their manga.[13] Creators gain a secondary income stream from artbooks with comparatively little exertion. They can also expand on their brand, as when Kaori Yuki reprinted pictures of her graduation project—an *Alice* calendar illustrated in a strikingly different style than she uses for her manga—in a 1997 artbook for her manga series *Angel Sanctuary*. *Tokyo Babylon Photographs* categorically differs from the artbook medium. Its images are clearly hand-drawn and portray the characters from the *Tokyo Babylon* manga, but the volume's format co-opts another medium, the gravure photobook.[14] A gravure photobook is a book of photographs featuring a specific model or group of models who pose for a male audience in themed, often-scanty clothing. The characters in *Tokyo Babylon Photographs* are fully clad, but CLAMP poses them provocatively in fashion-magazine-worthy costumes amidst simple, set-like backgrounds in a clear invocation of gravure photobooks.

CLAMP uses *Alice* to ensure *Tokyo Babylon Photographs*' coherence. The group effectively adapts three media—the gravure photobook, the manga artbook, and the manga itself—into a single product in the book. Doing so threatens the cohesion of the Tokyo Babylon world. Artbooks and manga are intimately connected, with the former often simply reprinting pictures from the latter at a larger size. Gravure photobooks, however, serve wildly different purposes and audiences, especially because the *Tokyo Babylon* manga was published in a

Detecting *Alice* on Page, Screen, and Street 161

magazine aimed at teenage girls and women. CLAMP solves the incongruity of these media by also adapting *Alice* into *Tokyo Babylon Photographs*. *Alice* symbols, including clocks and rabbit ears, are scattered throughout the volume, and characters are explicitly costumed as *Alice* characters in several images (plate 10).

Adapting *Alice* in *Tokyo Babylon Photographs* solves several problems. Alice's ability to transcend boundaries connects the images' different settings and styles of costume, lending a sense of cohesion to the otherwise-disparate set of pretend photographs. Because *Alice* has a history of adaptation in both manga and gravure photobooks, the shared connection bridges the two media. *Alice* further makes sense of the artbook–gravure photobook connection through its associated symbols—card suits, elaborate hats, rabbits, and clocks—all of which are not only commonly used in manga, but also lend themselves to fashionable interpretations of the sort a model might opt for in her personal photo shoot. Ultimately, CLAMP's adaptation of *Alice* in *Tokyo Babylon Photographs* maintains the coherence of the Tokyo Babylon world as it is incarnated into oppositional media.

Alice's ability to hold worlds together as they spread into diverse new media through media mix productions comes to the fore in the 1994 animated music video *CLAMP in Wonderland* (*CLAMP IN WONDERLAND*). This short film was produced by the Animate Film anime studio to be sold in the stores of its parent company, the manga, anime, and video game retailer Animate Ltd. Animate Film was not an anime studio in the way that most would imagine them; it existed solely to create small-scale, cheap animations that would be sold exclusively in Animate stores. Fans were enticed into Animate stores by these direct-to-video anime and bought other products while there. Animate Film's animations are thus best seen as a cousin of the manga industry's *furoku* giveaways (discussed in chapter 4).

CLAMP in Wonderland is unified by *Alice* instead of by a plot. The film consists of a series of vignettes in which CLAMP characters from different manga interact with each other while the specially penned song "Your Private Wonderland" ("Anata dake no WONDERLAND") plays, followed by an animated credits sequence that is nearly as long as the video itself. The film opens with an adaptation of the opening scene from *Miyuki-chan in Wonderland*. This time however, *X/1999*'s Kamui Shirō chases a strange orb into Wonderland rather than Miyuki-chan following a woman in a rabbit costume. The sequence layers world upon world, medium upon medium. *CLAMP in Wonderland* adapts *X/1999* and *Miyuki-chan in Wonderland*, which itself is an adaptation of Alice in Wonderland. The animated *CLAMP in Wonderland* adapts the manga of *X/1999* and *Miyuki-chan in Wonderland*, the game of chess, the Playboy bunny costume, the *Street Fighter* arcade game, Mahjong, live-action television shows . . . the

162 Chapter 5

CLAMP Universe appears to be spiraling out of control. Then, Miyuki-chan herself finally appears amongst a procession of CLAMP characters on the screen. A wind blows her skirt up to reveal an image of the strange orb that Kamui had chased earlier printed on her underwear. Miyuki-chan's underwear symbolically equates her to the orb that initially opened the door to Wonderland for Kamui. Miyuki-chan in her role as Alice thus unites the disparate worlds and media depicted in the film.

CLAMP in Wonderland concludes by emphasizing both the multiplicity of media that now create the CLAMP Universe and the limitations of said universe's reach. Junko Hirotani sings "Please wait in your private Wonderland" as Miyuki-chan flees a horde of CLAMP Universe characters. She is replaced by a character named Jojo, who was not created by CLAMP but adapted from Hirohiko Araki's manga *Jojo's Bizarre Adventure* (*JoJo no kimyō na bōken*, 1987–2004). Borrowing Araki's character nostalgically reminds fans of CLAMP's amateur days, during which they drew *dōjinshi* of *Jojo's Bizarre Adventure*. His appearance after Miyuki-chan's flight also denotes that the CLAMP Universe has limits. Even with *Alice*'s border-crossing power, every world must come to an end. Jojo's image thus fades into the word "END" (in English) as the camera pulls back to reveal a movie theater filled with applauding CLAMP Universe characters. Viewers were watching not a film but a film-within-a-film. The doubling of the filmic medium emphasizes the adaptation of CLAMP Universe into an ever-expanding list of media, while the proliferation of characters within the piece reflects the diversifying genres and narratives produced by CLAMP. The short film's doubled use of *Alice* (in the film and song titles, but also through Miyuki-chan's role in the film-within-a-film) connects media and stories. Miyuki-chan's flight from another artist's creation, however, shows that even CLAMP's spiraling ambitions are constrained by the natural and legal limitations of the world.

Alice appeared in CLAMP's oeuvre through the mystery genre at a pivotal point in CLAMP's development. The group had long been tying their assorted publications together. Their mystery series connected to each other quite easily due to the genre's shared character tradition, but CLAMP struggled to connect their non-mystery works in any substantial way. They were ultimately able to link all of their works into a greater CLAMP Universe by repeatedly using *Alice*'s liminality to bridge mystery with fantasy, action, and other genres.

Alice and the Media of Mystery

CLAMP's deployment of *Alice* to simultaneously connect and constrain its snowballing universe's many media and worlds reflects wider changes that took

Detecting *Alice* on Page, Screen, and Street 163

place in the Japanese media environment across the 1980s and into today. A different type of *Alice* world appears within this transforming media context that will wend its way into Japanese mysteries in the twenty-first century. *Alice* is adapted together with the French Rococo style into something called Lolita in the 1980s (Takemoto 2014).[15] Lolita is difficult to categorize. It coalesces around the medium of clothing and is often called a clothing style, but the (primarily young, female) people who wear Lolita developed their own norms and traditions much as prewar girls' magazine readers did. Unlike prewar girls, Lolitas (as those who engage in the Lolita subculture are called) hold their culture open to newcomers like boys, adults, and non-Japanese people. In fact, publicly parading through Tokyo's trendy Yoyogi Park on Saturday mornings in costume became one of the central social events of Lolita culture. Lolita fashion's exposure to, and photographing by, non-Lolitas is one by-product of this see-and-be-seen pastime. Photographs of Lolitas are replicated in fashion magazines and have inspired artists like the American singer Gwen Stefani, such that the Lolita subculture became fashionable around the world.

While the Lolita subculture is open to all, it resonates with the participatory nature of girls' culture. Visually, the prolific ribbons and lace of Lolita clothing replicate the *hirahira* "ribbons and frills" that Masuko Honda (2010, 28) identified in girls' magazine illustrations. However, the most important congruence lies in what the Lolita subculture and girls' culture provide for participants. Ostensibly, both provide a form of escape from societal control through the creation of dream-like space. Deeper examination reveals that both cultures enable participants to subvert societal pressure in support of their own individual desires. For example, the development of the boys' love genre of fiction within girls' culture allowed girls to imagine themselves as more active participants in romance than was socially acceptable. Lolitas in turn rebuff the uniforms that are "intrinsic to constructions of identity" (Cambridge 2011, 180) in contemporary Japan by creating a culture in which unique hand-sewn costumes are prized above standardized mass-market clothing. Social position is heavily demarcated through uniforms in Japan. School uniforms are extremely common, and after graduation workers don industry-, company-, and job-specific uniforms that mark their roles in society. Lolitas may dress in the standardized uniforms of Japanese culture during working hours, but Lolita enables them to journey to their own private Wonderland in their off-hours.

Stemming from the girls' culture tradition yet participated in by young and old, male and female, Lolita exemplifies what Masafumi Monden calls "the unstable nature of 'masculinity'" (2015, 9) in Japan today and how it is enabled by *Alice*'s liminality. Men like the author Novala Takemoto, *visual kei* musician

164 Chapter 5

Mana, and fashion designer Hiro'oka Naoto achieved global success through their support of and engagement in Lolita. Novala Takemoto achieved his greatest success with *Kamikaze Girls* (*Shimotsuma monogatari*, 2002), a novel about a Lolita's friendship with a female biker. *Kamikaze Girls* was adapted into a film and a manga, and all three iterations were later released in the United States. Mana is best known as the guitarist for the *visual kei* band Malice Mizer, but he also designs the Moi-même-Moitié line of Lolita fashions. All of Malice Mizer's members dressed in costumes that might be categorized as Lolita, but Mana particularly contests existing patterns of gendered clothing. Drawing on the kabuki theater's history of *onnagata*, or men who played female roles, Mana used his fantastical performance costumes to craft a gender-fluid public image. As with the male-Alice manga, *Alice*'s liminality enables Mana's gendered boundary crossing through the Lolita costumes and culture. *Alice*'s use here becomes subtle to the point of obscurity. Those on the lookout will notice how Moi-même-Moitié's Gardenia Apron resembles that of Disney's animated Alice—particularly in advertising photographs that feature it with a blue, A-line dress and black Mary Jane shoes on a blond model—but viewers unaware of Lolita's origin in *Alice* may not make the connection. Likewise, Moi-même-Moitié's partnership with the illustrator and manga artist Mitsukaz Mihara is founded on a shared preference for not only Lolita fashion, but also its basis in *Alice*. The *Alice* at the heart of Lolita can be quite subtle, but its shadowy presence strengthens whenever the border between two media is transgressed. Thus, though Hiro'oka Naoto's eponymous h.NAOTO punk/Lolita fashion line rarely references *Alice* visually, its in-house digital fashion magazine is named *Jabberwocky*. Japanese masculinity may be unstable, but Japanese men's adaptation of *Alice* through Lolita enables them to fuse clashing gender norms into coherent artistic visions.

Lolita filtered into Japanese culture and industry more widely through its own mix of media. There was clothing, obviously, but also photography, which then appeared in fashion magazines like *Gothic & Lolita Bible* (*Goshikku ando rorīta baiburu*, 2000–2017) and *FRUiTS* (1997–2017). The magazines contained columns by authors like Novala Takemoto and illustrations by artists like Mitsukaz Mihara (plate 11), which led to Lolita's movement into the novel, film, and manga media. Lolita fashion lines such as Baby, the Stars Shine Bright and Putumayo opened their own storefronts, which constitute a medium in and of themselves. Perhaps inspired by stores like these, restauranteurs opened themed restaurants that align with the Lolita aesthetic and its basis in *Alice*. Diamond Dining Group alone opened six *Alice* restaurants. Each restaurant has a slightly different theme, but all share elaborate, Lolita-esque detailing and uniformed Alices who wait upon the tables (plate 12). As a medium's primary reason for

Detecting *Alice* on Page, Screen, and Street 165

existence strays farther from self-expression, the Lolita layer falls away, leaving *Alice* behind. In contrast to Diamond Dining's uniformed Alices and ostentatiously Lolita-esque interior design, a small *Alice*-themed bar near Nakano Broadway, a Tokyo-area mall that is a mecca for fans of *dōjinshi* and anime, has little to do with Lolita. The interior of the bar is stuffed with plastic figures of characters from various manga and anime, while popular action anime play on a television in the corner. Yet, the lone bartender wears an *Alice* costume created for Lolitas. She lets slip in conversation that she applied for her job because she likes to dress as Alice. *Alice* is the essence, Lolita the stylish trappings.

As Lolita transformed from subculture to popular culture, the anti-uniformity at its heart dissipated, leaving only the visual style and *Alice* behind. Stylized restaurants clothe staff in flattering, but mandatory, Alice uniforms. Lolita comes to function as a set of *Alice*-ian visual conventions in the popular imagination.[16] The two main magazines behind Lolita, *Gothic & Lolita Bible* and *FRUiTS*, both folded in 2017 despite the continuing popularity of the Lolita aesthetic. *Gothic & Lolita Bible* appealed to Lolitas themselves with clothing patterns, interviews, and literature as well as photo spreads, so its closure reflects a dearth of consumers interested in actively participating in the Lolita subculture. Meanwhile, *FRUiTS*' founder, the street fashion photographer Shōichi Aoki, closed *FRUiTS* because he found it increasingly difficult to find a sufficient number of fashionable people on the street to fill *FRUiTS*' pages (Aoki 2017).

The waning of the subversive Lolita was matched by the spread of Lolita style in popular visual media like restaurants and manga. *Alice* comes to the fore in these new, twenty-first century adaptations of the Lolita style, which update how *Alice* is visualized. Lolita-style *Alice* works emphasize decorative details more than earlier imagery by the likes of John Tenniel and the Walt Disney Company. Lace, ruffles, patterns—in particular, stripes and checkerboards—appear more frequently, and characters are provided with more accessories. Men's participation in Lolita fashion furnished a style for depicting *Alice*'s male characters: slimline three-piece suits in black, white, and red with decorative details like ruffled plackets, accessorized with pocket watches. Both male and female characters are arrayed in a wide variety of headgear (as depicted in plate 11).

Three Lolita-style *Alice* worlds prompted a resurgence of *Alice* mysteries within manga and other popular visual media. Yana Toboso's *Black Butler* (*Kuroshitsuji*, 2006–present) depicts the young British earl cum detective Ciel Phantomhive as he tracks down his parents' murderers with the aid of a demon (plate 13).[17] Jun Mochizuki's *Pandora Hearts* (*Pandora Hearts*, 2006–2015) follows another young English nobleman, Oz Vessalius, who must solve the mystery of why he was cast into the Abyss by the Baskerville family. *Are You Alice?* (*Ā yū*

166 Chapter 5

Arisu?, 2008–2015) follows an amnesiac young man's journey through Wonderland in search of his identity.[18] Centering on male Alices searching fantastical environments for the reasons why they were horribly mistreated, these early Lolita-style *Alice* manga set the stage for more conventional, if still Lolita-style, *Alice* mystery manga.

The 2010s produced a slew of mysteries that adapted the Lolita-style *Alice* to reinvigorate the Orthodox tradition. Lolita-style *Alice* manga artists fully embraced the erotic grotesque nonsense of early Japanese mystery authors like Edogawa Ranpo. Ranpo's Phantom Thief evolves into the *Lovely Phantom Thief Alice* (*Uruwashi kaitō Arisu*, illustrated by Atsushi Suzumi, story by Romio Tanaka, 2010–2012), an impoverished orphan who transforms into the phantom thief Alice to "steal" enslaved fairies away to freedom. Ichi Kurage's *Gaitō Alice* (*Gaitō Arisu*, literally, "Corpse Thief Alice," c. 2015–2016) reiterates the male Alice trope in a tale about Hikaru Arisugawa, a boy who enters Dreamland as the phantom Corpse Thief Alice to steal the demons that cause humans to feel despair. Manga like *Lovely Phantom Thief Alice* and *Gaitō Alice* embrace the fantastical, dark elements of the early Japanese Orthodox mystery tradition through stock characters like the Phantom Thief. Because the Phantom Thief developed a heart of gold over the intervening decades, mystery manga are able to portray grotesque situations like slavery without disturbing readers by casting Phantom Thieves in the role of protagonist/savior. Intricate, Lolita-esque visual designs develop a sensuality that can read as erotic depending on an artist's needs. Finally, explicitly calling on *Alice* allows creators to sidestep the (fantastical) Orthodox/(realistic) Society debate that dominates prose Japanese mysteries. Instead, these new manga *Alice* mysteries use *Alice*'s liminality to suggest that a mystery's fantastical elements are merely part of another world—the world of fairies or demons—that only Alice can directly access.

Manga's maintenance of the Orthodox tradition in all its odd glory through Lolita-style *Alice* worlds parallels the mystery's development in another medium, the light novel. Light novels are a specific type of popular prose fiction that developed in the 1970s in Japan. Often serialized in a magazine prior to publication as a novel, these books of genre fiction are crafted as quick, easy reading for teenagers and young adults. They are often published in series of novels that mimic the plot progression of the hero series, that is, each novel presents and solves a smaller dilemma, but the protagonist faces an overarching issue that is not resolved for several novels. Light novels are illustrated in the manga style and often contain a set of full-color illustrations at the start of each collected volume. The worlds depicted in light novels are often also adapted into anime, CDs, and manga. The Japanese literary establishment treats light novels differently than

Detecting *Alice* on Page, Screen, and Street 167

other forms of fiction; the medium's focus on easy reading, genre fiction, and equality of imagery and text seem to mark it as lacking seriousness. In consequence, light novels are effectively shut out of prestigious literary awards.[19]

The prose Orthodox tradition finally comes to its gloriously over-the-top fruition in Hidehisa Nanbō's light novel trilogy, Alice in Gothicland (Arisu in Goshikkurando, illustrations by Ryō Ueda, 2011–2012). Set in a Victorian England where Sherlock Holmes is real, Alice in Gothicland follows Jeremy Griffith, a young nobleman and Scotland Yard detective, and Ygraine Holmes, Sherlock's younger, equally talented sister, as they investigate a series of murders. The titular Alice is a girl whom Jeremy first saves and then falls in love with despite her second personality, the Hyde-like murderer Jill. The series' casual adaptation of the world of Sherlock Holmes, insertion of fantastical elements and characters like *Peter Pan*'s Captain Hook and Mr. Smee, and use of the Lolita style to add visual drama all reflect the Orthodox school of mysteries as it developed in manga.[20] Nanbō merges these aspects of the Orthodox manga mystery with the techniques that Alice Arisugawa developed as part of the New Orthodox school of prose mystery. Like Arisugawa, Nanbō regularly cites other mysteries, and each chapter of Alice in Gothicland is followed by a one-page index that explains these citations so that readers can further explore the mystery canon. Where Arisugawa ends his books with a special Cheshire Cat sigil, Nanbō begins each chapter with a special Alice in Gothicland symbol (figure 5.1b). Nanbō explicitly notes the date and location of the events that take place in each chapter so that readers can form their own deductions, and he inserts an interlude chapter before revealing certain types of information. Finally, he ends the Alice in Gothicland books with an afterword supposedly written by "Hidehisa Nanbō, Griffith family butler" (2011, 1:255), suggesting that "Hidehisa Nanbō" is as much of a character as Alice Arisugawa. Alice in Gothicland unites the divergent strains of the manga and prose Orthodox mystery traditions with the New Orthodox prose mystery tradition even as its light novel form is a union of the manga and prose fiction media.

Alice and the Mundanity of Mysteries

Alice has long been adapted into the mystery genre. Its liminality makes it a perfect match for the shadowy, known-unknown specter who did . . . whatever it was that was done. Though foreign *Alice* mysteries circulated in Japan for many years, Japanese mystery creators only began to craft *Alice* mysteries in earnest after the Japanese mystery world split in two over the question of realism (and Society mysteries) or erotic grotesque nonsense (and Orthodox mysteries). The

Figure 5.1 (a) Alice Arisugawa's Cheshire Cat emblem as printed on the final page of *The English Garden Mystery* anthology (1997) and (b) Hidehisa Nanbō's Alice in Gothicland symbol as it appeared in the series' first volume, *The Master Pirate in the Misty Capital* (2011).

realists pushed *Alice* mysteries out of straightforward prose mystery fiction and into first genre-crossing prose fiction like Hirose's *Alice in Mirrorland*, then mystery manga like *CLAMP School Detectives*.

When the realists of prose mystery fiction provoked their own inevitable backlash, the young writers behind it brought back both *Alice* and the Orthodox style. The New Orthodox school is based in a very cerebral appreciation of mysteries' logic puzzles, but its authors were canny enough to know that a simple listing of facts does not literature make. Thus, Masahide Uehara based his career on both the Orthodox style and *Alice*. *Alice* granted his mysteries a sense of mystery, as it were, stripped of which they could devolve into blandness. Uehara further drew on *Alice*'s liminality to bridge fiction and reality, allowing Alice Arisugawa to take on jobs in the real world. Arisugawa's accomplishments in reality are in and of themselves an argument for why it is so important to study not just a work of art in a medium, but the overall media environment in which we live.

While Uehara merged *Alice* into his new conception of the Orthodox in prose fiction, the old Orthodox mystery tradition that had developed by merging with American superhero comics evolved in its own way. This Orthodox tradition was based in an assumption that new fictional worlds should be produced in as many media as possible. In fact, the livelihoods of artists and companies working in many popular media now depend on the adaptation of their worlds into multiple media. Meanwhile, creators have developed a shared set of famous mystery characters from assorted worlds that might be drawn upon in the construction of new worlds. CLAMP built a reasonably successful set of connected

Detecting *Alice* on Page, Screen, and Street 169

mysteries by adapting several of these shared characters, but they had to adapt *Alice* to first, fully connect their manga, and second, extend those manga to new media, such as anime and the photobook.

This promiscuous, popular media-based evolution of the Orthodox mystery tradition has drawn in even more media in the twenty-first century. By adapting not just *Alice*, but the Lolita world within the *Alice* universe, mystery writers working in the light novel medium were able to merge the Japanese mystery tradition as it had developed in popular media with the New Orthodox style of prose mystery fiction. *Alice* mysteries thus multiply at key inflection points in the history of the Japanese media environment. When the relationships between media are in flux, new media are introduced, or creators are attempting to connect aspects of different media, *Alice*'s liminality allows it to connect what was with what is coming into existence. There is nothing in particular about the narratives associated with *Alice* that would lead to its joining Kogorō Akechi, *Twenty Masks*, and the rest as a regular feature in Japanese mysteries. Rather, the world's ability to link disparate elements has made it indispensable in the modern Japanese media environment for this vibrant but divisive genre.

CHAPTER 6

In Conclusions

I hope that I have been able to convey the breadth and depth of *Alice*'s Japanese incarnations in this book. It is certainly an overwhelming body of work. Though I have included as much as I could, the absences stand out in much the same way that silhouettes of Alice draw our attention to her absence. Nonetheless, there does come a point when the pen must be laid down and the text allowed to see the light of day. There also comes a point when, no matter how fascinating you find Alice in Wonderland, you really want to see something—anything—else. That point arrived for me while I was finishing this manuscript.

I decided to take a break from *Alice* by watching *Kuroko's Basketball*, a smash hit anime from a decade back that I had never found the time to watch. It is a fairly standard entry in the genre of sports anime, which track a middle or high school student working their way toward and then winning some sort of national competition in a given sport. The titular Kuroko is an average boy who by his very normality seems to disappear among the tall, charismatic players on the basketball court. As part of an overwhelmingly strong middle school basketball team, he exploited his lack of magnetism to steal balls with unnerving aplomb. However, the series begins in high school with Kuroko's brilliant teammates dispersed to different schools and different teams. The crux of the story is Kuroko's quest to prove the value of his style of basketball, which relies on cooperative play rather than individual excellence, by beating his former teammates.

The television series concludes with Kuroko's inevitable victory and his old teammates' equally inevitable realization that Kuroko was right about the value of teamwork, but the series' success earned it a victory lap: a stand-alone theatrical film called *Kuroko's Basketball the Movie: Last Game* (*Gekijō-ban Kuroko no basuke rasuto gēmu*, 2017). *Last Game* is basically an excuse to show the star players of the TV series' various teams playing together on a single team. Its story begins with an ill-mannered but skilled and physically intimidating American street basketball team utterly destroying a Japanese team at an exhibition match and then throwing racist insults at Japanese basketball and the Japanese people in general. This monstrous team is called Jabberwock. After thirty volumes of

In Conclusions 171

manga, seventy-five episodes of an anime series, five spinoff novels, three direct-to-video anime shorts, and three theatrically released films compiling key scenes from the television series—all of it refreshingly unrelated to my immediate research—*Kuroko's Basketball* adapted *Alice*.

Adapting *Alice*'s famed monster for the street ball team is a shrewd move. The five members of Team Jabberwock are unknown to viewers, unlike the characters who previously appeared on the television series. Fleshing out all five new players' characters is unrealistic within the limited run time of a film. They are instead largely treated as a single unit. They appear on screen as a single group, behave similarly, and speak in much the same way. Jabberwock players consistently refer to Japanese people as "monkeys" ("*saru*"), for example, in contrast with the established characters' different attitudes and use of varied terms toward Jabberwock. The Jabberwock name efficiently characterizes this team as a monstrous antagonist, which is really all viewers need to know about its members.

Jabberwock's horrific behavior spurs Kuroko and his most-skilled friends to band together in a highly attended revenge match in a major arena, which constitutes the bulk of the film. This serendipitous team names itself the Vorpal Swords. As the announcer explains prior to the game's opening, the team's name "derives from the sword that defeated the monster Jabberwock when it appeared in *Through the Looking-Glass, and What Alice Found There*. That name is . . . Vorpal Swords!!!!" ("*Kagami no kuni no Arisu ni tōjō suru kaibutsu, Jabberwock wo taosu tsurugi ni yurai suru. Sono na ha . . . Vorpal Swords!!!!*").

The announcer's detailed explanation of the origin of the Vorpal Swords' name functions to ensure that no viewer misses the connection to *Alice* . . . which implies that some viewers might *not* have recognized the adaptation of *Alice* without an explanation. There are certainly other worlds that could be adapted to set up the invading bad guy–defending good guy duality. Devils and Angels, for example, would need no explanation. Creating the same dichotomy through *Alice* means drawing on less-famous aspects of the world. The invasive monster Jabberwock is not as renowned as the murderous Queen of Hearts, but the former implies a foreign threat compared to the latter's domesticity. Our heroes in turn are cast as militant Vorpal Swords rather than as the world's mannerly heroine, Alice, who merely reads a poem about the Jabberwock. So again, why adapt *Alice*?

As *Last Game* overturned my attempt to evade *Alice* for a while, I realized that I had never really escaped it at all. The entire point of *Kuroko's Basketball* is that liminality will emerge victorious over brute strength. Kuroko's style of basketball is positioned as being pro-teamwork throughout the series, but that style centers on the absent presence of Kuroko himself. Other characters constantly

172 Chapter 6

refer to his presence as "faint" ("*usui*"), and the series' comedy largely comes from other characters' outsized reactions to suddenly realizing that Kuroko is or is not present. Kuroko's negligible presence enables him to disappear from other players' perception on the court. Since no one senses his presence, no one tries to stop him when he steals the ball and passes it to his teammates. Kuroko is a brilliant basketball player because he is able to flutter into and out of other players' fields of vision. In other words, Kuroko is Alice. The explicit citation of *Alice* in *Last Game* is not a new adaptation so much as closing the loop on the main theme of *Kuroko's Basketball* world.

Liminality and *Alice*

Liminality is a key feature of contemporary culture. The digital world is often understood as a liminal space that connects to but is separate from the physical world. Trains, planes, and automobiles all function as transitional spaces for their occupants. Liminality surrounds us through security check points, rites of passage, doorways, disputed territories, gender transitions, and other transitions between and crossings over of borders. These liminal forms and spaces are becoming ever more important due to the basic structure of the media environment in which we live. The contemporary media environment consists of countless media interpolated around each other, such that we simultaneously experience multiple worlds. Media fill many liminal spaces in the form of televisions, posters, and smart phones, and mediatic worlds help us work through liminal experiences like rites of passage and gender transitions.

It is only natural that contemporary cultural production would investigate the forms taken by liminality and how it affects us. Art can indicate liminality in a variety of ways. An illustration of a shadow or silhouette on its own demonstrates that something exists even as the illustration withholds that something from our view. Mirrors reflect what lies before them, but in reverse, so that we see the mirror as lying between two different spaces, two different worlds. Mystery fiction is based on consumers' awareness of a forthcoming solution before the problem is even explained. Bridges cross various thresholds—rivers, train tracks, roads. Artists turn to tropes of liminality, such as ghosts and planes, to describe and react to the liminality of the contemporary world.

Liminality is even more central to contemporary Japanese media due to the basic structure of Japan's media environment, which adopted media mix production processes earlier and more thoroughly than other media environments. Modern Japanese culture has been marked by an explosion of genres and media. Individual creators earn astonishingly little for their creations in some of Japan's

In Conclusions 173

best-known media, including anime and manga. Today's most successful creators devise worlds geared for success in multiple media so that they can stack licensing fees and royalties together to increase their earnings from each new creation. In turn, the editors, producers, and other media industry professionals responsible for getting those worlds to market achieve success according to their skill at finding worlds fit for their media and collaborating with their peers to adapt those worlds at the proper time and price point. The many people involved in creating a world's media mix naturally have their own opinions, needs, and goals, which can propel the world's adaptations in opposing directions. As worlds expand across media, spaces open up between different iterations of each media mix. Further, consumers apply merchandise and create their own adaptations to connect their personal environments to other worlds of their choosing.

Alice has become omnipresent in this multiply liminal media environment. It has been adapted into films and television shows, fine art and makeup, clothing and food. Its adaptations have spawned their own media mix worlds, making *Alice* not so much a world as a universe. The overall body of Japanese *Alice* adaptations is incredibly diverse. Some adaptations include Alice but not the Mad Hatter. Others include playing cards, tea sets, and roses, but no characters. Some fall into the horror genre; others are gentle comedies. *Alice* can be visualized grotesquely, surreally, or childishly. The endless creativity that Japanese artists have applied to *Alice* made it difficult to connect Akutagawa's *Kappa* to Kusama's Infinity Mirror Rooms to Masahide Uehara's "Alice Arisugawa" identity. Consequently, *Alice*'s ever-presence in the Japanese media environment has been consistently underestimated. Carrollians have noticed that something unusual is going on with *Alice* in Japan, though they tend to frame it in terms of *Alice*'s popularity or the literary value of Carroll's books rather than in terms of the contemporary Japanese media environment and its needs. Still, suggestions of liminality appear, as when Zoe Jaques and Eugene Giddens note that the body of Japanese *Alice* adaptations "crosses boundaries" (2016, 227).

The superficial dissonance between Japan's myriad *Alice* adaptations obscures the fact that the Alice in Wonderland world is bound together not by a narrative or character, not by a medium or style, but by the concept of liminality. No one aspect of *Alice*, including the titular character herself, is necessary for an adaptation to provoke consumers into understanding it as an adaptation of *Alice*. The adaptation must, however, indicate liminality. Some of *Alice*'s popularity in Japan is due to local factors, like the twentieth- and twenty-first century preoccupation with the figure of the girl and Japan's more recent fixation with Victorian England as a symbolic stand-in for the Japanese Empire. However, *Alice* did not become central to Japanese culture merely because it is about a Victorian

174 Chapter 6

girl. The liminality at the heart of *Alice* is perfectly attuned for the media-rich contemporary moment. *Alice*'s liminality bridges the gaps between media, genres, nations, and time periods to exact a unifying force on the multi-mediated products that dominate today's media landscape. Moreover, Alice's ability to safely traverse dangerous lands subtly implies that consumers can and will navigate our own world, of whose dangers we are increasingly made aware by those same proliferating media.

Liminality and ... *Alice?*

Reviewing literature on liminality and liminal aspects of the contemporary media environment with detailed knowledge of the global body of *Alice* adaptations in mind leads to some rather interesting results. Knowingly and unknowingly, intellectuals draw on *Alice* adaptations to construct and frame their arguments. Heather Warren-Crow explicitly builds her analysis of the "malleability, transmediation, and instability" (2014, xiv) of digital images through studies of *Alice* adaptations. The cover of the second edition of Linda Hutcheon's seminal study of adaptation encapsulates its content with an image of Alice placing a tire over Tweedledee as they stand on a bridge in New York City (2013). More subtly, Henry Jenkins uses a case study of The Matrix world (an adaptation of *Alice*) to unfold his theory of transmedia storytelling. Jenkins connects the two for readers, but for him *Alice* constitutes only a few of "the film's endless borrowings" (2008, 100). At other times, authors do not connect *Alice* to their work at all. Satomi Saito's analysis of how Japanese publishing evolved within the digital realm is organized around Reki Kawahara's Sword Art Online series of online novels. Saito describes Sword Art Online as depicting

> a twisted relationship between the real world and the virtual—an imaginary world that irreducibly traps—literally and figuratively—[characters'] bodies and minds. Their awareness of belonging to multiple worlds—but not belonging to any one world—exemplifies recent trends in imaginary world-making and echoes the business of cross-media franchise. (2015, 144)

Saito ties Sword Art Online directly to the contemporary media environment and a liminal state of simultaneous existence in multiple worlds. Yet, he does not mention that the ninth volume of Sword Art Online launched a multivolume *Alice* story called "Alicization" (2016). Steven T. Brown likewise analyzes *Serial Experiments Lain*'s (dir. Ryūtarō Nakamura, 1998) treatment of "e-mail as an

uncanny gateway to another world" that creates a "blurring of boundaries" and an "electronic presence" (2010, 167) with no acknowledgment that the series is part of screenwriter Chiaki J. Konaka's well-known "'Alice' series" (Margherita Long 2007, 159). I point out these lacunae not because I think scholars ought to always note connections to *Alice* in our work, but as evidence of how *Alice*'s liminality makes it easy for us to simply overlook it. Neither Saito nor Brown is discussing *Alice*, fantasy, Victorian literature, or any number of other cultural categories to which *Alice* is commonly ascribed, so why would they identify it?

The same liminality that enables us to gloss over *Alice* so easily allows *Alice* to bind our infinitely proliferating media together into media environments full of works created by individuals who themselves are bound into networks by *Alice*. This is true of below-the-line employees of companies like Disney and Aniplex, who collaborated on the *Twisted Wonderland* game described in chapter 1. It is also true of above-the-line creators like Walt Disney himself, creator of the Alice Comedies (1923–1927) series of live-action short films as well as the 1951 animated film. One of the artistic influences behind the film was Disney's fellow *Alice* lover, Salvador Dalí (Salisbury 2016, 98). Disney and Dalí had struck up a friendship based on a mutual appreciation for each other's art. They attempted to make a film together in 1945, but it fell through. Their collaboration seems to have borne fruit later though, in the form of Disney's *Alice* film and Dalí's 1969 series of *Alice* illustrations. Dalí was also "on friendly terms" (Kusama 2011, 174) with Yayoi Kusama, who herself engaged in a long-term relationship with *Alice*-lover Joseph Cornell. Cornell produced several *Alice* works, including *A Pantry Buffet (for Jacques Offenbach)* (1942), which adapts the Lobster Quadrille sequence of *Alice's Adventures* while perhaps also being "a tribute to Dalí's *Lobster Telephone* (c. 1936)" (Waldman 2002, 64). Artists, like companies, connect through *Alice* and are driven to produce more *Alice* art.

Ultimately, *Alice*'s liminality greases its spread from medium to medium, artist to artist, even as it binds them all together into something resembling a cohesive whole. This book has focused on the Japanese media environment, but as these final examples of artistic circles demonstrate, neither *Alice* nor the networks it creates are limited to Japan. Japanese artists like Yana Toboso work with Americans at Walt Disney Company, which earlier worked with the Spanish Dalí. Japanese *Alice* novels like Sword Art Online are adapted into anime by the American company Netflix and then streamed around the world. Japanese *Alice* media are increasingly consumed across the globe in part because those aspects of the Japanese media environment that encourage the spread of *Alice* are increasingly part of global media environments. Understanding Japanese *Alice* adaptations consequently prepares us to understand how humanity's experience

176 Chapter 6

of its media environments will develop in the future. On that note, let me conclude by examining one last Japanese adaptation of *Alice*.

Many *Alice* adaptations conclude that despite the liminal environment in which we live, we can ultimately achieve a happy ending, the ultimate cessation of transition. Yet, the fact that *Alice* continues to be adapted at a great clip suggests the conclusion of *Alice in Borderland* (*Imawa no kuni no Arisu*, 2020) may be more apt. The Netflix adaptation of Haro Asō's hit manga depicts a young man named Alice drawn into another world where he must risk his life playing dangerous games if he wants to survive. Alice survives, but the series ends in classic horror style with Alice drawn into a new set of games. Like Alice, we may complete one transition, but we can never end the process of transitioning. Life is liminal.

Appendix
Japanese *Alices*

The Japanese section of Byron Sewell, Mark Burstein, and Alan Tannenbaum's Pictures and Conversations: Lewis Carroll in the Comics: An International Annotated Bibliography *(2005) lists several more manga.*

Akutagawa, Ryūnosuke. *Kappa: Gulliver in a Kimono.* Translated by Seiichi Shiojiri. Osaka, Japan: Akitaya, 1948.

——. *Kappa.* Translated by Geoffrey Bownas with an Introduction by G. H. Healey. Vermont: Charles E. Tuttle Company, 1990.

Akutagawa, Ryūnosuke, and Kan Kikuchi. *Arisu Monogatari.* Tōkyō: Kōbunsha, 1927.

Alice=Alice: Alice in the Forbidden World: Drama CD. Tōkyō: Rejet, 2013.

Alice=Alice: Alice in the Forbidden World: 1: Kuro usagi. Tōkyō: Rejet, 2013.

"Alice Hotel & Healing Spa." Alice Hotel & Healing Spa. f Garden Group, last modified November 30, 2020. http://f-garden.co.jp/alice/.

Alice in the Country of Hearts. Tōkyō: QuinRose, 2007.

> The first in a long-running series of games wherein gamers play Alice as she journeys through a Wonderland filled with attractive male characters like the Mad Hatter, the White Rabbit, and the Cheshire Cat. Players' goal is to enter into a romantic relationship with one of these characters. See also entries for Komaki, Shirakawa, and Tateyama.

"Amateur Theatrical Performance by Children." *Japan Weekly Mail* (Yokohama, Japan), May 31, 1890.

> Write-up of a theatrical performance of a one-act play entitled "Alice in Wonderland" in aid of Yokohama's Bluff Gardens on May 25, 1890. "Alice in Wonderland" was the second performance of the event; it followed "Little Red Riding Hood." The event was put on by an international audience intent upon charitable activities. No Japanese children seem to have

178 Appendix

performed, and it is unclear whether any Japanese people attended the performance.

Animēshon Carol vijuaru bukku. Tōkyō: CBS/SONY Publishing, 1990.

Arisugawa, Alice. *Suuēden kan nazo.* Tōkyō: Kōdansha, 1995.

———. *Burajiru chō no nazo.* Tōkyō: Kōdansha, 1996.

———. *Eikoku teien no nazo.* Tōkyō: Kōdansha, 1997.

———. *Jurietto no higeki.* Tōkyō: Kōdansha, Joy Novels, 2000.

———. *Akai tori ha yakata ni kaeru: Arisugawa Arisu esseī shū.* Tōkyō: Kōdansha, 2003.

———. *Nazo ha tokeru kata ga miryokuteki: Arisugawa Arisu esseī shū.* Tōkyō: Kōdansha, 2006.

———. *The Moai Island Puzzle.* Translated by Ho-Ling Wong. N.p.: Locked Room International, 2016.

Alice Arisugawa (or "Arisu" Arisugawa in Japanese) is the pen name of Masahide Uehara. Arisugawa is also a character of Uehara's creation; Arisugawa participates in various mysteries, which he then recounts in the books published under his name. Uehara also publishes essays under Arisugawa's name/through the persona of Arisugawa. *Alice* mainly appears in Uehara's novels through the Arisugawa character, but Uehara has adapted *Alice* in other ways as well. *Eikoku teien no nazo* (1997) contains the short story "Jabberwocky" ("Jabauokkii," originally published in 1996). All volumes feature an emblem of the Cheshire Cat surrounded by the phrase "Alice in Mysteryland" at the end of the text. At the moment, Uehara's only novel available in English is *The Moai Island Puzzle.* Originally published in 1989 by Tōkyō Sogensha Co., Ltd., *The Moai Island Puzzle* is Arisugawa's second to feature the amateur detective Jirō Egami.

Arisu misuterī kessakusen. Ed. Hideo Nakai. Tōkyō: Kawade bunko, 1988.

Asagiri, Kafka (story), Neco Kanai (art), and Sango Harukawa (character design). *Bungo Stray Dogs WAN! 1.* Translated by Kevin Gifford. New York: Yen Press, 2022.

A parody of the manga series *Bungo Stray Dogs*, Kanai adapts *Alice* for an interstitial illustration in *WAN!*

Bessatsu gendaishi techō dainigo: Ruisu Kyaroru, vol. 1 issue 2. Tōkyō: Shinchosha, 1972.

Betsuyaku, Minoru. *Fushigi no kuni no Arisu: Dai ni gikyokushū*. Tōkyō: San-Ichi Shobō, 1970.

A collection of six plays and an equal number of songs by absurdist playwright Minoru Betsuyaku (also known as Minoru Becchaku) centering on Alice. The fifth play, *Alice in Wonderland*, together with another not in this collection earned author the 1971 Kinokuniya Theater Award. Betsuyaku is also notable for having been born in Japanese-occupied Manchuria.

Carroll & Alice: "Fushigi no kuni no Arisu" ten. Ed. Aputo intānashonaru and Takashi Teraoka. N.p.: Aputo intānashonaru, 1993.

CLAMP. *Man of Many Faces: 1*. Translated by Ikoi Hiroe. Los Angeles: Tokyopop Manga, 2003. Published in Japan, 1990.

———. *Man of Many Faces: 2*. Translated by Ikoi Hiroe. Los Angeles: Tokyopop Manga, 2003. Published in Japan, 1991.

———. *CLAMP School Detectives: 1*. Translated by Ray Yoshimoto. Los Angeles: Tokyopop Manga, 2003. Published in Japan, 1992.

———. *CLAMP School Detectives: 2*. Translated by Ray Yoshimoto. Los Angeles: Tokyopop Manga, 2003. Published in Japan, 1993.

———. *CLAMP School Detectives: 3*. Translated by Ray Yoshimoto. Los Angeles: Tokyopop Manga, 2003. Published in Japan, 1993.

———. *Miyuki-chan in Wonderland*. Translated by Ray Yoshimoto. Los Angeles: Tokyopop Manga, 2003. Published in Japan, 1993.

———. *Tokyo Babylon Photographs*. Tōkyō: Kabushikigaisha Shinshokan, 1996.

———. *All about CLAMP*. Tōkyō: Kadokawa shoten, 2006, 2009, 2018.

———. *Cardcaptor Sakura: Clearcard: 3*. Translated by Devon Corwin. New York: Kodansha Comics, 2018. Published in Japan, 2017.

———. *Cardcaptor Sakura: Clearcard: 4*. Translated by Devon Corwin. New York: Kodansha Comics, 2018. Published in Japan, 2018.

———. *Cardcaptor Sakura: Clearcard: 5*. Translated by Devon Corwin. New York: Kodansha Comics, 2018. Published in Japan, 2018.

———. *Cardcaptor Sakura: Clearcard: 6*. Translated Erin Procter. New York: Kodansha Comics, 2019. Published in Japan, 2019.

———. *CLAMP in Cardland: Kōshiki kādo katarogu: Irreplaceable Book*. Tōkyō: The Upper Deck Company, 2008.

———. *Okimono Kimono*. Milwaukie, OR: Dark Horse Manga, 2007.

CLAMP's manga are discussed in chapters 4 and 5. *Cardcaptor Sakura: Clearcard*, sequel to manga collective CLAMP's blockbuster series

180 Appendix

Cardcaptor Sakura (1996–2000), sees the titular protagonist Sakura dealing with a new problem in her quest to master magic. Sakura's difficulties relate to a book entitled *Alice in Clockland* that one of the characters tells us "has a different author from that of the more famous *Alice in Wonderland* and *Through the Looking-Glass*. But it is quite good" (vol. 3, 102).

Fushigi no kuni no Arisu. Translated by Yukio Mishima. Tōkyō: Akane shobō, 1955.

Mishima, a famous author who ultimately committed suicide after a failed attempt to get the Japanese military to overthrow the Japanese government, seems to have translated the book according to his own whims. He omitted much of Carroll's scientific and mathematical humor, leaving a very slim volume. Carroll's name is even omitted from the book until a brief mention in a note at the end of the text!

Golduhr. *Alice in Narrlant Odoke no kuni no Arisu*. N.p.: n.p., 2019.

A self-published *dōjinshi* that merges *Alice* with the attitude (and bright colors) of the jester. Artist also goes by the name Micho. This *dōjinshi* is an example of new, digital distribution methods used by *dōjinshi* artists. Golduhr advertises the volume on Pixiv, an image-sharing website, and sells it through Alice-Books.com. It is unclear if Golduhr has sold the volume in person at a *dōjinshi* convention.

Gothic & Lolita Bible 56 (2015).

While all issues of *Gothic & Lolita Bible* qualify as *Alice* adaptations due to the Gothic & Lolita subculture's originary adaptation of *Alice,* this issue is particularly representative: its theme is "stylish Alice things" ("*oshare Alice no koto*").

Harada, Chiyoko. "*Arisu no doriimurando*." Ririka, August 1977.
Haruchika~ Haruta to Chika ha seishun suru~. Directed by Masakazu Kusumoto. 2016. Nantoshi, Toyama Prefecture: P.A. Works, 2016.

Episode ten of this series features the protagonists solving a minor mystery with clues from Alice in Wonderland (in particular, the phrase, "through the looking-glass" and the name Jabberwocky).

Japanese *Alices* 181

Hāto no kuni no Arisu ~Wonderful Wonder World~: Kōshiki bijuaru fanbukku. Tōkyō: enterbrain, 2007.

Hatori, Bisco. 2005. *Ouran High School Host Club: 4.* Translated by Gary Leach. San Francisco, CA: Viz Media LLC.

Hino, Matsuri. *MeruPuri 2.* Translated by Priscilla Yin. San Francisco: Viz Media, 2005.

An author's note discusses Hino's adaptation of *Alice* for one chapter and the cover of one volume in this series.

Hirai, Takako. *Alice in Calendarland: 2016.* Tokyo: Ehonkan, n.d.

Imai, Testuya. *Alice & Zoroku: Volume One.* Translated by Beni Axia Conrad. Canada: Seven Seas Entertainment, 2013.

Ina, Soraho. *Fairy Tale Battle Royale: Volume One.* Translated by Molly Rabbitt. Canada: Seven Seas Entertainment, 2018.

Comic book series about a teenage girl named Aoba Kuninaka who escapes brutal bullying through the pages of *Alice's Adventures in Wonderland.* One day, a paper appears in front of her offering her one wish in exchange for taking on the role of Alice in *Alice's Adventures.* From that point on, she must balance her everyday life with the strange Dark Fairy Tale world populated by zombie versions of the characters from various fairy tales, children's stories, and fables.

Ishikawa, Yugo. *Wonderland: Volume One.* Translated by Molly Rabbitt. Canada: Seven Seas Entertainment, 2018.

Iwai, Shunji, dir. Series of six Nestlé Kit Kat commercials, 2003.

———. *Hana and Alice (Hana to Arisu).* 2004; N.p.: Rockwell Eyes, 2007.

———. *The Case of Hana and Alice (Hana to Arisu Satsujin Jiken).* 2015; NY: GKids, 2015.

Iwai, Shunji, created by. Story and art, Dowman Sayman. *The Case of Hana and Alice (Hana to Arisu Satsujin Jiken).* 2015; Tōkyō: Shōgakukan, 2015.

Iwai, Shunji, created by. Written by Otsuichi. *The Case of Hana and Alice (Hana to Arisu Satsujin Jiken).* Tōkyō: Shōgakukan, 2015.

The Hana and Alice world has an interesting trajectory. When Nestlé hired the esteemed writer-director Shunji Iwai to film a series of commercials celebrating Kit Kat's thirtieth anniversary, Iwai created a dreamy set of short films about two girls, Hana (Anne Suzuki) and Alice (Yū Aoi). Iwai found the world so inspirational that he ended up creating a

182 Appendix

feature-length film about them. Yet, he could not let go of the world. He made a prequel film, *The Case of Hana and Alice,* using the same actors. Since they were too old to be believable by that point, Iwai turned to rotoscoping to create his first anime. *The Case of Hana and Alice* was produced in media mix fashion with an accompanying manga and a novelization by the trendy author Otsuichi.

Kaishaku. *Eternal Alice Rondo 2.* Translated by Gretchen Kern. Fremont, CA: DrMaster Publications Inc., 2007.

——. *Eternal Alice Rondo 3.* Translated by Gretchen Kern. Fremont, CA: DrMaster Publications Inc., 2007.

——. *Eternal Alice Rondo 4.* Translated by Gretchen Kern. Fremont, CA: DrMaster Publications Inc., 2007.

Kanou, Ayumi (art) and Visualworks (story). *I am Alice?: Body Swap in Wonderland: Volume One.* Translated by Jocelyne Allen. Canada: Seven Seas Entertainment, 2014.

Katagiri, Ikumi. Story by Ai Ninomiya. *Are You Alice? 1.* Translated by Alexis Eckerman. New York: Yen Press, 2013.

——. *Are You Alice? 2.* Translated by Alexis Eckerman. New York: Yen Press, 2013.

——. *Are You Alice? 3.* Translated by Alexis Eckerman. New York: Yen Press, 2013.

——. *Are You Alice? 4.* Translated by Alexis Eckerman. New York: Yen Press, 2014.

——. *Are You Alice? 5.* Translated by Alexis Eckerman. New York: Yen Press, 2014.

Kawahara, Reki. *Sword Art Online: Alicization Beginning.* Translated by Stephen Paul. New York: Yen On, 2012.

Kawasaki, Daiji. *Fushigi no kuni no Arisu.* Illustrated by Seiichi Yuno. Tōkyō: Dōshisha, 1992.

Reprint of two 1965 *kamishibai* (or paper theater) plays that retell *Alice's Adventures* in two parts. The set is made so that while the audience sees a picture on the front card, the story teller can read the story for that card off the back of the previous card. Kawasaki was a member of the proletarian children's literature movement, and Yuno was a successful painter who eventually became a major force in the world of illustrations for children's literature.

Kingdom Hearts. Square Enix. First game, 2002.

A long-running series of video games that merge characters from the Walt Disney Company's animated films and Square Enix's flagship *Final Fantasy* series of video games.

Japanese *Alices* 183

Kinoshita, Sakura. *The Mythical Detective Loki Ragnarok: 2*. Translated by Eiko McGregor. Houston, TX: ADV Manga, 2003.

——. *Alice in Wonderland Picture Book*. Tōkyō: Gentōsha Kommikusu, 2006.

Kittaka, Yumie. *Fushigi no kuni no Arisu*. Tōkyō: Kin no hoshi sha, 1990.

Komaki, Momoko. *Hāto no kuni no Arisu: Tokeijikake no Kishi*. Tōkyō: Ichijin-sha, 2008. Novel. See entry for *Alice in the Country of Hearts*.

Konaka, Chiaki J., dir. *Alice 6*. 1995. Live-action film.

——. *Serial Experiments Lain*. 1997. Anime television series.

——. *Fun-Fun Pharmacy*. 1998–1999. Anime television series.

——. *Malice@Doll*. 2001. Original Video Animation.

——. *Digimon Tamers*. 2001–2002. Anime television series.

Konaka, Chiaki J., written by. *Alice in Cyberland*. Directed by Kazuyoshi Yokota. 1996; N.p.: Guramusu kabushikigaisha, 1996. CD. Video game.

Screenwriter Chiaki J. Konaka is famous for the cult hit anime *Serial Experiments Lain*, but few viewers realize that not only was it an adaptation of Alice in Wonderland, it was only one of a series of *Alice* works Konaka released. Scholars Margherita Long ("*Malice@Doll*: Konaka, Specularization, and the Virtual Feminine," 2007) and Susan Napier ("When the Machines Stop: Fantasy, Reality, and Terminal Identity in 'Neon Genesis Evangelion' and 'Serial Experiments Lain,'" 2002) have analyzed Konaka's *Alice* works.

Kusumoto, Kimie. *Hon'yaku no kuni no Arisu: Ruisu Kyaroru hon'yakushi, hon'yakuron*. Tōkyō: Michitani, Co. Ltd, 2001.

Kusuyama, Tadao. *Fushigi no kuni*. Tōkyō: Katei dokubutsu kankōkai, 1920.

Kyaroru, Ruisu. 2013. *Fushigi no kuni no Arisu. With artwork by Kusama Yayoi*. Hon'yaku: Kusumoto Kimie. Tōkyō: Kabushikigaisha gurafikkusha.

Mahō shōjo nantemō ī desu kara. Directed by Kazuhiro Yoneda. PINE JAM, 2016.

March Hare Tea Party Club. *Arisu Bukku I*. Ed. by Norie Masuyama. Tōkyō: Shinchosha, 1991.

——. *Arisu Bukku II*. Ed. by Norie Masuyama. Tōkyō: Shinchosha, 1991.

Märchen Maze (Meruhen meizu). Namco, 1988. Video game.

Mari, Anna. *Ningyō no kuni no Arisu*. Tōkyō: Shōgakukan, 2015.

Matsukuni, Mika, dir. *Futome no kuni no Arisu*. 2012. Tōkyō: Toriuddo sutajio purojekuto, 2012.

Mihara, Mitsukazu. *Arisu chūdoku*. Tōkyō: Indekkusu magajinzu, 2002.

——. "Alice in Underground." In *chocolate*, pp. 97–100. Tōkyō: Indekkusu maga-jinzu, 2005.

184 Appendix

Miyazaki, Hayao, dir. *My Neighbor Totoro.* New York: GKids, 2017. DVD.
———. *Spirited Away.* New York: GKids, 2017. DVD.

These two films by Japan's best-known anime director, the brilliant Hayao Miyazaki, are often said to have been inspired if not outright adapted from *Alice.* In a book about Miyazaki's oeuvre, Jeremy Mark Robinson repeatedly compares both films to *Alice.* Of *Totoro,* he notes that "the *Alice's Adventures in Wonderland* affinities are clear: the Cat-bus has a giant grin like the Cheshire Cat (and sits in a tree like the Cheshire Cat), and can disappear like the Cat; Mei chases the little Totoro like the White Rabbit; and the entrance to the magical camphor tree is along a tunnel (Mei falls down the hole in the tree's roots like Alice at the beginning of *Alice's Adventures in Wonderland*" (202). Regarding *Spirited Away,* he asks, "Wouldn't it be amazing to see Hayao Miyazaki take on *Alice's Adventures in Wonderland* and *Through the Looking-Glass?* Actually, he has: it's this movie. . . . This is Miyazaki's take on Lewis Carroll" (339). Whether these films are full-blown adaptations of *Alice* or merely bricolages is unclear, but the clear relationship merits their being mentioned here.

Mizushiro, Setona. *Black Rose Alice: 1.* Translated by John Werry. San Francisco: Viz Media, 2008.
———. *Black Rose Alice: 2.* Translated by John Werry. San Francisco: Viz Media, 2009.
———. *Black Rose Alice: 3.* Translated by John Werry. San Francisco: Viz Media, 2009.
———. *Black Rose Alice: 4.* Translated by John Werry. San Francisco: Viz Media, 2010.
———. *Black Rose Alice: 5.* Translated by John Werry. San Francisco: Viz Media, 2011.
Mochizuki, Jun. *Pandora Hearts: 2.* Translated by Tomo Kimura. New York: Yen Press, 2010.
———. *Pandora Hearts: 4.* Translated by Tomo Kimura. New York: Yen Press, 2011.
———. *Pandora Hearts: 5.* Translated by Tomo Kimura. New York: Yen Press, 2011.
———. *Pandora Hearts: 8.* Translated by Tomo Kimura. New York: Yen Press, 2012.
———. *Pandora Hearts: 9.* Translated by Tomo Kimura. New York: Yen Press, 2012.

Japanese *Alices* 185

———. *Pandora Hearts: 11*. Translated by Tomo Kimura. New York: Yen Press, 2012.

———. *Pandora Hearts: 12*. Translated by Tomo Kimura. New York: Yen Press, 2012.

———. *Pandora Hearts: 13*. Translated by Tomo Kimura. New York: Yen Press, 2012.

———. *Pandora Hearts: 14*. Translated by Tomo Kimura. New York: Yen Press, 2013.

———. *Pandora Hearts: 15*. Translated by Tomo Kimura. New York: Yen Press, 2013.

———. *Pandora Hearts: 17*. Translated by Tomo Kimura. New York: Yen Press, 2013.

———. *Pandora Hearts: 18*. Translated by Tomo Kimura. New York: Yen Press, 2013.

———. *Pandora Hearts: 19*. Translated by Tomo Kimura. New York: Yen Press, 2013.

———. *Pandora Hearts: 20*. Translated by Tomo Kimura. New York: Yen Press, 2014.

———. *Pandora Hearts: 21*. Translated by Tomo Kimura. New York: Yen Press, 2014.

———. *Pandora Hearts: 22*. Translated by Tomo Kimura. New York: Yen Press, 2014.

———. *Pandora Hearts: 23*. Translated by Tomo Kimura. New York: Yen Press, 2015.

———. *Pandora Hearts: 24*. Translated by Tomo Kimura. New York: Yen Press, 2016.

Mochizuki, Jun (created and illustrated by) and Shinobu Wakamiya (written by). *Pandora Hearts: Caucus Race*. Translated by Taylor Engel. New York: Yen On, 2015.

Nanbō, Hidehisa. *Arisu in goshikkurando: Kiri no miyako no daikaizoku*. Tōkyō: Kadokawa bunko, 2011.

———. *Arisu in goshikkurando: Kaitō shinshi to daiseitō no hihō*. Tōkyō: Kadokawa bunko, 2011.

———. *Arisu in goshikkurando: Kyūketsuki Dorakyura*. Tōkyō: Kadokawa bunko, 2012.

———. *Karei naru tantei Arisu & Pengin*. Tōkyō: Shōgakukan junia bunko, 2014.

———. *Karei naru tantei Arisu & Pengin: Gōsuto Kyasuru*. Tōkyō: Shōgakukan junia bunko, 2020.

———. *Karei naru tantei Arisu & Pengin: Mirā Rabirinsu*. Tōkyō: Shōgakukan junia bunko, 2015.

———. *Karei naru tantei Arisu & Pengin: Wandā chenji!*. Tōkyō: Shōgakukan junia bunko, 2014.

———. *Karei naru tantei Arisu & Pengin: Uerukomu Mirārando*. Tōkyō: Shōgakukan junia bunko, 2021.

———. *Karei naru tantei Arisu & Pengin: Ritoru ridoru Arisu*. Tōkyō: Shōgakukan junia bunko, 2020.

186 Appendix

———. *Karei naru tantei Arisu & Pengin: Misuteriosu naito.* Tōkyō: Shōgakukan junia bunko, 2016.

———. *Karei naru tantei Arisu & Pengin: Fanshī fantajī.* Tōkyō: Shōgakukan junia bunko, 2019.

———. *Karei naru tantei Arisu & Pengin: Arabian dēto.* Tōkyō: Shōgakukan junia bunko, 2017.

———. *Karei naru tantei Arisu & Pengin: Arisu VS. Hōmusu!.* Tōkyō: Shōgakukan junia bunko, 2016.

———. *Karei naru tantei Arisu & Pengin: Pāti pāti.* Tōkyō: Shōgakukan junia bunko, 2017.

———. *Karei naru tantei Arisu & Pengin: Toraburu Haroin.* Tōkyō: Shōgakukan junia bunko, 2015.

———. *Karei naru tantei Arisu & Pengin: Hōmusu in Japan.* Tōkyō: Shōgakukan junia bunko, 2018.

———. *Karei naru tantei Arisu & Pengin: Uicchi Hanto!.* Tōkyō: Shōgakukan junia bunko, 2018.

———. *Karei naru tantei Arisu & Pengin: Samā torejā.* Tōkyō: Shōgakukan junia bunko, 2015.

———. *Karei naru tantei Arisu & Pengin: Pengin Panikku!.* Tōkyō: Shōgakukan junia bunko, 2016.

Nanbō wrote two series of *Alice* mystery books, the gothic Lolita-style *Alice in Gothicland* (*Arisu in goshikkurando*) for young adults, and the children's series *Beautiful Detective Alice & Penguin* (*Karei naru tantei Arisu & Pengin*).

Niwa, Haruki (art), and Mai Mochizuki (story). *Alice in Kyoto Forest 1.* Translated by David Bove. Marina del Ray, CA: Tokyopop, 2022.

Okada, Tadataka. *Kagami no kuni no Arisu.* Tōkyō: Kadokawa Bunko, 1959, 1975.

Translation of *Looking-Glass*. The book bears an afterword by Kadokawa Bunko's founder, Gen'yoshi Kadokawa. Gen'yoshi would make Kadokawa Bunko into a major force in the Japanese publishing industry, after which his son, Haruki Kadokawa, would innovate what is today called the media mix style of multimedia production.

Okazaki, Kyoko. *Pink.* New York: Vertical, Inc., 2013.

Oshimi, Shuzo. *Welcome Back, Alice 1.* Translated by Daniel Komen. New York: Kodansha, 2020.

Ōtomo Katsuhiro. *Henzeru to Gurēteru*. Tōkyō: Sony Shuppan, 1981.

An anthology of classic tales like Snow White and the titular Hansel and Gretel, this book contains a short adaptation of *Alice's Adventures* that is inflected by communism (through the White Rabbit's Mao suit). While the artist, Ōtomo, has published many manga, he is best known as the screenwriter and director behind the global hit anime *Akira* (1988, based on his manga of the same name, 1982–1990). Ōtomo is a member of the French Ordre des Arts et des Lettres at the Officier rank (the same rank held by Yayoi Kusama). He has been inducted into the Eisner Award Hall of Fame and granted the Grand Prix de la ville d'Angoulême for his manga, while his directorial efforts earned him the Winsor McKay Award.

Oya, Chiki. "Okashina na kuni no Arisu." Ririka, August 1978.

Oyamada, Hiroko. *The Hole*. Translated by David Boyd. New York: New Directions, 2020.

Sakamoto, Maaya. *Shōnen Arisu*. CD. Saku, henkyoku: Yōko Kanno. 2003. Victor. Entertainment.

Titled *Boy Alice,* Maaya Sakamoto's fourth studio album features the entrancing love song "Makiba Arisu," or "Pasture Alice." Sakamoto is a successful voice actress and singer. She has acted in many *Alice* adaptations: the video games *Sword Art Online: Alicization Lycoris* ("Administrator," 2020) and the *Kingdom Hearts* series ("Aerith Gainsborough," 2002; 2005; 2007), and the anime *Black Butler* ("Ciel Phantomhive," 2008–2010; 2014; 2017), *Code Geass: Akito the Exiled* ("Leila Malkal," 2012; 2013), *Alice in Borderlands* ("Saori Shibuki," 2014), *Reservoir Chronicle: Tsubasa* ("Tomoyo," 2005–2006; 2009), and *Ouran High School Host Club* ("Haruhi Fujioka," 2006). She has also provided songs for the soundtracks of *Alice* anime *Cardcaptor Sakura: Clear Card Arc* (2018) and *Reservoir Chronicle: Tsubasa* (2005–2010). Perhaps Sakamoto's early *Alice* album should have been a hint. The album was composed and arranged by the highly regarded Yōko Kanno, whose many works include songs for CLAMP's *X/1999, CLAMP School Detectives,* and *Cardcaptor Sakura*.

Sakuma, Yui. *Complex Age: Volume One*. Translated by Alethea Nibley and Athena Nibley. New York: Kodansha USA Publishing, 2016.

Shirakawa, Sana. *Kurōbā no kuni no Arisu: Howaito kōringu*. Tōkyō: Ichijinsha, 2009.

———. *Kurōbā no kuni no Arisu: Puromisu redo*. Tōkyō: Ichijinsha, 2010.

———. *Jōkā no kuni no Arisu: Shīzu obu rōzu*. Tōkyō: Ichijinsha, 2010.

188 Appendix

Novels. See entry for *Alice in the Country of Hearts*.

Suzumi, Atsushi. *Uruwashi Kaitō Arisu: 1*. Tōkyō: Dengeki comikkusu, 2011.

Takayama, Hiroshi. *Arisu gari*. Tōkyō: Shunjusha, 2008.

Takemiya, Keiko. *Watashi wo Tsuki made Tsuretette!: 2*. Tōkyō: Shōgakukan, 1982.

The "Have a Tea-Party with Jabberwock!" ("Jabbāwokku to ochakai wo!") chapter of this book follows the series' protagonist on a trip to Wonderland by way of an amusement park. Takemiya also contributed a one-shot manga to the March Hare Tea Party Club's *Arisu Bukku*.

Tateyama, Midori (author). *Hāto no kuni no Arisu: Rōzu tī pātī*. Tōkyō: Ichijinsha, 2008.

———. *Kurōbā no kuni no Arisu: Gādian gēmu*. Tōkyō: Ichijinsha, 2009. Novels. See entry for *Alice in the Country of Hearts*.

Terayama, Shūji. *The Crimson Thread of Abandon: Stories*. Translated by Elizabeth L. Armstrong. Portland, ME: MerwinAsia, 2014.

Tsuda, Masami. *Kare Kano: His and Her Circumstances: 2*. Translated by Amy Forsyth. Los Angeles: Tokyopop, 2003.

Tsuda, Mikiyo. *Princess Princess Premium*. Tōkyō: Shinshokan, 2007.

An art book for the manga *Princess Princess*. (*Princess Princess* is about a boys' high school whose cheerleaders dress up as women.) Tsuda drew the protagonists costumed as Alice surrounding a stuffed bunny wearing a top hat, waistcoat, and watch. Tsuda returns to the cover in her editorial manga near the end of the book as well, explicitly stating that the image's theme was *Alice*.

Uchida, Yasuo. *Karuizawa no kiri no naka de*. Tōkyō: Kadokawa bunko, 1995.

Watase, Yū. *Arisu 19th: vol. 1*. Tōkyō: Kabushikigaisha Shōgakukan, 2001.

———. *Arisu 19th: vol. 2*. Tōkyō: Kabushikigaisha Shōgakukan, 2002.

———. *Arisu 19th: vol. 3*. Tōkyō: Kabushikigaisha Shōgakukan, 2002.

———. *Arisu 19th: vol. 4*. Tōkyō: Kabushikigaisha Shōgakukan, 2002.

———. *Arisu 19th: vol. 5*. Tōkyō: Kabushikigaisha Shōgakukan, 2002.

———. *Arisu 19th: vol. 6*. Tōkyō: Kabushikigaisha Shōgakukan, 2003.

———. *Arisu 19th: vol. 7*. Tōkyō: Kabushikigaisha Shōgakukan, 2003.

Wonderful Wonder Book: Alice Archives: Greencover~ hāto & kurōbā & jōkā no kuni no Arisu SS & irasuto shū. Edited by Kabushikigaisha heddo rūmu. Tōkyō: Ōzora shuppan, 2010.

Yabūchi, Takahiro. *In Wandārando.* Tōkyō: Beam Comix, 2010.

Yuki, Kaori. *Alice in Murderland: Volume One.* Translated by William Flanagan. New York: Yen Press, 2015.

———. *Alice in Murderland: Volume Two.* Translated by William Flanagan. New York: Yen Press, 2015.

———. *Alice in Murderland: Volume Three.* Translated by William Flanagan. New York: Yen Press, 2015.

———. *Alice in Murderland: Volume Four.* Translated by William Flanagan. New York: Yen Press, 2016.

———. *Alice in Murderland: Volume Five.* Translated by William Flanagan. New York: Yen Press, 2016.

———. *Alice in Murderland: Volume Six.* Translated by William Flanagan. New York: Yen Press, 2017.

———. *Alice in Murderland: Volume Seven.* Translated by William Flanagan. New York: Yen Press, 2017.

———. *Alice in Murderland: Volume Eight.* Translated by William Flanagan. New York: Yen Press, 2017.

———. *Alice in Murderland: Volume Nine.* Translated by William Flanagan. New York: Yen Press, 2017.

———. *Alice in Murderland: Volume Ten.* Translated by William Flanagan. New York: Yen Press, 2018.

———. *Alice in Murderland: Volume Eleven.* Translated by William Flanagan. New York: Yen Press, 2018.

———. *The Cain Saga: Forgotten Juliet: 1.* Translated by Akira Watanabe. San Francisco: Viz Media, 2006.

———. *The Cain Saga: The Sound of a Boy Hatching: 2.* Translated by Akira Watanabe. San Francisco: Viz Media, 2006.

———. *The Cain Saga: Kafka: 3.* Translated by Akira Watanabe. San Francisco: Viz Media, 2007.

———. *The Cain Saga: The Seal of the Red Ram Part 1: 4.* Translated by Akira Watanabe. San Francisco: Viz Media, 2007.

———. *The Cain Saga: The Seal of the Red Ram Part 2: 5.* Translated by Akira Watanabe. San Francisco: Viz Media, 2007.

———. "The God of Never Never." In *Neo Parasyte f,* 78–111. New York: Kodansha Comics, 2015.

———. *Godchild: 1.* English adaptation by Trina Robbins, translated by Akira Watanabe. San Francisco: Viz Media, 2006.

———. *Godchild: 2.* English adaptation by Trina Robbins, translated by Akira Watanabe. San Francisco: Viz Media, 2006.

190 Appendix

——. *Godchild: 3.* English adaptation by Trina Robbins, translated by Akira Watanabe. San Francisco: Viz Media, 2006.

——. *Godchild: 4.* English adaptation by Trina Robbins, translated by Akira Watanabe. San Francisco: Viz Media, 2007.

——. *Godchild: 5.* English adaptation by Trina Robbins, translated by Akira Watanabe. San Francisco: Viz Media, 2007.

——. *Godchild: 6.* English adaptation by Trina Robbins, translated by Akira Watanabe. San Francisco: Viz Media, 2007.

——. *Godchild: 7.* English adaptation by Trina Robbins, translated by Akira Watanabe. San Francisco: Viz Media, 2007.

——. *Godchild: 8.* English adaptation by Trina Robbins, translated by Akira Watanabe. San Francisco: Viz Media, 2008.

——. *Grand Guignol Orchestra: Volume One.* Translated by Camellia Nieh. San Francisco: Viz Media, 2009.

——. *Grand Guignol Orchestra: Volume Two.* Translated by Camellia Nieh. San Francisco: Viz Media, 2009.

——. *Grand Guignol Orchestra: Volume Three.* Translated by Camellia Nieh. San Francisco: Viz Media, 2009.

——. *Grand Guignol Orchestra: Volume Four.* Translated by Camellia Nieh. San Francisco: Viz Media, 2010.

——. *Grand Guignol Orchestra: Volume Five.* Translated by Camellia Nieh. San Francisco: Viz Media, 2010.

——. *Tenshi Kinryoku Angel Gate.* Tōkyō: Hakusensha, 1997.

——. *Tenshi Kinryoku Lost Angel.* Tōkyō: Hakusensha, 2000

Yurīka (*Eureka*) 657. Tokyo: Seidosha, 2015. "150nenme no 'Fushigi no kuni no Arisu.'"

—— 663. Tokyo: Seidosha, 2015. "Kaneko Kuniyoshi."

—— vol. 3, issue 3. Tokyo: Seidosha, 1978. "Haniya Yutaka."

—— vol. 8, issue 7. Tokyo: Seidosha, 1976. "Shururearisumu."

Each month, the magazine *Yurīka* (i.e., *Eureka*) contains essays, art, poetry, and other materials on a given theme. *Alice* is clearly popular with *Yurīka's* editorial staff, having prompted a special issue on the 150th anniversary of the publication of *Alice's Adventures*, as well as regular themed issues on Lewis Carroll (not listed here) and the *Alice*-focused painter Kuniyoshi Kaneko. *Alice* has also been the subject of essays in other issues, such as the 1976 issue on Surrealism and a 1978 issue devoted to the author Yutaka Haniya.

Notes

Chapter 1: A Re-introduction

1. "Alice in Wonderland" and "*Alice*" are both used in this text to refer to the world in question, except when a specific adaptation titled "Alice in Wonderland" is being specified (i.e., the 1951 animated Disney film *Alice in Wonderland*).

2. *Alice* is also popular fodder for film in the United States and Britain. The all-star *Alice in Wonderland* of 1933 (dir. Norman McLeod) is particularly amusing; its cast features W. C. Fields, Cary Grant, Gary Cooper, and more Hollywood stars.

3. Japan has produced a host of *Alice* computer games. Beginning with *Märchen Maze* (*Meruhen meizu*, 1988), games both forgettable and iconic have been launched featuring *Alice*. The two most prominent are both series: Square Enix's *Kingdom Hearts* (first game, 2002) and QuinRose's *Alice in the Country of Hearts* (first game, 2007). Both series include several installments on assorted platforms and have been adapted into manga and other media.

4. It is impossible to include every notable *Alice* adapter. In particular, actors have been almost entirely ignored here. If further evidence is needed, please see Angela Carter, Rudyard Kipling, Aldous Huxley, Ellery Queen, Agatha Christie, Dorothy Sayers, Joseph Cornell, Jorge Luis Borges, A. A. Milne, Diana Thater, Alice Rahon, the Right Honourable Bertrand Russell, Ralph Steadman, Arthur Rackham, Beatrix Potter, Walt Kelly, and Louise Nevelson.

5. While *Through the Looking-Glass* appeared on the market in 1871, the first edition's title page is actually dated 1872. The former date is given above, as the books' circulation is the subject of this study.

6. Lest it be mistaken as a typo, let me here explain that "unlogic" is a technical term. It refers to something that appears illogical or off, but actually has an internal logic. Wonderland and its residents display unlogic rather than illogic. They think things through quite rationally, but because they pay a high degree of attention to the way that words work, their reasoning often leads them to conclusions that strike readers as strange. As Patricia Meyer Spacks notes, "Through what appears to be mere verbal play, Carroll succeeds in suggesting that the apparent chaos of the dream-world is less disorderly than the lack of discipline in the real world, that the problem of appearance and reality has to do with value as well as perception" (1971, 268).

7. For simplicity's sake, the books will be referred to in future as follows: *Alice's Adventures (Alice's Adventures in Wonderland), Looking-Glass (Through the Looking-Glass, and What Alice Found There), Nursery Alice (The Nursery Alice), Under Ground (Alice's Adventures Under Ground)*, and *Snark (The Hunting of the Snark: An Agony in Eight Fits)*. The year 2015, the 150th anniversary of the publication of *Alice's Adventures*, saw the publication of many *Alice* books in Japan, including multiple translations of *The Nursery Alice*. It is probable that

192 Notes to Pages 13–26

this has spread awareness of this particular book, but it is still a minor work compared to both *Alice's Adventures* and *Looking-Glass*.

8. Ōtsuka uses a variety of simple terms interchangeably to define his two terms. *Sekai*, worldview (*sekaikan*), program (*puroguramu*), software (*sofuto*), order (*chitsujo*), system (*shisutemu*), and grand narrative (*ookina monogatari*) form one set; *shukō*, small narrative (*chiisana monotagatari*), individual product (*kobetsu no shōhin*), thing (*mono*)—in the sense of Jean Baudrillard's thing-as-sign—and original work (*gensaku*) the other. This book uses only *sekai* and *shukō*. Translations from Ōtsuka's text are thus the author's own, but Marc Steinberg's translation (in Ōtsuka 2010) maintains the nuances of the original.

9. Similar to Bourriaud's later concept of postproduction in art.

10. The numbers can also be quite tricky. Japanese publishers tend to print books in small runs, which means that popular books can ultimately be published in many editions. By way of example, Toshi Tanaka's 1955 translation of *Alice's Adventures in Wonderland* was printed for the fifty-seventh time in 1999 (*Alice in a World of Wonderlands* 2015). I have strived to strip new editions from my own calculations of the number of *Alice* translations, but it is not possible to achieve either complete certainty or precisely comparable numbers as far as Japanese translations of other books are concerned.

11. Carroll's copyright lapsed in 1907, and none of the Japanese translations published prior to that date seem to have been produced with any thought for Carroll's rights.

12. Translation scholar Susan Bassnett (2014) details how this process worked in the realm of translation.

13. While the United States' Academy of Motion Picture Arts and Sciences offered Oscars for Best Writing (Original Story) and Best Writing (Adaptation) from its very first ceremony in 1929, most grantors of film awards began with a single award for best writing. Thus this new respect for adaptation amongst filmmakers often meant expanding from one annual award for best screenplay into two awards, one for best screenplay and the other for best adapted screenplay. The Australian Film Institute split its award in 1978, with Taiwan's Golden Horse Film Festival and Awards close on its heels in 1979. Britain's BAFTA Award for Best Screenplay divided in 1983, while France's Académie des Arts et Techniques du Cinéma was a bit late with its 2006 split of the César award. The USC Scripter Awards were created specifically to celebrate adapted film screenplays in 1988, with a second award created for adapted television screenplays in 2016. In theater, the Tony Award for Best Revival was divided into awards for Best Revival of a Musical and Best Revival of a Play in 1994. Awards were established later for the comics medium than for film and theater. The Harvey Awards offered an award for Best American Edition of Foreign Material in 1988, the year of their establishment. The Will Eisner Comic Industry Awards, which were also established in 1988, did not initially have a specific award for adaptation, but ten of the eleven awards granted were explicitly for adaptations; the final award was the induction of artist Milton Caniff into a Hall of Fame. Today the Eisners offer ten awards explicitly for adaptations (Best Reality-Based Work, Best Graphic Album— Reprint, Best Adaptation from Another Medium, Best U.S. Edition of International Material, Best U.S. Edition of International Material—Asia, Best Archival Collection/Project—Strips, Best Archival Collection/Project—Comic Books, Best Comics-Related Periodical/Journalism, Best Comics-Related Book, and Best Academic/Scholarly Work).

14. Over the past few years, some small, professional imprints that publish *dōjinshi* anthologies have appeared on the market. Each anthology collects comics and stories by a variety of artists adapting a single video game, anime, or other property. It is not clear what

Notes to Pages 30–45 193

these publishers' relationships are to the manga companies whose work they are using, but there are hints that rights-holders are either receiving royalties or directly subcontracting these publications of supposedly amateur works. Additionally, some companies are producing their own lines of manga anthologies themed on their properties which blur the lines between *dōjinshi* and manga.

15. Articles about *Alice* also appeared in magazine issues devoted to apparently unrelated topics. For example, the author Shirō Hasegawa published "Lewis and Alice" ("Ruisu to Arisu," 1978) in a special issue of the magazine *Eureka* that was dedicated to the author and critic Yutaka Haniya despite the fact that Haniya does not seem to have had any particular relation to either Carroll or *Alice*.

16. As part of the Ronettes.

17. Yui Sakuma's *Complex Age* (*Komupurekkusu ēji*, 2014–2015) exemplifies this while adapting *Alice*. *Complex Age* shows the pains that cosplayers take to not only dress as the characters they portray, but also act like the character would while in public. The series' protagonists undergo discomfort, pain, and fatigue in order to bring their characters to life. Sakuma situates the cosplay subculture as a descendant of the earlier Gothic Lolita subculture, which is analyzed in chapter 5.

Chapter 2: Ryūnosuke Akutagawa in the Shadow of Early *Alice* Translations

1. Modern Japanese literature has a strong tradition of collaboration between artists in the form of ghostwriting. Further, Kensuke Kōno points out that any given ghostwritten work could be seen as "a collaborative enterprise" (2018, 63) between two authors who differed in their levels of success and seniority, but who nonetheless respected each other's work. This tradition is worthy of greater study, but it is not relevant here as the Akutagawa-Kikuchi translation was not produced in this manner.

2. It is worth noting that literature rewritten in this fashion, like the NewSouth edition of *Huckleberry Finn* edited by Alan Gribben, is also a type of translation. Modern English versions of the Old English *Beowulf* (c. 700–1000) or Geoffrey Chaucer's Middle English *The Canterbury Tales* (c. 1400) may be easier to recognize as translations, but Gribben's *Finn* clearly functions as one of Indra Levy's "hybrid languages" (2006). One might also consider the evolving fairy tales of the Brothers Grimm in this vein.

3. *Alice* translations in other languages also feature changes to Carroll's books. The most common changes involve inserting local animals for the nonhuman characters (i.e., the cats, caterpillar, walrus, etc.) and dressing characters in local garb. Nancy Sheppard's *Alitji in Dreamland: Alitjinya Ngura Tjukurmanjala* (1992), a translation into one of the aboriginal languages of Australia, features outstanding illustrations with local resonance by Donna Leslie. Alice is nude, per the local custom, and she chases a white kangaroo instead of a white rabbit.

4. This flexibility with the source text declined over time, though it never disappears. In a 1955 translation, Yukio Mishima elided many of Carroll's mathematical and scientific references in favor of a tight focus on Carroll's wordplay.

5. It is unclear why the second *Alice* novel was translated before the first. One suspects that the translators either did not realize that another novel preceded it or did not have access to the first volume, as it would have been more suitable for translation during this time period.

6. Wakabayashi points in particular to red books, or *akahon*, a genre of woodblock-printed picture book for children that was popular from 1662 to roughly 1750 as a predecessor

194 Notes to Pages 45–51

to children's literature. Referring to Joan Ericson's introduction to *A Rainbow in the Desert: An Anthology of Early Twentieth-Century Japanese Children's Literature*, Wakabayashi notes that red books served as primers for schoolchildren rather than as children's literature.

7. The collection in question held twelve books, ten of which Kimbrough describes as "children's picture books" (2015, 112). Of these, three books retell stories about two legendary samurai, Minamoto no Yoshitsune and Benkei. Yoshitsune is depicted as a child within some of these stories, but his childhood within them seems incidental to the authors' greater goal of retelling Yoshitsune and Benkei's legends, which also include tales of Yoshitsune's adulthood. Outside of these appearances, children are not protagonists in these books.

8. Changing conceptions of childhood have naturally had an effect on how *Alice* has been translated throughout its history. Today, translations of the story hew closely to the English novels and their characterization of Alice, but a host of literary adaptations have arisen that use *Alice* tropes to tell new stories. *Alice in Toyland* (*Ningyō no kuni no Arisu*, 2015), Mari Anna's sequel to *Looking-Glass*, is one of the latter. In Mari Anna's novel, Alice is playing with her dollhouse when she suddenly shrinks and is sucked down a mysterious, spiral staircase into Toyland. New characters like Bricks Brocks are introduced as Alice pursues a new, wondrous adventure that draws on the *Alice* world without retelling the narratives of Carroll's novels.

9. For more on the vernacular literature debate, see Indra Levy's *Sirens of the Western Shore: The Westernesque Femme Fatale, Translation, and Vernacular Style in Modern Japanese Literature* (2006).

10. See Indra Levy's introduction to her edited volume *Translation in Modern Japan* (2011) for a concise description of the introduction of Chinese characters to Japan, from which the following explanation is drawn.

11. Called *kanbun kundoku*, this method of writing presents an interesting problem for theorists of translation: since it predates written Japanese—or rather, *was* written Japanese in a time when written Japanese did not correspond with the spoken language—how could *kanbun kundoku* be a "translation"? It was not "translating" one language into another. It merely consisted of a method for reading and annotating Chinese language materials so that Japanese speakers could understand them. The question is not academic; Japanese translations of *Alice* still use many of Carroll's invented English words written out in the katakana syllabary today. In *Alice*'s case, those words are considered loan words or translation words that are arguably part of Japanese.

12. This is suggestive of the general trend toward more realistic young characters in Japanese children's literature described above.

13. As this section analyzes how gendered Japanese terms were used and how their meanings changed over time, those terms are given precedence here over their English translations.

14. Though the magazines are ostensibly divided by gender and age group, actual readerships vary greatly from the official target audience. This is discussed further in chapter 4, but of interest here is the development in Japanese culture of first the idea of the child and then steadily more specific subtypes of child.

15. One of which translations was a revised version of 1908's serialization, Sumako's *Golden Key* (*Kogane no kagi*).

16. Since 1920, Arisu has even become a common name for Japanese girls. *The Name Dictionary* (*Onamaejiten*), a website dedicated to helping parents name their children, lists Arisu as the 104th most popular name for girls. The site also offers an astonishing 135 different ways to write Arisu with *kanji*.

Notes to Pages 52–54 195

17. Sumako was a pen name used by the novelist Shizuo Nagayo. In 1912, Nagayo revisited *Golden Key*, using it as the basis for the stand-alone novel *Alice Story* (*Arisu monogatari*).

18. Publishing data for Korean translations is also drawn from *Alice in a World of Wonderlands* (Lindseth and Tannenbaum 2015), though translations of the Korean titles are the author's own.

19. The role of Carrollians in spreading Carroll's works is difficult to underestimate. For instance, when in the process of creating *Alice in a World of Wonderlands* certain languages were revealed to lack a translation of *Alice*, new translations were commissioned. The sole Hawaiian translations of *Alice's Adventures* and *Through the Looking-Glass* were created in this manner. While this process might seem unnatural at first, it can give rise to unexpected benefits. Keao NeSmith, the Hawaiian language professor and linguist commissioned for the project, has situated his translation as fighting against the extinction of the Hawaiian language. He notes that Hawaiian "is one of the most severely endangered languages in the world today" (in Lindseth and Tannenbaum 2015, 282) and that attempts to save it have included translations of literature into Hawaiian to serve as language learning aids for would-be new speakers.

20. For more on the erotic grotesque in early twentieth-century Japan, see Miriam Silverberg's *Erotic Grotesque Nonsense: The Mass Culture of Japanese Modern Times* (2009).

21. Glenn Shaw, an early translator of Akutagawa's work, calls him "a sort of literary ascetic" who "had more individuality than any other writer of his time" (in Akutagawa 1938, vii). Susan Napier gives Akutagawa the backhanded compliment of "popular but serious" (1996, 14) where Edward Fowler simply calls Akutagawa an "acclaimed short story writer" (1988, 250). Angela Yiu goes into more detail, arguing that Akutagawa "transcend[s] the narrow confines of a single school or movement by virtue of [his] versatility and prolific career" (in Akutagawa 2013, 9–10), while Mark Silver writes that Akutagawa is a "highbrow writer" who became "trapped in the shadow of . . . Western models" (2008, 2).

22. For a nuanced look at political issues that extend across the Taishō and Shōwa eras and their roles in various wars, see Frederick Dickinson's *World War I and the Triumph of a New Japan, 1919–1930* (2013).

23. Interestingly, focusing on Akutagawa's suicide when analyzing his works may have covered up at least one way in which Akutagawa was very much part of wider events in the publishing world—drawing on work by Shizuo Takei and Tatsuya Shōjo regarding a "grueling" lecture tour that the publisher Kaizōsha sent Akutagawa on in May of 1927, Edward Mack suggests that it "may very well have hastened his mental and emotional collapse and subsequent suicide" (2010, 113). This lecture tour was part of the publisher's attempt to reshape the Japanese literature industry as part of the launch of a new series of books.

24. The early translator Glenn Shaw described Akutagawa as "an Oriental saturated with western [sic] literature playing with an old theme in a highly amusing and clever way" (in Akutagawa 1938, v). Beongcheon Yu summed up early critical views of Akutagawa's work in Japan by saying that "his art is all imitation, devoid of a sense of life" (1972, 21) and that "perfect form compensates for insufficient content" (18). Yu notes that this concern with originality in Akutagawa's oeuvre lingered with the Japanese up to the time of Yu's writing in the early 1970s (Yu 1972, 22). More recently, Susan Napier commented that *Kappa* is "problematic," because "it seems to combine aspects of the confessional *shishōsetsu* [genre] within a clearly fantastic genre inspired by both [Jonathan] Swift's *Gulliver's Travels* and Samuel Butler's *Erewhon*" (1996, 191). Even in the new millennium, Seiji Lippit notes that "perhaps the most frequently repeated criticism of Akutagawa's work was its supposed lack of originality" (2002, 42).

196 Notes to Pages 55–68

25. Other adaptations by Akutagawa include "The Ball" ("Butōkai," 1920)—from Pierre Loti's "Un Bal à Yeddo" (1887)—"Rashōmon" from *Konjaku monogatari*, and the early story "Hyottoko." David Fahy notes similarities between "Hyottoko" and Jun'ichirō Tanizaki's "Hōkan" (1989, 624), and it resembles *Dr. Jekyll and Mr. Hyde* in some respects as well. Thomas Beebee and Ikuho Amano suggest that another of Akutagawa's final works, *A Fool's Life* (*Aru ahō no ishō*, 1927) might be considered a pseudotranslation of Johann Wolfgang von Goethe's *Western-Eastern Divan* (*West-östlicher Divan*, 1919).

26. The English name of this novel obscures just how superficially Tanizaki treated Naomi. The Japanese title, *Chijin no ai*, literally means "A Fool's Love," reflecting the novel's focus on its male protagonist and his emotions regarding Naomi over Naomi herself.

27. For more on Akutagawa's life, see Donald Keene's *Dawn to the West* (1984, 556–593).

28. For more on Akutagawa's friendship with Kikuchi, see G. H. Healey's introduction in Bownas's translation of Akutagawa's *Kappa* (Akutagawa 1990) or Glenn Shaw's introduction to *Tales Grotesque and Curious* (Akutagawa 1938).

29. In particular, Kikuchi founded the monthly literary magazine *Bungeishunjū* in 1923. *Bungeishunjū* remains one of Japan's most respected literary magazines today and still nurtures talent in part through an award established by Kikuchi in honor of Akutagawa. The semi-annual Ryūnosuke Akutagawa Prize, commonly called simply the Akutagawa Prize, is awarded to the best work of literature to run in a newspaper or magazine, with winning works republished in *Bungeishunjū*. Since the prize was established in 1935, it has been awarded to a diverse group of authors including Taeko Kōno, Kōbō Abe, Kyoko Hayashi, Kenzaburō Ōe, Miri Yū, Ryū Murakami, Yangji Lee, Kō Machida, and Mieko Kawakami.

30. The title of *Kappa* refers to one of Japan's traditional demons. Kappa are notable for carrying bowls full of water on their heads. For more on kappa, see Michael Dylan Foster, *Pandemonium and Parade: Japanese Monsters and the Culture of Yōkai* (2008) and *The Book of Yōkai: Mysterious Creatures of Japanese Folklore* (2015).

31. More tenuously, Angela Yiu argues that "Wonder Island" ("Fushigi na shima," 1924) is "a draft version" (in Akutagawa 2013, 201) of *Kappa* in various respects, and that this draft is "modeled on *Alice in Wonderland*" (Akutagawa 2013, 201).

32. *Katakana* are reserved primarily for foreign loan words, though they are also used for sound effects.

33. Akira Lippit further notes Carroll's influence in a kappa who lives his life backwards, which Lippit compares to a conversation in which Alice and the White Queen discuss the same concept (2008, 240 n. 46).

34. *Kappa*'s opening and ending sequences, which portray the narrator as mad, show the strongest influence of *Gulliver's Travels*. Nine years after its initial publication, Swift added a trio of prefatory materials to *Gulliver's Travels* that call Gulliver's sanity into question (Seidel 2003, xiii). Though *Gulliver* lacks a closing frame, his madness becomes steadily clearer at the close of the novel as he discusses preferring his horses to his family and servants in a clear satire of the horse-mad British nobility.

35. This study will largely forgo an analysis of these foreign illustrators in favor of a focus on Japanese artists, but it is important to note that foreign artists' work continues to circulate among new readers and influence Japanese artists just as Carroll's writing continues to circulate and influence people in Japan and around the world.

36. Though his surname is Unno, Seikō signed his works "Seikō."

Notes to Pages 70–110 197

37. There was a similar usage of silhouettes in early anime, which declined as animation quality improved.

38. This has begun to change through the work of scholars like Indra Levy, Judy Wakabayashi, Rebecca Copeland, and Elizabeth L. Armstrong.

Chapter 3: Yayoi Kusama, the Modern Alice (Through the Looking-Glass)

1. Quotations from Kusama's first autobiography are taken from the 2011 English translation. The 2002 date is cited in the text here to situate the publication within Kusama's oeuvre and distinguish it from Kusama's second autobiography, which was published in Japanese in 2011. The second book has not been translated into English yet, though it contains materials that Kusama wrote in English (such as press releases for events that took place in America). For the second autobiography, such translations as are present in this article are the author's own.

2. The specific ways in which Kusama referenced and played with Asian, and particularly Japanese, stereotypes is beyond the scope of this work. However, Bert Winther-Tamaki has ably limned the relevant issues in "Six Episodes of Convergence between Indian, Japanese, and Mexican Art from the Late Nineteenth Century to the Present" (2014).

3. The word Kusama uses for world (*sekai*) is the same term used to theorize kabuki's world and variation, as described in the first chapter of this book.

4. Because Japanese lacks the letter "l," one could argue that "-ri" sounds like "-ly," a syllable with which Japanese people are familiar because the school system requires everyone to study English. Read that way, the text suggests that Alice makes "polka dot-ly" (as opposed to Alice making "a pool"). Personally, I feel that that is a bit of a stretch, but it is worth mentioning given the prevalence of wordplay in the text and the fact that I have heard Japanese people make similar "-ly" puns.

Chapter 4: A Profusion of Alices Flutter through Manga for Girls and Boys

1. Yuko Kako is one such case. There does not appear to be any hard evidence behind this assertion, so this author assumes that the translator is indeed of the gender indicated by the name Yuko (i.e., female). It is worth noting that *Alice* translators are not the only Japanese women to have their accomplishments questioned. Mari Kotani, an author, creator, and scholar of science fiction, was accused of having lent her name to a work actually written by her husband, a scholar of English and a famous lover of science fiction, in the 1990s. Her accusers based their assertion on nothing more than how surprised they were that a science fiction book by a female author could be as good as Kotani's novel, *Evangelion as the Immaculate Virgin (Seibo Evangerion)*, was. After many years of litigation, Kotani was victorious in court. However, this type of gossip has the dual effects of hindering women from pursuing careers and hiding the accomplishments of past women in such a way as to make the hard-earned accomplishments of women like Kotani appear suspect.

2. Analysis of translators' gender is hampered by the existence of translations whose creators are unknown and by undated publications. Moreover, it has been suggested that two translators may have been men writing under female pen names. As with Kako Yuko, these suggestions appear to be based on rumors and are thus discounted by this scholar.

3. Though it is less relevant for this project, girls' literary magazines, manga magazines, and *dōjinshi* share certain narrative preoccupations—like an interest in same-sex relationships that at least verge on romantic, if not being outright sexual in nature.

198 Notes to Pages 112–126

4. This series was released in the United States as *Ouran*, rather than Ōran, so that romanization is followed here.

5. Comics artists outside of Japan have also depicted male Alices. American deployments of male Alices, like George Carlson's "Alec in Fumbleland" (1946), tend to be of shorter duration than Japanese male-Alice manga, suggesting that artists were briefly inspired by an idea, but were not drawn to engage with it extensively.

6. The White Rabbit appears in *Alice's Adventures*, where he serves the Queen of Hearts. The Red Queen, often confused with the Queen of Hearts, actually appears in *Looking-Glass*, where she is opposed by the White Queen and the White Knight (among others). Thus, the White Rabbit is either no threat to the Red Queen or serves her (if she is conflated with the Queen of Hearts in a given adaptation). However, the White Knight is inarguably sided against the Red Queen.

7. In addition to the teleporting character, another character named Johannes is depicted as only a smile in an otherwise black panel at one point in a clear reference to the scene where the Cheshire Cat disappears entirely but for his smile.

8. In Izumi Tsubaki's gag manga *Monthly Girls' Nozaki-kun* (*Gekkan shōjo Nozakikun*), a pair of manga artists are harassed into repeatedly incorporating a raccoon-like animal called a *tanuki* into their manga by their *tanuki*-loving editor. Though played for humor, Tsubaki's take on manga production is not fantastical: Sharon Kinsella has documented turn-of-the-century manga editors' hands-on role in story development in her seminal volume, *Adult Manga* (2000), and it is worth remembering that Eiji Ōtsuka was working as a manga editor when he created his narrative consumption theory. Consequently, when something appears repeatedly in a manga artist's oeuvre, especially when that artist has mainly worked with a single publisher as Kaori Yuki has done, it is worth considering where the impetus lies for that thing's inclusion. Yuki began producing *Alice* works while working with the publisher Hakusensha, with whom she worked for most of her career. However, she continued to produce *Alice* manga after switching to the publisher Kodansha in 2010, so it is likely that she herself is the reason Alice reappears throughout her oeuvre. Moreover, Yuki has written about *Alice* regularly in artists' columns, her blog, and other venues. Where other manga are concerned, this volume assumes that the creator named on a manga's cover is indeed responsible for creating the interior material unless evidence is produced to the contrary.

9. "*Dōjinshi*" has two meanings. First, they are individual fan-made works—comics, stories, art, poetry, and even video games—that almost always adapt professionally published manga and other media. However, the various fan works are often collected into single volumes for sale. These volumes of collected *dōjinshi* are also called *dōjinshi*.

10. This description covers the dynamics of the majority of *dōjinshi*, which are the focus of this analysis. There are exceptions, such as when a professional manga artist creates *dōjinshi* of their own manga or an amateur creates their own original *dōjinshi*. However, the vast majority of *dōjinshi* are created by fans of something for other fans' enjoyment. As long as fans do not seem to be profiting at the expense of the work they are adapting, rights-holders in Japan have been content to overlook or even encourage *dōjinshi* artists.

11. The manga *Wotakoi: Love Is Hard for Otaku* by Fujita depicts the amount of effort necessary to create and sell *dōjinshi* through the character of Narumi Momose, a *dōjinshi* artist.

12. A similar process can be observed in Japan with the 1899 film *Momijigari*, which merely contains a section of the titular kabuki play as performed by professional kabuki actors. *Momijigari*'s strength is film's ability to record and replay a performance that not everyone could see in person.

Notes to Pages 126–139 199

13. While exact market sizes of the different publishing industries are not available, this estimate subtracts ICv2's estimate of the 2018 American comics market (Griepp 2019) from the Association of American Publishers' estimate of the American publishing industry's overall net income (Rowe 2019).

14. In fairness, it is collaborative, but most of the labor does not get paid well.

15. Iterative storytelling can be used to refer to an artist refining a story every time they tell it. The Indian theatrical group Indianostrum's production process is a prime example; the troupe develops its storylines and characters as it practices and performs each play such that later performances can differ strikingly from early performances. The group's production of *Janani's Juliet*, an adaptation of *Romeo and Juliet*, develops a commentary on Indian caste discrimination and the treatment of the disabled over the course of its performance run (depicted in Kumar 2019). My usage here differs in that Yuki's *Alices* iterate across discrete manga series. Admittedly, it can be a technical qualification: each staging of *Janani's Juliet* can be viewed as a unique adaptation. However, the individual pieces of each staging—characters, sets, etc.—are connected to each other in a way that Yuki's manga are not.

16. Yuki has used this technique with a few different cultural lodestones—most prominently, Jack the Ripper and Snow White, but *Alice* appears most commonly and in the greatest depth.

17. The Count Cain manga have a complicated publication history. Initially, the titular Count Cain and his butler appeared in self-contained stories. Each of the first eight stories began and ended within a single chapter and without connecting to any of the other Count Cain stories beyond the appearance of one or two shared characters. In fact, Yuki published a two-chapter story in *Cruel Fairytales* before she managed one in what was by then already her longest-running manga. Even after Yuki began writing Count Cain stories that were serialized across multiple chapters, they were organized into short series: *Kafka* (*Kafuka*, 1994) consists of five chapters and only one collected volume, while the two volumes of *The Seal of the Red Ram* (*Akai hitsuji no inshō*, 1994) contain the titular story's eleven chapters and one additional single-chapter story. Count Cain finally turned into a regularly published series with the eight-volume masterpiece of mellifluous murder known as *Godchild* (*Goddochairudo*, 2001–2004). Here, "Count Cain series" refers to the entirety of manga by Yuki about Count Cain. Individual volumes and series are referred to by the volume name (i.e., *Godchild* 1), while specific chapter titles are put in quotation marks (i.e., "Elizabeth in the Mirror").

18. My thanks to Franziska Kohlt for sighting Yuki's calendar in Alice's Shop.

19. The British aristocracy has earls, not counts. It is France that produced *les comtes*, or counts. Unaware of this distinction, Yuki named her protagonist the alliterative Count Cain. Later translations have attempted to move away from that title, but the original is retained here because it better showcases the gothic drama that is Yuki's specialty.

20. Yuki, like many, conflates the Queen of Hearts (*Alice's Adventures*) with the Red Queen (*Looking-Glass*).

21. Detailed in chapter 1.

Chapter 5: Detecting *Alice* on Page, Screen, and Street

1. The American mystery television show *Criminal Minds*, which adapted *Alice* in the third episode of its eighth season, uses a term that emphasizes the simultaneously known and unknown state of a mystery's solution even more than "whodunit." The detectives of *Criminal Minds* search for the "unsub," or "unknown subject," who committed whatever act(s) set a given episode's narrative in action.

200 Notes to Pages 140–163

2. Ruikō has achieved such a degree of fame in Japan that he is commonly referred to as Ruikō rather than with his family name, Kuroiwa. That practice is continued here.

3. While other Japanese names in this book are written in the Western naming order, the Japanese order is preserved here to highlight the name's antecedent. Like Ruikō, Edogawa Ranpo is commonly referred to by just the name "Ranpo" in a practice that I have continued here.

4. It is worth noting that some earlier Orthodox mystery authors continued to publish in this style in the postwar period. For example, the established mystery author Seishi Yokomizo debuted his influential Great Detective, Kosuke Kindaichi, in the 1946 novel *The Honjin Murders*. *The Honjin Murders* features the erotic grotesque nonsense of earlier Orthodox mysteries as well as the explicit references to global mysteries (such as A. A. Milne's *The Red House Mystery*) that came to mark the genre. However, it also reflects the emerging Society mystery through critiques of the traditional Japanese social class structure and the biases that faced returning Japanese soldiers.

5. Hero series are sometimes also called *tokusatsu* (special effects) shows. However, *tokusatsu* literally refers to specific special effects technologies that are usually traced back to the film *Godzilla* (*Gojira*, 1954). Those technologies do appear in hero series, but hero series also have specific character types and narratives that are not necessarily present in *tokusatsu* films.

6. The Japanese name of Hirose's novel, *Kagami no kuni no Arisu*, is the standard Japanese translation of *Through the Looking-Glass, and What Alice Found There*. It is translated as *Alice in Mirrorland* here to differentiate Hirose's mystery from Carroll's novel.

7. In *The Mad Hatter Mystery*, 1933.

8. To avoid confusion between the character-author Alice Arisugawa and the real-life author Masahide Uehara, Arisugawa will be treated as an individual in his own right, while Uehara will be referred to with his legal name.

9. Monkey Punch's *Lupin the Third* (*Rupan sansei*, 1967–1969) could be considered part of the prehistory of this genre, though the titular Lupin's mission seems to be merely to have fun and acquire things that catch his eye. The subgenre was perfected in the 1990s with works like Megumi Tachibana's *Saint Tail* (*Kaitō Seinto Tēru*, 1995–1996) and Arina Tanemura's *Phantom Thief Jeanne* (*Kaitō Jannu*, 1998–2000).

10. The series was published in English as *The Man of Many Faces*. A literal translation is used here because the Japanese term officially translated as "faces" (*mensō*) is the same term used for Ranpo's *Twenty Masks*.

11. CLAMP's modus operandi resembles that of influential earlier manga artist Osamu Tezuka in this last respect.

12. The dating simulation genre challenges players to build a romantic relationship between the game's protagonist and one of several potential love interests.

13. Some artbooks also contain how-to-draw sections, interviews with the artist(s), and other materials.

14. Commonly called photograph collections or *shashin shū* in Japanese, the specialized term gravure photobook is used here to separate the books in question from other photograph collections, such as those published by art photographers.

15. Lolita develops a variety of subtypes, such as Sweet Lolita and Gothic Lolita, over time. While there is not space to properly detail these varieties here, Masafumi Monden's *Japanese Fashion Cultures: Dress and Gender in Contemporary Japan* (2015) does so very well.

Notes to Pages 165–167 201

16. To be clear, this is not the only way that people engage in Lolita. However, as Lolita fashions became more visible, it became possible for creators who did not identify as Lolitas themselves to adapt the style to their own uses. Consumption of these non-Lolita adapters' creations far outpaced the activities of Lolitas themselves by the mid-2010s.

17. *Black Butler* is highly reminiscent of Yuki's Count Cain series, to the point that one wonders whether Toboso was inspired by the earlier works.

18. First adapted into a drama CD in 2008 by the record label IM with scripts by Ai Ninomiya, this sprawling world eventually came to encompass twenty-one CDs, a manga (story by Ai Ninomiya and art by Ikumi Katagiri, 2009–2015), a trio of novels by Masami Morokuchi (2010–2012), an artbook by Toyoru Takura, a video game by Idea Factory, and a DVD of a recording session (2009). *Are You Alice?* is a quintessential media mix world: no single person seems to have created or to be in control of the world, which seems to have been developed with adaptation into multiple media in mind. The drama CD medium is often used to test potential worlds. Producing a drama CD costs little, so companies can test a world's popularity at little risk to themselves. Drama CDs contain aspects of several more expensive media—imagery on the CD case, narrative in the recording's content, and aural qualities such as voice acting and sound effects—all of which make the medium a useful test case for media like anime, manga, and video games.

19. The publisher MediaWorks created the Dengeki Novel Prize for light novels (to advertise its own publications), but light novels do not win mainstream awards. Hiro Arikawa's *Library Wars* (*Toshokan Sensō*, 2006) is the exception that proves this rule. *Library Wars* presents an alternate history wherein the Japanese government establishes an organization to censor books and local governments fight back by funding library defense forces to defend their libraries' books. The novel's creative portrayal of literary freedom and the importance of (prose) literature earned it the Seiun Award, which is Japan's oldest speculative fiction award, as well as fifth place in the Japan Booksellers' Award, which is voted on by booksellers around Japan. These two awards are quite prestigious, but they are also the most prominent awards that are open to more popular fiction. Awards focused on supposedly serious fiction, like the Akutagawa Prize, did not recognize it.

20. Illustrator Ryō Ueda's portrayal of Alice owes far more to Lolitas than the imagery of Tenniel or Disney. Alice's tiered skirts, ample lace and bow detailing, ruffled sleeves, corseted waist, and detached wristbands are all common in Lolita clothing, as is the black, white, and red color scheme of Alice's costume.

Works Cited

Abel, Jonathan. 2012. *Redacted: The Archives of Censorship in Transwar Japan*. Berkeley: University of California Press.

Ada Deene: Her Book. 1904. Edited by Mary F. Groom. N.p.: n.p.

Admin. 2019. "Blue Chalcedony: A Lapidary Superstar." *Rock & Gem*. February 12. https://www.rockngem.com/blue-chalcedony-a-lapidary-superstar/.

Akutagawa, Ryūnosuke. 1938. *Tales Grotesque and Curious*. Translated by Glenn W. Shaw. Tokyo: Hokuseido Press.

———. 1948. *Kappa: Gulliver in a Kimono*. Translated by Seiichi Shiojiri. Osaka, Japan: Akitaya.

———. 1958. *Akutagawa Ryūnosuke zenshū*. Tōkyō: Chikuma Shobō.

———. 1990. *Kappa*. Translated by Geoffrey Bownas with an Introduction by G. H. Healey. Vermont: Charles E. Tuttle Company.

———. "Wonder Island." 2013. In *Three-Dimensional Reading: Stories of Time and Space in Japanese Modernist Fiction, 1911–1932*, translated and edited by Angela Yiu, 201–210. Honolulu: University of Hawai'i Press.

"Akutagawa Ryūnosuke," *Aozora Bunko*. n.d. Aozora Bunko, accessed July 9, 2020, https://www.aozora.gr.jp/index_pages/person879.html#sakuhin_list_1.

"Akutagawa Ryūnosuke ichinaru yorokobi to kunō." n.d. Nihon kindai bungakukan. Accessed January 19, 2017. http://www.bungakukan.or.jp/cat-exhibition/cat-exh_rend /522/.

"Akutagawa Ryūnosuke no kappazu." n.d. Kanren: Nandemo kanteidan. Accessed January 19, 2017. http://www.tv-tokyo.co.jp/kantei/kaiun_db/otakara/20150811/07.html.

Alice in Comicland. 2014. Edited by Craig Yoe. San Diego, CA: IDW Books.

Allison, Anne. 2006. *Millennial Monsters: Japanese Toys and the Global Imagination*. Berkeley: University of California Press.

Aoki, Shōichi. 2017. "'Oshare na ko ga torenakunatta' sunappushi 「FRUiTS」 ga gekkan hakkō wo shūryō shita riyū." Fashionsnap.com, February 3. Accessed April 20, 2021. https://www.fashionsnap.com/article/2017-02-03/fruits-stop/.

Aoyama, Tomoko. 2011. "The Genealogy of the 'Girl' Critic Reading Girl." In *Girl Reading Girl in Japan*, edited by Tomoko Aoyama and Barbara Hartley, 38–49. London: Routledge.

Aoyama, Tomoko, and Barbara Hartley. 2011. "Introduction." In *Girl Reading Girl in Japan*, edited by Tomoko Aoyama and Barbara Hartley, 1–15. London: Routledge.

204 Works Cited

Applin, Jo. 2012. "Resisting Infinity." In *Yayoi Kusama*, 2–5. N.p.: Victoria Miro.

Araki, Hirohiko. 2015. *Manga in Theory and Practice: The Craft of Creating Manga*. Translated by Nathan A. Collins. San Francisco: Viz Media.

"Arisu." n.d. *Onamaejiten*. Accessed August 18, 2015. http://name.m3q.jp/list?g=2&s=ありす.

Artaud, Antonin. 1976. *Antonin Artaud: Selected Writings*. Edited by Susan Sontag. New York: Farrar, Straus & Giroux.

———. 1979. *Œuvres Complètes IX*. France: Gallimard.

———. 2004. *Œuvres*. Edited by Évelyne Grossman. France: Quarto Gallimard.

Atsuko Tanaka: The Art of Connecting. 2011. Birmingham, UK: Ikon Gallery.

Azuma, Hiroki. 2009. *Otaku: Japan's Database Animals*. Minneapolis: University of Minnesota Press.

Bardsley, Jan. 2021. *Maiko Masquerade: Crafting Geisha Girlhood in Japan*. Oakland: University of California Press.

Barthes, Roland. 2013. *Mythologies*. Translated by Richard Howard and Annette Lavers. New York: Hill & Wang.

Bassnett, Susan. 2014. *Translation Studies: Fourth Edition*. New York: Routledge.

Beaton, M. C. 2016. *Death of a Liar*. London: Constable, 2016.

———. 2016. *Death of a Nurse*. New York: Grand Central Publishing.

Beckman, Karen. 2003. *Vanishing Women: Magic, Film, and Feminism*. Durham, NC: Duke University Press.

Beebee, Thomas, and Ikuho Amano. 2010. "Pseudotranslation in the Fiction of Akutagawa Ryūnosuke." *Translation Studies* 3, no. 1: 17–32.

Benjamin, Walter. 1973. *Illuminations*. Edited by Hannah Arendt. London: Fontana.

Berger, John. 1972. *Ways of Seeing*. London: British Broadcasting Corporation and Penguin Books.

"Beyond Wonderland." n.d. *Beyond Wonderland*, accessed February 10, 2017. http://beyondwonderland.com/.

Blake, Nicholas. 1940. *Malice in Wonderland*. London: Vintage Books. Reissued 2012.

Bolter, Jay David, and Richard Grusin. 2000. *Remediation: Understanding New Media*. Cambridge, MA: MIT Press.

Borges, Jorge Luis. 1999. "Ryunosuke Akutagawa, the Kappa." In *Selected Non-Fictions: Jorge Luis Borges*. New York: Viking.

Borzello, Frances. 2016. *Seeing Ourselves: Women's Self-Portraits*. London: Thames & Hudson.

Bourriaud, Nicolas. 2007. *Postproduction*. Translated by Jeanine Herman. New York: Lukas & Sternberg.

Boyd, Nolan. 2018. "The Altered Shall Inherit the Earth: Biopower and the Disabled Body in Texhnolyze." *Science Fiction Studies* 45, no. 2: 91–110.

Braudy, Leo. 2016. *Haunted: On Ghosts, Witches, Vampires, Zombies, and Other Monsters of the Natural and Supernatural Worlds*. New Haven, CT: Yale University Press.

Brown, Steven T. 2010. *Tokyo Cyberpunk: Posthumanism in Japanese Visual Culture*. New York: Palgrave Macmillan.

Bukatman, Scott. 1993. *Terminal Identity: The Virtual Subject in Postmodern Science Fiction*. Durham, NC: Duke University Press.

Works Cited

Calsimsek, Nilay. 2013. "Gender Identity Formation in Children's Magazines in Japan during the Meiji Era." *Hemispheres* 28:57–76.

Cambridge, Nicholas. 2011. "Cherry-Picking Sartorial Identities in Cherry-Blossom Land: Uniforms and Uniformity in Japan." *Journal of Design History* 24, no. 2: 171–186.

Carroll, Lewis. 2015. *The Annotated Alice: 150ᵗʰ Anniversary Deluxe Edition Alice's Adventures in Wonderland & Through the Looking-Glass.* Edited by Martin Gardner, expanded and updated by Mark Burstein. New York: W. W. Norton & Company.

Carter, Nona. 2009. "A Study of Japanese Children's Magazines 1888–1949." Dissertation, University of Pennsylvania, Philadelphia.

Chance, Linda. 2011. "Genji Guides, or Minding Murasaki." In *Manners and Mischief: Gender, Power, and Etiquette in Japan*, edited by Jan Bardsley and Laura Miller, 38–55. Berkeley: University of California Press.

Chimori, Mikiko. 2006. *Alice in the Orient.* London: Anthem Press.

———. 2015. *Hyōshō no Arisu: Tekisuto to zushō ni miru Nihon to Igirisu.* Tōkyō: Hōsei daigaku shuppan kyoku.

Christie, Agatha. 2015. *N or M?* New York: William Morrow. Originally 1941.

———. 2015. *Postern of Fate.* London: Harper. Originally 1973.

Chun, Jayson Makoto. 2007. *"A Nation of a Hundred Million Idiots"?: A Social History of Japanese Television, 1953–1973.* New York: Routledge.

Clements, Jonathan. 2013. *Anime: A History.* London: BFI by Palgrave Macmillan.

Clingham, Greg. 2021. "Foreword: Global Johnson." In *Johnson in Japan*, edited by Kimiyo Ogawa and Mika Suzuki, ix-xviii. Lewisburg, PA: Bucknell University Press.

Coats, Karen. 2004. *Looking Glasses and Neverlands: Lacan, Desire, and Subjectivity in Children's Literature.* Iowa City: University of Iowa Press.

Comic Market Committee. 2014. "What is Comic Market?" Comiket. Comiket, January. https://www.comiket.co.jp/info-a/WhatIsEng201401.pdf.

Condry, Ian. 2013. *The Soul of Anime: Collaborative Creativity and Japan's Media Success Story.* Durham, NC: Duke University Press.

Copeland, Rebecca. 2000. *Lost Leaves: Women Writers of Japan.* Honolulu: University of Hawai'i Press.

Death in Paradise. 2020. "Pirates of the Murder Scene." Directed by Paulette Randall. Written by Will Fisher.

Deleuze, Gilles. 1990. *The Logic of Sense.* Translated by Mark Lester. New York: Columbia University Press.

Denison, Rayna. 2015. "American Superheroes in Japanese Hands: Superhero Genre Hybridity as Superhero Systems Collide in *Supaidāman.*" In *Superheroes on World Screens*, edited by Rayna Denison and Rachel Mizsei-Ward, 53–72. Jackson: University Press of Mississippi.

de Waal, Edmund. 2013. "Introduction." In *Facing the Modern: The Portrait in Vienna 1900*, edited by Gemma Blackshaw, 9–11. London: National Gallery Company.

Dickinson, Frederick. 2013. *World War I and the Triumph of a New Japan, 1919–1930.* Cambridge: University of Cambridge Press.

206 Works Cited

"Documents: Yayoi Kusama." 2004. Edited by Yayoi Kojima and Mayumi Uchida. In *Kusamatrix*, edited by Takashi Azumaya, Kenichi Kondo, Yayoi Kojima, Mayumi Uchida, and Akihiro Kurata, 96–123. Tokyo: Kadokawa Shoten Publishing.

Dollase, Hiromi Tsuchiya. 2010. "Ribbons Undone: The *Shōjo* Story Debates in Prewar Japan." In *Girl Reading Girl in Japan*, edited by Tomoko Aoyama and Barbara Hartley, 80–91. London: Routledge.

Dumbadze, Alexander. 2017. "Infinity and Nothingness." In *Yayoi Kusama Infinity Mirrors*, edited by Mika Yoshitake, 118–127. Munich: DelMonico Books.

Edogawa, Rampo. 2012. *The Fiend with Twenty Faces*. Fukuoka, Japan: Kurodahan Press.

———. 2015. *Yūreitō*. Tokyo: Iwanami Shoten.

Elliott, David. 2004. "Kusama: The Modern Alice in Wonderland." In *Kusamatrix*, edited by Takashi Azumaya, Kenichi Kondo, Yayoi Kojima, Mayumi Uchida, and Akihiro Kurata, 87–92. Tokyo: Kadokawa Shoten Publishing.

Exner, Eike. 2021. *Comics and the Origins of Manga: A Revisionist History*. New Brunswick, NJ: Rutgers University Press.

Fahy, David. 1989. "Review: *Akutagawa and Dazai: Instances of Literary Adaptation*." *Journal of Asian Studies* 48, no.3: 623–624.

Fairman, Richard. 2020, "Alice's Adventures Under Ground—children's opera by Gerald Barry is a Rollercoaster Ride." *Financial Times* (London), February.

Fluke, Joanne. 2008. *Carrot Cake Murder*. New York: Kensington Books.

Foster, Thomas C. 2014. *How to Read Literature Like a Professor: A Lively and Entertaining Guide to Reading between the Lines*. New York: Harper Perennial.

Fowler, Edward. 1988, *The Rhetoric of Confession: Shishōsetsu in Early Twentieth-Century Japanese Fiction*. Berkeley: University of California Press.

Gerow, Aaron. 1995. "The Self Seen as Other: Akutagawa and Film." *Literature/Film Quarterly* 23, no. 3: 197–203.

Grant, Simon, and Marco Pasi. 2016. "'Works of Art without Parallel in the World': Georgiana Houghton's Spirit Drawings." In *Georgiana Houghton: Spirit Drawings*, edited by Ernst Vegelin van Claerbergen and Barnaby Wright, 9–23. London: Courtauld Gallery.

Gravett, Paul. 2004. *Manga: Sixty Years of Japanese Comics*. New York: Harper Collins.

Griepp, Milton. 2019. "Comics and Graphic Novel Sales Hit New High in 2018: According to ICv2 and Comichron." ICv2. ICv2, May 2. https://icv2.com/articles/markets/view/43106/comics-graphic-novel-sales-hit-new-high-2018#:~:text=Comics%20and%20graphic%20novel%20sales%20hit%20a%20new,an%20%2480%20million%20increase%20over%20sales%20in%202017.

Guth, Christine. 2015. *Hokusai's Great Wave: Biography of a Global Icon*. Honolulu: University of Hawai'i Press.

Hara, Sho. 1986. "Waga kuni ni okeru Alice's Adventures in Wonderland no hon'yaku juyō: Nansensu no warai no sōshitsu." *Chukyo English Literature* 7:45–75.

Hayashi, Michiyo, and Ariko Kawabata. 2003. "Children's Literature Research in Japan." *Children's Literature Association Quarterly* 28, no. 4: 241–246.

Hess, Joan. 2015. *Pride v. Prejudice*. Auckland, NZ: Wheeler Publishing.

Honda, Masuko. 2010. "The Genealogy of *Hirahira*: Liminality and the Girl." In *Girl Reading Girl in Japan*, edited by Tomoko Aoyama and Barbara Hartley, 19–37. London: Routledge.

Works Cited

Hoptman, Laura, et al. 2000. *Yayoi Kusama.* London: Phaidon.

Hutcheon, Linda, with Siobhan O'Flynn. 2013. *A Theory of Adaptation.* 2nd edition. New York: Routledge.

Ishihara, Tsuyoshi. 2005. *Mark Twain in Japan: The Cultural Reception of an American Icon.* Columbia: University of Missouri Press.

Itō, Gō. 2006. *Tezuka izu deddo: Hirakareta manga no hyōgenron he.* Tōkyō: NTT Shuppan.

Ito, Mizuko, Daisuke Okabe, and Misa Matsuda, eds. 2006. *Personal, Portable, Pedestrian: Mobile Phones in Japanese Life.* Cambridge, MA: MIT Press.

Iwabuchi, Koichi. 2002. *Recentering Globalization: Popular Culture and Japanese Transnationalism.* Durham, NC: Duke University Press.

Jacobsen, Signe Marie Ebbe. 2015. "In(de)finite Spaces / Yayoi Kusama's Infinity Mirror Rooms." *PAPER: Platform for Architectural Projects, Essays & Research* 23:1–2.

Japan and Sherlock Holmes. 2004. Edited by Hirayama, Higurashi, and Ueda. New York: Baker Street Irregulars.

Jaques, Zoe, and Eugene Giddens. 2016. *Lewis Carroll's* Alice's Adventures in Wonderland *and* Through the Looking-Glass*: A Publishing History.* London: Routledge.

Jefferson Airplane. 1966. "White Rabbit." By Grace Slick. Recorded November 3. Track 10 on *Surrealistic Pillow.* RCA Victor.

Jenkins, Henry. 2008. *Convergence Culture: Where Old and New Media Collide.* New York: New York University Press.

John, Juliet. 2012. "Global Dickens: A Response to John Jordan." *Literature Compass* 9, no. 7: 502–507.

Johnson in Japan. 2021. Edited by Kimiyo Ogawa and Mika Suzuki. Lewisburg, PA: Bucknell University Press.

Jones, Anna Maria. 2018. "Transnational Neo-Victorian Studies: Notes on the Possibilities and Limitations of a Discipline." *Literature Compass* 15, no. 7: n.p.

Jones, Darynda. 2011. *First Grave on the Right.* New York: St. Martin's Press.

Joubin, Alexa Alice. 2021. *Shakespeare and East Asia.* Oxford: Oxford University Press.

Kan, Satoko, Hiromi Tsuchiya Dollase, and Kayo Takeuchi. 2012. ⌈*Shōjo manga*⌋ *Wandārando.* Tokyo: Meiji Shoin.

Karatani, Kojin. 1998, *Origins of Modern Japanese Literature.* Edited by Brett de Bary. Durham, NC: Duke University Press.

Karlsson, Mats. 2011. "Literary Appropriations of the Modern: The Case of Akutagawa Ryūnosuke and August Strindberg." In *Rethinking Japanese Modernism,* edited by Roy Starrs, 164–187. Leiden: BRILL.

Kawamura, Yuniya. 2012. *Fashioning Japanese Subcultures.* London: Berg.

Kawana, Sari. 2008. *Murder Most Modern: Detective Fiction and Japanese Culture.* Minneapolis: University of Minnesota Press.

Keene, Donald. 1984. *Dawn to the West: Japanese Literature in the Modern Era.* New York: Henry Holt & Company.

Kennell, Amanda. 2016. "Origin and Ownership from Ballet to Anime." *Journal of Popular Culture* 49, no. 1: 10–28.

Kidd, Chip, Geoff Spear, and Paul Ferris. 2008. *Batmanga!: The Secret History of Batman in Japan.* New York: Pantheon Books.

208 Works Cited

Kimbrough, R. Keller. 2015. "Bloody Hell! Reading Boys' Books in Seventeenth-Century Japan." *Asian Ethnology* 74, no. 1: 111–139.

King, Hobart. n.d. "Gem Silica." *Geology.com*. Accessed December 15, 2020. https://geology.com/gemstones/gem-silica/.

Kinoshita, Shinichi. n.d. "Kikuchi Kan Akutagawa Ryūnosuke Kyōyaku 'Arisu monogatari' no nazo." N.p.: n.p., n.d.. http://www.hp-alice.com/lcj/ronbun/article2008.pdf.

Kinoshita, Shinichi, and Amanda Kennell. 2021. "Alice Manga." *Knight Letter* 3, no. 7: 19–30.

Kinsella, Sharon. 2000. *Adult Manga: Culture and Power in Contemporary Japan*. Honolulu: University of Hawai'i Press.

Kishi, Tetsuo, and Graham Bradshaw. 2006. *Shakespeare in Japan*. London: Continuum.

Kōno Kensuke. 2018. "The Collaboration of 'Ghostwriting' and Literature—The Case of Kawabata Yasunari." Translated by Ron Martin Wilson. *Japan Forum* 30, no. 1: 60–68.

Kotani, Mari. 2007. "Alien Spaces and Alien Bodies in Japanese Women's Science Fiction." In *Robot Ghosts and Wired Dreams: Japanese Science Fiction from Origins to Anime*, edited by Christopher Bolton, Istvan Csicsery-Ronay, Jr., and Takayuki Tatsumi, 47–74. Minneapolis: University of Minnesota Press.

———. 2015. "Kyaroru gari." *Yuriika* 657.47–3: 62–71.

Kumar, Pankaj Rishi, dir. 2019. *Janani's Juliet*; Kumar Talkies. DVD.

Kusama, Yayoi. 2011. *Infinity Net: The Autobiography of Yayoi Kusama*. Translated by Ralph McCarthy. London: Tate Publishing.

———. 2011. *Kusama Yayoi, tatakau*. Edited by Takashiro Akio, Tomonaga Fumihiro, Akashi Yasumasa (Paddo kabushikigaisha), and Ōta Kyōko. Tōkyō: ACCESS Company.

———. 2017. "The Struggle and Wanderings of My Soul (extracts), 1975." In *Yayoi Kusama*, edited by Michele Robecchi, 115–120. New York: Phaidon Press.

Kusumoto, Kimie. 2001. *Hon'yaku no kuni no 'Arisu': Ruisu Kyaroru hon'yakushi hon'yakuron*. Tōkyō: Miwatani.

Kuwata, Jiro. 2015. *Batman: The Jiro Kuwata Batman: Volume 2*. N.p.: DC Comics.

Laurberg, Marie. 2015. "Deep Surfaces: Yayoi Kusama in Infinity." In *Yayoi Kusama in Infinity*, edited by Lærke Rydal Jørgensen, Marie Laurberg, and Michael Juul Holm, 6–28. Denmark: n.p.

Lefevere, André, ed. 1992. *Translation/History/Culture: A Sourcebook*. London: Routledge.

Lenz, Heather, dir. 2018, 2019. *Kusama Infinity: The Life and Art of Yayoi Kusama*. 2018; Los Angeles: Magnolia Home Entertainment. DVD.

Levy, Indra. 2006. *Sirens of the Western Shore: The Westernesque Femme Fatale, Translation, and Vernacular Style in Modern Japanese Literature*. New York: Columbia University Press.

———, ed. 2011. *Translation in Modern Japan*. London: Routledge.

Life Is the Heart of a Rainbow. 2017. Edited by Russell Storer. Singapore: National Gallery Singapore.

Lindseth, Jon (general ed.), and Alan Tannenbaum (technical ed.). 2015. *Alice in a World of Wonderlands*. New Castle, DE: Oak Knoll Press.

Lippit, Akira Mizuta. 2008. *Electric Animal: Toward a Rhetoric of Wildlife.* Minneapolis: University of Minnesota Press.

———. 2012. *Ex-cinema.* Berkeley: University of California Press.

Lippit, Seiji. 2002. *Topographies of Japanese Modernism.* New York: Columbia University Press.

Long, Hoyt. 2021. *The Values in Numbers: Reading Japanese Literature in a Global Information Age.* New York: Columbia University Press.

Long, Margherita. 2007. "*Malice@Doll*: Konaka, Specularization, and the Virtual Feminine." *Mechademia* 2:157–173.

Love Forever: Yayoi Kusama, 1958–1968. 1998. Edited by Lynn Zelevansky, Laura Hoptman, and Akira Tatehata. Los Angeles: Los Angeles County Museum of Art.

Macdonald, Christopher. 2005a. "Yuki Suetsugu Copies Art from Other Manga." Anime News Network. Anime News Network, October 19. https://www.animenewsnetwork.com/news/2005-10-19/yuki-suetsugu-copies-art-from-other-manga.

———. 2005b. "Slam Dunk Plagiarism Scandal." Anime News Network. Anime News Network, October 19. https://www.animenewsnetwork.com/news/2005-12-22/slam-dunk-plagiarism-scandal.

Mack, Edward. 2010. *Manufacturing Modern Japanese Literature: Publishing, Prizes, and the Ascription of Literary Value.* Durham, NC: Duke University Press.

Major, Amanda. n.d. "Mickey Mouse Decorating on a Cheapskate Princess Budget!" Disney's Cheapskate Princess. Accessed May 5, 2021. https://cheapskateprincess.com/disney-decorating/.

Marran, Christine. 2007. *Poison Woman: Figuring Female Transgression in Modern Japanese Literature.* Minnesota: University of Minnesota Press.

McKinlay, Jenn. 2014. *Death of a Mad Hatter.* New York: Berkeley Prime Crime.

McKnight, Anne. 2011. *Nakagami, Japan: Buraku and the Writing of Ethnicity.* Minneapolis: University of Minnesota Press.

McLuhan, Marshall. 1964. *Understanding Media: The Extensions of Man.* New York: Signet.

"Media fakutorī shin komikku shi 'Komikku Jīn' saito ōpen!!!!!." 2010. *Comic-gene.com.* Last modified December 2. http://www.comic-gene.com/blog/?m=201012.

Mickenberg, Julia, and Lynne Vallone. 2011. "Introduction." In *The Oxford Handbook of Children's Literature,* edited by Julia Mickenberg and Lynne Vallone, 3–21. Oxford: Oxford University Press.

Miller, J. Scott. 2001. *Adaptations of Western Literature in Meiji Japan.* New York: Palgrave.

Miller, Jonathan. 1998. *On Reflection.* London: National Gallery Publications.

Minami, Yusuke. 2017. "Creation and Re-creation of Yayoi Kusama by Yayoi Kusama." In *Yayoi Kusama: My Eternal Soul,* edited by the National Art Center, Tokyo, and the Asahi Shimbun, 262–265. N.p.: Asahi Shimbun.

Mitchell, Gladys. 2014. *Speedy Death.* London: Vintage Books.

Miyadai, Shinji, Hideki Ishihara, and Meiko Ōtsuka. 2012. *Zōho sabukaruchā shinwa kaitai: Shōjo, ongaku, manga, sei no hen'yō to genzai.* Tōkyō: Chikuma Bunko.

Mizuki, Shigeru. 2019. *Showa: A History of Japan, 1953–1989.* Translated by Zack Davisson. Canada: Drawn & Quarterly.

210 Works Cited

Momma, Yoshiyuki. 1994. "Why Is *Alice* Popular in Japan." In *Proceedings of the Second International Lewis Carroll Conference*, edited by Charlie Lovett, 135–138. Winston-Salem, NC: Lewis Carroll Society of North America.

———. 2015. "*Alice* in Japanese: Named One of the Best 100." In *Alice in a World of Wonderlands vol. 1*, edited by Jon A. Lindseth and Alan Tannenbaum, 316–319. New Castle, DE: Oak Knoll Press in collaboration with the Lewis Carroll Society of North America.

Momma, Yoshiyuki, and Amanda Kennell. 2021. "Carroll in Japan: A Discussion with Yoshi Momma." Digital presentation at the Lewis Carroll Society of North America (LCSNA) Spring 2021 Meeting, April.

Monden, Masafumi. 2015. *Japanese Fashion Cultures: Dress and Gender in Contemporary Japan*. London: Bloomsbury.

Morton, Leith. 2009. *The Alien Within: Representations of the Exotic in Twentieth-Century Japanese Literature*. Honolulu: University of Hawai'i Press.

Mulryne, J. R. 1998. "Introduction." In *Shakespeare and the Stage*, edited by Takashi Sasayama, J. R. Mulryne, and Margaret Shewring, 1–11. Cambridge: Cambridge University Press.

Murai, Mayako. 2015. *From Dog Bridegroom to Wolf Girl: Contemporary Japanese Fairy-Tale Adaptations in Conversation with the West*. Detroit, MI: Wayne State University Press.

Nakano, Haruyuki. 2004. *Manga Sangyōron*. Tōkyō: Chikuma shobō.

Napier, Susan. 1996. *The Fantastic in Modern Japanese Literature: The Subversion of Japanese Modernity*. London; New York: Routledge.

———. 2007. "When the Machines Stop: Fantasy, Reality, and Terminal Identity in *Neon Genesis Evangelion* and *Serial Experiments Lain*." In *Robot Ghosts and Wired Dreams: Japanese Science Fiction from Origins to Anime*, edited by Christopher Bolton, Istvan Csicsery-Ronay, Jr., and Takayuki Tatsumi, 101–122. Minneapolis: University of Minnesota Press.

Natalie. 2009. "Manga taishō 2009 happyō! Taishō ha Suetsugu 'Chihayafuru'". Komikku Natalie. Natalie, March 24. https://natalie.mu/comic/news/14699.

NCIS: New Orleans. 2015a. "Broken Hearted." Directed by Elodie Keene. Written by Zach Strauss and Greta Heinemann.

———. 2015b. "I Do." Directed by Tony Wharmby. Written by Sam Humphrey.

———. 2017. "Down the Rabbit Hole." Directed by David Ornelas. Written by Brad Kern.

Neri, Louise, and Takaya Goto. 2012. *Yayoi Kusama*. New York: Rizzoli.

Nice, David. 2016. "Alice's Adventures Under Ground, Barbican." *theartsdesk.com*. The Arts Desk Ltd., November 29. https://theartsdesk.com/opera/alices-adventures-under-ground-barbican.

Nikkei BP sha gijutsu kenkyūbu hen, ed. 1999. Anime bijinesu ga kawaru. Tōkyō: Nikkei BP sha.

Nozawa, Shunsuke. 2013. "Characterization." *Semiotic Review* 3:1–30.

O'Brien, James, translator. 1988. *Akutagawa and Dazai: Instances of Literary Adaptation*. With Introduction by O'Brien. Tempe, AZ: Center for Asian Studies.

Works Cited 211

Ohnishi, Shousei. 2021. "'Fushigi no kuni' shoshi (kamishibai, manga, anime, myūjikaru)," *Shin 'Arisu' Yakkai.* Revised October 12. http://shousei.g1.xrea.com /alice/Reference-mix.html

Okada, Akiko. 2006. *Keats and English Romanticism in Japan.* Bern, Switzerland: Peter Lang.

"Onna no ko no namae ninki rankingu." n.d. Onamae jiten. Accessed August 18, 2015. http://name.m3q.jp/ranking?g=2&page=3.

Ono, Kosei. 2014. "The Charm of Kuwata's Version of Batman as a Scientific Detective." In *Batman: The Jiro Kuwata Batmanga: Volume 1,* by Jiro Kuwata, 358–359. New York: DC Comics.

Orbaugh, Sharalyn. 2003. "Busty Battlin' Babes: The Evolution of the *Shōjo* in 1990s Visual Culture." In *Gender and Power in the Japanese Visual Field,* edited by Joshua Mostow, Norman Bryson, Maribeth Graybill, 201–228. Honolulu: University of Hawai'i Press.

Ortabasi, Melek. 2008. "Brave Dogs and Little Lords: Some Thoughts on Translation, Gender, and the Debate on Childhood in Mid Meiji." *Review of Japanese Culture and Society* XX:178–205.

Oshiyama, Michiko. 2018. *Shōjo manga jendā hyōshōron: "Dansō no shōjo" no zōkei to aidentiti.* Tōkyō: Arufa beta bukkusu.

Ōtsuka, Eiji. 2001. *Teihon Monogatari Shōhiron.* Tōkyō: Kadokawa bunko.

———. 2010. "World and Variation: The Reproduction and Consumption of Narrative." Translated by Marc Steinberg. *Mechademia* 5, no. 1: 99–116.

Pascoe, Judith. 2017. *On the Bullet Train with Emily Brontë: Wuthering Heights in Japan.* Ann Arbor: University of Michigan Press.

Penney, Matthew. 2012. "Making History: Manga between Kyara and Historiography." In *Manga and the Representation of Japanese History,* edited by Roman Rosenbaum, 146–170. London: Taylor & Francis Group.

Performing Shakespeare in Japan. 2001. Edited by Ryuta Minami, Ian Carruthers, and John Gillies. Cambridge: Cambridge University Press.

Pes, Javier, and Emily Sharpe. 2015. "Visitor Figures 2014: The World Goes Dotty over Yayoi Kusama." *Art Newspaper* (London, England), April 1.

Peters, Luc, and Anthony R. Yue. 2018. *On Mirrors!: Philosophy—Art—Organization.* Newcastle-upon-Tyne, UK: Cambridge Scholars Publishing.

Platt, Brian. 2005. "Japanese Childhood, Modern Childhood: The Nation-State, the School, and 19th-Century Globalization." *Journal of Social History* 38, no. 4: 965–985.

Prévost, Adèle-Elise. 2008. "The Signal of Noise." *Mechademia* 3:173–188.

Prolix. 2000. "Review: *American McGee's Alice.*" *Game Over.* Game Over Online, Incorporated. Dec. 15. http://www.game-over.net/reviews.php?id=406&page=reviews.

Re-imagining Shakespeare in Contemporary Japan: A Selection of Japanese Theatrical Adaptations of Shakespeare. 2021. Edited by Motoyama, Tetsuhito, Rosalind Fielding, and Fumiako Konno. New York: Bloomsbury Publishing.

Richards, Bree. 2011. "Yayoi Kusama: Performing the Body." Queensland, Australia: Queensland Art Gallery. https://play.qagoma.qld.gov.au/looknowseeforever/essays /performing-the-body/index.html.

212 Works Cited

Rowe, Adam. 2019. "U.S. Publishing Industry Revenues Reached $6 Billion In First Half Of 2019." *Forbes*. Forbes, August 29. https://www.forbes.com/sites/adamrowe1/2019/08/29/us-publishing-industry-revenues-reached-6-billion-in-first-half-of-2019/?sh=219bbcfb16b5.

Rutherford, Emma. 2009. *Silhouette*. New York: Rizzoli.

Saito, Kumiko. 2014. "Magic, *Shōjo*, and Metamorphosis: Magical Girl Anime and the Challenges of Changing Gender Identities in Japanese Society." *Journal of Asian Studies* 73:1, 143–164.

Saito, Satomi. 2015. "Beyond the Horizon of Possible Worlds: A Historical Overview of Japanese Media Franchises." *Mechademia* 10: 143–161.

Sakai, Naoki. 1997. *Translation and Subjectivity: On "Japan" and Cultural Nationalism*. Minneapolis: University of Minneapolis Press.

Salisbury, Mark. 2016. *Walt Disney's Alice in Wonderland: An Illustrated Journey through Time*. Los Angeles: Disney Editions.

Saltzman-Li, Katherine. 2010. *Creating Kabuki Plays: Context for Kezairoku, "Valuable Notes on Playwriting."* Boston: Brill Academic Publishers.

Sasayama, Takashi. 1998. "Tragedy and Emotion: Shakespeare and Chikamatsu." In *Shakespeare and the Stage*, edited by Takashi Sasayama, J. R. Mulryne, and Margaret Shewring, 145–158. Cambridge: Cambridge University Press.

Sayers, Dorothy L. 2013a. *Busman's Honeymoon*. New York: Bourbon Street Books.

———. 2013b. *Murder Must Advertise*. New York: Bourbon Street Books.

———. 2013c. *The Complete Stories*. New York: Bourbon Street Books.

Schodt, Frederik. 2007. *The Astro Boy Essays: Osamu Tezuka, Mighty Atom, Manga/Anime Revolution*. Berkeley, CA: Stone Bridge Press.

Scrase, David. 2011. *Flower Drawings: Redouté and His Pupils*. Cambridge: Fitzwilliam Museum.

Seidel, Michael. 2003. "Introduction." In *Gulliver's Travels*, Jonathan Swift, xiii–xxxi. New York: Barnes & Noble Classics.

Seki, Naoko. 1999, "In Full Bloom: Yayoi Kusama, Years in Japan." In *In Full Bloom: Yayoi Kusama, Years in Japan*, edited by Tōkyōto gendai bijutsukan, 153–168. Tōkyō: Tankōsha.

Shakespeare and the Japanese Stage. 1998. Edited by Takashi Sasayama, J. R. Mulryne, and Margaret Shewring. Cambridge: Cambridge University Press.

Shamoon, Deborah. 2012. *Passionate Friendship: The Aesthetics of Girls' Culture in Japan*. Honolulu: University of Hawai'i Press.

Sherif, Ann. 2001. "A Confucian Utopia: Kōda Aya and Kōda Rohan." In *The Father-Daughter Plot: Japanese Literary Women and the Law of the Father*, edited by Rebecca Copeland and Esperanza Ramirez-Christensen, 238–264. Honolulu: University of Hawai'i Press.

Sherman, Jennifer. 2019. "Japan's Manga Market Grows 1.9% in 2018." Anime News Network. Anime News Network, April 8. https://www.animenewsnetwork.com/news/2019–04–08/japan-manga-market-grows-1.9-percent-in-2018/.145512.

Shimada, Sōji. 2016. Introduction to *The Moai Island Puzzle*, 9–16. By Alice Arisugawa, translated by Ho-Ling Wong. N.p.: Locked Room International.

Shimazaki, Satoko. 2016. *Edo Kabuki in Transition: From the Worlds of the Samurai to the Vengeful Female Ghost.* New York: Columbia University Press.

Shōjo zasshi furoku korekushon. 2007. Edited by Keiko Nakamura and Keiko Todate. Tokyo: Kawade Shobō Shinsha

Silver, Mark. 2008. *Purloined Letters: Cultural Borrowing and Japanese Crime Literature, 1868–1937.* Honolulu: University of Hawai'i Press.

Silverberg, Miriam. 2009. *Erotic Grotesque Nonsense: The Mass Culture of Japanese Modern Times.* Berkeley: University of California Press.

Somers, Sean. 2008. "*Anne of Green Gables*/Akage no An: The Flowers of Quiet Happiness." *Canadian Literature* 197:42–60.

Spacks, Patricia Meyer. 1971. "Logic and Language in *Through the Looking-Glass.*" In *Aspects of Alice: Lewis Carroll's Dreamchild as Seen through the Critics' Looking-Glasses,* edited by Robert Phillips, 267–275. New York: Vintage Books.

Steinberg, Marc. 2012a. *Anime's Media Mix: Franchising Toys and Characters in Japan.* Minneapolis: University of Minnesota Press.

———. 2012b. "Condensing the Media Mix: Multiple Possible Worlds in the Tatami Galaxy." *Canadian Journal of Film Studies* 21, no. 2: 71.

Stevenson, Robert Louis. 2022. *The Strange Case of Dr. Jekyll and Mr. Hyde.* N.p.: Project Gutenberg.

Sugawara, Mizuki. 2016. "Analyzing Jiro Kuwata's 'Batman'". In *Batman: The Jiro Kuwata Batmanga: Volume 3,* by Jiro Kuwata, 334–335. N.p.: DC Comics.

Sumiyoshi, Chie, and Naoko Aono. 2017. "Yayoi Kusama." *Elle Japan* March: 57–61.

Sutton, Gloria. 2017. "Between Enactment and Depiction: Yayoi Kusama's Spatialized Image Structures." In *Yayoi Kusama Infinity Mirrors,* edited by Mika Yoshitake, 138–155. Munich: DelMonico Books.

Takayama, Hiroshi. 2008. *Arisu gari.* Tōkyō: Seidosha.

Takemoto, Novala. 2014. "Keynote." *Mechademia,* Minneapolis College of Art and Design, September 27.

Tatsumi, Takayuki. 2000. "Generations and Controversies: An Overview of Japanese Science Fiction, 1957–1997." *Science Fiction Studies* 27, no. 1: 105–114.

———. 2008. "Prescriptions for Rampo Mania." In *The Edogawa Rampo Reader,* edited by Seth Jacobowitz, vii–xiv. Fukuoka, Japan: Kurodahan Press.

Telegraph Reporters. 2016. "The book most people have lied about reading—and it's not War and Peace." *Telegraph* (London, England), February 3.

Tezuka, Miwako. 2017. "Chronology." In *Yayoi Kusama Infinity Mirrors,* edited by Mika Yoshitake, 190–213. Munich: DelMonico Books.

Toritamari, Asuka. 2011. "The History of Alice's Image in Japan." *MischMasch* 13: 11–26.

Treat, John Whittier. 1993. "Yoshimoto Banana Writes Home: Shojo Culture and the Nostalgic Subject." *Journal of Japanese Studies* 19, no. 2: 353–387.

Tsuji, Nobuo. 2018. *History of Art in Japan.* Translated by Nicole Coolidge Rousmaniere. New York: Columbia University Press.

Tyler, William. 2008. *Modanizumu: Modernist Fiction from Japan 1913–1938.* Honolulu: University of Hawai'i Press.

214 Works Cited

Uchiyama, Akiko. 2013. "Meeting the New Anne Shirley: Matsumoto Yūko's Intimate Translation of *Anne of Green Gables*." *TTR: Traduction, Terminologie, Redaction* 26, no. 1: 153–175.

Vaclavik, Kiera. 2014. "The Dress of the Book: Children's Literature, Fashion and Fancy Dress." In *Beyond the Book: Transforming Children's Literature*, edited by Bridget Carrington and Jennifer Harding, 62–76. Newcastle-upon-Tyne, UK: Cambridge Scholars Publishing.

Venuti, Lawrence. 2008. *The Translator's Invisibility: A History of Translation*. London: Routledge.

Viagas, Robert. 2015. "Beach Read to Broadway! How Lin-Manuel Miranda Turned a History Book into Hamilton." *Playbill*. August 5. https://www.playbill.com/news/article/beach-read-to-broadway-how-lin-manuel-miranda-turned-a-history-book-into-hamilton-355514.

Wada-Marciano, Mitsuyo. 2010. "J-HORROR: New Media's Impact on Contemporary Japanese Horror Cinema." *Canadian Journal of Film Studies* 16, no. 2: 23–48.

Wakabayashi, Judy. 2008. "Foreign Bones, Japanese Flesh: Translations and the Emergence of Modern Children's Literature in Japan." *Japanese Language and Literature* 42, no. 2: 227–255.

———. 2012. "Japanese Translation Historiography: Origins, Strengths, Weaknesses and Lessons." *Translation Studies* 5, no. 2: 172–188.

Wakeling, Edward. 2012. "Robinson Duckworth." With translation by Kimie Kusumoto. *MischMasch* 14: 89–114.

Waldman, Diane. 2002. *Joseph Cornell: Master of Dreams*. New York: Harry N. Abrams.

Warren-Crow, Heather. 2014. *Girlhood and the Plastic Image*. Hanover, NH: Dartmouth Press.

Winther-Tamaki, Bert. 2014. "Six Episodes of Convergence between Indian, Japanese, and Mexican Art from the Late Nineteenth Century to the Present." *Review of Japanese Culture and Society* 26:13–32.

Xu, Xu. 2018. "The Construction of a Modern Child and a Chinese National Character." In *The Routledge Companion to International Children's Literature*, edited by John Stephens. London: Routledge.

Yamamura, Midori. 2015. *Yayoi Kusama: Inventing the Singular*. Cambridge, MA: MIT Press.

Yano, Christine. 2013. *Pink Globalization: Hello Kitty's Trek across the Pacific*. Durham, NC: Duke University Press.

Yayoi Kusama. 2012. Edited by Frances Morris. New York: D.A.P./Distributed Art Publishers Inc.

———. 2012. Edited by Louise Neri and Takaya Goto. New York: Rizzoli.

———. 2017. Edited by Akira Tatehata, Laura Hoptman, Udo Kultermann, and Catherine Taft. New York: Phaidon Press.

Yayoi Kusama: I Who Have Arrived in Heaven. 2014. Edited by Julia Joern. New York: David Zwirner.

Yayoi Kusama in Infinity. 2015. Edited by Lærke Rydal Jørgensen, Marie Laurberg, and Michael Juul Holm. Denmark: n.p.

Works Cited 215

Yomota, Inuhiko. 2019. *What Is Japanese Cinema? A History.* Translated by Philip Kaffen. New York: Columbia University Press.

Yoshida, Seiichi. 1942. Gendai sakka kenkyū sōsho 121: Akutagawa Ryūnosuke. Tōkyō: Nihon tosho sentā, kono ban 1993.

Yoshimoto, Midori. 2005. *Into Performance: Japanese Women Artists in New York.* New Brunswick, NJ: Rutgers University Press.

Yoshimoto, Mitsuhiro, Eva Tsai, and JungBong Choi, eds. 2010. *Television, Japan, and Globalization.* Ann Arbor, MI: Center for Japanese Studies.

Yu, Beongcheon. 1972. *Akutagawa: An Introduction.* Detroit, MI: Wayne State University Press.

Zahlten, Alexander. 2007. "The Role of Genre in Film from Japan: Transformations 1960s–2000s." Ph.D. Johannes Gutenberg-Universitaet Mainz (Germany). Germany: *ProQuest Dissertations & Theses Full Text, ProQuest Dissertations & Theses Global.*

———. 2017. *The End of Japanese Cinema: Industrial Genres, National Times, and Media Ecologies.* Durham, NC: Duke University Press.

Index

Page numbers in boldface type refer to illustrations.

adaptation: *Alice* around the world and, 3–6, 20–23, 159; audience response and, 98,105, 127; characters and, 32–33, 128; definitions of, 23–26, 104–105, 136–137; Eiji Ōtsuka and, 12, 14–15, 26; in Japan, 7–16; liminality and, 35, 36, 112–113, 173–174; plagiarism and, 125–126; reasons for, 126–128; reception of English literature and, 16–19, 22, 42–43, 45–48, 51–53, 59; scholarly production and, 26–33; *sekai/shukō* and, 14. *See also* film; *kaisaku*; manga; translation

Ai-chan's Dream Story (*Ai-chan no yume monogatari*), 47

Akechi, Kogorō, 141, 142, 144, 151, 154, 169

Akutagawa, Ryūnosuke, 27, 53–54: *Alice Story* and, 39, 56–59, 70; authorial career of, 53–56, 195n21; foreign adaptations and, 54–56, 195n24, 196n25; Kan Kikuchi and, 27, 39, 58–59, 63–64, 68, 193n1, 196n28; *Kappa* and, 57, 59–68; kappa illustrations of, 36–37, **60**, 69–73; madness and, 57–58, 67–8, 72; memorialization of, 54, 56–58, 60–61, 65, 70, **71**, 72–73; suicide of, 54, 67–8, 195n23. See also *Alice Story*; *Kappa*

Alice in Borderland (*Imawa no kuni no Arisu*), 38, 106, 115–116, 176, 187

Alice in the Country of Hearts, 10–12, 177, 183, 188, 191n3

Alice in Gothicland (*Arisu in Goshikkurando*), 167, **168**, 185–186

Alice in Mirrorland (*Kagami no kuni no Arisu*), 149, 168, 200n6. *See also* Hirose, Tadashi

Alice in Murderland, 1, 117–123, **120, 121**, 131, **133**, **135**, 189–190; multiplicity in, 118, 119, 122–123

Alice's Adventures in Wonderland, 15, 42, 46, 49, 50, 190; and Alice in Wonderland name, 5–6; Japanese translations of, 18, 27–29, 31, 42–43, 51, 52, 68, 70; Lewis Carroll and, 6, 29, 42; manga adaptations of, 112, 119, 129, 119n20. See also *Alice Story*; *Kappa*; *Mirror World*

Alice's Adventures Under Ground, 6, 7, 15, 42, 43, 191n7

Alice School (*Gakuen Arisu*), 113–114

Alice's Dream Story (*Arisu yume monogatari*), 52

Alice Story, 39, 56–59, 70; illustrations in, 68–73; *Kappa* and, 60–65

anime, 19, 40, 98, 106, 146, 148, 157, 170–171; adaptation and, 22, 24, 25–26, 123, 127, 134–136, 158–160, 161, 175, 192n14; as part of Japanese media environment, 9; dynamic immobility of, 77, 103; media mix and, 10–11, 14, 25, 26, 110, 111, 161, 166. See also *dōjinshi*; film; magazines; manga

Anne of Green Gables, 20–22, 134, **135**

Are You Alice?, 114–117, 165–166, 201n18

Arisugawa, Alice, 150–153, 167, **168**. *See also* Uehara, Masahide

Arisu monogatari. See *Alice Story*

217

218 Index

Astro Boy, 25, 32, 126. *See also* Tezuka, Osamu
Ā yū Arisu?. See *Are You Alice?*
Azuma, Hiroki, 13, 14

Batman, 145, 146–147
Benjamin, Walter, 24, 36
Betsuyaku, Minoru, 29, 30
Black Butler, 14, 21, 157, 165, 201n17, **Plate 13**
Breton, André, 29
Brontë, Emily, 16–17

Carroll, Lewis: adaptations of, 14–15, 59, 88–89, 101, 173, 195n19; Charles Lutwidge Dodgson and, 5, 83; children's literature and, 48; idea of "Alice in Wonderland" and, 5–7, 14, 42–43; Japanese scholarship and, 27–31. *See also* Lewis Carroll Societies
Cat's Eye (Kyattsu ai), 153–154
characters (theories of), 6–7, 15, 25–26, 32–35, 37, 45–46, 171, 173; in the art of Yayoi Kusama, 76–77, 91–92, 96, 98, 103; in the manga of Kaori Yuki, 130–131, 132–136; in the mystery genre, 142–143, 150–151, 152–153, 154, 156, 160–162, 167, 168–169, 178; multiplicity and, 112–115, 118, 122–123, 128; silhouettes and, 69–70, 72, 172
Cheshire Cat, 122, 153, 167, **168**, 198n7
Chesterton, G. K., 29
children's literature, 28–29, 39, 43–49, 57, 70, 72, 193n6
Chimori, Mikiko, 44, 50, 56–57
China, 16, 46–47, 194n10, 194n11
Christie, Agatha, 139, 144, 191n4
CLAMP, 3, 179–180: *Alice* adaptations and, 128–129, 155–157, 169; detective fiction of 128–129, 142, 154–155, 168; *dōjinshi* and, 110–111, 154–155, 200n11; media mix production of, 158–162, 169; polymorphic worlds and, 157–158. See also *CLAMP School Detectives*; *CLAMP in Wonderland*; *Miyuki-chan in Wonderland*; *Tokyo Babylon*; *X/1999*

CLAMP in Wonderland, 161–162
CLAMP School Detectives, 154–155, 168
Cornell, Joseph, 175, 191n4
Count Cain, 129–131, 136, 199n17, 199n19, 201n17

Dalí, Salvador, 5, 175
Deleuze, Gilles: sense and, 34–35
detective fiction, 138–139. *See also* mystery (genre)
digital media, 2, 19, 57, 164, 180, 194; (theories of), 34, 98, 157–158, 172, 174–175
Dodgson, Charles Lutwidge, 5, 83. *See also* Carroll, Lewis
dōjinshi, 180; adaptation and, 111, 123, 127, 128; definition of, 26, 110, 123, 198n9, 198n10; girls' culture and, 110–112, 197n3; plagiarism and, 125–126; publication process of, 123–124, 132, 154–155, 159, 162, 192–193n14, 198n11. *See also* film; magazines; manga
Doyle, Sir Arthur Conan, 18, 141, 144, 152. *See also* Holmes, Sherlock

Edogawa, Ranpo, 140–144, 150, 151, 153, 166, 200n3, 200n10
English literature, 16–19, 42–43; Lewis Carroll and, 14–15, 59, 88–89, 101, 173, 195n19; reception of, 16–19, 22, 43–45, 46–47, 48–53, 59. See also *Anne of Green Gables*; Brontë, Emily; Chesterton, G. K.; Christie, Agatha; Doyle, Sir Arthur Conan; Twain, Mark
Eureka (Yurīka), 27, 29, 30, 31, 190, 193n15
explanation (*kaisetsu*), 27–29

fashion: gender and, 9, 83, 134–136, 104–105, 160, 163–165; girls' culture and, 104–105, 111; Lolita style of, 3, 163–165, 193n17, 200n15, 201n16; modernization and, 44, 45–46; visual kei style of, 163–164; within Alice depictions, 7, 35, 53, 68–69, 201n20, 193n3, **Plate 3**, **Plate 9**; Yayoi Kusama and, 76, 79, **80**, 83, 89–90, 91
film, 3, 19, 160, 162, 170–172, 181–182, 183, 184; adaptation and, 126–128, 144, 158,

164, 174, 175, 192n13; analysis of, 8–9, 34, 98, 161–162; Japanese history and, 40, 60. See also *kaisetsu*; Walt Disney, Co.
Fushigi no kuni no Miyukichan. See *Miyuki-chan in Wonderland*

Gackt, 124. *See also* Malice Mizer, Mana
genbun itchi, 47–48
girls' culture: Lolita fashion and, 163–164; origins of, 106–108; subversive potential of, 107–108; theories of liminality in, 37–38, 105–106, 111–112. See also *dōjinshi*; *hirahira*; Honda, Masuko; magazines; manga
Gothic & Lolita Bible (*Goshikku ando Rorīta Baiburu*), 164, 165, 180, **Plate 11**
Grand Guignol Orchestra, 129, 131–137
Gulliver's Travels, 61, 63, 64, 65, 72, 195n24, 196n34
Gundam, 11

Hasegawa, Tenkei: *genbun itchi* and, 47; *Mirror World* and, 39–40, 43–44, 45, 48–52; plagiarism and, 68. See also *Mirror World*
Hasegawa, Yuko, 90, 92
Hatori, Bisco, 112–113, 180
Hello Kitty, 9, 158
hero series (genre), 147, 148, 150, 153, 154, 155, 166, 200n5
hirahira, 37, 105–106: *Alice* manga and, 106, 113, 115, 136–137; girls' culture and, 111–112, 163; subversive potential of, 111–112. *See also* Honda, Masuko
Hirai, Takako, 5, 31, **Plate 2**
Hirasawa, Bunkichi, 68–69
Hirose, Tadashi, 148, 149, 168, 200n6. See also *Alice in Mirrorland*
Holmes, Sherlock, 18, 141, 142, 154, 167
Honda, Masuko: theory of liminality and, 30, 31, 37–38, 105–106, 111–112, 163. *See also* girls' culture; *hirahira*
honkadori, 13. *See also* poetry; theater
Houghton, Georgiana, 83–84, 87, 88, 89
Hunting of the Snark, 6, 42, 43, 191n7
Hutcheon, Linda, 24, 104–105, 126–127, 174

Igarashi, Yumiko, 112
Infinity Mirrored Room, 74–75, 76–77, 96, 101, **Plate 5**. *See also* Kusama, Yayoi
Inoue, Takehiko, 125
Ishikawa, Takashi, 149
iteration. See *shukō*

Jenkins, Henry, 10, 12, 174

kabuki: actors of, 164, 198n12; *sekai/shukō* and 12–14, 197n3
Kagami sekai. See *Mirror World*
kaisaku, 24. *See also* adaptation; translation
kaisetsu. *See* explanation (*kaisetsu*)
Kakei no Arisu. See *Alice in Murderland*
Kako, Yuko, 108, 109, 197n1
kamishibai, 40–41, 113, 182
Kappa: adaptation and, 66–68, 143, 173, 195n24, 196n31; *Alice Story* and, 60–65; other influences on, 196n30, 196n34; Ryūnosuke Akutagawa and, 57, 59–68, 69–73; silhouettes and, 70–73
Karatani, Kōjin, 47
Katagiri, Ikumi, 114, 182, 201n18. See also *Are You Alice?*
Kawana, Sari, 139, 140, 141
Kikuchi, Kan: *Alice Story* and, 58; early career of, 58; legacy of, 27, 39, 158, 196n29; Ryūnosuke Akutagawa and, 27, 39, 58–59, 63–64, 68, 193n1, 196n28; translation activities of 58–59, 158
Kinoshita, Shinichi, xi, 12, 59, 113
Kōga, Yun, 112
Komaki, Momoko, 11, 182
Konaka, Chiaki J., 1, 3, 19, 175, 183
Korea, 3, 5, 53, 195n18
Kotani, Mari, 31, 109, 197n1
Kuroiwa, Ruikō, 140–141, 200n2
Kuroko's Basketball, 11, 170–172
Kusama, Yayoi: Alice happenings and, 84–89; Alice oeuvre and, 28, 37, 75, **85**, 87–89, **95**, 99–100, 103; *Alice's Adventures* and, 92–96, **Plate 6**; audience relationship and, 76–77, 81, 89–90, 94, 96, 153; early career of, 75–76, 81–82; fashion and, 76, 79, **80**, 83, 89–90, 91;

220 Index

gender and, 77, 81–83, 84, 103; liminality and, 75–76, 95; mental illness and, 77–79; mirrors and, 100–101, **Plate 5**; as modern Alice, 3, 87–89, 94–95; polka dots and, 73, **80**, 89–96, **Plate 6**; self-portraits of, 76–77, 79–84
Kusumoto, Kimie, 18, 31, 51, 56, 93–94, 95
Kusuyama, Masao, **51**–52, 59, 63, 64. See also *Wonderland*
Kuwata, Jiro, 146–147

Las Meninas, 81, 96, 97
Leblanc, Maurice, 141, 144, 158
Lewis Carroll Societies, 18–19, 31. *See also* Carroll, Lewis
Liddell, Alice: as inspiration for *Alice*, 6, 42, 59, 96, 113, 115; sisters and, 130–131
light novel, 166–167, 169, 201n19. See also *Alice in Gothicland*; Komaki, Momoko
liminality: adaptation and, 35, 36, 112–113, 173–174; Alice and, 33–38, 138, 156, 158, 163–164, 167–168, 172–176; characters and, 32–35; contemporary culture and, 172–173, 176; girls' culture and, 37–38, 105–106, 111–112; mystery (genre) and, 138–139, 158, 166, 167, 168, 169; Yayoi Kusama and, 75–76, 95. See also *hirahira*; mystery (genre); silhouette
Lippit, Akira, 34, 61, 66–67, 196n33
Lippit, Seiji, 54, 61, 195n24
Lolita: Alice adaptations and, 165–167, 169, 193n17, **Plate 11, Plate 12**; fashion of, 3, 163–165, 193n17, 200n15, 201n16; gender and, 163–164, 165–166; girls' culture and, 163–164; visual kei and, 163–164
looking-glasses, 34, 96–99, 129–131, 136, 149, 168, 172, 199n17, 200n6; Yayoi Kusama and, 37, 79, **80**, 81, 87, 88, 96–99, 100–102
Lupin, Arsène, 141–142, 158. See also *Lupin III*, phantom thief
Lupin III, 128, 200n9

Mad Hatter: adaptations and, 70, 173, 200n7; advertising and, **4**; Carroll's *Alice* and, 35, 63; Kaori Yuki and, 117, 118, 134, 136; Yayoi Kusama and, **85**, 87–88

magazines: *dōjinshi* and, 111; fashion and, 163–164; gendering of, 48–49, 52–53, 106–109, 116–117, 194n14; manga eclipse of, 36, 109–110, 115–117, 166; Meiji modernization and, 43–53; silhouettes and, 69–70. See also *dōjinshi*; manga
Malice Mizer, 124. *See also* Gackt; Mana
Mana, 164. *See also* Malice Mizer
manga, xi, 1, 3, 9, 24, 40; adaptation and, 37–38, 104–105, 112–115, 126–128; centrality of, 10, 36, 126; *dōjinshi* and, 26, 110–111, 125, 192n14; Eiji Ōtsuka and, 12–14, 26; girls' culture and, 106, 109–112, 197n3; *hirahira* in, 105–106; literature and, 109–110 ; male Alice adaptations and, 66, 113–117, 198n5, 198n10. See also *Alice School*; anime; *Are You Alice?*; *Astro Boy*; *Black Butler*; CLAMP; *Count Cain*; *dōjinshi*; Igarashi, Yumiko; magazines; Mizuki, Shigeru; Mochizuki, Jun; Ōtomo, Katsuhiro; *Ouran High School Host Club*; *Pandora Hearts*; *Princess Princess*; Toboso, Yana; Watase, Yū; *X/1999*; Yuki, Kaori
McLuhan, Marshall, 7, 8, 34, 157
media mix: anime and, 10–11, 25, 26, 110, 111, 161, 166; CLAMP and, 159–161; cultural production of, 8–13, 15–16, 21, 22–23, 36, 158; Eiji Ōtsuka and, 12–14, 26, 156–157; environment of, 7–9, 14–15, 36; liminality and, 172–173; Marc Steinberg and, 25; mystery (genre) and, 144–145; Yayoi Kusama and, 76, 77, 92
mirrors. *See* looking-glasses
Mirror World: genre and, 50–52; Hasegawa Tenkei and, 39–40, 43–44, 45, 48–52; plot of, 49–50; serialization of, 43–44; *Through the Looking Glass* and, 43–45, 48, 50–51; *Youth World* and, 43–44, 48–49, 52
MischMasch, 18, 31
Mishima, Yukio, 3, 28, 144, 193n4
Miyuki-chan in Wonderland, 128–129, 155–156, 157, 161–162, 179
Mizuki, Shigeru, 127, 148
Moai Island Puzzle (*Kotō Pazuru*), 151–152, 178

Index 221

Mochizuki, Jun, 114, 165
Momijigari, 40, 198n12
Momma, Yoshiyuki, 3, 19, 29, 30
Monden, Masafumi, 9, 15–16, 163, 200n15
Moriguchi, Yūji, 35, **Plate 1**
mystery (genre): definition of, 138; early
 development of, 139–143; global commons
 of, 140–141; liminality and, 138–139, 158,
 166, 167, 168, 169, 172; *New Orthodox* style
 of, 150, 152, 168–169; *Orthodox* and
 Society styles of, 144–145, 147, 149–150,
 152, 153, 166–169, 200n4; postwar
 expansion of, 143–148. See also *Alice in
 Gothicland*; Arisugawa, Arisu; Chesterton,
 G. K.; Christie, Agatha; CLAMP; Doyle,
 Arthur Conon; Holmes, Sherlock;
 Leblanc, Maurice; Lupin, Arsène; Ranpo,
 Edogawa; Uehara, Masahide

Nanbō, Hidehisa, 167, 168. See also *Alice in
 Gothicland*
Neo Parasyte f, 127, 129
Ninomiya, Ai, 114, 201n18. See also *Are You
 Alice?*
Nursery Alice, The, 6, 7, 42–43, 191n7, **Plate 3**

Oguri, Mushitarō, 143
Oshii, Mamoru, 112, 114
Ōtomo, Katsuhiro, 106, 112, 187
Ōtsuka, Eiji: adaptation and, 12, 14–15, 26;
 media mix and, 7, 12–14, 26, 156–157;
 sekai/shukō and, 12–14, 192n8
Ouran High School Host Club (*Ouran kōkō
 hosutobu*), 112–113, 115, 180, 187, 198n4

Pandora Hearts (*Pandora hātsu*), 114, 115,
 116, 165, 166
phantom thief (character type), 142,
 153–154, 166, 200n9. See also mystery
 (genre); *Please, Twenty Masks!*;
 Tanemura, Arina
Phantom Tower, The (*Yūreitō*), 140, 141, 142
Please, Twenty Masks! (*Nijū Mensō ni
 onegai!*), 142, 154–155, 159, 160
poetry: *honkadori* and, 13; media and, 27,
 29–30, 107, 198n9; Yayoi Kusama and, 76

Princess Princess, 104–105, 113, 127, 128, 137,
 Plate 7
Princess Tutu, 25

Queen of Hearts, **2**, 37, 66, 134, 172, 198n6,
 199n20. See also *Grand Guignol
 Orchestra*
QuinRose, 10–12, 191n3. See also *Alice in the
 Country of Hearts*

Ranpo. *See* Edogawa, Ranpo
Resident Evil (*Baiohazādo*), 98, 159
Reynard the Fox. See *Story of Reynard the Fox*
Ruikō. *See* Kuroiwa, Ruikō

Saitō, Mokichi, 64, 65
Saito, Satomi, 174–175
Sakamoto, Maaya, 32
Saltzman-Li, Katherine, 13
sekai: definition of, 12–13; Eiji Ōtsuka and,
 12–14, 192n8; Yayoi Kusama and, 197n3
Serial Experiments Lain, 98–99, 174–175, 183
Shamoon, Deborah, 13, 107, 109, 110, 111
Shimazaki, Satoko, 13
shōjo: definition of, 49; literary audience of,
 52, 64, 106, 116; social codification of,
 48–49
shōnen: definition of, 49; literary audience
 of, 52, 64, 106, 116; social codification of,
 48–49
Shōnen sekai. See *Youth World*
shukō: definition of, 13; Eiji Ōtsuka and,
 12–14, 192n8
silhouette: Alice and, **2**, 36–37, 47, 69–73;
 qualities of, 36–37, 41; Ryūnosuke
 Akutagawa and, 54, 60, 70–73. See also
 kamishibai; *hirahira*; liminality
Steinberg, Marc: characters and, 32–33, 103;
 media mix theory and, 25, 37, 91
Story of Reynard the Fox, 64, 65
Suetsugu, Yuki, 125
Swift, Jonathan. See *Gulliver's Travels*
Sword Art Online, 21, 174, 175, 182, 187

Takahashi, Yasunari, 19, 29
Takarazuka Revue, 107

222 Index

Takayama, Hiroshi, 30–31
Takemiya, Keiko, 106, 112, 188
Tamamura, Yoshiko, 108
Tanemura, Arina, 142, 200n9
Tanizaki, Jun'ichirō, 27, 57, 111, 196n25, 196n26
Tatsumi, Takayuki, 28–29, 31, 144, 149
Tenniel, John, 15, 27, 68, 114, 134, 158, 165, 201n20, **Plate 3**
Terayama, Shūji, 30
Tezuka, Miwako, 100–101, 102, 103
Tezuka, Osamu, 126, 200n11
theater, 13, 40–41, 164, 192n13. See also *honkadori*; kabuki; *kamishibai*
Through the Looking-Glass: illustrations in, 7, 68–70; Japanese translations of, 18, 29, 43–44, 47, 49–53; Kaori Yuki and, 117–118, 131, 134; Lewis Carroll and, 5, 42, 191n5, 191n7; Yayoi Kusama and, 37, **85**, 87, 88. See also *Mirror World*
Toboso, Yana, 14, 21, 157, 165, 175, 201n17
Tokyo Babylon, 155, 156, 160–161, **Plate 9, Plate 10**
translation: Alice and, 3, 5, 20–23, 27–28, 53, 193n3, 195n18–19; early Alice corpus and, 31, 39–40, 43, 44–45, 48, 192n11; modern development of, 20–21, 48, 57, 194n11; names and, 47–48; relationship to original text of, 16–19, 193n4; Ryūnosuke Akutagawa and, 42, 58, 59, 64; women and, 93–94, 108–109, 111. *See also* adaptation; *kaisaku*
Travels in Looking-Glass Land (*Kagamigoku meguri*), 69–70
Tsuda, Mikiyo, 104, 105, 127–128, 137, 188, **Plate 7**
Twain, Mark, 17, 20, 42

Uehara, Masahide, 150–153, 168–169, 173, 200n8. See also *Arisugawa, Alice*
Unno, Seikō, 68, 69, 196n36
Urasawa, Naoki, 126

video games, 177, 182, 183; Alice adaptations and, 3, 5, 6, 19, 98, 153, 201n18; CLAMP and, 159–160, 161; contemporary culture and, 1, 3, 9, 11, 106, 111, 159; *dōjinshi* and, 111, 123, 159–160, 161, 193n14, 198n9; gender and, 104, 107; QuinRose and, 10, 11; Walt Disney, Co. and, 21–22
visual kei: characteristics of, 124; fashion and, 163–164; Kaori Yuki's use of, 124–125, 128, 132; Lolita culture and, 163–164

Wada, Shinji, 113
Wakabayashi, Judy 44–45, 193n6
Walt Disney, Co.: Alice and, 1, **2**, 5, 21–22, 25, 28, 88, 175, **Plate 4**; fashion and, 164, 165
Washio, Tomoji, 70
Watase, Yū, 126
Wizard of Oz, The, 32, **135**, 136
women: liminal potential of, 33–34; literary and artistic expression of, 82, 108–111; literary gendering of, 49, 52–53, 57, 107; as manga/*dōjinshi* authors, 110–111, 125–126; modernity and, 44–46, 108–109; as translators, 108–109, 197n1. *See also* girls' culture; hirahira; Houghton, Georgiana; Kusama, Yayoi
Wonderland (*Fushigi no kuni*), **51**, 59
Wondrous Garden, The (*Fushigi na oniwa*), 70
world. See *sekai*

X/1999, 156, 161

Yamato, Waki, 112, 126
Yoshida, Seiichi, 57, 61, 64, 65
Youth Garden (*Shōnen'en*), 49
Youth World: *Mirror World* and, 43–44, 48–49, 51, 52
Yuki, Kaori: *dōjinshi* career of, 110, 123–125, 132; Gemsilica and, 132–136; iterative storytelling and, 129–131, 136, 199n15; manga career of, 1, 106, 123–128, 136, 154, 157, 198n8; *visual kei* and, 124–125, 128, 132. See also *Alice in Murderland*; *Count Cain*; *Grand Guignol Orchestra*; *Neo Parasyte f*

About the Author

Amanda Kennell is an assistant professor of East Asian Languages and Cultures at the University of Notre Dame. Her work has been published by the British Museum and in *Journal of Adaptation in Film & Performance, Journal of Popular Culture, Film Criticism,* and the *Washington Post.* She hosts a podcast about scholarly books for the New Books Network.